THE RAMA EPIC

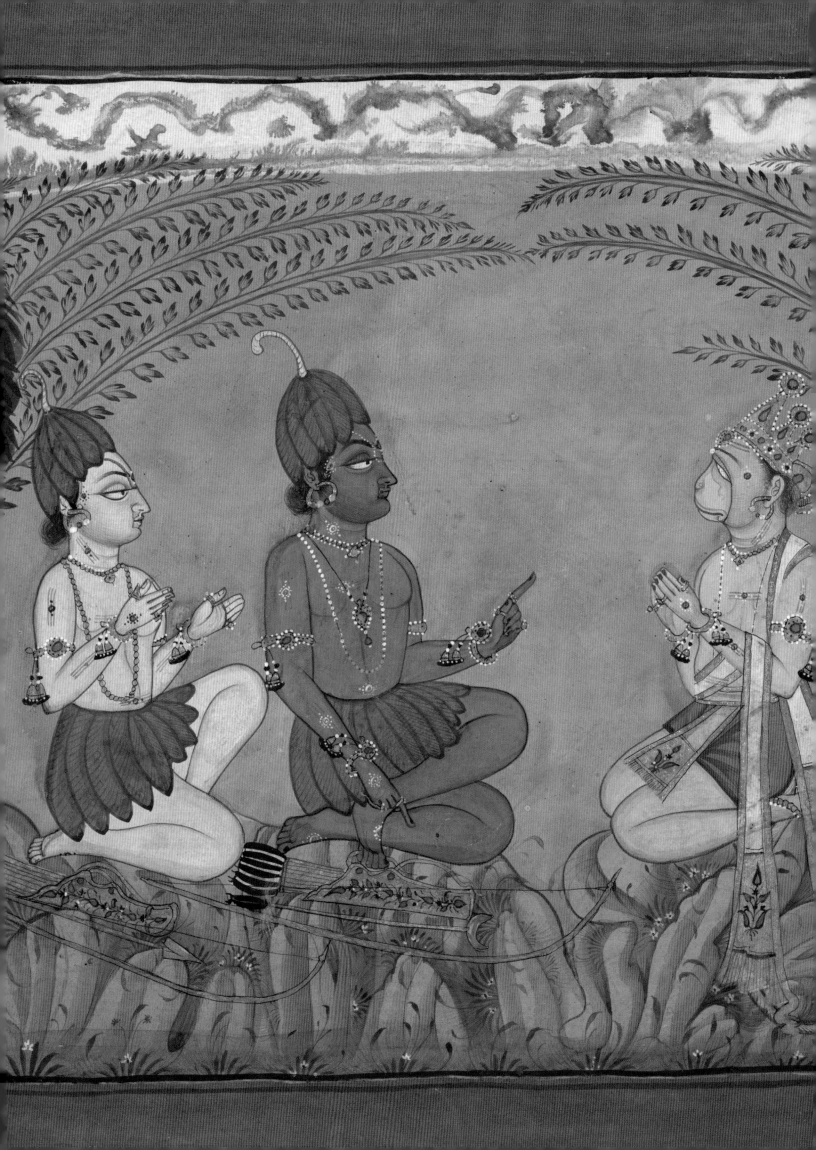

THE RAMA EPIC

Hero
Heroine
Ally
Foe

EDITED BY FORREST McGILL

Introduction Pika Ghosh

Essays Robert P. Goldman
Sally J. Sutherland Goldman
Philip Lutgendorf
Forrest McGill

Entries Qamar Adamjee
Jeffrey Durham
Pika Ghosh
Forrest McGill
Natasha Reichle

ASIAN ART MUSEUM
SAN FRANCISCO

⩓ Asian

Published by
Asian Art Museum
Chong-Moon Lee Center for Asian Art and Culture
200 Larkin Street
San Francisco, CA 94102
www.asianart.org

Copyright © 2016 by Asian Art Museum
Printed and bound in China
19 18 17 16 4 3 2 1
First edition

LIBRARY OF CONGRESS CATALOGING-IN-PUBLICATION DATA
Names: McGill, Forrest, 1947– editor. | Ghosh, Pika, 1969–
 writer of introduction. | Goldman, Robert P., 1942– |
 Sutherland Goldman, Sally J. | Lutgendorf, Philip. | Asian
 Art Museum of San Francisco, organizer, host institution.
Title: The Rama epic : hero, heroine, ally, foe / Edited by
 Forrest McGill ; Introduction by Pika Ghosh ; Essays by
 Robert P. Goldman, Sally J. Sutherland Goldman, Philip
 Lutgendorf, and Forrest McGill ; Entries by Qamar Adamjee,
 Jeffrey Durham, Pika Ghosh, Forrest McGill, and Natasha
 Reichle.
Description: San Francisco : Asian Art Museum, 2016. | Includes
 bibliographical references and index.
Identifiers: LCCN 2016005075| ISBN 9780939117765 (hardback) |
 ISBN 9780939117772 (paperback)
Subjects: LCSH: Vālmīki. Rāmāyaṇa —Illustrations—
 Exhibitions. | Rāma (Hindu deity)—Art—Exhibitions. |
 Arts, South Asian—Themes, motives—Exhibitions. | Arts,
 Southeast Asian—Themes, motives—Exhibitions. | BISAC:
 ART / Asian.
Classification: LCC NX680.3.R35 R35 2016 |
 DDC 700/.48294592—dc23
LC record available at http://lccn.loc.gov/2016005075

Grateful acknowledgment is made for permission to reprint
the following copyrighted work. Selection adapted from
Robert P. Goldman, "Introduction," in *Bālakāṇḍa*, Book 1 of
The Rāmāyana of Vālmīki: An Epic of Ancient India, translation
and annotation by Robert P. Goldman and Sally J. Sutherland.
© 1984 Princeton University Press. Reprinted by permission of
Princeton University Press.

Published on the occasion of the exhibition

THE RAMA EPIC
Hero, Heroine, Ally, Foe

presented at the Asian Art Museum–Chong-Moon Lee Center
for Asian Art and Culture, October 21, 2016–January 15, 2017.

The Rama Epic: Hero, Heroine, Ally, Foe is organized by the
Asian Art Museum. Presentation at the Asian Art Museum
is made possible with the generous support of Helen and
Rajnikant Desai, The Akiko Yamazaki and Jerry Yang Fund
for Excellence in Exhibitions and Presentations, Martha Sam
Hertelendy, Vijay and Ram Shriram, Society for Asian Art,
Meena Vashee, Kumar and Vijaya Malavalli, and Nordstrom.

Major support of the exhibition publication
is provided by Society for Art & Cultural
Heritage of India.

The Asian Art Museum–Chong-Moon Lee Center for Asian
Art and Culture is a public institution whose mission is to lead
a diverse global audience in discovering the unique material,
aesthetic, and intellectual achievements of Asian art and culture.

p. ii: Hanuman before Rama and Lakshmana, cat. no. 86 (detail)
p. v: Shadow puppet of Rama, cat. no. 9 (detail)
p. vi: Vishvamitra leads Rama and Lakshmana to the forest,
 cat. no. 12 (detail)
pp. 20–21: Rama and Lakshmana on Mount Prasravana,
 cat. no. 34 (detail)
pp. 98–99: Rama's concerns for Sita, cat. no. 59 (detail)
pp. 144–145: Hanuman leaps across the ocean, cat. no. 93 (detail)
pp. 196–197: The demon Maricha tries to dissuade Ravana,
 cat. no. 119 (detail)
p. 258: Hanuman returns with medicinal plants, cat. no. 97
 (detail)
p. 260: Rama, cat. no. 5 (detail)
p. 267: Rama and his companions cross the Ganges River into
 exile, cat. no. 18 (detail)

Distributed by:
North America, Latin America, and Europe
Tuttle Publishing
364 Innovation Drive
North Clarendon, VT 05759-9436 U.S.A.
Tel: 1 (802) 773-8930; Fax: 1 (802) 773-6993
info@tuttlepublishing.com
www.tuttlepublishing.com

Asia Pacific
Berkeley Books Pte. Ltd.
61 Tai Seng Avenue #02-12
Singapore 534167
Tel: (65) 6280-1330; Fax: (65) 6280-6290
inquiries@periplus.com.sg
www.periplus.com

Epic's purpose is to make
the distant past as immediate
to us as our own lives, to make
the great stories of long ago
beautiful and painful now.

—Adam Nicolson,
Why Homer Matters

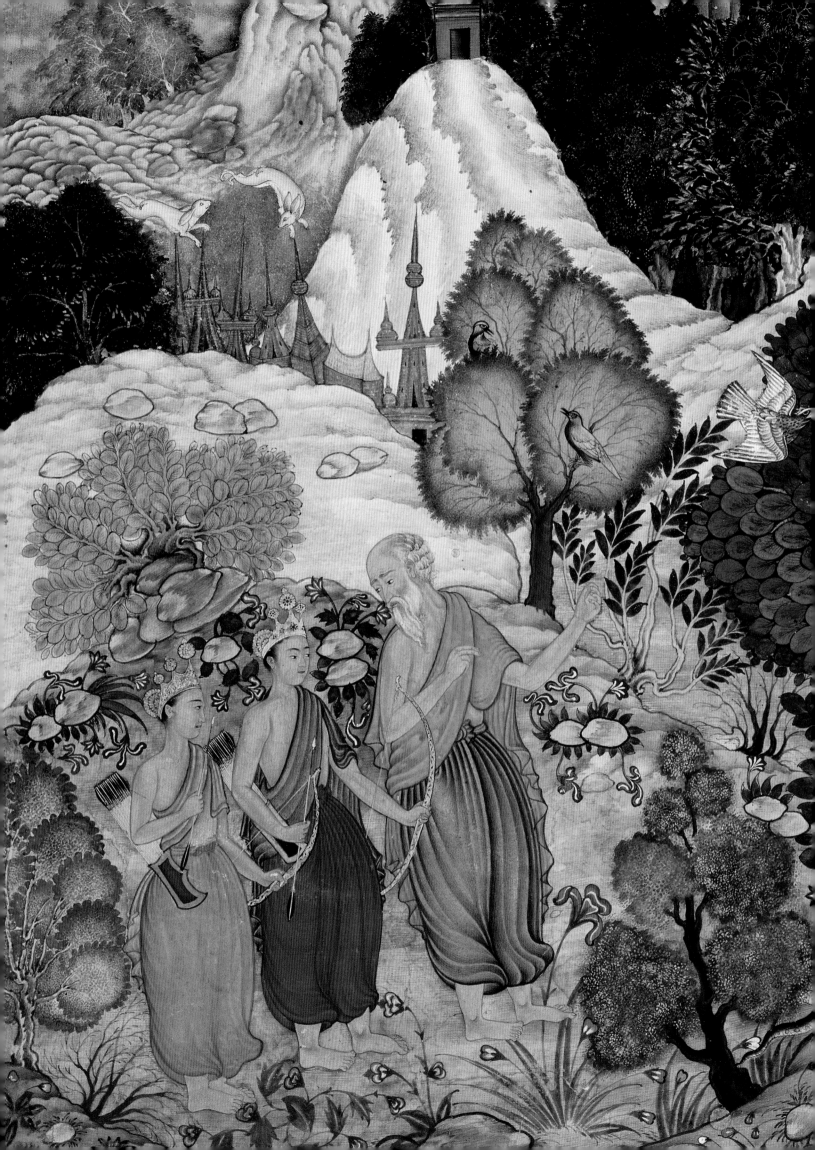

Contents

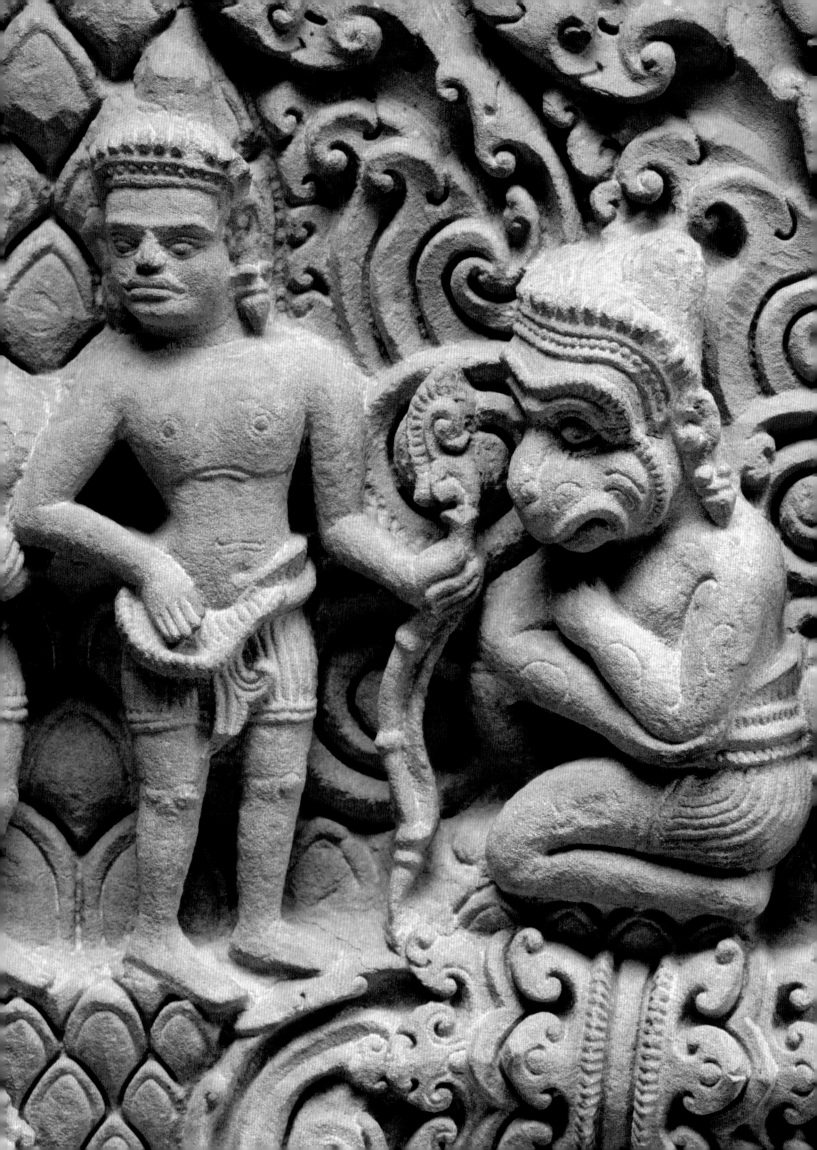

Foreword

The Rama epic is a magnificent story from ancient northern India. Yet it has timeless value and myriad manifestations in different cultures, particularly across South and Southeast Asia. The story evinces itself in a global setting. In fact, my first encounter with the epic was during a trip to Myanmar. It was engulfing; I became totally mesmerized by it. And my experience was not unique. People from every culture bring their own appreciations of the power of the story to their understandings of it.

Though its tale is thousands of years old, the Rama epic is a living tradition and is constantly evolving, being reenacted in endless realizations in both visual and performing arts. The story remains relevant because its lessons are applicable to many real-life situations. In today's globalized world, the Rama epic provides not only a means but also substance for us to understand the past and present of India and their significance to our lives. San Francisco has always been at the forefront of introducing Asian art, culture, and religion to the United States, and the Asian Art Museum of San Francisco is very happy that we are the first American museum to mount such a comprehensive exhibition of the Rama epic and all its magical tellings, including sculpture, painting, and narrative and theatrical arts.

The exhibition and this, its publication, celebrate the fiftieth anniversary of the Asian Art Museum, as they hark back to the museum's founding principle of serving as a bridge to understanding between the United States and Asia. That principle has inspired a new vision for the museum since I joined six years ago: to connect art of the past with art of the present.

FACING
Detail of cat. no. 32

Through both missions, the museum aims to connect art to life by making artworks—no matter when and where they were made—engaging for our lives today. In sharing a story that crosses both place and time, *The Rama Epic* manifests both our founding principle and our new vision.

Many people and institutions came together to stage *The Rama Epic*. I am indebted to Helen and Rajnikant Desai, The Akiko Yamazaki and Jerry Yang Fund for Excellence in Exhibitions and Presentations, Society for Asian Art, and Nordstrom for their generosity; this project would not have been possible without them. Additional thanks go to Society for Art & Cultural Heritage of India for their kind support of this publication. I am grateful to all of the museums, libraries, and private collectors who have lent artworks to this exhibition and thus allowed us to present such a wide variety of material. Thanks to Forrest McGill, Wattis Senior Curator of South and Southeast Asian Art of the Asian Art Museum, for conceiving and spearheading *The Rama Epic*. His inventive approach and tireless efforts have produced an exceptional work. I extend further gratitude to Forrest's collaborating curators at the museum—Qamar Adamjee, Jeffrey Durham, and Natasha Reichle. Each brought a unique perspective that added depth and breadth to the exhibition and book. Finally, I offer my sincere appreciation to essayists Pika Ghosh, Robert P. Goldman, Sally J. Sutherland Goldman, and Philip Lutgendorf, whose specialties in literature and cultural studies as well as art history enriched this book.

Jay Xu
Director, Asian Art Museum of San Francisco

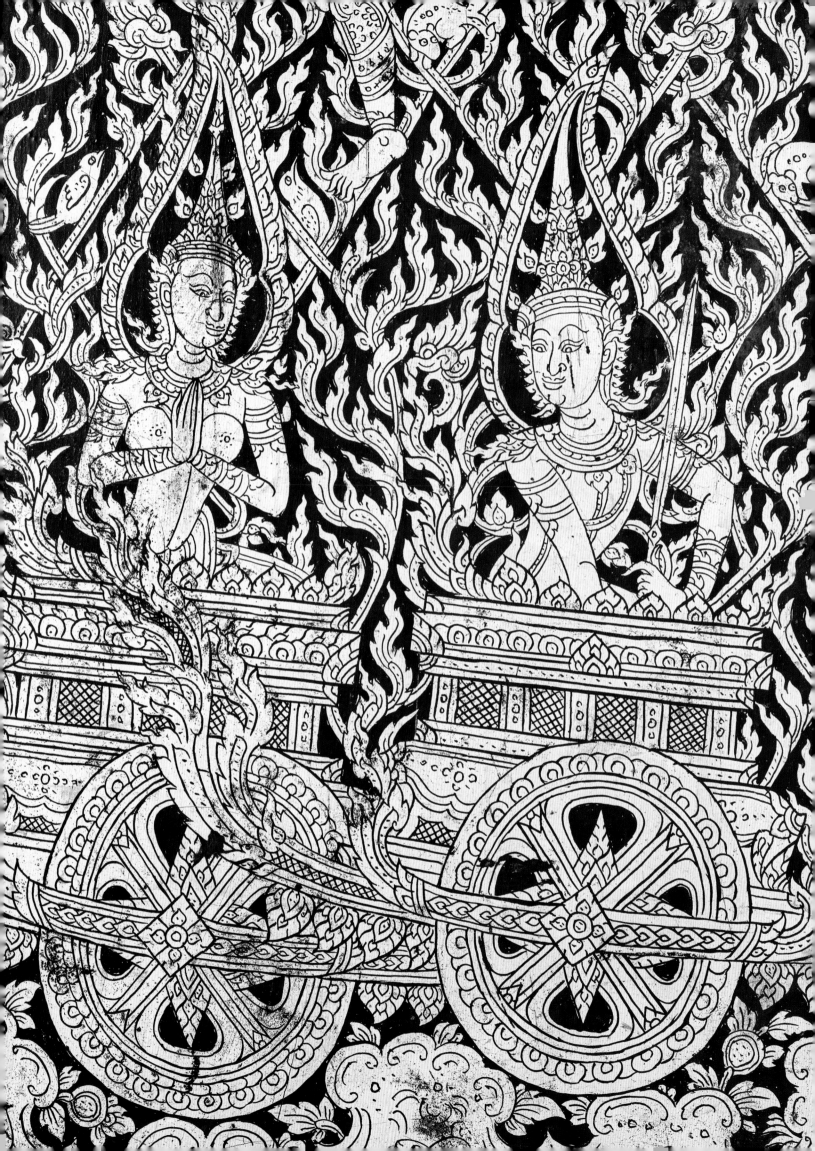

Preface

For most people of South Asian heritage, the cultural importance of the Rama epic is a given. For others to gain a sense of its importance (and pervasiveness), they could think of the legends of King Arthur. Camelot (as both a mythic place and a sociopolitical ideal), Excalibur, the sword in the stone, the Lady of the Lake, Merlin, the knights of the Round Table, Lancelot and Guinevere —whether any of us can recount the legends of King Arthur in an orderly way, these names and themes are likely to resonate. But the person of non-South-Asian heritage must then imagine the importance of the Arthurian stories doubled or quadrupled, and must add a powerful religious dimension. American Hindus have repeatedly reminded us that "the Ramayana is our Bible."

Just as the Arthurian stories have for centuries been conveyed in poetry, bardic storytelling, drama, amateur reenactments, puppet theater, opera and ballet, painting and sculpture, and, more recently, in movies, television, and video games, so have the stories of Rama and his allies and adversaries. But in addition, Rama, Sita, and Hanuman are recognized by millions of Hindus as deities (Rama and Sita as ultimate, transcendent ones and Hanuman as the most widely worshiped in the Hindu world). They are honored with offerings, processions, and hymns. Further, the epic and its

FACING
Detail of cat. no. 41

characters have become increasingly politicized, with office-seekers using them as ideals of well-ordered society and good governance to strive toward, or as wedges to drive apart neighbor from neighbor and rouse communal or partisan passions.

This publication and the exhibition that it accompanies focus more on culture and the arts than on politics, but the significance of the activities and personalities of Rama and those associated with him should not be underestimated in any sphere.

How might we as a group of essayists and a museum staff effectively suggest the richness, profundity, and delight of the Rama epic in its many manifestations? Art objects (broadly defined) are our medium, and we have been able to gather, from institutions and collectors around Europe and the United States, a hundred thirty-five splendid ones, ranging from fifteen-hundred-year-old Indian temple reliefs to puppets made in Indonesia only yesterday, and including works by European and American artists, for whom the Rama epic has also been of interest.

The story of Rama, seven volumes long in its classical telling, is too vast to cover in an exhibition and publication. We have found that many educated Americans have hardly—or never—heard of Rama, and fear becoming overwhelmed by the epic's multiple locales and races of beings with different powers and drives,

myriad characters with unfamiliar names, complicated court politics, and so on.

Our solution (and we'll see whether it works) is to focus on four main characters and their archetypal roles as hero, heroine, ally, and foe. We present what they have been thought to look like through fifteen hundred years in multiple countries, and we suggest what they have meant as positive or negative role models. (For centuries, countless young South Asian men and women have been enjoined by their relatives to emulate Rama and Sita. What has this meant?) Then we sketch the story from each character's point of view, emphasizing major episodes that present a dilemma or turning point for the character. Some episodes naturally appear more than once: the abduction of Sita is critical in both Sita's and Ravana's stories. Its absence from the section on Rama reminds us that he did not witness the event but only heard of it secondhand.

In descriptions of episodes we have often followed the great Ramayana ascribed to the "first poet" Valmiki more than two thousand years ago. But for all its prestige, Valmiki's epic has not, in some places and periods, been the best-known telling of the story, and we have sought to suggest the bounteous variety of what the Indian scholar A. K. Ramanujan has called "three hundred Ramayanas." We have tended to use the term "Rama epic" as a generic to encompass tellings in multiple South Asian vernaculars as well as Persian, Cambodian, Burmese, Thai, Javanese, Balinese, and so on—many of which went by names such as "The Divine Lake of Rama's Deeds" or "The Glory of Rama" rather than "Ramayana."

Mentioning all these languages leads to another point about our Rama epic project: to emphasize the variety of ethnic and religious contexts from which the works of art come. Most, of course, are from Hindu contexts (which are themselves magnificently varied), but some come from Buddhist contexts and others from Islamic contexts as disparate as the Mughal court and the Javanese wayang theater. Also, about a quarter of the artworks come not from the Indian subcontinent but from Southeast Asia, underlining the fact that the Rama epic has been, for well over a thousand years, a key component of the high cultures of Cambodia, Indonesia, and Thailand. The reliefs of the Rama epic at Candi Prambanan in central Java and Angkor Wat in Cambodia match, in both quality and ambition, anything in India.

The word "tellings" used several times so far emphasizes another essential point. The Rama epic was seldom read in the way we might read a book while sitting on the sofa. It was read aloud, or declaimed, or sung, or retold from memory and embroidered upon in front of paintings or sculptures, or acted out, or danced, or performed with a variety of sorts of puppets—but *performed*. This, too, we have tried to make clear in this publication and the exhibition.

Our central hope is that readers and visitors will discover, as millions before them have, that the Rama epic and its lovely, stalwart, frightening, clever, complicated, ambiguous characters mirror our own experiences and engage our innermost thoughts and feelings.

List of Key Characters

RAMA Heroic and righteous prince; a god, as an incarnation of Vishnu

SITA Faithful and virtuous wife of Rama; a goddess, associated with Lakshmi

HANUMAN Brave and wise monkey ally of Rama; a god in his own right

RAVANA Demon king of Lanka and abductor of Sita

BHARATA One of Rama's brothers, who rules Ayodhya as Rama's regent

INDRAJIT Ravana's most prominent son, a mighty and treacherous warrior

JATAYUS Vulture king who tries to prevent Ravana from abducting Sita and is dealt a mortal blow

KUMBHAKARNA Giant demon, brother of Ravana

LAKSHMANA Rama's devoted brother

MANDODARI Admirable chief wife of Ravana

MARICHA Demon whom Ravana orders to take the form of a golden deer to lure Rama away from Sita

SHURPANAKHA Demoness who makes advances to Rama and Lakshmana and is rebuffed. She threatens Sita; Lakshmana cuts off her nose and ears

SUGRIVA Monkey king assisted in taking the throne by Rama in exchange for his help in recovering Sita

VALIN Monkey king killed by Rama to enable Sugriva to reclaim the throne

VIBHISHANA Principled brother of Ravana who goes over to Rama's side

VISHVAMITRA Sage who serves as teacher to the young Rama and Lakshmana

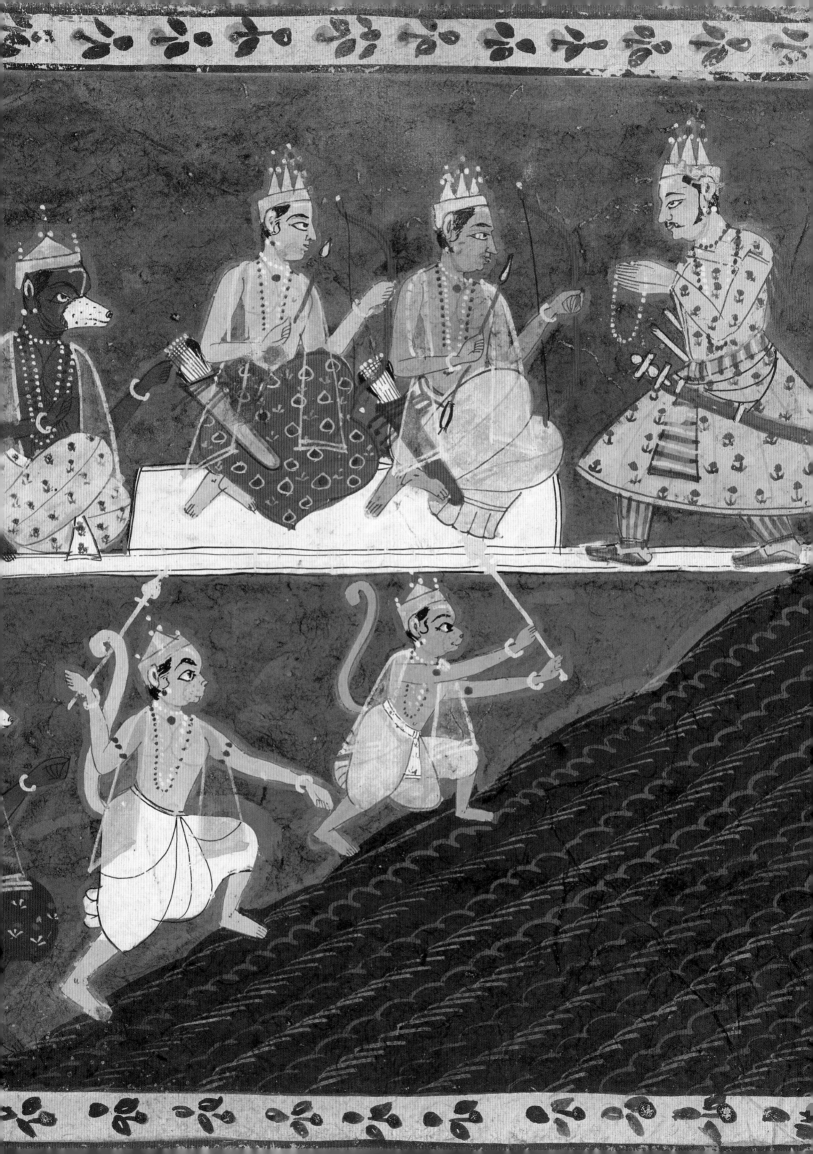

ROBERT P. GOLDMAN

The Story in the
Ramayana of Valmiki

Valmiki's Ramayana is divided into seven books, or *kanda*s.

The *Balakanda* (Boyhood)

The poem, in its surviving form, begins with a curious and interesting preamble that consists of four chapters in which the audience is introduced to the theme of the epic, the story, and its central hero. This section also contains an elaborate account of the origins of the poem and of poetry itself and a description of its early mode of recitation by the rhapsodist-disciples of the traditional author, the sage Valmiki.

The epic proper, which begins with the fifth chapter, tells us of the fair and prosperous kingdom of Kosala whose king, the wise and powerful Dasharatha, rules from the beautiful, walled city of Ayodhya. The king possesses all that a man could desire except a son and heir. On the advice of his ministers and with the somewhat obscure intervention of the legendary sage Rishyashringa, the king performs a sacrifice, as a consequence of which four splendid sons are born to him by his three principal wives. These sons, Rama, Bharata, Lakshmana, and Shatrughna, we are given to understand, are infused with varying portions of the essence of the great Lord Vishnu who has agreed to be born as a man in order to destroy a violent and otherwise invincible demon, the mighty rakshasa (demon) Ravana

FACING
Detail of cat. no. 37

who has been oppressing the gods, for by the terms of a boon that he has received, the demon can be destroyed only by a mortal.

The king's sons are reared as princes of the realm until, when they are hardly past their childhood, the great sage Vishvamitra appears at court and asks the king to lend him his eldest and favorite son, Rama, for the destruction of some rakshasas who have been harassing him. With great reluctance, the aged king permits Rama to go. Then, accompanied by his constant companion, Lakshmana, the prince sets out on foot for the sage's ashram. On their journey, Rama receives instruction in certain magical spells and in response to his questions, is told a number of stories from ancient Indian mythology that are here associated with the sites through which the party passes. At one point Rama kills a dreadful demoness and as a reward for his valor, receives from the sage a set of supernatural weapons. At last the princes reach the hermitage of Vishvamitra where, with his newly acquired weapons, Rama puts an end to the harassment of the demons.

Vishvamitra's ostensible goal accomplished, the party proceeds to the city of Mithila where King Janaka is said to be in possession of a massive and mighty bow.

No earthly prince has so far been able to wield this divine weapon, and the old king has set this task as the price for the hand of his beautiful daughter, Sita. After arriving at Mithila, Rama wields the bow and breaks it. Marriages are arranged between the sons of Dasharatha and the daughters and nieces of Janaka. The weddings are celebrated at Mithila with great festivity, and the wedding party returns to Ayodhya. On the way, Rama meets and faces down the brahman Rama Jamadagnya, legendary nemesis of the warrior class. At last the brothers and their brides settle in Ayodhya where they live in peace and contentment. This brings to a close the first book of the epic.

The *Ayodhyakanda* (Ayodhya)

The second book of the epic is set, as the name suggests, largely in the city of Ayodhya. Here we find that, in the absence of Prince Bharata, Dasharatha has decided to abdicate his sovereignty and consecrate Rama as prince regent in his stead.

The announcement of Rama's succession to the throne is greeted with general rejoicing, and preparations for the ceremony are undertaken. On the eve of the great event, however, Kaikeyi, one of the king's junior wives—her jealousy aroused by a maidservant—claims two boons that the king had long ago granted her. The king is heartbroken, but constrained by his rigid devotion to his given word, he accedes to Kaikeyi's demands and orders Rama to be exiled to the wilderness for fourteen years while the succession passes to Kaikeyi's son, Bharata.

Rama exhibits no distress upon hearing of this stroke of malign fate but prepares immediately to carry out his father's orders. He gives away all his personal wealth and, donning the garb of a forest ascetic, departs for the wilderness, accompanied by his faithful wife Sita and his loyal brother Lakshmana. The entire population of the city is consumed with grief for the exiled prince, and the king, his cherished hopes shattered and his beloved son banished by his own hand, dies of a broken heart.

Messengers are dispatched to bring back Bharata from his lengthy stay at the distant court of his uncle. But Bharata indignantly refuses to profit by his mother's wicked scheming. He rejects the throne and instead proceeds to the forest in an effort to persuade Rama to return and rule. But Rama, determined to carry out the order of his father to the letter, refuses to return before the end of the period set for his exile. The brothers reach an impasse that is only resolved when Bharata agrees to govern as regent in Rama's name. In token of Rama's sovereignty, Bharata takes his brother's sandals to set on the throne. He vows never to enter Ayodhya until the return of Rama and to rule in his brother's name from a village outside the capital.

Rama, Sita, and Lakshmana then abandon their pleasant mountaintop dwelling and move south into the wild and demon-infested forests.

The *Aranyakanda* (The Forest)

The third book recounts the dramatic events that occur during the years of Rama's forest exile. The trio has now pushed on into the forest, a wilderness inhabited only by pious ascetics and fierce rakshasas. The former appeal to Rama to protect them from the demons, and he promises to do so. Near the beginning of the book, Sita is briefly carried off by a rakshasa called Viradha in an episode that strongly prefigures her later abduction by Ravana, the central event of the book and the pivotal episode of the epic.

While the three are dwelling peacefully in the lovely woodlands, they are visited by a rakshasa woman, Shurpanakha, the sister of Ravana. She attempts to seduce the brothers and failing in this, tries to kill Sita. She is stopped by Lakshmana, who mutilates her. She runs shrieking to her brother, the demon Khara, who sends a punitive expedition against the princes. When Rama annihilates these demons, Khara himself comes at the head of an army of fourteen thousand terrible rakshasas, but the hero once more exterminates his attackers. At last news of all this comes to the ears of Ravana, the brother of Khara and Shurpanakha and the lord of the rakshasas. He resolves to destroy Rama by carrying off Sita. Enlisting the aid of the rakshasa Maricha, a survivor of the battle at Vishvamitra's ashram, the great demon comes to the forest. There Maricha, assuming the form of a wonderful deer, captivates Sita's fancy and lures Rama off into the woods. At Sita's urging, Lakshmana, disregarding his brother's strict orders, leaves her and follows him.

Ravana appears and after some conversation, carries off the princess by force. Rama's friend, the vulture Jatayus, attempts to save Sita, but after a fierce battle, he falls mortally wounded. Sita is carried off to the island fortress of Lanka where she is kept under heavy guard.

Upon discovering the loss of Sita, Rama laments wildly and maddened by grief, wanders through the forest vainly searching for her. At length he is directed to the monkey Sugriva. This brings the *Aranyakanda* to a close.

The *Kishkindhakanda* (Kishkindha)

The fourth book of the epic is set largely in the monkey citadel of Kishkindha and continues the fable-like atmosphere of the preceding book. Rama and Lakshmana meet Hanuman, the greatest of monkey heroes and an adherent of Sugriva, the banished pretender to the throne of Kishkindha. Sugriva tells Rama a curious tale of his rivalry and conflict with his brother, the monkey king Valin, and the two conclude a pact: Rama is to help Sugriva kill Valin and take both his throne and his queen. In return for this, Sugriva is to aid in the search for the lost Sita.

Accordingly, Rama shoots Valin while the latter is engaged in hand-to-hand combat with Sugriva. Finally, after much delay and procrastination, Sugriva musters his warriors and sends them out in all directions to scour the earth in search of Sita. The southern expedition, under the leadership of Angada and Hanuman, has several strange adventures, including a sojourn in an enchanted underground realm. Finally, having failed in their quest, the monkeys are ashamed and resolve to fast to death. They are rescued from this fate by the appearance of the aged vulture Sampati, brother of the slain Jatayus, who tells them of Sita's confinement in Lanka. The monkeys discuss what is to be done, and in the end, Hanuman volunteers to leap the ocean in search of the princess.

The *Sundarakanda* (Sundara)

The fifth book of the poem is centrally concerned with a detailed, vivid, and often amusing account of Hanuman's adventures in the splendid fortress city of Lanka.

After his heroic leap across the ocean, the monkey hero explores the demons' city and spies on Ravana. The descriptions of the city are colorful and often finely written. Meanwhile Sita, held captive in a grove, is alternately wooed and threatened by Ravana and his rakshasa women. Hanuman finds the despondent princess and reassures her, giving her Rama's signet ring as a sign of his good faith. He offers to carry Sita back to Rama, but she refuses, reluctant to allow herself to be willingly touched by a male other than her husband, and argues that Rama must come himself to avenge the insult of her abduction.

Hanuman then wreaks havoc in Lanka, destroying trees and buildings and killing servants and soldiers of the king. At last he allows himself to be captured and brought before Ravana. After an interview he is condemned, and his tail is set afire. But the monkey escapes his bonds and, leaping from roof to roof, sets fire to the city. Finally, Hanuman returns to the mainland where he rejoins the search party. Together they make their way back to Kishkindha, destroying on the way a grove belonging to Sugriva. Hanuman then reports his adventures to Rama.

The *Yuddhakanda* (War)

The sixth book of the poem is chiefly concerned with the great battle that takes place before the walls of Lanka between the forces of Rama (Sugriva's monkey hosts) and the demon hordes of Ravana.

Having received Hanuman's report on Sita and the military disposition of Lanka, Rama and Lakshmana proceed with their allies to the shore of the sea. There they are joined by Ravana's renegade brother Vibhishana who, repelled by his brother's outrages and unable to reason with him, has defected. The monkeys construct a bridge across the ocean, and the princes and their army cross over to Lanka. A protracted and bloody battle rages. The advantage sways from one side to the other until, at length, Rama kills Ravana in single combat. The prince then installs Vibhishana on the throne of Lanka and sends for Sita. But Rama expresses no joy in recovering his lost wife. Instead, he abuses her verbally and refuses to take her back on the grounds that she has lived in the house of another man. Only when the princess is proved innocent of any unfaithfulness through a public ordeal by fire does the prince accept her.

At last, traveling in a flying palace which Vibhishana had given him, Rama returns to Ayodhya where, the period of his exile now over, his long-delayed coronation is performed.

The *Uttarakanda* (The Last Book)

The seventh book of the *Ramayana* is entitled simply "The Last Book" and is more heterogeneous in its contents than even the *Balakanda*. Of the nature of an extensive epilogue, it contains three general categories of narrative material. The first category includes legends that provide the background, origins, and early careers of some of the important figures in the epic whose antecedents were not earlier described. Approximately the first half of the book is devoted to a lengthy account of the genealogy and early career of Ravana and to a much shorter account of the childhood of Hanuman. In this section many of the events of the central portion of the epic story are explained as having their roots in encounters and curses in the distant past.

The second category of *Uttarakanda* material consists of myths and legends that are only incidentally related to the epic story and its characters. Some of these episodes concern ancestors of the epic hero and in the main, are related to the central story only in a loosely topical or associative way.

The last and in several ways the most interesting category of material in the *Uttarakanda* concerns the final years of Rama, his wife, and his brothers. Struggle, adversity, and sorrow seemingly behind him, Rama settles down with Sita to rule in peace, prosperity, and happiness. We see what looks like the perfect end to a fairy tale or romance. Yet the joy of the hero and heroine is to be short-lived.

It comes to Rama's attention that, despite the fire ordeal of Sita, rumors of her sexual infidelity with Ravana are spreading among the populace of Ayodhya along with criticism of him for having taken her back. In conformity to what he sees as the duty of an ideal sovereign, Rama banishes the queen, although she is pregnant and he knows the rumors to be false. After some years and various minor adventures, Rama performs a great horse sacrifice during which two handsome young bards appear and begin to recite the *Ramayana*. It turns out that these two, the twins Kusha and Lava, are in fact the sons of Rama and Sita who have been sheltered with their mother in the ashram of the sage Valmiki, the author of the poem. Rama sends for his beloved queen, intending to take her back. But Sita, asked to take a public oath of her fidelity, calls upon the Earth, her mother, to testify to her chastity and to receive her. The ground opens, and Sita is taken back by her mother the Goddess of the earth. Consumed by an inconsolable grief, Rama divides the kingdom between his sons, and then, followed by all the inhabitants of Ayodhya, enters the holy waters of the Sarayu River. Abandoning his earthly body, he returns at last to heaven as the Lord Vishnu.

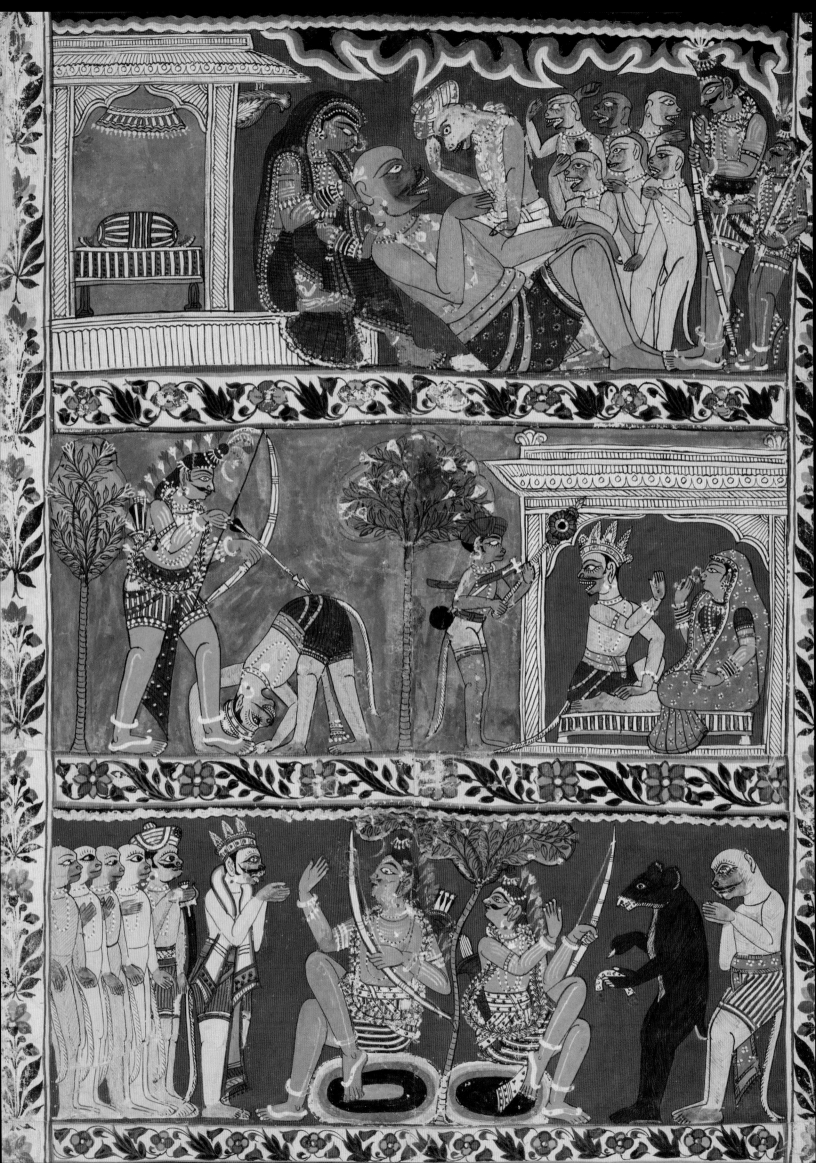

PIKA GHOSH

A Ramayana
of One's Own

Amagical golden deer who called out in human voice (fig. 1), looming grotesque demonesses (fig. 2, cat. nos. 13 and 14), and valorous vultures (fig. 3, cat. nos. 27 and 120) peopled my childhood, along with Cinderella's stepmother, Rapunzel's witch, and Sleeping Beauty's wicked fairy. At bedtime, my nanny conjured wondrous images of supernatural monkeys leaping to the rescue (cat. no. 93), zooming across oceans to deliver mountain peaks fragrant with herbs (cat. nos. 96 and 97), and an impossible ogre (cat. nos. 43 and 94), who slumbered away for months on end, only to awaken at the call of his stomach and munch on armies of creatures for a snack. My earliest memories are filled with such vibrant characters from the Rama story, or Ramayana. I learned these enthralling tales before I knew they were pieces of a longer narrative of such remarkable endurance and pervasiveness that many scholars have spent their careers puzzling over how it has lived among so many different cultures for more than two thousand years. Such was the power of these stories that I was scared to step out of bed in the darkness of the night because those monsters were lurking to get me. I stared up at dark monsoon clouds, imagining the devious spells conjured by demons like Indrajit, who used the clouds for cover (cat. no. 95). I wondered if the elderly blind

FACING
Detail of cat. no. 2

man who came knocking at the door at lunchtime, begging for food, might transform into a ten-headed demon and sweep us off into the skies in a chariot (cat. no. 61).

These stories have offered a flexible framework that yields to countless variations among people of vastly different social, political, and religious backgrounds across enormous areas of South and Southeast Asia and diasporic communities scattered across the world. Visual, textual, oral, and performed versions of the Rama story have connected individuals and communities with its characters and situations overtly as well as more subtly and elusively. Many find role models for their particular concerns or reject its models with equal passion. Although today the story is most often associated with Hinduism, parallel Buddhist and Jain narrative traditions have flourished. The Islamic Mughal emperors, a dynasty of conquerors from Central Asia, were seduced by it. They commissioned translations and deluxe manuscripts with exquisite paintings to enjoy these stories along with others they had brought from their mountainous homeland (see, for example, cat. no. 12). Political leaders such as Mahatma Gandhi envisioned an independent India as a new version of Rama's idyllic reign, liberated from the demons of colonialism. Conversely, communities have used the story of Rama to voice dissension. In post-independent

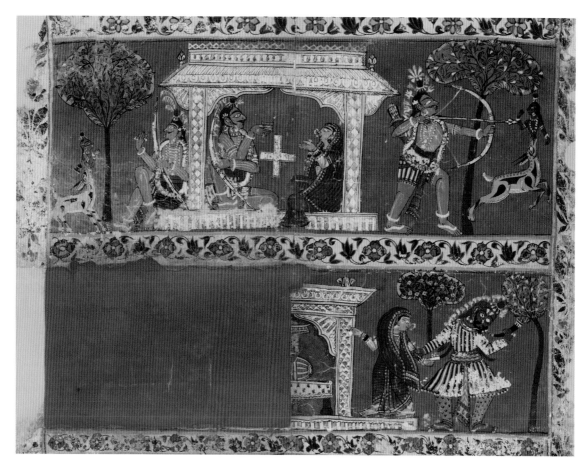

FIG. 1. The magical golden deer approaches Rama, Sita, and Lakshmana, and Rama shoots it;
below: Ravana seizes Sita (detail of cat. no. 2).

India, the Dravidian language movement, in the far southern Tamil region of India, protested the domination of the north by mapping their perceptions onto the epic, casting Rama as the oppressor from the north. More recently, women have turned to the story to express their demands for equal treatment, as in the film *Sita Sings the Blues.* The town of Ayodhya, in northern India, has experienced massive changes in the urgency to excavate and commemorate Rama's birthplace, believed by many to be located there. And today the epic has inspired the Asian Art Museum to assemble a Rama story of its own for San Francisco, attesting to the allure of the narrative for community building.

For those of us who have lived with the epic, multiple versions coexist and can challenge, affirm, nuance, and complicate one another, sometimes fleetingly, but often profoundly, if we stop to think about them in the messiness of our everyday experiences. These encounters with the epic are also impossible to isolate from the contexts in which we experience them. They are steeped with memories and tinged with sounds and smells, excitement and anticipation, specific locations, and intimate moments in family life. And they are colored by the sensibilities of the individuals from whom we learned the stories. Thus many narrators have introduced us to the pleasures and pangs of the Rama epic, despite the lingering image of an original teller, the venerable Valmiki, a bearded sage with a spectacular tale of transformation of his own (cat. no. 1).[1] Writing for this publication has given me an opportunity to reflect on my own early encounters of the epic, going back to my childhood in a predominantly Bengali Hindu community in Kolkata. Those early encounters have profoundly affected my present-day understanding of artistic and performance practices and my appreciation of the epic.

For one thing, oral, visual, and performed Ramayana stories made an impression long before I learned to read. Itinerant entertainers who wandered the neighborhoods in the late afternoons often introduced a segment of the Rama story into their routines. A monkey trainer, who made his rounds with his pair of monkeys, called out to lure us away first from afternoon naps and later from homework. Our hearts beat louder with the sound of his drum as he turned the corner of our street. Would we be allowed to run out and call the man into the driveway? Would a grown-up pay for a show (*bandar naach,* literally, monkey

dance)? These performances included the hero Rama and his wife Sita as key players in one of a series of acts that also included dances to Bollywood numbers and contemplation of current political affairs. As Sita, the female monkey is presented to the suitors waiting to woo her. Each of these suitors is the same male monkey, transformed through costume changes and instructions from the trainer. She invariably manages to select the right one, of course. Next comes the bride's toilette, perhaps the most appealing segment for us as little girls. She sits patiently on a tin drum, draped in red scraps with gold tinsel and foil for a wedding sari, adorned with cheap bracelets and beads, and powdered and primped for the wedding. Likewise, the Rama monkey is prepared for the ceremonies with his hair slicked back, and his stride transforming to a strut. The performer then skillfully guides their leashes and the monkeys walk to the beat of his drum, circling around him. This ritual walk, seven times around the sacred fire, is a key element of most Hindu wedding ceremonies, after which they are husband and wife. Such enactments as the *bandar naach* also reinforced many social values, including the importance of marriage as a sacred institution, and the notion of Rama and Sita as an ideal couple, with the bride demurely walking half a step behind her husband.

Always present in our lives were the strains of songs, whether from Bollywood and Bengali films or from the best-known Bengali composer, Rabindranath Tagore. In Kolkata in those days, most Bengalis probably recognized lyrics such as "Amar Shonar Horin Chai" (I want the golden deer), blaring from stereo speakers

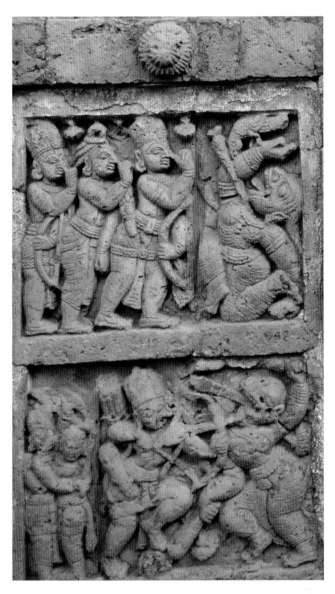

FIG. 2 (*above left*). Rama overcomes demonesses. Terra-cotta plaques on the Keshta Ray Temple, Bishnupur, West Bengal, 1655.

FIG. 3 (*above right*). The vulture Jatayus attempts to stop Ravana from abducting Sita by swallowing his chariot (detail of cat. no. 2).

at all hours before noise pollution became a concern. Such lines gained currency as warnings and rebukes for girls who dreamed of fancy stuff or yearned for other unattainables, much like wanting the moon. Likewise, proverbs based on stories from the epic permeated our daily lives. One I heard often was "shaat kanda Ramayan, Sita kaar baba"—after hearing all seven books of the Ramayana, how could anybody possibly be asking whose father Sita might be? Our teachers rebuked daydreamers with such disarming incisiveness.

Ordinary activities were also understood in comparison to episodes from the Rama story, and sometimes in not so straightforward ways. The woman who cleaned our home used to sprinkle pesticide powder along the cracks where the walls met the marble floor, to prevent ants from encroaching. She called this undertaking the *Lakshmana-rekha,* referring to the boundary with which Rama's brother delineated a zone of protection for Sita, who was not to step foot outside of the circumscribed area. Beyond, he warned her, lay danger. This circle was, of course, breached in the epic, and Sita was abducted, which culminated in the war to rescue her (see figs. 1 and 3, cat. nos. 61–67). In hindsight, what did it mean to name an act of sprinkling pesticide powder in such epic terms? Did it suggest a conviction that the boundaries instated with white powder would not be breached because they were imbued with the power of the epic, even if the lines in the story had been so obviously ruptured?

Many strands of the Ramayana across multiple media thus intertwined in our lives long before the epic was televised. Indeed, no single version, despite the seduction of various media—televised serials, comic books, or political posters—has erased the specificities of individual moments and perceptions. Only later did I read the Amar Chitra Katha comic books in English, and Upendra Kishore Ray Choudhury's bowdlerized Bengali version for children in school.

Two of my early childhood encounters with the epic keep popping up in my research, and they are interconnected in some ways.[2] *Sandhi puja* is a Bengali ritual reenactment of Rama's appeal to the goddess Durga for assistance in his fight with Ravana, the demon king of Lanka, who had abducted his wife (figs. 4 and 5). The ritual is also a convergence of two major narratives and religious traditions that is, as I have now come to realize, quite distinctive to the Bengali region. *Sandhi* (conjunction) usually refers to the specific time determined by the astrological priorities of the ritual calendar. It is also a collaboration established between two divine powers, Durga and Rama, through his acts of devotion.[3]

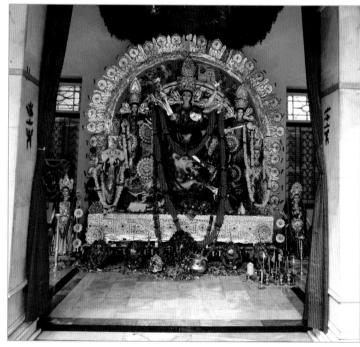

FIG. 4 (*left*). Rama worships the goddess (detail of cat. no. 2).

FIG. 5 (*above*). Durga with her children. Clay icon installed for the annual Durga Puja in the Sardar family home, Hatibagan, West Bengal, autumn 2007.

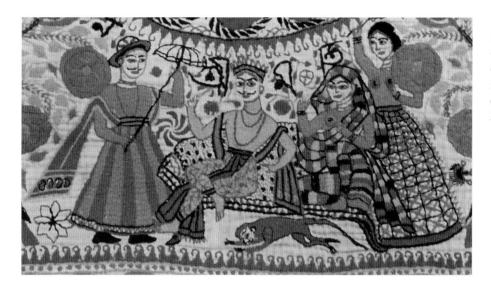

FIG. 6. Rama and Sita enthroned. Kantha embroidery from Khulna, Bangladesh, early twentieth century. Victoria and Albert Museum, IS 16-2008.

This particular ritual is a key moment in the five days of Durga Puja, the annual worship of the goddess that is Bengal's most exuberant Hindu celebration (see fig. 5).[4] I recall vividly the excitement of staying up late at night to go with my grandmother or mother to watch the priests offer the goddess one hundred eight rosy lotuses, as had Rama. When appeased, she smiled at her own image in the reflection in a basin of water, much as she had smiled beneficently upon Rama, and assured him of victory in his battle against Ravana.

My very earliest recollections of Rama stories, however, are bedtime tales before the era of TV, which has inspired a love for stories and a curiosity to keep following the epic to this day. My beloved nanny Kali Didi introduced me to the pleasures of the stories while my parents went out in the evenings. My most vivid memories of those stories are thus entangled with images of her kneading flour to make *chapatis* (flat bread) in the kitchen, mingled with the dust of flour, the smell of the iron griddle heating up, and her soft, worn cotton saris, more gray than white. Of course her stories usually had happy endings as demons were punished and order was restored for the most part. So skillful were the omissions that I never quite realized these were also tales about betrayals, moral ambiguity, infertility, infatuation, transgressions, lust, loss, longing, and struggles about being and belonging (see fig. 1 and cat. nos. 72 and 73).

In my eyes Kali Didi was pretty and dignified, but she was dark, had a limp, and likely wasn't considered attractive in conventional terms. That is probably why she wound up working for my grandmother. From there she came with my mother, at the time of her wedding, to her new home. Here she took care of all sorts of household chores, including indulging me with stories.

For my mother, she was probably a vital conduit to the life she had known before. For me, she was no less a caregiver than my mother in those earliest years of my life, and her impact on my life is witnessed in this essay. What might the tales that she recounted have meant to her? She must have felt somewhat abandoned by her own family, coping with early widowhood on her own. With no children to take care of her in her old age, she was struggling, I assume, with financial insecurity. Did she relate to some of the vulnerability that Sita experienced as she was displaced over and over in the unfolding of the epic events (cat. nos. 49 and 76)? Did she, as a single woman, respond to the resilience that Sita needed to resist the overtures and threats of the lusting demon king, and later to cope with the humiliation of defending herself against rumors about her chastity?[5] Even if my nanny had intimated such resonances, they were lost on me at the time.

I also wonder where she had assembled her repertoire of Ramayana stories that so enthralled me. Prior to joining our household, she had lived at the Kashipur (Cossipore) estate in North Calcutta, the natal home of my grandmother's sister-in-law. As she did not read or write, it is most likely that the oral, performed, and visual versions of the epic made a significant impression upon her. It is possible that she participated in embroidering images from the epic, since these skills were employed by women of various classes, or that she at least saw some of the quilted embroideries that were produced during this time (fig. 6). Recitations and songs (*gayen*), as well as theater performances (*jatradal*), were sponsored at such mansions for family and friends and also for the many employees who supported such estates. She may also have been exposed to the collections of paintings and prints assembled

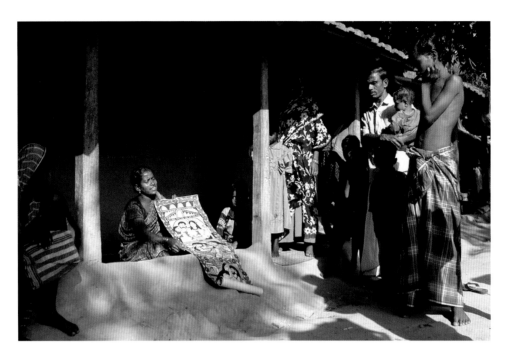

FIG. 7. Moyna Chitrakar singing to a scroll at the home of Gurupada Chitrakar in their town of Noya, Medinipur District, West Bengal, January 2000.

as part of the pastimes indulged in by such families.[6] Women employed as domestic help participated in the cleaning and maintenance of domestic interiors. Such experiences thus urge us to consider the many interactions across classes and genders that shape perceptions of the epic and its characters. If the landed gentry commissioned and collected works of art, people from lower-income groups, such as my nanny, would also have had access to cheap toys at country fairs and souvenirs at pilgrimage sites (see figs. 13, 14, and 15).

Landed estates across South Asia hosted a variety of performances whereby the Ramayana was experienced in the eighteenth and nineteenth centuries. With the breakup of the Mughal Empire, local kings sponsored the artists who carried the legacy of the imperial painting workshops, and a profusion of distinctive regional styles emerged for picturing the Rama epic at this time. Rama as ideal king was a very popular model for local rulers, who not only worshiped him as a family deity but also perceived him as living in their midst. They are often depicted interacting with Rama, or even in the guise of Rama himself. For example, maharajas are frequently depicted as courtiers receiving divine sanction for their reign from Rama, sometimes in the form of a sword (cat. no. 11).[7]

In Bengal, itinerant bards (*patuas*) were often commissioned to perform with their illustrated scrolls in the courtyards of elite residences as part of festival celebrations, including the annual Durga Puja.[8] They usually sang during a break between priestly rituals,

along with various other entertainers.[9] The songs typically elaborated upon specific episodes corresponding to a framed register of the scroll, which was held up for viewing (fig. 7).[10] Rama stories are usually interspersed with others, fragments of a series of songs that together constituted a whole performance. The Ramayana scroll in this publication, an elaborately detailed and carefully designed one, may well have been used for such entertainment (cat. no. 2). Although today we sometimes separate the visual from the performed genres, and distinguish devotional enactments from entertainment, such practices suggest otherwise.

The episode of Rama's worship of the goddess has persisted in these scrolls; it is sometimes given a large and prominent place to acknowledge its critical role in determining the outcome of the epic as well deference to the goddess (fig. 8). In the earliest surviving Bengali versions of the epic, attributed to the fifteenth-century Bengali poet Krittibasa, Ravana had Durga's support, but the goddess switched allegiances when appeased by Rama (fig. 9).[11] It was possible that Durga might switch allegiances once more, so Brahma, the cosmic creator, intervened, advising Rama to offer her worship, even though the autumn was not the conventional time to do so (*akal bodhan*). Moved by Rama's unwavering devotion, Durga inhabited the clay image he had created, and glanced upon him favorably. Rama, however, failed to see her and panicked. At this juncture, he was advised to offer her one hundred eight blue lotus blossoms. They were rare and beautiful, and almost unattainable, even by the gods, and would hence demonstrate Rama's commitment. Hanuman was dispatched

to obtain these flowers from the remote and inaccessible Devi Lake. Rama, however, was harried again while he was offering the flowers as he realized that the last of the blossoms was missing. Hanuman insisted, however, that Durga must have stolen one to test him. In desperation, Rama prepared to offer the goddess his blue eye, at which point, satisfied with his intention, Durga appeared, stopped him, and assured him of victory. As she vanished, Rama immersed the clay image, which had served its purpose as her bodily vehicle, in the ocean. He then proceeded to attack Ravana and, with Durga's support, won the war.

The emphasis on true devotion as the determinant of success or failure is pronounced, and the devotional worldview (*bhakti*) that infuses this episode is shared with many other regional versions of the Rama epic, such as those of Tulsidas in North India, and Kamban much earlier, in Tamil South India. Nineteenth-century scroll painters express such convictions in their choices of colors and compositions. In this scroll, the painter visualizes the martial goddess in the form of the clay icon used in worship, vanquishing Mahisha, the buffalo demon that she was originally created to destroy (see fig. 4). Rama is in the act of worship, offering her pink and green lotuses (shown falling from his hands). Significantly, the artist has chosen the same shade of green to depict Rama and Mahisha, surely inviting us to explore the commonalities between them. Both figures, heroic and demonic, made mistakes and are rendered vulnerable. In the end, both become devotees when they recognize the ultimate power of the goddess and submit to her.[12]

Moreover, the goddess is distinguished with a pronounced blue eye, the color associated explicitly with Rama. He had been prepared to pluck out his blue eye as an offering when the goddess tested his faith. The blue eye visualizes the inseparable, symbiotic, even reciprocal relationships between deity and devotee that are at the heart of expressive devotion in this region.[13] It condenses the episode, drawing on the familiarity of viewers, who would know that the color choice displays Durga's acknowledgment of Rama's devotional ardor. It thereby visibly marks her shift in allegiance from Ravana to Rama, and it foretells the epic outcome.[14]

During a performance, such details may or may not have been given the kind of attention that we can lavish upon them when contemplating the unrolled scroll leisurely in a gallery. Yet they demonstrate how each rendition of a story highlights specific values and perspectives through the distinctive qualities of the medium. The creative choices that artists contemplate reiterate

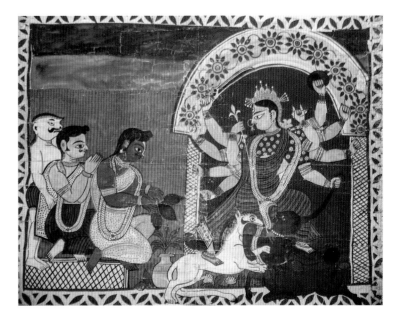

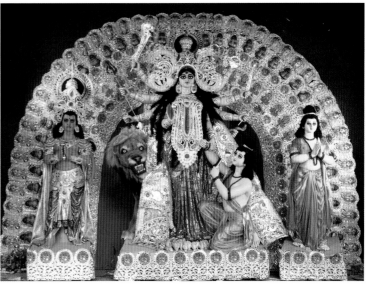

FIG. 8 (*top*). Rama worships the goddess. Section of a Bengali scroll. British Museum, 1955,1008,0.96.

FIG. 9 (*above*). Rama's devotion to the goddess. Here Rama replaces the typical depiction of the green-skinned buffalo demon Mahisha at the goddess's feet. Rama is offering to pluck out his eye with an arrow. Clay icon at the Venus Club, Kidderpore Durga Puja, Kolkata, 2010.

that, rather than assuming that an artwork illustrates an original text of the Rama epic, we will find it more productive to examine the sophisticated interchanges and references to multiple beliefs and practices across a range of media that enrich the narrative and make it meaningful at particular moments for its various communities.

Even though Rama appears as a supplicant in the scroll, he is also worshiped as a divine being in Bengal, as in most other parts of South Asia (cat. no. 5). The landed gentry in Bengal often dedicated a wing of

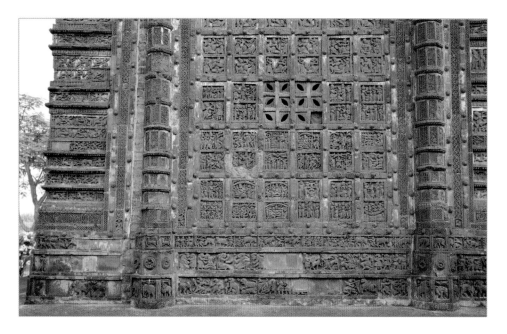

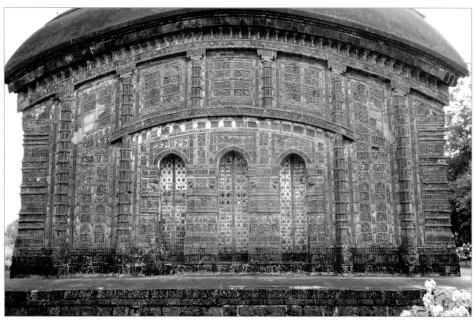

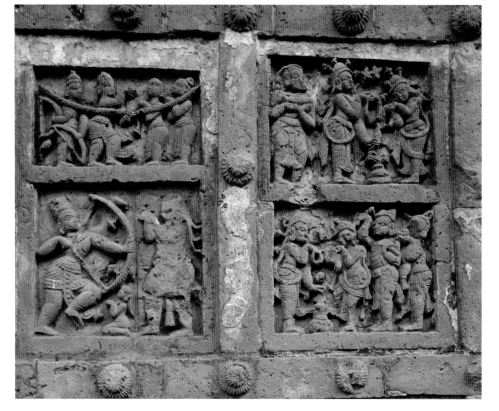

FIG. 10 (*top*). West façade, Keshta Ray Temple, Bishnupur, West Bengal, 1655.

FIG. 11 (*middle*). North façade, Keshta Ray Temple, Bishnupur, West Bengal, 1655.

FIG. 12 (*left*). Clockwise from upper left: Rama lifts Shiva's bow; Rama and Sita wed; Rama's brothers exchange garlands with their brides; and Rama encounters Parashurama(?). West façade, Keshta Ray Temple, Bishnupur, West Bengal, 1655.

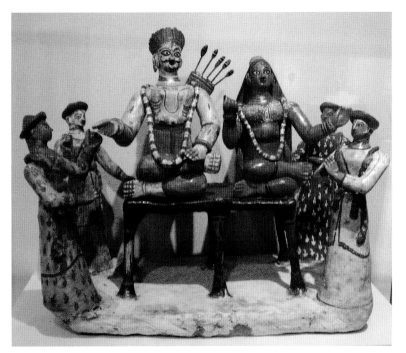 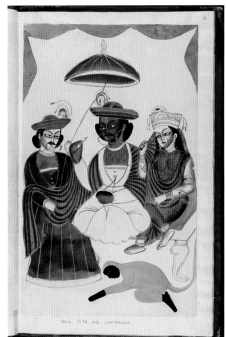

FIG. 13 (*above left*). Rama and Sita. Clay assemblage. Peabody Essex Museum, E7674f.

FIG. 14 (*above right*). Rama and Sita enthroned, with Lakshmana and Hanuman. Kalighat painting from Calcutta, 1875. Bodleian Libraries, Oxford University.

their mansions or established a temple for their family gods. Rama is usually worshiped here as an avatara of the divine protector Vishnu.[15] On the exterior surfaces of these brick temples, Rama's biography was narrated, often in remarkable detail. A terra-cotta panel depicts Rama and Sita, reunited after their estrangement following Sita's abduction (cat. no. 52). Here the seated couple is depicted poised and at ease, honored by attendants with raised parasols and fans. The devoted monkey Hanuman pays obeisance below. The scene probably also represents the much-awaited coronation of Rama after his displacement for fourteen years from his role as heir apparent.

The Asian Art Museum's terra-cotta panel may have belonged to a sequence of panels elaborating the Rama story, much as it was laid out in manuscript pages such as the ones commissioned by Jagat Singh of Mewar (for example, cat. nos. 128–130), or the Mughal general Abdur Rahim (cat. no. 75). As early as 1655, the Bishnupur rajas at the eastern end of the Mughal Empire had patronized a temple with a third of its exterior walls dedicated to Rama episodes (figs. 10–12). The narrative proliferated across the north and west walls, including the birth of Rama and his brothers, the sage Vishvamitra's

claim upon the princes to assist him in vanquishing disruptive demons such as Tataka, and the weddings of the princes after Rama lifted the god Shiva's bow (fig. 12; and see fig. 2). The entire back wall is devoted to the battle between Rama's and Ravana's forces, which complements the Mahabharata war on the front (see fig. 11).

Such plaques also reveal how intimately the god is embraced in the daily lives of his followers. He is sometimes presented as a slightly foppish figure, immaculately attired in an elegant pleated lower garment (*dhoti*), with a hat sitting at a rakish angle upon his head (cat. no. 52). Indeed, he is not unlike the Bengali elite, who were satirized as being excessively preoccupied with their appearance and amusements, running their estates into the ground through their extravagance.[16] In the hands of colonial-period artists, Rama begins to look like an earthly prince, with a flourishing mustache and sometimes with stylish, pointed shoes, surely handmade, perhaps even from Europe (figs. 13–15; and see fig. 6). In watercolors, woodcut prints, oil paintings, and embroidery, these artists bring the narrative into the colonial world of merchants, money, and newer media, making the Rama epic significant for another set of consumers.

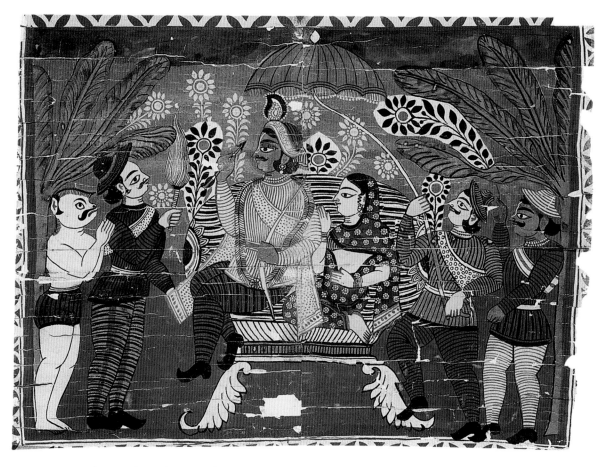

FIG. 15. Rama and Sita enthroned. Section from a mid-nineteenth-century
Bengali Ramayana scroll. British Museum, 1955,1008,0.96.

In looking at these images, brought together for this publication from so many different places, and retrieving my memories of a variety of childhood experiences to understand the material, I have become aware of how deeply and intimately the epic still lives with me. Today I pick and choose, adapting my own Rama stories to tell my students in the classroom, who enjoy sculpture and paintings of the kind included here. I tell another set of stories to my children, another generation of bedtime tales that renews my sense of home and the comfort and security I continue to associate with my nanny, who has passed on. This assemblage of epic pieces in the Asian Art Museum guides us through the narrative in tangible, specific, and evocative ways. It invites us to engage with the multiplicity of viewpoints from which the narrative is experienced by its characters. Stimulating more associations and networks of relationships, it undoubtedly renews Rama's story as each of us engages with and makes the epic our own.

ACKNOWLEDGMENTS

Conversations with Mary Beth Heston and Neeraja Poddar helped me understand how deeply the Ramayana runs through our lives. Branavan Ganesan offered an array of titles to select from, and I thank him for his abiding interest in the epic, which has expanded my horizons. Above all, I remember Kali Didi, my nanny, who was also the first of my many Valmikis, with love and gratitude.

NOTES

1. Scholars have urged us to heed the invocation of Valmiki as author for a number of reasons. Many writers paid homage, and claimed legitimacy for their versions in highly sophisticated ways. Moreover, oral and performed versions surely preceded extant textual accounts. Valmiki, then, is in some ways generic rather than the specific author of a particular text. Many of the later narratives can hardly be considered translations, but rather are creative adaptations and variations that must be acknowledged as independent works in their own right. These issues have been discussed at length by scholars, including Ramanujan, "Three Hundred *Rāmāyaṇas*"; Pollock, "Rāmāyaṇa and Political

Imagination"; Goldman, *Bālakāṇḍa,* 14–59; Bose, *Rāmāyaṇa Revisited* and *Rāmāyaṇa Culture;* Thiel-Horstmann, *Rāmāyaṇa and Rāmāyaṇas;* Raghavan, *Ramayana Tradition in Asia;* Smith, *Rāmāyaṇa Traditions in Eastern India;* Dehejia, *Legend of Rama;* and Krishnan, *Ramayana in Focus.*

2. I have explored visual versions of the epic in the following essays: "Story of a Storyteller's Scroll"; "Unrolling a Narrative Scroll"; and "Embroidering Ramayana Episodes."

3. Scholars such as W. L. Smith have suggested that we can conceptualize the historical phenomena as the growing following of the goddess laying claims to the enormous popularity of Rama, and more broadly to Vishnu's worship; *Rāmāyaṇa Traditions in Eastern India,* 100–126.

4. For a recent discussion of the festival in English, see McDermott, *Revelry, Rivalry.*

5. Sally J. Sutherland Goldman, for example, has addressed these questions in essays, including "Gendered Narratives" and "Anklets Away."

6. Elaborate forms of public entertainment at such occasions provided patronage to a variety of traditional artists and contributed to the creation of what anthropologist Milton Singer has called a "cosmopolitan folk culture, sometimes little modified from its village counterpart and sometimes assimilated to the mass culture of the urban center"; *Semiotics of Cities, Selves, and Cultures,* 35.

7. Such may also have been the case during the heyday of the Mughal Empire. Some scholars have interpreted depictions of Rama in battle bearing the solar standard in one of the best-known Ramayana manuscripts, for example, as an attempt at aligning the local court of Mewar with Rama. See the British Library Add. MSS 15297 (1), f.158a and f.162a, illustrated in Losty, *Ramayana: Love and Valour,* pls. 112, 113; Dehejia, "Treatment of Narrative," 303–324; and Joffee, "Art, Architecture and Politics in Mewar," 120–121. More recent scholarship, however, has complicated the discussion; see Aitken, *Intelligence of Tradition,* 64–68.

8. Traces of such performance can still be encountered sporadically in rural West Bengal, but most living performers attribute the decline in the practice to the competition from newer media, primarily cinema and television.

9. Scroll painters not only provided entertainment but also played a vital role in the ritual dimensions of this festival. Before the occasion, they were summoned to these houses in the summer and commissioned to make clay images to the particular specifications of each family. In addition to painting the clay images, these artists also depicted the two-dimensional scenes in the arch of the *chalachitra* (bamboo frame) behind the sculpted forms. Here, among the other episodes of Durga's biography, were included scenes from her participation in the Ramayana, such as Rama worshiping the goddess and the culmination of the battle that she enabled him to win.

10. The origins of the scrolls and also the performative dimensions of this practice are less than clear, impeded both by the methodological difficulties involved in grappling with the essentially ephemeral nature of the practice, and by the scarcity of interest in documentation prior to the turn of the twentieth century. At this time, the scrolls and performances emerged as sites where the interests of British ethnology in the colonies converged with the nationalist quest for an essentially Indian art that was untainted by European influence. The major historical collections, housed in museums in Kolkata, London, and Philadelphia, were assembled from this confluence of investments.

11. Krittibasa and Mukhopādhyāya, *Rāmāyaṇa.* For an English summary translation, see Krittibasa and Mazumdar, *Ramayana.*

12. Resonances of such twists and turns in the narrative appear in a range of media. Among the canonical literary works produced in Bengal, Rabindranath Tagore's *Balmiki Pratibha* [The genius of Vālmīki], for example, is a musical play composed in 1881 exploring the story of the thug Ratnakara, who changed his ways and became the sage better known as Valmiki. The text is available in Bengali as part of the *Rabindra Rachanabali* [Collected works of Rabindranath Tagore]. Michael Madhusudan Dutt offered a reassessment of the conventional narrative of good and evil in *Meghnad Badh Kabya.* For a translation by Seely, see Dutt, *Slaying of Meghanada.* Seely has analyzed Dutt's sophisticated use of metaphors, for example, with which he jolted readers through comparisons of demons with gods, notably Ravana's favorite son Indrajit with Krishna; he bequeathed grandeur and dignity to the rakshasas (demons) while simultaneously calling into question that of the divinely favored; see Seely, "Raja's New Clothes," 137–155.

13. The goddess herself is conceived through the two most intimate human relationships. She is worshiped as a mother who takes care of us as well as a daughter who needs our blessings to return to her life with a rather difficult and eccentric spouse.

14. Another example of devotional ardor is offered in the depiction of the loyal monkey Hanuman ripping his chest open to reveal Rama and Sita residing inside him (cat. no. 99).

15. In the eastern region, a new deity also emerged with strong visual connections to Rama. As the Bengali mystic Chaitanya came to be acknowledged as another incarnation, he was visualized with an overlay of the insignia of the two most popular previous avataras, Krishna and Rama. The six-armed deity, literally called Sharabhuja, raises the bow and arrow of Rama overhead in his uppermost pair of arms, plays Krishna's flute with a second pair of arms, and holds the waterpot and prayer beads (or staff in some instances) that marked the ascetic Chaitanya.

16. For a thoughtful discussion of the construction of the Bengali elite, see Sinha, *Colonial Masculinity.*

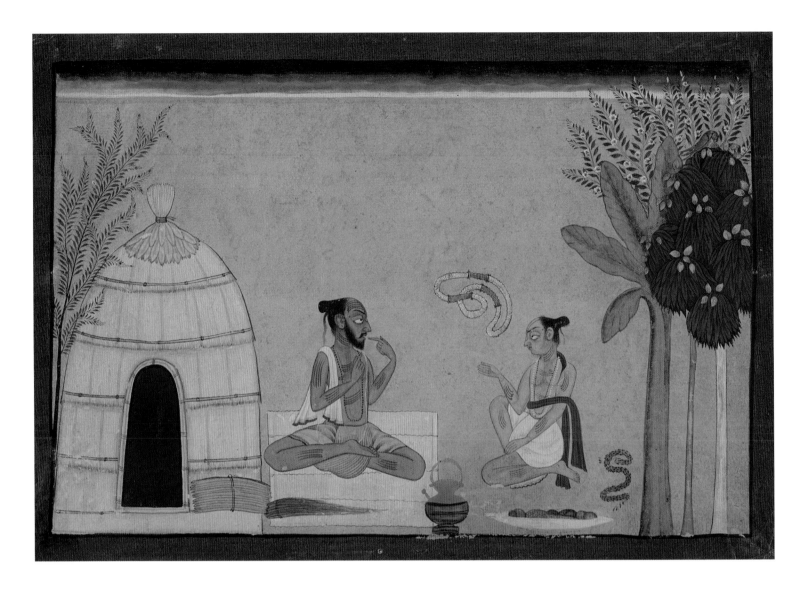

1

Valmiki describes the origin of the verse
form later used for the Ramayana to
his pupil Bharadvaja, approx. 1700–1710

India; Jammu and Kashmir state,
former kingdom of Kulu or Bahu
Opaque watercolors on paper
Image: H. 19.1 × W. 29.2 cm
Los Angeles County Museum of Art,
From the Nasli and Alice Heeramaneck Collection,
Museum Associates Purchase, M.83.105.9

The Ramayana, like many Indian literary
compositions, contains an account of its own origins.
This painting depicts one of the key episodes in the
Ramayana's account of itself: when the specific poetic
meter in which the epic is written was discovered.

The sage Valmiki is traditionally understood to be
the author of the Ramayana. In this painting, Valmiki
sits bearded and dressed in saffron robes before his
grass hermit's hut. In front of Valmiki, his pupil
Bharadvaja, with one knee on the ground, raises his
right hand in conversation. Beneath Bharadvaja sits
a plate of fruits, while two rope-like objects appear
in front of and behind him; it is likely that one is a
garland and the other a yoga strap. Both Bharadvaja
and his teacher bear four red streaks on each limb, an
identifying mark used by sages in ancient India.

What we do not see in this painting are the events
that have just taken place. Valmiki, entranced by the
natural beauty of his hermitage, was watching two
birds at play. At that moment, a hunter's arrow struck
one of the birds. Indignant at the injustice, Valmiki
cursed the hunter for the sorrow (*shoka*) he had
caused. Yet despite the negative nature of the curse,
Valmiki uttered it in a beautiful poetic meter, which
he called *shloka*. Astonished at himself, Valmiki asked
Bharadvaja if he has heard the marvelous rhythm.
Bharadvaja answered in the affirmative, and Valmiki
then used this same poetic meter to compose the
Ramayana. J.D.

2 *also p. xx and figs. 1, 3, 4*

Scenes from the Rama epic, approx. 1800

India; West Bengal state
Scroll, opaque watercolors on paper, mounted on cloth
H. 863 × W. 51 cm
Victoria and Albert Museum, London, Purchased with
the assistance of the Art Fund, IS.105:1 to 3-1955

This Bengali Ramayana *pata* (narrative handscroll), although worn and incomplete, is of the highest quality; it shares numerous features—including colors, figure profiles, delicate foliage, and waves—with the court paintings commissioned by the rulers of Bengal in the atelier at their capital in Murshidabad. Indeed, it is tempting to associate the turbulent history of the English merchant armies' deposition of the nawabs in the eighteenth century with the trials and tribulations of succession in Rama's story, since both tales are steeped with moral dilemmas and treacherous machinations. With the dispersal of artists as courtly patronage dwindled, artists may have turned to alternative modes such as painting and singing as part of itinerant show-and-tell performances using scrolls.

The worn and fragmentary opening scene [1] would probably have depicted King Dasharatha's pronouncement of his eldest son, Rama, as successor (*yuvaraja*). The next two scenes, also incomplete, suggest a complementary pairing of supine figures that leads viewers from one to the next, visually moving us along the length of the roll. The first [2] presents the melodramatic figure of Kaikeyi, the besotted king's gorgeous younger wife, whose wiles include rejecting Dasharatha if he fails to keep his promise to banish Rama and put her son, Bharata, on the throne. Directly below [3], Dasharatha collapses in shock as he realizes the implications of keeping his word—his beloved eldest son and heir, Rama, will have to be disinherited, deprived of his princely status, and sent into exile in the forests beyond the kingdom of Ayodhya.

As these scrolls are performance props created by professional painter-minstrels to illustrate sung stories, we can imaginatively attempt to reconstruct how they may have worked together. The lines of a song collected in the mid-twentieth century describe these episodes (although this song is probably not one that was sung with this particular scroll):

> The marriage took place, and then Ramchandra's
> [Rama's] first day with the bride.
> To carry out the promise of his father,
> Rama goes to live in the forest.

> First goes Ramchandra, and Janaki [Sita] behind
> him,
> And behind her goes Lakshmana, the keeper of
> the bow.
> With his hands upraised, King Dasharatha hurries
> after them:
> "How far away are my Rama, Sita and Lakshmana
> going?
> Who has removed the ornaments from the ears of
> my son?
> Who has made the moon of Ayodhya wear the bark
> of trees?
> Come back now, Rama, don't go away for fourteen
> years!
> Without you my Ayodhya city is in darkness!"[1]

To the right, Rama, Lakshmana, and Sita depart for the Panchavati Forest. On the next panel [4], the narrative continues from right to left as the entourage departs and they cross the river.

Next, Rama, Sita, and Lakshmana ease into life in the wilderness, receiving acknowledgment from other forest-dwelling ascetics, before the disruptions from the demons ensue. The staid composition of these two scenes [5 and 6] juxtaposed with the disorderliness of the following one is an old and familiar visual strategy for contrasting good and evil.

In the next scene [7], from right to left, Rama and Sita are approached by the demoness Shurpanakha, who is attracted to Rama. She is separated from the couple by her own bubble, in almost comic-book fashion, as if to assure us that the hero is not tainted by her. To the left, and a little below, the trio is again shown with Shurpanakha's entreaty. At left, Lakshmana cuts off her nose, the diagonal of entangled bodies contrasting with the serenity of the seated pair.

Variations abound in the tellings of these episodes, and comparison with the songs that were sung by these scroll painter-performers—later collected by folklorists early in the twentieth century—suggests such variance. Sometimes the words and pictures do not offer one-to-one correspondence; that is, the pictures alone do not always make sense because it is the performance, with its words and gestures, that creates a meaningful narrative sequence. To complicate the matter further, performers often borrow a scroll created by another, and hence their stories do not necessarily synchronize. An index finger pointing to a specific figure or feature can produce a nuance or emphasis or clarification that is a particular bard's interpretation of a narrative. Ultimately, as in most

performances, each telling becomes a singular event that can never be repeated exactly.

A painter-performer's song, transcribed by the civil servant Gurusaday Dutt in the early part of the twentieth century, describes the events:

> They built a hut of teak leaves in the Panchavati
> Forests . . .
> They sat in it and Janaki [Sita] played dice
> Rama and Sita played dice keeping Lakshmana at
> the door to guard the entrance . . .
> Ravana's sister Shurpanakha went that way to pick
> flowers
> From the corner of her eyes she spied them.
> She ran to Lakshmana, begging him to marry her
> Lakshmana replied he would rather remain single
> for fourteen years
> "Get away from me, Ugly One!"
> Hearing that, she flew into a rage.
> Lakshmana, in his anger, cut off her nose.[2]

In the next panel [8], Shurpanakha returns to Lanka to register her complaint with another of her brothers, who sends an army to attack Rama and Lakshmana in retribution for the disfigurement of Shurpanakha [9]. Rama defeats the entire army with little effort [10]. Then,

> That day Ravana's sister went to Lanka,
> To tell Ravana what had happened she went.
> Ravana asked, "Sister, who took your nose and
> nostril hairs?"
> "Two boys, Rama and Lakshmana, have come to
> the Panchavati Forests.
> A woman more beautiful than Rani Mandodari
> [Ravana's wife] they have brought."
> Hearing this, Ravana called for the magic-making
> demon Maricha.
> On getting his orders, Maricha went dancing to
> the door of the hut.
> When Sita saw [Maricha, who had assumed the
> form of a deer], her mind was distracted.[3]

Next in the scroll we see the domestic bliss of the couple as they play games to entertain themselves, with Lakshmana keeping guard. The tantalizing golden deer approaches the hut at the left, and at the right, Rama destroys him [11]. Multiple episodes are condensed here as the demon erupts from the throat of the animal, likely dying at Rama's hands on the right but possibly calling out Lakshmana's name in

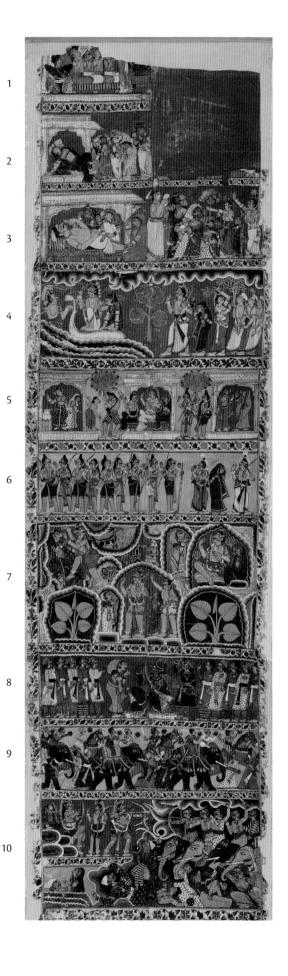

1

2

3

4

5

6

7

8

9

10

Rama's voice on the left, to lure him away from his post as guard.[4]

The song continues, in Sita's voice,

"Get that deer! We will keep him as a pet!
After the fourteen years when we return home, we'll
 take him."
Honoring the request of a woman, Rama went chasing
 the bounding animal.
The deer split in two from the force of Rama's arrow.
From the carcass emerged the demon Maricha.
Then Rama began his fight with the demon Maricha.
Shouting the name of Lakshmana, the demon
 expired.
His words floated to Sita's ear.
She said to Lakshmana, "Your brother went to catch
 the golden deer.
Somewhere in the forests something has happened.
 He calls out your name. Go quickly."
"O Sita, my brother is invincible, there is no hero that
 can take him."
"I see your loyalty to your brother—Bharata took his
 kingdom, you keep his wife."
Hearing this, Lakshmana was furious.
He stepped outside the hut and marked it with three
 magic rings:
"Sita, stay within these markings and you will be safe.
If you step beyond, you face danger."[5]

Next [12], in a section of which only the right part survives, we see Sita, having been lured beyond the safety zone, being abducted by Ravana in the guise of an ascetic. Then a large iconic scene [13] is devoted to the spectacular figure of the vulture Jatayus valiantly attempting to thwart Ravana's abduction of Sita by swallowing his flying chariot. The image would surely have invited viewers to linger on intricacies in the rendition of details such as the coloration of the bird's feathers, the plump flying geese, and the marvelous striped clouds. This subject is especially popular in collections of both scrolls and songs.

The painter plays with the height of the scroll's individual panels, which also suggests a range of possibilities in handling during performance. Guided by the tempo of the song, such longer scenes might allow for a fuller verbal account of a dramatic episode or repetition of a refrain for emphasis. In contrast, a quicker recounting of stanzas may accompany shorter panels, with the possibility of seeing more than one scene at a time. The manipulation of the scroll, to display scenes to the words of a song, generates

momentum in performance. The dynamic movement of such a scroll in the hands of the performer as the song is articulated and the variations that we can discern among practitioners today allow us to imagine the malleability in the use of such an exceptionally long and elaborately painted scroll.

This dramatic episode leaves us to conclude that Sita has been carried off to Lanka, as the words of a storyteller's song suggest:

> King *Ravan* was flying to Lanka in his chariot:
> *Sitadevi* weeping freely tells everybody of her sorrows.
> *Jatayu* was nearby and chanced to see what was happening:
> He seizes the chariot of Ravan in his beak.
> "Don't bite hard, Jatayu, don't bite hard—
> Sita, the daughter-in-law of your friend [Rama's father], is in my chariot!"
> Hearing the name of his friend's daughter-in-law, Jatayu was abashed—
> He had swallowed the little chariot, but now he brought it up again.
> Ravan had the *Brahmasell* [his magic weapon] in his hand, and threw it at Jatayu.
> Jatayu fell down covering a quarter of an acre or so.[6]

Rama returns with the golden deer to an empty hut and Sita gone [14], and he weeps in anguish, begging the birds and animals for information about her whereabouts. Lakshmana tries to comfort him. Below [15], we see the cremation of Jatayus. The performer's song would have explained that Jatayus died after reporting to Rama the events he had witnessed.

The left half of this section [16] proceeds to the first meeting of the brothers with Hanuman. The various alliances with forest creatures ensue as part of the preparations to rescue Sita. First [17], Rama proves his might to the monkeys by shooting an arrow through seven trees, and then he intervenes on the side of the monkey prince Sugriva in Sugriva's battle with his rival Valin. The next register [18] shows Valin lying dead in the arms of his wife, slain by Rama, who stands at the very edge of the panel, perhaps reflecting on the implications of his choices.

Rama's alliances are consolidated [19 and 20], and several scenes later a war council discusses battle strategies [21]. The planning culminates in Hanuman's reconnaissance trip to Lanka to search for Sita. With hands folded in a gesture of humility, Hanuman receives Rama's blessings, garlands, and a signet ring

16, 15
17
18
19
20
21
22
23

for Sita wrapped in a red cloth [22]. In the next scene [23], Hanuman, on the way to Lanka, escapes a sea monster, who challenges him to enter her mouth.

Hanuman then arrives in Lanka and hides in the forest until he allows himself to be captured as part of his reconnaissance strategy [24–27]. When negotiation with Ravana fails, and Ravana sets Hanuman's tail on

24

25

26

27

28

29

30

31

32

33

34

35

36

37

38

fire, the monkey uses the length of his tail as a weapon to wreak havoc, setting fire to Ravana's city [28]. In these scenes, Hanuman is shown bigger than Ravana, emphasizing his miraculous power to grow larger and smaller.

The population flees the fire in their city [29]. On the left of the section below [30], Hanuman calls on the goddess Durga, the tutelary deity of Lanka. Krittibasa, the earliest author of a regional Bengali Ramayana, described her: "Her eyes looked like a pair of suns with a splendor like Brahma-fire and were terrifying to see. Her tongue lolled, her teeth were enormous, and ascetic locks weighed down her back. Her color, that of a pot-black cloud, was beautiful to see. She was dressed in a tiger-skin with a garland of skulls around her neck."[7] With her help, Hanuman finds Sita in the ashoka grove (on the right), where he presents her with Rama's ring. He also brings back a ring that Sita had been given by her father-in-law, one that only Rama knew about. In the next section [31], Hanuman delivers this ring to Rama.

Next [32], in the effort to move his troops across the sea to Lanka, Rama seeks the support of the god of the ocean. The god is unresponsive until Rama grows impatient and fires volleys of arrows into the waters. The god appears and agrees to permit the building of a bridge. In the section below [33], on the left, Rama appeals to the goddess Durga, praying to her for support in the upcoming confrontation. To the right of this scene, monkeys lay a bridge to Lanka in white and blue rocks.

Below [34], Rama's troops begin to cross the bridge. The god of the ocean acknowledges them and calms the waters, which are teeming with fish, sea creatures, and crocodiles.

After a few sections of Rama and his allies in Lanka [35–37], the exact interpretation of which is uncertain, the final surviving sections hint at the ultimate outcome of the battle as a monkey confronts and topples Ravana [38]. It may be Angada, the son of Valin and his wife. Angada was sent as Rama's envoy in an attempt to avoid military conflict. P.G.

NOTES

1. Storyteller's song cited by McCutchion and Bhowmik, *Patuas and Patua Art*, 70.

2. Song of Gunamani Patua of Dwaraka (Bankura district), transcribed by Dutt, *Paṭuẏā saṅgīta*, 50–51 (my translation).

3. Ibid.

4. A similar rendition of the human upper body emerging from the deer torso in terra-cotta relief is in the collection of the Asian Art Museum (B62S43.10) and can be seen in the museum's online collections database.

5. Dutt, *Paṭuẏā saṅgīta*, 50–51.

6. Storyteller's song cited by McCutchion and Bhowmik, *Patuas and Patua Art*, 71–72.

7. Translated by Smith, *Ramayana Traditions in Eastern India*, 132.

3 *also p. 248*

Scenes from the Rama epic, approx. 1800–1850

Sri Lanka or India; Tamil Nadu state
Stenciled, painted, and dyed cotton
H. 110 × W. 762.5 cm
The British Museum, 1993,0724,0.2, purchased with
assistance from the Brooke Sewell Permanent Fund

This painting, more than eight yards wide, reveals
successive episodes from early portions of the Rama
epic. It seems to be arranged in a left-to-right, top-to-
bottom manner. However, the painting must instead
be read in a zigzag way: from the bottom register,
left to right; then the middle register, right to left;
and finally the top register, once again left to right.
This arrangement of the narrative episodes can easily
be discerned through the directions in which the
majority of the acting characters face.[1]

 The method of dividing an otherwise continuously
linear story into more visually distinctive and
artistically manageable registers can be seen as early as
the Ramayana reliefs at Ellora's Kailasanatha temple in
central India; it suggests one way that mythic narratives
can be incorporated into architectural temples.

Bottom Register

1. In the first scene in the bottom register, Rama's
 brothers Bharata and Shatrughna visit him and
 Sita on a sacred mountain.
2. Rama, Sita, and Lakshmana visit the sage
 Vasishtha, identified by the inscription below
 the scene.
3. Rama gives his sandals to Bharata and
 Shatrughna; Bharata will later place them
 on the throne in Ayodhya to show that Rama
 is really still the ruler of the kingdom.

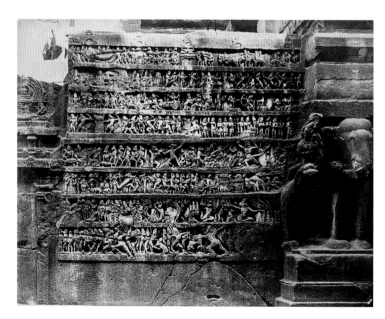

Frieze of battle scenes from the Ramayana, Kailasanatha temple, Ellora.
Photo by Henry Cousens, 1867.

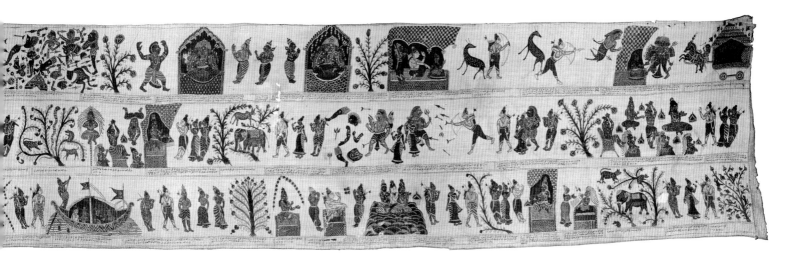

4. Everyone except Rama, Sita, and Lakshmana—including Ayodhya's military—leaves for the capital.

5. Bharata, Shatrughna, and Vasishtha cross the Ganges River and approach Ayodhya.

6. Bharata worships Rama's sandals to show that he still regards Rama as king.

7. Rama, Sita, and Lakshmana visit the sage Atri and his wife Anusuya, who gives Sita advice regarding the duties of a wife.

8. Rama, Sita, and Lakshmana enter the forest.

Central Register

9. Rama, Sita, and Lakshmana encounter a group of seven ascetics before their sacred fires.

10. A demon named Viradha attempts to abduct Sita.

11. Rama fights and kills Viradha.

12. The exiles meet ascetics in the forest; these meetings comprise the bulk of the second register.

13. The vulture king Jatayus, recognizable by his wings, appears prior to his battle with Ravana.

Top Register

14. Shurpanakha, Ravana's sister, is about to embrace Rama. The prince mocks her, recommending instead that she pursue Lakshmana; she agrees.

15. Lakshmana returns Shurpanakha's affections by cutting off her breasts and nose; in the Valmiki Ramayana, however, Lakshmana cuts off merely her ears and nose in a less explicit desexualization of the demoness.

16. Mutilated, Shurpanakha runs to her demon brother Khara and complains of her injury; he sends a host against Rama and is soundly defeated, along with his followers.

17. Shurpanakha then appeals her case to her ten-headed brother, Ravana. By simultaneously complaining of her mistreatment and praising the beauty of Sita, she incites Ravana to abduct the queen.

18. Ravana persuades the demon Maricha to transform himself into a golden deer to lure Rama away from Sita.

19. Maricha, here depicted as half-man-half-deer, fools Rama into hunting him as if he were a deer, but he is eventually struck by Rama's arrow and killed.

20. In the final scene at the top right of the painting, Ravana seizes the opportunity provided by Maricha's diversion. He captures Sita, who is seated in her hut; to the right, Ravana's chariot awaits the demon king and his prize. J.D.

NOTE

1. This painting and its narrative are described in detail in Dallapiccola, *South Indian Paintings,* 243–250.

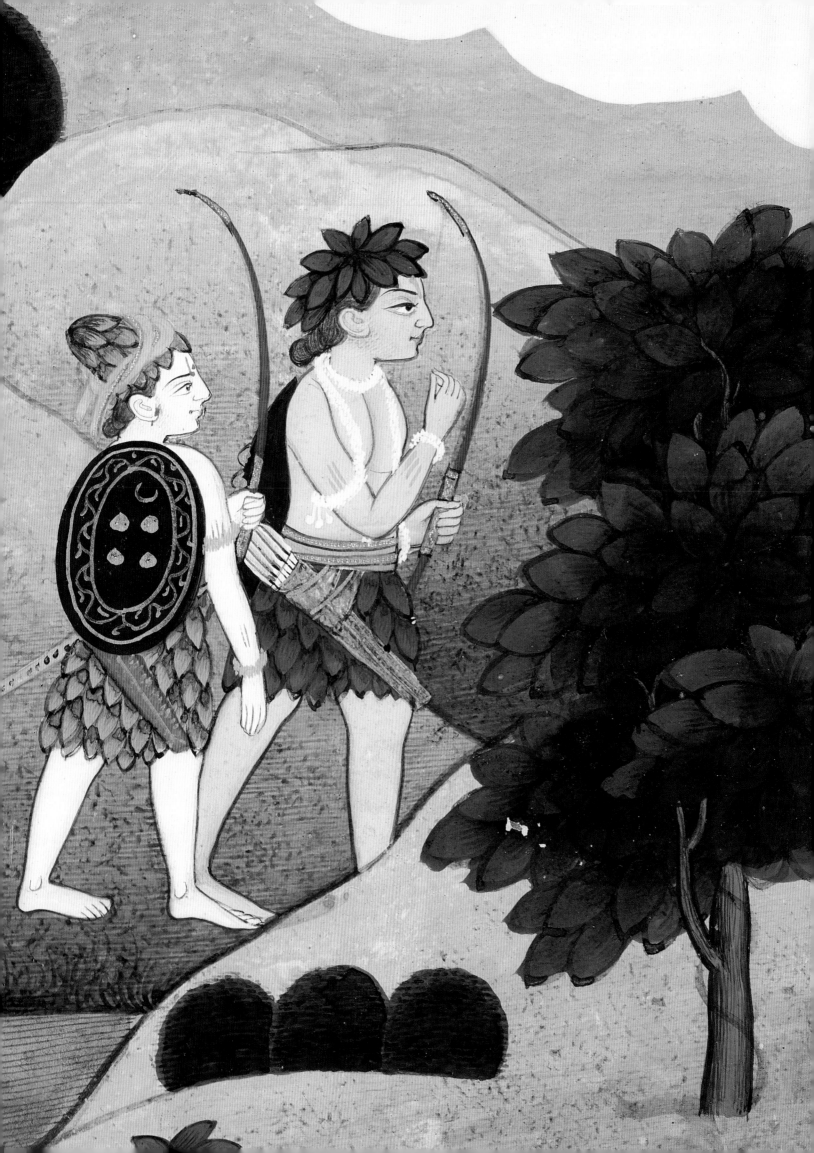

ROBERT P. GOLDMAN

Hero of a
Thousand Texts

For educated Westerners raised on texts such as the Old and New Testaments, the Greek and Roman epics, and the dramas of Shakespeare, as well as basic instruction in European and American history and literature, the mention of figures such as Moses, Jesus of Nazareth, Judas Maccabeus, Zeus, Achilles, Ulysses, Julius Caesar, King Arthur, El Cid, Hamlet, and so on would immediately conjure up at least a general sense of a great hero and his story. They would immediately recognize these figures as saviors, deities, divine incarnations, patriarchs, warriors, princes, emperors, or literary heroes who played some major role—legendary, historical, or both—in the history of their respective cultures and the general Western imaginary. Some, like Jesus, transcend cultural, ethnic, linguistic, and national boundaries to become central figures of a worldwide religious tradition.

Now imagine, if you will, a figure who fits *all* of the above categories—saviors, deities, literary heroes, and so on—and has served for at least the past two and a half millennia as a central deity, ideal man, culture hero, model monarch, and literary hero for many hundreds of millions of people of different religions, speaking dozens of languages, in what are now more than a dozen countries across South Asia and beyond. Consider that this immensely important figure is

FACING
Detail of cat. no. 28

someone you may never even have heard of. Or, if you have, it may be only as a dimly recognized name from some old Eastern story or at most as a hero of some ancient Indian tale. This is Rama. Between antiquity and early modernity, by whatever of his many names and epithets he may be known and in whatever language of the region, Rama more than any other figure has established himself in the hearts and minds of countless Hindus, Jains, Buddhists, Muslims, and others across the vast expanse of South and Southeast Asia—from Afghanistan in the west to the Philippines in the east and from Tibet in the north to Sri Lanka in the south.[1] Today, as a result of colonialism, migration, and globalization, he is a familiar and beloved figure in many ethnically Asian communities throughout the world. In India alone, a staggering number of versions of the Rama tale are prevalent, and tradition has it that there are in fact one *crore* (ten million). As the great linguist and folklorist A. K. Ramanujan famously put it,

The number of *Rāmāyaṇas* and the range of their influence in South and Southeast Asia over the past twenty-five hundred years or more are astonishing. Just a list of the languages in which the Rāma story is found makes one gasp: Annamese, Balinese, Bengali, Cambodian, Chinese, Gujarati, Javanese, Kannada, Kashmiri, Khotanese, Laotian,

Malaysian, Marathi, Oriya, Prakrit, Sanskrit, Santali, Sinhalese, Tamil, Telugu, Thai, Tibetan—to say nothing of Western languages.[2]

In these different but interconnected cultures, Rama appears in many roles, which vary according to the particular religious and cultural beliefs and values of the author and audiences of the history of Rama. In virtually all he is the hero of a diverse but thematically connected spectrum of texts—epic, literary, theological, folk, dramatic, and cinematic—which we refer to generically by the Indic name Ramayana, that is to say, "The Tale of Rama." For Hindus, especially those who identify themselves as devotees of the Lord Vishnu, he is one of the principal avataras (divine incarnations) of that deity, who is often represented as one of the Hindu Trinity consisting of Brahma, Vishnu, and Shiva, who respectively create, maintain, and destroy the successive cycles of creation. He is also represented as a perfectly righteous man in his roles as a son, a husband, a brother, a warrior, and, ultimately, as the universal sovereign of a utopian age.

The tale of Rama is also very popular in Jain versions of the story. The Jains, however, believe neither in the whole concept of divine incarnation nor in the idea that salvation is to be achieved through the worship of any divinity. In Jain versions of the Rama story, such as the famous first-century *Paumacariya* of the poet Vimalasuri, the hero is represented not as a god on earth, but as an ideal Jain layman destined to be reborn as one of the Jain holy men and world teachers (*tirthankaras*) who appear in different ages of the world to teach the Jain dharma or doctrine and to found once again the order of Jain monks. For the Buddhists, whether in the Pali-language stories of the Buddha's previous lives or the poetic versions of the story in the Buddhist kingdoms of Southeast Asia (such as Thailand, Burma, Cambodia, and Laos), Rama is a wise prince who exemplifies the Buddhist virtues of stoicism and control of one's emotional life. In the Muslim countries of the region (Malaysia and Indonesia), Rama serves as the model for an ideal Islamic ruler.[3]

Let us look somewhat more closely at the various aspects of the characterization of Rama across the eras, regions, and national and religious cultures where he remains the great paragon of what it means to be a true hero. If Westerners know anything at all about the Ramayana and its protagonist, they would generally recognize it as an epic poem held in high esteem as a religious text of Hinduism and Rama as a form of one of the principal divinities of Hinduism, Vishnu. Some

who follow international news might be aware that the poem and its hero have been placed in recent decades at the center of the politics of religious nationalism in India. Others with a bit more specialized interest in South Asian culture or religion would additionally be aware that it is one of the primary early literary sources for the specifically Vaishnava theological motif of the avatara. This is the periodic incarnation or "descent" into the affairs of the world on the part of Vishnu, in one form or another, in order to reestablish the reign of the gods, the representatives of dharma or righteousness, whose dominion has been subverted and overthrown through the agency of a powerful, demonic figure. Through the acquisition of a divine boon of some kind, this figure has managed to tip the moral balance of the universe in favor of what Darth Vader liked to call "the dark side." This doctrine of the avatara is perhaps best known and most succinctly stated in its often-quoted formulation from the Bhagavad Gita, "Whenever righteousness declines, and unrighteousness is rampant, I project myself into the world. It is for the protection of the virtuous, the destruction of the wicked and the re-establishment of righteousness that I take birth age after age."[4]

According to Hindu scriptures, particularly those that form a part of the Vaishnava canon, time is cyclical and is divided into an endlessly recurring series of cosmic eras, or *yugas*. Whenever, in the course of these eras, the world, the gods, humanity, or dharma, righteousness, are threatened by the forces of *adharma,* or unrighteousness, the Lord puts forth or takes on a human or animal form to restore the dominance of the former. Different texts speak of a varying number of these manifestations of the divine, but a consensus finally emerged to the effect that there are ten principal avataras (fig. 16). By this calculus, Rama is the seventh incarnation and appears in the second of the recurrent *yugas,* the *Treta Yuga.* Vishnu takes on this incarnation at the behest of the gods, who are being terrorized by the mighty ten-headed rakshasa Lord Ravana. Through a boon of invulnerability to the gods and other supernatural beings that he had secured from the creator Brahma, Ravana can be killed only by a human.

As a consequence of this boon, Vishnu cannot slay Ravana *in propria persona* as the highest of the gods. Nor can he merely take on the appearance of a lesser being, such as a human, while retaining consciousness of his own divinity. Therefore, according to Valmiki, author of the oldest known version of the Rama story, Rama, uniquely among the Vaishnava avataras, must carry out his divine mission without knowledge of his

FIG. 16 (*top*). The ten incarnations of Vishnu. Rama is the second from the left (cat. no. 4).

FIG. 17 (*above*). Rama is despondent over the loss of Sita; the monkeys exhort him to action. Advertising card.

FIG. 18 (*right*). The birth of Rama and his three brothers. Detail of page from the Mewar Ramayana, 1649–1653. The British Library.

true identity. This feature of his incarnation, although eroded or ignored by many later authors of the tale, is central to Valmiki's portrayal of his hero, who, like a real human, suffers greatly throughout his long life as a result of personal tragedies, emotional losses, and even physical injuries (fig. 17). In Valmiki's epic, it is only at the end of the sixth of the work's seven books, and after he has succeeded in destroying Ravana in battle, that Rama is informed by the gods of his true nature as the Supreme Lord. When the gods praise him, he expresses puzzlement, saying, "'I think of myself only as a man, Rama, the son of Dasharatha. May the Blessed Lord please tell me who I really am, to whom I belong, and why I am here.'"[5]

This motif, so central to Valmiki's portrait of Rama as an ideal man who, as some later commentators note, must suffer or at least appear to suffer like an ordinary mortal for the edification and emulation of real people,

is carried through in some important early literary and religious works.[6] It is, however, largely superseded in the early modern period with the rise of the more devotionally inspired versions of the Rama story.[7]

Another important point to note about the Lord's incarnation in the Ramayana is that, unlike all but one of his other principal incarnations, Vishnu does not incarnate as a single individual.[8] Instead, through the mechanism of having King Dasharatha's three wives consume varying portions of a dish infused with the blazing energy of the divinity, Lord Vishnu is incarnated in the form of Rama and his three younger brothers (fig. 18). This critical feature of the story allows the author of the poem to further elaborate, through replication and contrast, a more complex personality of the epic hero.[9]

For the vast majority of Hindus, the overwhelmingly central aspect of the characterization of Rama is

exactly this shared understanding that Rama is a major incarnation of the Supreme Lord. He is thus a principal object of worship in India's numerous temples dedicated to him and to his eternal royal consort, the goddess Sita; in personal shrine rooms; at the annual religious dramatizations of his career, the famous Ramlilas (fig. 19); and even, as recent history has shown, as the lead character in a massively popular TV serialization of the epic, Ramanand Sagar's *Ramayan* (fig. 20).[10]

A closer look at the Indic materials, however, suggests that the Rama story came to be popular and widely circulated in a variety of contexts in which the divinity of its hero was either only a collateral issue or even entirely antithetical to the purposes and interests of the authors and audiences of its various versions. Consider, for example, what may be the oldest retelling of Valmiki's tale, the *Ramopakhyana* of the Mahabharata. This version occupies nine chapters of the great Sanskrit epic's third book (Mahabharata 3.257–

FIG. 20. The actors Arun Govil and Deepika Chikhalia as Rama and Sita in Ramanand Sagar's TV serialization, 1986.

276). The narrator acknowledges the avataric character of Rama but appears to be more interested in using the narrative as an exemplary tale. For the Mahabharata poet, Rama's virtues of self-sacrifice, filial devotion, and stoic endurance in the face of adversity are held up as examples to the similarly long-suffering epic hero, Yudhishthira. This is thus not principally a celebration of God's earthly incarnation. Moreover, within the capacious boundaries of Hinduism the Rama legend has often been used as a vehicle for the magnification of divinities other than Vishnu. Thus, as W. L. Smith and others have pointed out, numerous versions of the story have been composed by adherents of *Shakta* schools of theology, in which the power of the mother Goddess is regarded as greater than that of any male divinity (fig. 21).[11] In such versions, Rama is by no means omnipotent. On the contrary, he is often represented as running into insuperable difficulties and superior adversaries from which he must be rescued by his spouse, Sita.

It is, moreover, a commonplace of post-Valmiki versions of the Rama story to depict Rama, although he is an incarnation of Vishnu, as a devotee of Shiva (fig. 22).

But the Rama epic in India has by no means been popular only among the adherents of the various branches of Hinduism. The tale and its hero were of considerable importance to the followers of ancient India's two great surviving non-Hindu religious traditions, Buddhism and Jainism. This is so despite the fact that both religions steadfastly deny the divinity or salvific power of Rama or indeed of any deity.

The story of Rama was adapted early by Buddhist authors, and its various parts figure significantly in

the important collection of Jataka tales, which provide accounts of the previous births of the Buddha. One of these recounts a version of the epic story that makes no mention of Rama as a divine incarnation or of the abduction of Sita. Instead it focuses on Rama's emotional self-control as an exemplar of this cardinal Buddhist virtue. In another, an episode in which Rama's banishment is attributed to a curse laid upon his father is reworked with a different cast of characters. Moreover,

Valmiki's poem was admired by the first-century Buddhist poet Ashvaghosha, who used it as a model for his poetic biography of the Buddha.

Jain authors, too, have been especially fond of the Rama legend, regarding its hero not as an incarnation of Godhead but as one of the sixty-three exemplary Jain laymen (*shalakapurushas*), who appear in each age of the world. Rama thus becomes the hero of numerous Jain Ramayanas (fig. 23). Here even the martial

FIG. 21. Rama invokes the goddess Durga as he shows his devotion by preparing to shoot out his own lotus-like eye to make up the auspicious number of 108 lotus blossoms on her altar. Popular print from Bengal.

FIG. 22. Rama, accompanied by Lakshmana and Hanuman, worships the Shiva linga as Shiva and Parvati look on approvingly. Popular print.

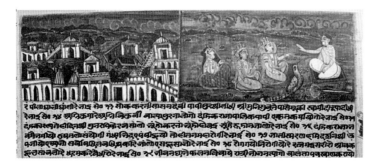

FIG. 23. Rama and Sita are blessed by a Jain monk. Painting from the Ramayashorasayana of Kesharaja, eighteenth-century Rajasthan.

character of the epic warrior must give way before the Jain imperative of non-injury to all living beings (*ahimsa*). Thus Rama's most defining feat as an avatara, the killing of Ravana, must be assigned in most Jain versions of the tale to Lakshmana, who unavoidably, in keeping with Jain doctrine, must suffer the karmic consequences of his actions.[12]

So we see that in many ways, over time, with numerous shifts of emphasis and of religious and philosophical orientation, the Rama story came to dominate the folk, literary, artistic, performative, and religious literatures of nearly every one of South Asia's numerous languages and regions. Hindus revere and worship Rama as a living god on earth; this belief is surely a major factor that explains the prominence and durability of this hero in the overwhelmingly Hindu nation of India and throughout the worldwide diaspora of Hindus. But what is it about Rama that accounts for his extraordinary popularity and influence among non-Hindu Indians and across the vast cultural areas of Buddhist and Islamic Southeast Asia? How has he so powerfully transcended the starkly different religious landscapes of this widely diverse region that the Jains see him as one of their great exemplars; some Buddhist kings of Thailand took his name as their dynastic name and that of his capital, Ayodhya, as that of their own, Ayutthaya; while the puppeteers of the Malay-Indonesian shadow-puppet theater represent him as the ideal Islamic man and prince?

The answer lies in the characterization of Rama in most versions of the Ramayana, from the time of Valmiki onward, as an exemplar of social and political conduct. This has been the most "exportable" feature of the story, which, in its innumerable local variations, has most fully accounted for the spread and popularity of the Rama legend through so much of Asia.

According to the original Ramayana, Valmiki first heard the tale of Rama in the form of a brief narrative told to him by the divine seer Narada. That very compressed version of the tale makes no explicit reference to theology or indeed to any cosmic or even "national" mission of its hero. It is instead the story of an ideal prince, endowed with all the virtues of an ancient Indian aristocrat. Rama willingly forgoes his royal inheritance in deference to a vow of his father and cheerfully accepts a life of banishment and penury rather than assert his own claims against his society's powerful imperatives of filial deference, truthfulness (*satya*), and righteousness (*dharma*). In exile, he suffers the abduction of his beloved wife but exhibits exemplary fortitude and perseverance, mounting a successful military campaign to recover her and punish her abductor. Finally, he returns home, regains his birthright, and rules wisely as a righteous emperor, maintaining ritual order and social harmony throughout his vast realm through his exemplary conduct and his sagacious governance. In order for him to achieve this *summum bonum,* he must once again prove to the world his conformity to an austere social and political code by abandoning his beloved queen, yet again sacrificing personal happiness on the altar of public duty (fig. 24). There is no happy ending in Valmiki's epic as it has come down to us.

What Narada's tale sets forth—and what Valmiki and later authors, reciters, and performers embellish and enrich—is the classic, idealized representation of the normative South Asian male personality: powerful, lovable and learned, capable of commanding nations and contesting even the gods, but always ready to renounce his own interests and desires in favor of those of the social and ritual order. Rama is above all a prodigy of self-control, of the mastery of the senses, and of the submission of the individual to the demands of his society. One might say that he is a living example of the triumph of the superego over the id; and as such, he has become the standard of behavior for countless generations, the radical opposite of his demonic antagonist, Ravana, the grotesque caricature of

FIG. 24. Rama instructs his brothers that Sita is to be banished. Detail of page from the Mewar Ramayana, 1649–1653. The British Library.

AYODHIA PATI RAM

FIG. 25. King Rama, flanked by Lakshmana and Sita, blesses Hanuman kneeling at his feet. Popular print.

unbridled self-indulgence and contempt for his elders and legitimate authority. The characterization of the self-abnegating and dispassionate hero stands as well in contrast to that of the classical Western hero, who is represented as a rebellious figure, contemptuous of authority, such as Achilles and Robin Hood or the heroes of modern Hollywood thrillers.

In this way Rama comes to be regarded as the paragon of filial devotion. His heroism occurs not only on the battlefield but also in calmly—even cheerfully—giving up his rightful succession to the throne on the very eve of his consecration to maintain the truthfulness of his father's word and to gratify the wishes of a scheming stepmother. In this, he fits into the well-known mold of the self-sacrificing son that lies at the heart of many tales from the Indian epics.[13]

But Rama is not only the ideal son. He is also the ideal monarch. Indeed, the particular representation of kingship put forward in the Ramayana tradition as inaugurated by Valmiki has had considerable influence on the ideology of governance across South Asia. On this level the story presents in one of its most dramatic

and widely popular forms the early Indic notion of the divinity of the king. Here the traditional representation of the king as a god on earth takes on a specifically Vaishnava coloration in the portrayal of the avatara as the monarch who literally establishes God's kingdom on earth.[14] Thus Valmiki, when describing Rama's utopian reign, depicts Rama as the model for all earthly rulers and the period of his rule as the millenarian heaven on earth that, in later times, comes to be known as the Ramarajya or Ramrajya. According to the Valmiki Ramayana and the Hindu tradition that has followed it, this was a period during which there were no illnesses, no natural disasters, no crime, and no social disharmony. The idea of the possibility of such a utopia has gained significant political traction in modern and contemporary India at least since the time of Mahatma Gandhi. In this reading, Rama is represented not only as the martial warrior hero of the epic but also as the loving shepherd of his people (fig. 25).

This characterization of the king as a god on earth resonated widely across premodern South and Southeast Asia to the point where, by the medieval period,

FIG. 26. Rama and Ravana in combat (detail of cat. no. 46).

many Hindu and Buddhist rulers invested heavily in the expansion of the temple cult of Rama. It can also be seen in the construction of sovereignty in premodern Java and Cambodia and in several nations of the region, such as Thailand, right down to today (fig. 26). Even Muslim rulers were deeply enamored of the Rama story, which came to be widely represented in the literary, visual, and performative arts of the Malay-Indonesian world.

It is this characterization, surely, and not his status for Valmiki and the Hindu tradition as an avatara of Vishnu, that has led Buddhist, Jain, and Muslim authors and singers of tales to adapt the Rama epic to their own purposes and their own cultures. This is why, as a former incarnation of the Buddha, Rama becomes an exemplar of the Buddhist virtues of self-control in the Buddhist birth stories and the Thai Rama epic. This is also why, in the seventeenth-century Burmese version of the tale, he is referred to as the Bodhisat King, the account of whose birth closely parallels the birth stories of the historical Buddha himself.[15] It is, moreover, why the Jains revere Rama as an ideal practitioner of nonviolence, *ahimsa,* in their Ramayanas and as a man who is destined to be reborn as a world teacher (*tirthankara*) in a future existence. It explains as well why the Malay-Indonesian world sees Rama as a paragon of the clever and resourceful Islamic prince, whether in the Old Javanese Ramayana Kakawin, the Malay Hikayat Seri Rama, or the various forms of shadow-puppet performances.

The above brief survey, by touching on only a very few examples, shows how the almost innumerable versions of the story of Rama have, over the past two and a half millennia, captured the imagination of the people of virtually every culture, region, religion, and language of South and Southeast Asia. As we have seen, Rama is portrayed very differently in the different versions. In some he is a veritable god on earth; in others an ideal king; in still others a clever prince—and he is sometimes represented as all of these at once. But in practically every such example Rama is depicted in glowing terms as an ideal person.[16]

Nonetheless, a character study of this great figure should also take note of a history of ambivalent and

even countervailing responses to the representation of Rama in some quarters during the *longue durée* of the Ramayana's career as a principal cultural medium in Asia. These responses have been pronounced in India, particularly in more modern times with the rise of social, regional, and political movements that have developed critiques of the Ramayana and its pervasive influence on culture and society. It would therefore be appropriate to provide some background and historical context within which one might understand these developments.

In the first six of the seven books that constitute the complete Ramayana as it was revealed to and rendered in poetic verse by the poet-seer Valmiki, Rama, no matter what reverses and provocations he suffers in undergoing an unjust exile and the abduction of his beloved wife, remains always a paragon of self-restraint and righteousness. Very few of his actions in this massive amount of narrative are questioned by characters in the epic text itself, its medieval commentators, authors of later versions of the tale, or its modern audiences. Exceptions include his shooting of the monkey king Valin from ambush (fig. 27), the harsh treatment of his recovered wife, and his killing of a low-caste ascetic. In the first case Rama successfully persuades the mortally wounded monkey of the righteousness of his actions, but the moral qualms the incident has engendered reverberate to this day in the ephemeral literature on "doubts" concerning the Ramayana.[17]

Another concern about the character of Rama has to do with his treatment of Sita. In many versions of the story, it is said that when Rama recovers his abducted wife, he harshly says he will not accept her because she has lived in the house of another man. To prove her fidelity, Sita must then undergo an ordeal by fire. Only when she emerges from the flames unscathed and the fire god testifies to her purity does Rama take her back. The incident is controversial in the epic itself and in various retellings of the story. By the medieval period, with the rise of ever more devotional representations of Rama and Sita, a motif was developed in which the whole incident is seen as a supernatural device to conceal the fact that Sita had never truly been abducted, but had created an illusory likeness of herself which is abducted while she herself remained hidden in the bosom of the sacred fire.[18] This device spares Rama both the accusation of mistrusting his wife and any hint of cruelty toward her as well as sparing Sita, a goddess in her own right, the indignity of being captured by the monstrous Ravana.

FIG. 27. Rama, Lakshmana, and Hanuman watch as Valin and Sugriva battle (cat. no. 31).

But Valmiki's Ramayana and many others that follow his version contain a seventh book, an elaborate epilogue concerning the hero's life after the success of his divine mission. This, the Uttarakanda, or "Last Book," has been ignored or excised by many later versions of the story. One of its episodes concerns Rama's harsh treatment of the long-suffering Sita. After the couple's triumphal return to Ayodhya Rama learns that his people are criticizing him for having taken the queen back and they fear that they, too, will now have to put up with unchaste wives. In his determination to be a perfectly righteous monarch and to be perceived as such by his subjects, Rama resolves to have Sita taken from the city on the pretext of a visit to some forest hermitages, and abandoned in the wilderness. Sita spends twelve years in Valmiki's hermitage, where she bears Rama's twin sons, Lava and Kusha. At last, the sage brings her and her sons back to Ayodhya during Rama's performance of a sacrifice. Asked once again to give a public demonstration of her absolute fidelity, the queen takes recourse to an "act of truth," calling upon her mother, the Earth Goddess, to take her back. Sita disappears beneath the earth, to the shock and dismay of Rama.

Authors and audiences have struggled with this episode from antiquity to the present day. Treatment of the episode has varied over time, with different strategies employed to deal with it. Nonetheless, the basic position of the text is that, in abandoning his beloved wife in order to retain his subjects' faith in his righteousness, Rama embellishes rather than diminishes his reputation as the ideal monarch. Parted from his wife, Rama forswears taking another, causing a golden image of the banished queen to stand as a surrogate in the role of the spouse in his ritual performances. For the ideal man, in the culture of the Ramayana, is precisely the one who subordinates his personal happiness to the welfare and happiness of the people. Later authors are not so sure of this. For example, at least two of the great icons of Sanskrit literary culture who deal with the theme of the abandonment of Sita, the poet Kalidasa and the playwright Bhavabhuti, are rather critical of Rama on this account.

Medieval and early modern authors of texts that retell the Rama story, including the hugely influential Hindi version of the poet-saint Tulsidas, often cope with the problem simply by excising the controversial episode, and indeed virtually the entire substance of Valmiki's Uttarakanda from their texts. The issue came to a head with the screening of the widely watched TV serialization of the epic in the 1980s. The original ending, with the consecration of Rama and Sita, angered a lower-caste community that identified heavily with Valmiki, who plays a major role in fostering the exiled Sita and her sons and brings them back to Rama. The question of whether to script and screen the episode of the queen's banishment was so contentious that it could only be resolved by a court ruling.[19]

These two episodes, Sita's ordeal by fire and her abandonment by Rama, have been criticized by various social, regional, and political groups in modern India.[20] Indeed, feminists and leaders of a South Indian separatist movement have critiqued the entire Ramayana as a socially regressive text.[21]

Another episode in the final book of Valmiki's epic poem that has drawn criticism of the character of Rama has to do with his harsh treatment of a man of low social status. Shortly after his consecration, Rama is confronted by a brahman who approaches holding the body of his dead child. As the ideal monarch, Rama accepts responsibility for the untimely death and reasons that there must be some discrete flaw in the perfect fabric of righteousness somewhere in his kingdom. Learning that a low-caste person is performing religious austerities that are the preserve of the higher orders of the socio-ritual hierarchy, Rama locates the man and summarily executes him, an act that results in the instantaneous revivification of the dead child. Rama is rewarded for the deed and celebrated by the gods themselves.

Unsurprisingly, in the modern era of caste politics, specifically with the political rise of lower castes, this episode has captured the attention and sparked the condemnation of historically disadvantaged groups in India. Such groups, along with the leftist and Dravidian parties, have come to regard the incident as emblematic of the top-down, oppressive caste hierarchy historically associated with brahmanical religion and society. In this view, Rama is represented as the enforcer of an ancient system of societal division into four hierarchically ranked social classes with the brahmans at the top.

This has been a very brief account of the career and character of Rama, a god on earth, righteous universal monarch, ideal son and brother, protagonist of poetry, stage, and screen, darling of painters and sculptors, the hero of a thousand tales, and the object of devotion for hundreds of millions of people from antiquity to the present day. We have seen how the hero of an ancient Indian epic came to be regarded as an avatara of the Hindu Lord Vishnu, a Buddhist bodhisattva, a Jain *shalakapurusha*, a Muslim sultan, and a model for princes and commoners alike from Tibet to Sri Lanka and from

Afghanistan to the Philippines. Yet, as we have also seen, such a dominating and powerful figure has not gone entirely without critique and remains an object of both powerful devotion and social critique today. Few figures in world literature and religion have made and continue to make such an impact on the world.

NOTES

1. For a sense of the vast spread of the Rama story in India and the rest of Asia, see the forty-four essays on different versions of the tale in Raghavan, *Ramayana Tradition in Asia.*

2. Ramanujan, "Three Hundred *Rāmāyaṇas*," 24. Ramanujan's list of languages in which there are versions of the Rama story is not inclusive. It merely shows the diversity and breadth of the story across Asia and could be easily extended. One could also mention Persian, as the Mughal emperor Akbar had the epic translated into that language, and even Japanese, where some episodes of the Rama story are to be found. See Das, "Notes," 144–153; and Hara, "Rama Stories in China and Japan," 340–356.

3. On the Malay Ramayana, see Sweeney, *Rāmāyaṇa and the Malay Shadow Play.* For the tale in Indonesia, see Saran and Khanna, *Ramayana in Indonesia.*

4. Bhagavad Gita, 4.7–8.

5. Goldman, Sutherland Goldman, and van Nooten, *Yuddhakāṇḍa,* 459.

6. This is the case, for example, in the mammoth Vaishnava *Padmapurana,* the iconic narrative poem of Kalidasa, the *Raghuvamsha,* and, most notably of all, the famous long drama of the poet-playwright Bhavabhuti, the *Uttararamacarita.*

7. One of the best-known and most widely influential of these is the Ramcaritmanas of the sixteenth- to seventeenth-century poet-saint Goswami Tulsidas, which is, for hundreds of millions across the vast Hindi-speaking belt of North India, *the* Ramayana.

8. The other exception to the rule is Rama's successor incarnation, Krishna. Here, in many texts Vishnu is born as both Krishna and his elder half brother, Baladeva (Balarama). In some versions of this legend Krishna is the direct incarnation of Vishnu while Baladeva is a manifestation of Shesha, the cosmic serpent lord. This idea is also represented in the incarnation of Rama and his brothers in the works of Vaishnava theologians of different schools. Thus, for example, Lakshmana, like Baladeva, is often thought of as an incarnation of Shesha.

For a detailed discussion of the complex theology involved, see Goldman and Sutherland Goldman, introduction to *Uttarakāṇḍa.*

9. On the contrasts and complementarity of Rama and his three brothers, see Goldman, "Rāmaḥ Sahalakṣmaṇaḥ."

10. For discussions of the serial and its impact on the culture and political life of contemporary India, see Tully, "Rewriting of the *Ramayan*"; Lutgendorf, "Ramayan: The Video"; and Rajagopal, *Politics after Television.*

11. Smith, *Rāmāyaṇa Traditions in Eastern India.* A Sanskrit example of this type is the Ananda Ramayana.

12. For a recent study of some Jain Ramayanas, see Granoff, "A la mode," 22–45.

13. Goldman, "Father, Sons and Gurus."

14. For a discussion of the divinity of kings in the Indian tradition with special relevance to the Ramayana, see Pollock, "Divine King of the Rāmāyaṇa," in *Araṇyakāṇḍa,* 15–54.

15. Han and Zaw, "Rāmāyaṇa in Burmese Literature and Arts," 301–331.

16. The very diversity of the Ramayana tradition—the adoption of Rama and his history by authors and audiences of so many different religions, languages, and nations—has itself proved controversial with the resurgence of political Hinduism in recent years, since many orthodox Hindus understand there to be only one "true" representation of Rama, that in which he is seen as an avatara of Vishnu. In the early 1990s an exhibit on the Rama story by a progressive Indian artists' collective was attacked in New York City for representing the Buddhist Dasaratha Jataka version, in which Rama and Sita are represented as brother and sister. More recently, in 2011, even Ramanujan's essay, quoted above, sparked violent opposition when a group of Hindu activists demanded that both the essay and an anthology of Ramanujan's work, published by Oxford University Press, be removed from the syllabus of a history course at the University of Delhi. See Biswas, "Ramayana: An 'Epic' Controversy."

17. Lefeber, *Kiṣkindhākāṇḍa,* 45–50.

18. For a discussion of the rejection of Sita and the controversy it has engendered, see Hess, "Rejecting Sita," 1–32; and Goldman and Sutherland Goldman, introduction to *Uttarakāṇḍa.*

19. See Tully, "Rewriting of the *Ramayan*"; and Lutgendorf, "Ramayan: The Video."

20. Goldman and Sutherland Goldman, introduction to *Uttarakāṇḍa;* and Kishwar, "Yes to Sita, No to Ram," 285–308.

21. Richman, "E. V. Ramasami's Reading of the *Rāmāyaṇa*," 175–210.

What Does Rama Look Like?

Rama is a brave and handsome young prince (and eventually king), and so he looks like each culture's and period's ideal of such a figure. One of the features that frequently helps identify him is a bow, appropriate for a universally renowned archer. But many handsome princes, such as Rama's brother Lakshmana, also carry bows. The other key characteristic of Rama, then, is the color of his skin, which is blue or bluish or green or greenish, like that of the deity Vishnu, of whom Rama is an incarnation [1].

When Rama goes into exile in the forest accompanied by Sita and Lakshmana, he and they exchange their sumptuous finery for the leaf or bark garments of ascetics [2].

Later, when the battles to rescue Sita from Ravana are under way, Rama appears as a warrior and commander, resuming his princely attire and diadem or crown [3].

Finally, upon his installation as king, Rama is seen in full royal regalia [4]. F.McG.

[1] *Detail of cat. no. 14.*

[2] *Detail of cat. no. 58.*

[3] *Detail of cat. no. 46.*

[4] *Detail of cat. no. 51.*

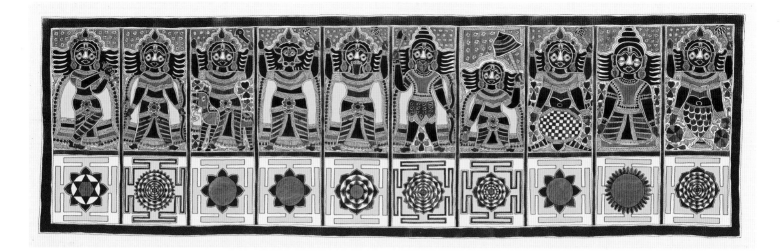

4

4 *also fig. 16*

The ten incarnations of the Hindu deity Vishnu, approx. 1975–1982

By Batohi Jha (Indian, active approx. 1975–2000)
Ink and colors on paper
H. 50.8 × W. 151.8 cm
Asian Art Museum, Museum purchase, 1999.39.45

Vishnu maintains order in the cosmos and descends from the celestial realm when chaos and injustice have disrupted life on earth. According to most Hindu traditions, Vishnu has ten avataras (Sanskrit, "descent"), and he assumes a different human or part-animal form in each instance. Rama—the epitome of the perfect son, brother, husband, and king—is the seventh avatara; like Krishna, he is recognized as a deity in his own right.

The ten avataras of Vishnu often appear together in religious imagery, as in this painting. From left to right, they are Krishna, Rama, Kalki, the boar Varaha, the lion Narasimha, Parashurama, the dwarf Vamana, the tortoise Kurma, Buddha, and the fish Matsya. Rama and Parashurama, two of Vishnu's human forms, belong to the warrior class (*kshatriya*) and are sometimes difficult to tell apart. Both have a bow in one hand as their attribute, a symbol of their military skills, but Rama typically holds an arrow while Parashurama carries a battle-ax. Q.A.

5 *also p. 260*

Rama, 1000–1100

India; Tamil Nadu state
Chola period (880–1279)
Copper alloy
H. 95.9 × W. 44.5 × D. 24.1 cm
Asia Society, New York: Mr. and Mrs. John D. Rockefeller 3rd Collection, 1979.23

In Indian artistic conventions, a deity's spiritual perfection is expressed in his or her idealized beautiful form. Rama, the archetypal god-king, is depicted here with an elegant body in a dance-like three-bend (*tribhanga*) pose that is employed for both male and female divinities. His face is calm and controlled, as befits a deity; strength and agility are apparent in his pose, while the sense of a living, breathing body is conveyed through the soft folds of flesh cast in metal. Rama's role as a king is denoted by the tall crown that takes the form of a distinctive Chola-period style and is further emphasized by the many intricately rendered adornments of jewelry and fine textiles. His status as a warrior is indicated by his weapons (here missing).

The holes at the base of this sculpture indicate that this image was used in processions and carried during festivals. On such occasions, the figure of Rama would have been dressed in clothes, jewelry, and garlands; he would be holding his identifying bow and arrow. A devotee would probably never see the bare form that we see here; yet even unadorned, Rama's perfect body is splendorous. Q.A.

6

The Hindu deity Rama, approx. 1400–1500
India; Karnataka state, former kingdom of Vijayanagara
Granite
H. 269.2 × W. 71.1 × D. 35.6 cm
Asian Art Museum, The Avery Brundage Collection, B60S53+

Though Rama's divinity had been recognized for many centuries, his "temple cult"—that is, temples dedicated to him and representations made of him not in action performing heroic deeds but in the form of an icon—became common only perhaps nine or ten centuries ago.[1]

The cult of Rama was particularly important in Vijayanagara, the capital of the South Indian empire of the same name in which this sculpture was made. Various episodes of the story of Rama's life were thought to have taken place near the capital. The very plan of the city, with a temple to Rama at a key focal point, was "designed to establish a homology of the king and the divine hero-king Rāma and a congruence between the terrestrial realm of the king and that of the god."[2] The walls of this temple, the Ramachandra Temple (sometimes called the Hazara Rama Temple), are lined with dozens of reliefs depicting the Rama epic.

Large, freestanding stone sculptures of Rama such as this one, which may have served as the primary, immovable image in a temple (in contrast to the metal

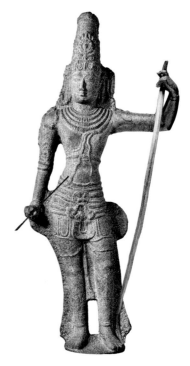

Conjectural reconstruction.

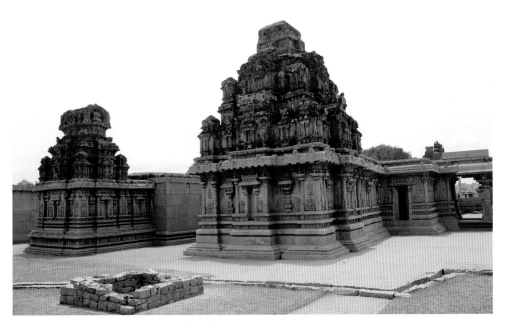

Ramachandra Temple, Vijayanagara, early fifteenth century.

images such as cat. no. 5, which were conveyed in processions), are very rare. No other example of this size is known in a European or American collection.

Though the sculpture's proper left arm is lost, other images that survive intact, such as the one shown here (cat. no. 7), give a clear sense of what the image looked like originally. Its left arm would have been raised high and would have held a bow, perhaps of gold or silver. Rama has always been thought of as a superbly skilled bowman; indeed, Kodanda Rama, "Rama-with-a-bow," becomes one of his important epithets, and the bow becomes his primary attribute in artistic representations. The sculpture's proper right fist has a hole drilled through, no doubt to accommodate an arrow. At the back of its head is the stub of an iron pin that once must have supported a circular radiance similar to those seen on Chola bronzes.[3]

This sculpture would likely have been flanked by sculptures of Sita and Rama's brother Lakshmana, as this triad can be seen in some South Indian temples (and many other representations, such as calendar prints) today, and probably occupied the central sanctuary of the Ramachandra Temple at Vijayanagara.[4] F.McG.

NOTES

1. Pollock, "Rāmāyaṇa and Political Imagination," 264–269; note his contention that Chola bronzes of Rama with a bow "seem to have been highly restricted in both time and place, to tenth-century Thanjavur district and the reign of Āditya [approx. 871–907]."

2. Ibid., 268. See also Fritz, "Vijayanagara: Authority and Meaning"; Dallapiccola et al., *The Ramachandra Temple*; and Verghese, *Religious Traditions at Vijayanagara*.

3. I appreciate the thoughts on this sculpture and its likely former accessories provided by Anna Dallapiccola in an e-mail of April 24, 2012.

4. Verghese, *Religious Traditions at Vijayanagara*, 47.

Rama, flanked by Sita and Lakshmana, in the sanctuary of the Kodandaramaswamy Temple, Hiremagalur, Karnataka state.

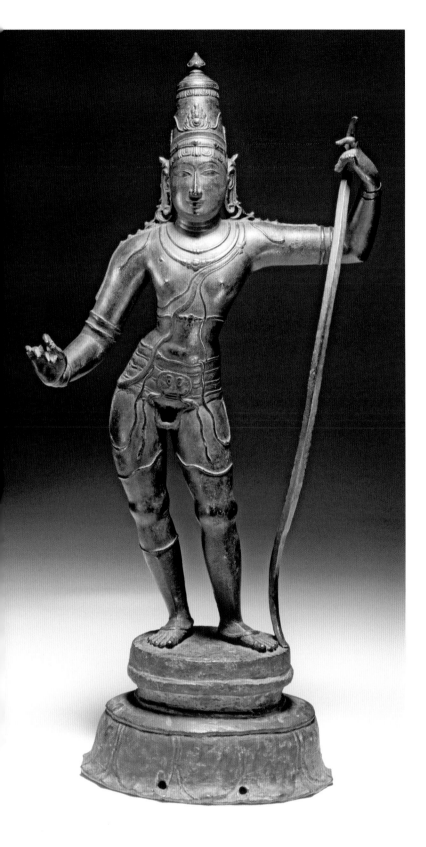

7

Rama, 1500–1700

India; Madurai, Tamil Nadu state
Copper alloy
H. 94 × W. 37 × D. 21 cm
Victoria and Albert Museum, London, IM.71-1927

This sculpture suggests the original configuration of the large stone Rama above (cat. no. 6). The use of bronze allowed greater suavity of modeling and allowed the right hand, which would have held an arrow, to be positioned away from the hip, not requiring support to prevent breakage.

Originally, separate images of Sita and Rama's brother Lakshmana probably joined this figure in a triad. F.McG.

For many centuries, aspects of the legends of Rama have been important in mainland Southeast Asian Buddhist art and culture.[1] An early Buddhist version, a *jataka,* presented Rama as the Buddha-to-be in one of his previous lives. Other versions were less—or not at all—explicit in situating the legends in Buddhist contexts, but associations were still drawn and understood.[2]

Some twelfth-century temples in Cambodia and northeastern Thailand display reliefs with content drawn from both Buddhist lore and Rama legends.[3] Monarchs of Thai Buddhist kingdoms from the thirteenth century onward bore such names as Ram Khamhaeng ("Rama-the-brave"), Ramadhipati ("Rama-the-lord"), Rameshvara ("Rama-the-ruler"), and Ramaraja ("Rama-the-king"). In 1351 a new city and kingdom were founded and given the name "Ayutthaya," the Thai version of the name of Rama's capital, Ayodhya. A royal temple in Ayutthaya built in the fourteenth or fifteenth century was called "Wat Phra Ram" ("Temple of Exalted Rama"), though its surviving decoration is entirely Buddhist, and the reason for its being named for Rama is not known.

Much was destroyed at the fall of Ayutthaya in 1767, including, no doubt, manuscripts, paintings, and other artworks that would have given us a better understanding of the place and roles of the Rama legends in the city's culture. With the reestablishment of peace and prosperity in the new capital of Bangkok, however, representation of the mythology of Rama in the visual and performing arts flourished, all within an ostensibly orthodox Buddhist context.

The first king of the new dynasty commissioned a new compilation of the Rama epic, known as the Rammakian (Sanskrit: *Ramakirti,* "The Glory of Rama"). He had extensive murals depicting its scenes painted on the walls of the gallery enclosing the primary royal temple, which housed the Emerald Buddha, the palladium of the kingdom. Dance-drama troupes sponsored by the king and princes competed in performing the epic's famous episodes.

In fact, in the late eighteenth and nineteenth centuries a web of symbolic connections linked the Thai monarch with the legendary king of the gods Indra, the ideal earthly king Rama, the princely Buddha-to-be Vessantara, and even, "though in proper Theravāda [Buddhist] fashion this always remained ambiguous," the Buddha.[4] Further research is likely to yield enhanced understanding of the royal Buddhism

of mainland Southeast Asia in recent centuries, and the significance in it of Rama and his accomplishments.

In the course of the nineteenth century, Rama legends and characters turn up in all sorts of Buddhist contexts. Some 150 reliefs of scenes from the Rammakian, famous in the West through rubbings, were installed along the balustrade of the ordination hall of another major Buddhist temple, Wat Phra Chettuphon, and the abbot's apartment at the same temple was decorated with painted scenes of combat between the epic's heroes and their adversaries (cat. nos. 67–69).[5] At a much smaller scale, Rama epic scenes or characters are depicted in such seemingly unlikely places as a compilation of Buddhist texts (cat. no. 10) and the sides of a tiered stand for Buddha images.[6]

Meanwhile, in other Buddhist countries of Southeast Asia, dancers, actors, and puppeteers also brought to life the Rama legends for the entertainment and edification of courtiers and commoners alike. Artists carved or painted the great moments of intrigue, romance, and conflict on the walls of buildings in Buddhist monasteries without, apparently, finding any incongruity. Such depictions are found as far apart as those commissioned by a Burmese king in the late 1840s for the Lawkamara-zein Stupa and those commissioned by a Cambodian king in 1903–1904 for the galleries surrounding the Buddhist temple of the royal palace of Phnom Penh.[7] The tradition continued into the mid-twentieth century with the installation in 1962 of elaborate reliefs of scenes of the Rama epic on the building housing the king's funeral chariot and other relics at Wat Xieng Thong, a royal temple in Luang Prabang, Laos.

F.McG.

NOTES

1. They also have been important, to an uncertain extent, in Indian Buddhist culture; see, for example, Agrawala, "Identification of Hanūmān"; Haque, *Pāhārpur,* 172, 179, 186, 230, 282; and Ray, "Narratives in Stone," 215. On the question of whether the Ramayana reliefs at Paharpur may have come from a different site, see Jordaan, *In Praise of Prambanan,* 42.

2. See Reynolds, "Holy Emerald Jewel," 185; and Reynolds, "*Rāmāyaṇa, Rāma Jātaka, and Ramakien.*" For a summary of the place of the Rama epic in Cambodian Buddhism, including esoteric interpretations explored by François Bizot, see Harris, *Cambodian Buddhism,* 90–102.

3. Those at Phimai, though, seem to have played an apotropaic, rather than narrative, role; Ly, "Protecting the Protector of Phimai," 43.

4. Reynolds, "*Rāmāyaṇa, Rāma Jātaka, and Ramakien,*" 58–59. Also needing further study are the meanings of the Buddha images wearing royal regalia that were produced in increasing numbers.

5. Niyada, *Hotrai Krom Somdet Phraparamanuchit Chinorot.*

6. Asian Art Museum 2006.27.19, pictured and discussed in McGill et al., *Emerald Cities,* 122–123.

7. On the Lawkamarakein, see Rooney, "Rama Story"; on the temple in the palace of Phnom Penh, see, for example, San Phalla, "Influence of the Ramakien Murals"; late nineteenth-century paintings of Rama epic episodes appear on the walls of the vihara of Wat Bo, Siem Reap.

8

Pediment with the hero Rama standing on a monkey, approx. 1750–1825

Thailand, Laos, or Cambodia
Tropical hardwood with remnants of lacquer,
gilding, and mirrored-glass inlay
Assembled: H. 281.9 × W. 246.4 cm
Asian Art Museum, Gift of the San Francisco Botanical
Garden Society from the Doris Duke Charitable Foundation's
Southeast Asian Art Collection, 2011.67.a–c

Rama, a renowned archer, fires an arrow at an unseen foe. A performer in the classical dance-drama would strike a similar pose, and because of the close relations between the visual and performing arts, both the pose and the details of Rama's costume could be matched in shadow puppets, paintings, and gilded decoration on lacquer.

Here Rama stands on the head of a monkey. We would expect his animal vehicle to be Hanuman, but this monkey lacks the coronet (see cat. no. 82) and garments usually worn by Hanuman, so its identity is uncertain.

This pediment is one of a pair in the museum's collection. The other shows a figure called in Thai Maiyarap (and in Indian traditions Ahiravana or Mahiravana), the demonic king of the Underworld in some mainland Southeast Asian (and Indian) versions of the Rama epic.[1] In the long struggle of Rama and his forces against the demons, Maiyarap manages, through magic and trickery, to kidnap Rama with the intention of killing him. Rama is eventually rescued by Hanuman. This episode is a popular one in performances of the classical dance-drama.

An unanswered question is what type of building would have represented on its pediments a legendary villain as well as a hero. Possibly the building had some sort of theatrical use. Generally similar wooden pediments with Rama epic scenes can be seen on a secondary vihara at Wat Phra Chettuphon, Bangkok, and detached ones are preserved in the storage of the Conservation d'Angkor in Siem Reap, Cambodia, or pictured in old photos.[2] F.McG.

NOTES

1. On Ahiravana/Mahiravana in India, see Lutgendorf, *Hanuman's Tale,* 53, 211–216.

2. *Samutphap/Pictorial Book,* 115; online photo archive of the École française d'Extrême-Orient, inventory number EFEO_CAM15609.

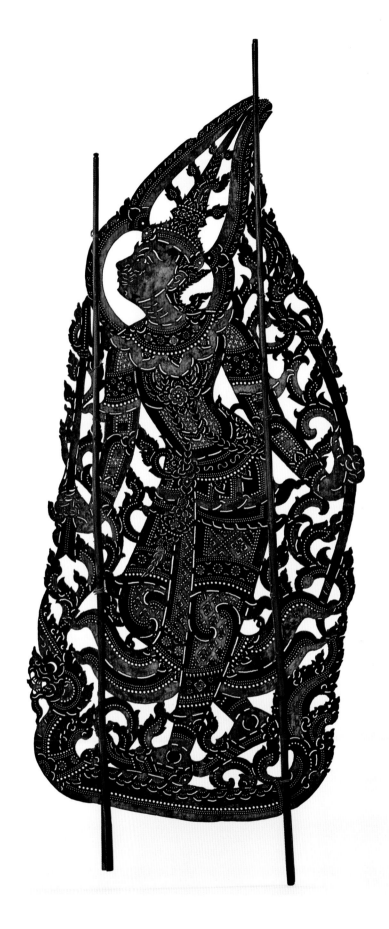

9 *also p. v*

Shadow puppet of Rama, 1900–1950
Thailand
Hide with pigments and wood
H. 179.7 × W. 67.3 cm
Asian Art Museum, Gift of the
Randall Museum Friends, 2010.534

Rama wears princely garments and crown, as he
usually does in Thai visual and performing arts,
rather than the ascetic's garb of one exiled to the forest
often seen in Indian depictions. He carries the bow
and arrow in the use of which he is so skilled.

Thai shadow puppets of the "large puppet"
(literally, "hide") type have no moving parts. Each
is held by a performer who carries it, with dancing
steps, back and forth. Each performer's movements
and stances must be appropriate to the particular
character; thus for Rama, they must be both heroic
and refined. Puppets are held in front of a white cloth
screen lighted from the opposite side by lamps or a
bonfire. The silhouette of the puppet registers strongly
and is enriched by the elaborate perforation and the
colors that have been applied to the translucent hide.

F.McG.

Possibly Ravana or Mara.

10

Illustrated manuscript of excerpts from Buddhist texts, 1857

Thailand
Paint, gold, lacquer, and ink on paper
H. 8.3 × W. 35.5 × TH. 5.7 cm
Asian Art Museum, Transfer from the Fine Arts Museums of San Francisco, Gift of Katherine Ball, 1993.27

The interior walls of many Buddhist temples in Thailand are lined with murals of the "Celestial Assembly," rows of divine or legendary figures kneeling in respectful homage to the Buddha. In this manuscript, similar figures pay homage to the Buddha's message, the dharma, as presented in excerpts from sacred texts.[1]

Among the figures are

- legendary serpents (personified, but recognizable by the serpent heads at the tip of their crowns),
- garudas (mythical birds with some human characteristics),
- celestial beings (who appear human),
- and Brahma beings from the highest heavens (recognizable by their multiple arms and faces).

Intriguingly, other figures may be characters from the Thai version of the Rama epic. A princely figure with green skin could be either Rama or the deity Indra. A multiheaded, multiarmed figure could be either Ravana or the demon Mara, who threatens the Buddha but is eventually defeated and converted.[2]

A green-skinned demon appears to be Ravana's son Indrajit, and another, with a particular, characteristic crown, appears to be the demonic magician called in Thai Maiyarap, who plays a role in the Thai version of the Rama epic.[3] Thus, it seems, Rama epic characters join other divine and legendary figures in veneration of the Buddhist dharma.

The manuscript includes excerpts from several Abhidharma texts in the Theravada Buddhist religious language of Pali, here written in two Southeast Asian alphabets.

An inscription in the manuscript gives the date of its donation and the name of its donor. It expresses her pious intention and her hope that her donation may bring happiness and prosperity. F.McG.

NOTES

1. The Celestial Assembly can be seen, for example, at the Phutthaisawan Chapel (*Buddhaisawan Chapel*, 86–87), Wat Yai Intharam (*Wat Yai Intharam*, 78–79), Wat Ratchasittharam (*Wat Ratchasittharam*, discussion, 43–44; illustrations, 94–95), and Wat Dusitdaram (*Wat Dusidaram* [*sic*], 82). All these temples date from the late eighteenth to mid-nineteenth centuries. Further information on this manuscript can be found in McGill et al., *Emerald Cities*, 182–183.

2. Identifying the Mara-(or Ravana-)like figures here is complicated by the fact that both Mara and Ravana in Thai representations usually have green skin.

3. Demons are identified by their skin color, eye shape ("crocodile eyes" versus bulging eyes), nose shape, mouth configuration, and exact crown type. See Dhanit, *Khon Masks; Nithatsakān hūakhōn / Exhibition of Khon Masks;* and Natthaphat and Promporn, *Thai Puppets and Khon Masks.*

Possibly Maiyarap.

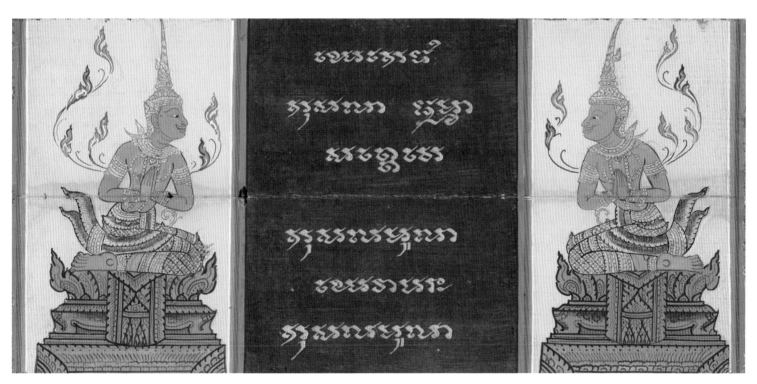

Rama or Indra.

11

Raja Gulab Singh receives his shield and sword from Rama, approx. 1830

India; Jammu and Kashmir state, former kingdom of Jammu
Opaque watercolors and gold on paper
H. 23.8 × W. 18.4 cm
The San Diego Museum of Art,
Edwin Binney 3rd Collection, 1990.1220

Rama is revered and remembered in textual, oral, and cultural sources as a righteous king.[1] He rules over a peaceful kingdom, governs according to the laws of righteous moral conduct (dharma), and commands the loyalty of all—including his devoted brother and wife, but also the bears and monkeys.

In this painting, the ruler Raja Gulab Singh of Jammu (ruled 1822–1857) receives a sword and shield, symbols of investiture, from Rama. The mythic ideal monarch here confers approval upon and gives the right of rule to a historical sovereign. The painting visually and conceptually links a mythic past with contemporary reality. Images such as this one represent the ways in which Rama's story retains potency across time and beyond ideologies, and reinforces the enduring central place that Rama holds in Indian culture. Q.A.

NOTE

1. Rama's reign (*ramarajya*) represents—even today—an ideal standard of sociopolitical and religious governance.

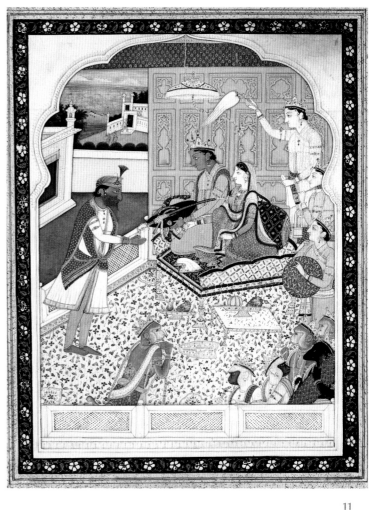

11

12 *also p. vi*

Vishvamitra leads Rama and Lakshmana to the forest, approx. 1594

India; Agra, Uttar Pradesh state
Opaque watercolors and gold on paper
Image: H. 32.8 × W. 21.2 cm
Museum Rietberg Zurich, Gift of the Rietberg Society, RVI 1840

This painting illustrates an early section of the Ramayana story when the sage Vishvamitra takes the young Rama and Lakshmana into the forest to defeat demons, who, led by the powerful demoness Tataka, are causing destruction.

Standing at the edge of Tataka's forest and gesturing toward it, the sage tells his companions, as the two lines of text on the page inform us, about the demoness Tataka who is as strong as "one thousand elephants." The poet Valmiki had described the forest as an inhospitable place swarming with crickets, fearsome beasts of prey, harsh-voiced vultures, and screeching birds. Here the forest setting is indicated by trees and birds, as well as snakes and foxes to emphasize its menacing quality. In this artist's hands, though, the landscape becomes far less ominous than the text's description, with a fish-laden river, flowering plants, and naturalistically rendered birds.

The scene of city life in the painting's upper right contrasts with the forest locale. It places the structure of urban (human) society—governed by communal norms within clearly defined spaces—in opposition to the unregulated (nonhuman) forest abode of wild creatures and demons, where the laws of righteous moral conduct do not operate. This distinction is important for the narrative and is visually drawn to attention here.

Rama's killing of the demoness Tataka (see cat. nos. 13 and 14) poses a significant moral conflict: between the maintenance of social order and the taking of a life. Rama is forced to make a difficult choice. But his action is defendable on the grounds

that the life taken was of a havoc-wreaking demoness who threatened peace.

This painting comes from one of several copies of the Persian Ramayana produced during the Mughal period. The emperor Akbar commissioned the translation of all seven books of the Sanskrit epic into Persian. The poetic structure of the original was rendered into prose form, as seen here in the two lines of text on the page. Although the Persian Ramayana text drew from varied sources, the subject matter of this painting and its lines of text align closely with Valmiki's version.

The Persian Ramayana gained immense popularity, especially during the late sixteenth and early seventeenth centuries, and was extensively copied as unillustrated and illustrated manuscripts. This painting originally belonged to the copy made for Akbar's mother, Hamida Banu Begum, and was subsequently owned by Akbar's son Prince Salim (later Emperor Jahangir). Q.A.

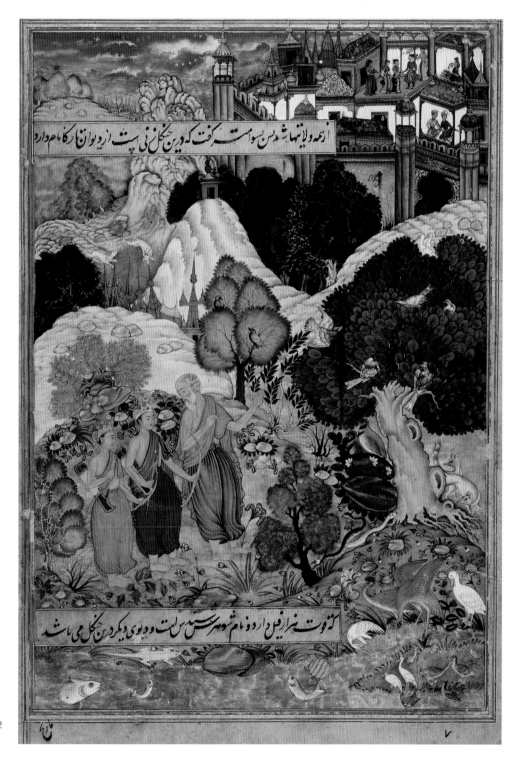

12

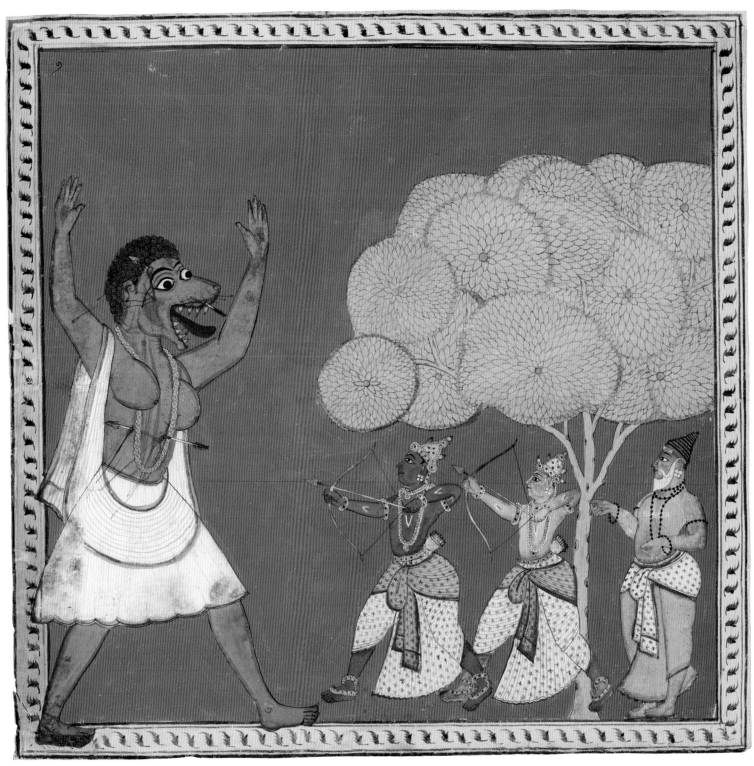

13

13

Rama slays the demoness Tataka, watched by
Vishvamitra, approx. 1750

India; Andhra Pradesh state
Opaque watercolors on paper
H. 35.9 × W. 36.7 cm
Victoria and Albert Museum, London, Given anonymously
in memory of Peter Cochrane, IS.233-2006

14 *also p. 34*

Rama slays the demoness Tataka, watched by
Vishvamitra, approx. 1780–1785

India; Himachal Pradesh state, former kingdom of Kangra
Opaque watercolors on paper
Image: H. 21.4 × W. 31.8 cm
From the Collection of Gursharan S. and Elvira Sidhu

Artists present two responses to the same subject in
these nearly contemporary paintings that illustrate
Rama's defeat of the powerful demoness Tataka, who

lived in a forbidding forest (cat. no. 12), ruled over
demons and beasts, and brought destruction.[1]

Several philosophical questions are raised in this
episode in which Rama kills a woman, one who,
according to moral law (dharma), should be protected.
In the text, the sage Vishvamitra presented convincing
arguments to persuade Rama: in his role as a prince,
he was duty-bound to protect the welfare of all his
people, and to uphold righteousness in the face of evil.
Rama agreed to do as told for two different reasons:
first, because his father instructed him to obey the
great sage, and as a son, it was his duty to respect his
father's words; and, second, because he could not
disregard a learned and pious man's request. Rama
resolved the morality question by valorizing filial
obligation and reverence for elders.

The paintings convey nothing of this conflict,
as such philosophical questions are inherently

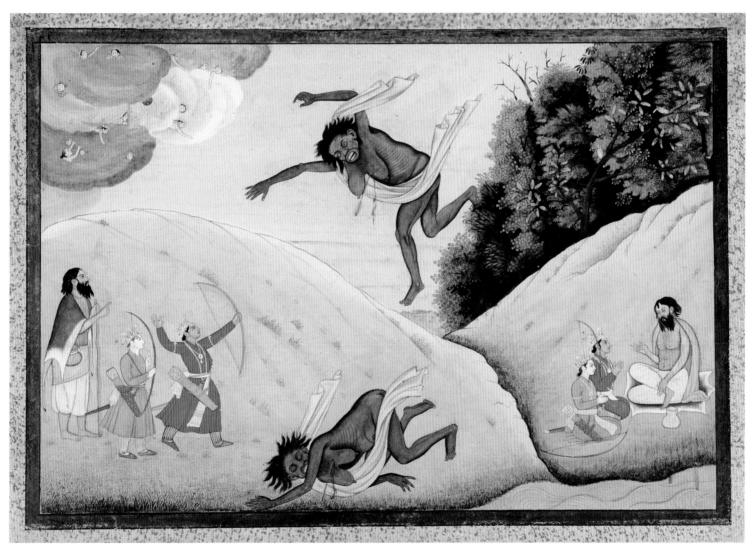

14

unillustratable. Here we see Rama neither as a dutiful prince nor as a dutiful son, but instead as a righteous and fearless warrior (*kshatriya*). When Tataka first appeared before the brothers, Rama commented on her hideous appearance and extraordinary size, intending to simply injure and humiliate her. But when the enraged Tataka raised her arms and charged at Rama, he shot a fatal arrow into her chest. Cat. no. 13 depicts these details in a plain and direct manner, capturing the moment right before the demoness falls. On the painting's right half, framed by the tree trunk and foliage into a single visual unit, stand Rama, Lakshmana, and Vishvamitra. Tataka's enormous figure occupies the painting's left half, her demonic nature conveyed by her dark skin, animal face and fangs, woolly hair, naked torso, and pendulous breasts. Two arrows pierce her body: one through the nose (Rama had initially meant to shoot only that one) and the other through her chest.

Cat. no. 14 is a more complex and dramatic depiction of the same episode. The painting presents two separate narrative moments, with the key characters represented twice. Unfolding in a cinema-like progression from left to right, the two scenes are divided by landscape features. We first see our three protagonists face the demoness, who has leaped toward them; Rama is captured in action, having just released the arrow that causes Tataka (shown twice) to fall to the ground in pain. Above them, peering from dense clouds, celestial divinities celebrate the event. The scene shifts on the right to a later moment after Rama, Lakshmana, and Vishvamitra have left the forest behind and Vishvamitra rewards Rama's bravery and righteousness by giving him magical weapons. Q.A.

NOTE
 1. Goldman, *Bālakāṇḍa*, 173–175 (25:1–22).

Rama bends the bow, approx. 1700

India; Kulu, Himachal Pradesh state
Opaque watercolors on paper
H. 22 × W. 32.8 cm
The San Diego Museum of Art,
Edwin Binney 3rd Collection, 1990.1102

Physical strength was one of the many facets of Rama's character, a necessary quality that marked him as a brave warrior capable of defeating the mightiest of foes, whether human or demon. Rama demonstrates this trait when he breaks the deity Shiva's unbendable bow; for this remarkable feat, he earns the hand of Sita in marriage.

King Janaka, Sita's father, had received Shiva's bow as patrimony. When the time came to select the right husband for his daughter, Janaka wanted to find a worthy man who, among other skills, possessed great might. Until Rama came to his court, none of Sita's suitors—or, for that matter, any living being—had been able to even lift the bow. To give a sense of its enormous size and weight, Valmiki writes that "five thousand tall and brawny men were hard-put to drag its [the bow's] eight-wheeled chest."[1]

Set at the court of Sita's father (seen crowned and seated on a throne at the right), this painting depicts Rama's display of immense power. Witnessed by sages and noblemen, women and attendants, the hero not only succeeded in effortlessly lifting the bow out of its box (the wheeled chest at bottom left) but also proceeded to bend it, attach a bowstring and arrow, and, while drawing it back, broke the bow. Rama's ease at this near-impossible task is conveyed through the large size of Shiva's bow (compared with Lakshmana's bow), his casual posture, and the awe-filled gazes and gestures of the onlookers. Q.A.

NOTE
 1. Goldman, *Bālakāṇḍa*, 250 (66:4).

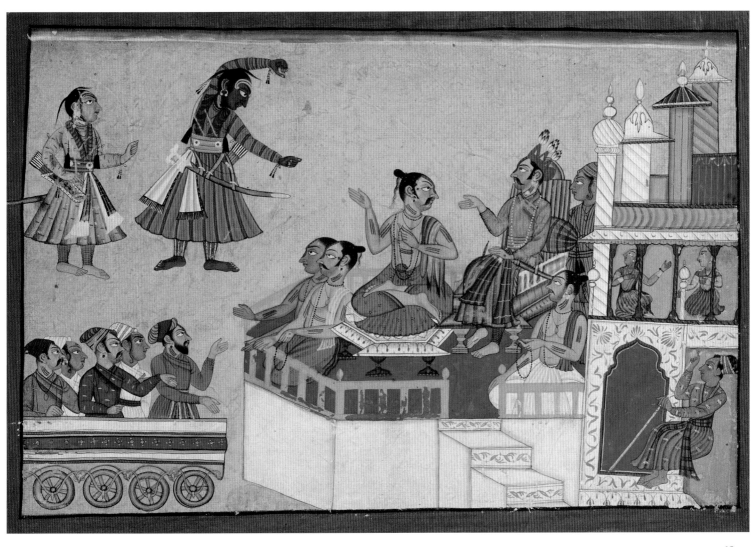

15

Scenes from the Burmese version of the epic of Rama, approx. 1850–1900

Myanmar (Burma)
Cotton, wool, silk, and sequins
H. 55.3 × W. 580.4 cm
Asian Art Museum, Museum purchase, 1989.25.1

This hanging shows Rama's winning of Sita's hand in marriage and subsequent events. At the left end Sita is seen sitting on a couch beneath a tree, attended by her lady's maids. Next she is shown again, seated to one side of a royal pavilion. In the center of the pavilion is her father the king, and beside him sits a rishi or ascetic, who may be the young hero Rama's preceptor, called Vishvamitra in the Valmiki Ramayana.[1]

Sita's father has proclaimed that only the man who can string his miraculous bow will win the hand of his daughter. Beyond the royal pavilion the young hero Rama is shown succeeding with the bow after all other suitors have failed. His faithful brother Lakshmana kneels nearby watching.[2]

The next scenes are hard to identify. Within another pavilion a crowned demonic figure appears, flanked by two courtiers. The crowned figure is probably the demon king Ravana,[3] who much later in the story abducts Sita. In some Southeast Asian versions of the Rama legend, but not in the famous Indian version by Valmiki, Ravana hears of Sita's father's challenge and tries his hand at the bow-bending contest. Though he manages to lift the bow, which no other suitor except Rama is able to do, he cannot bend it to attach the string. After Rama's triumph, the abashed Ravana returns to his own kingdom.

A little farther on a princely figure on horseback approaches the city gate; perhaps another suitor is arriving to try his hand at the bow contest. Behind him, the demonic figure who may be Ravana flies in an aerial chariot. Perhaps he too is arriving for the contest, in a sort of flashback. Next, in what may also be a flashback, Rama and his brother follow their preceptor through the forest; possibly they are arriving as well to try the bow.

Beyond a wavy diagonal line that presumably signals a change of scene, we see a young man in aristocratic garments seated next to stylized rocks while two attendants kneel respectfully. This young man, in his red vest and jaunty head wrap, closely resembles one of the figures flanking Ravana in an earlier scene and is presumably the same character, but his identity has not been determined.

Finally, Rama, Sita, and Lakshmana walk through the forest behind a rishi who appears identical, in his orange robes and hermit's turban, to Rama's preceptor shown twice before.

The difficulty is this: though Rama and his wife and brother eventually go into exile in the forest, many events—not least a grand royal wedding—and many years intervene between Rama's winning Sita's hand in the bow challenge and their entry into the forest for a life among the hermits and wild creatures. Is the narrative here radically condensed, or are the proposed interpretations of the later scenes incorrect?[4]

This long narrative textile has along its upper edge a large number of tabs by which it could have been hung. Where it would have been hung, and for what purpose, remains uncertain. One possibility is that it served as a backdrop for puppet performances. Some late nineteenth-century photographs of puppet performances show rather similar sequined narrative backdrops at the back of the puppet stage.[5] Having one narrative depicted on a backdrop while another was performed in front might be thought to have caused confusion, but apparently it did not. F.McG.

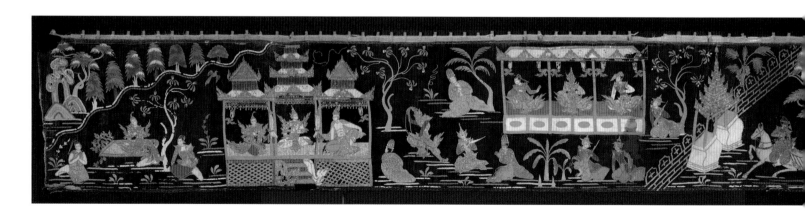

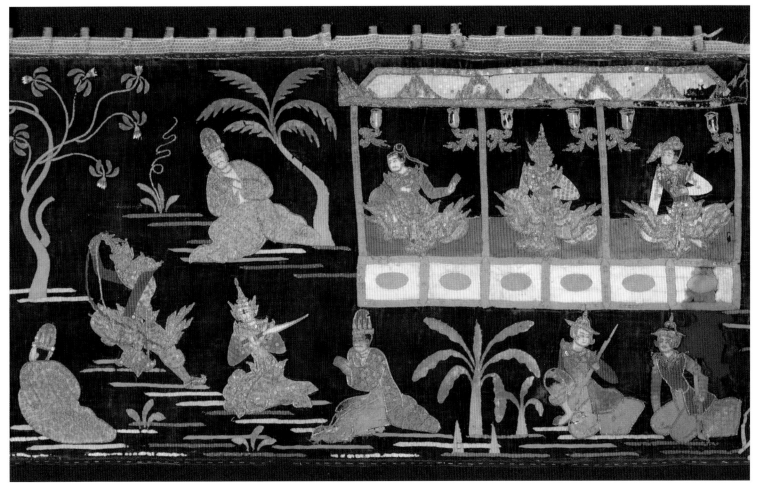

Rama succeeds in bending the bow.

NOTES

1. This entry is based on a longer one in McGill et al., *Emerald Cities*, 90–92.

2. An old tag pasted to the back of this work bears a handwritten inscription in Burmese reading, according to Min Zin, "Rama bending the bow."

3. Ravana would, however, usually be expected to have small versions of several of his ten heads shown in his headdress; Singer, "The Ramayana," 100; Kam, *Ramayana*, 108.

4. On various versions of the Rama legends in Burma, see Ohno, *Burmese Ramayana*.

5. Ferrars and Ferrars, *Burma*, fig. 397. A puppet stage was much wider than might be expected—certainly wide enough to accommodate a backdrop of this size—as can be seen in old photographs.

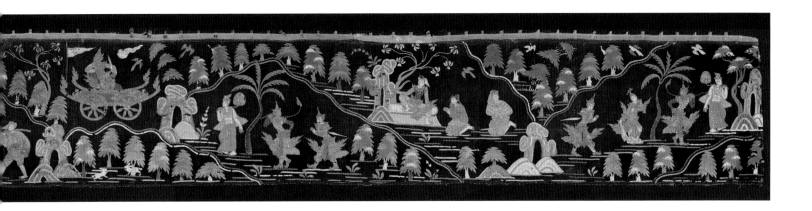

17

Rama tells Kausalya that he has been exiled
to the forest, from the "Shangri" Ramayana,
approx. 1690–1710

India; Jammu and Kashmir state,
former kingdom of Kulu or Bahu
Opaque watercolors and ink on paper
H. 21.6 × W. 31.4 cm
Virginia Museum of Fine Arts, Nasli and Alice Heeramaneck
Collection, Gift of Paul Mellon, 68.8.90

In the absence of accompanying written text, it is
sometimes difficult to identify the precise subject of
a painting. This work seems to align with the textual
episode in which Rama takes leave of his mother,
Queen Kausalya, before departing from Ayodhya for
his fourteen-year exile into the forest. At left we see
Kausalya in conversation with Rama and Lakshmana.
Her facial expression, pose, and gesture suggest

that the story moment depicted here is after she has
recovered from her initial distress upon hearing of
Rama's banishment and showers farewell prayers of
well-being on her son.

A prominent point of visual focus here are the
trees at the right, a feature also seen in other paintings
from this manuscript. Clearly demarcated by space
and color on the page, they occupy one-third of the
picture area, raising the question for modern viewers
about their role and function in the narrative. They
seem to be extratextual details included by the
artists to evoke emotion and create a mood. At the
risk of overinterpretation, can these trees—a pair of
cypresses encircled by vines and separated by another
tree—be seen as representations of feelings of love and
loss, and forced separation of a mother and her son?

Q.A.

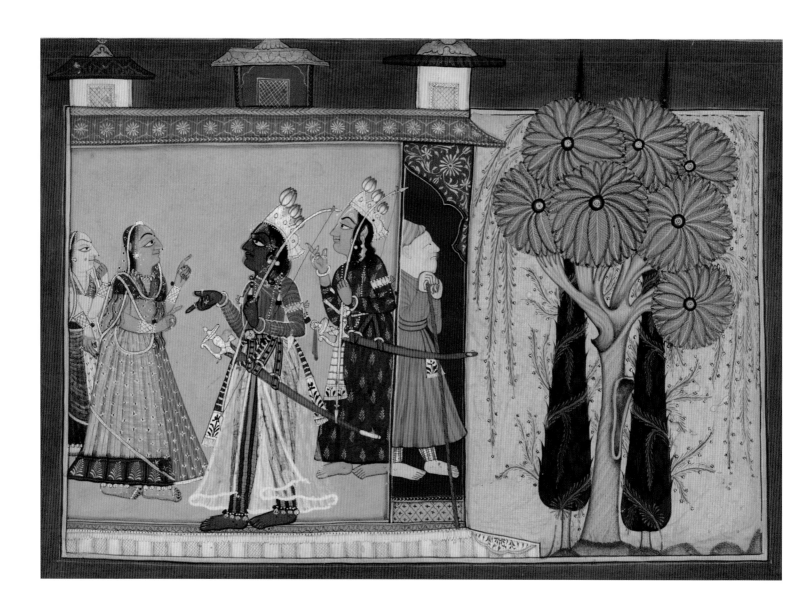

18 *also p. 267*

Rama and his companions cross the Ganges River into exile, approx. 1780

India; Pahari region, Himachal Pradesh state
Opaque watercolors and gold on paper
Image: H. 24.5 × W. 31 cm
Collection of Barbara and Eberhard Fischer,
on loan to the Museum Rietberg Zurich, REF 40

Variations on the central story of Rama exist in the many local oral and textual traditions of India. When we encounter painted depictions of the story with no accompanying text, we are confronted with a rich range of stories that lend themselves to different identifications.

Such minor ambiguity is present in this painting that illustrates Rama crossing the river into exile. Following their departure from the kingdom of Ayodhya, Rama, Sita, and Lakshmana first come to the banks of the "swift-flowing, eddying" Tamasa River. Leaving behind their entourage of grieving townspeople, Rama and his companions—along with their horses, chariot, and charioteer—cross the river in the middle of the night.[1] At a slightly later moment in the story, Rama asks the charioteer to return to Ayodhya while he traverses the "swift-flowing" Ganges River, "guided by the helmsman and propelled by the rush of their strong oars,"[2] into the forest. In both episodes, crossing the river represents yet another stage of the journey that increases the distance from Rama's life as a prince in a city and moves him closer to the world of asceticism in the forest.

Here we see an unusual and powerful composition.[3] The river landscape is used not only to convey the narrative events in the story but also, more poignantly, to express the symbolic and emotional impact of those events. The fast-moving river dominates the painting; a sliver of the lush riverbank representing the world Rama and his companions left behind (at the bottom right corner) contrasts with the barren hills (at the upper left) that they are headed toward. The small boat appears lost in the landscape; on closer look we see the forlorn figure of Lakshmana folding his head over his arms, Rama looking resolutely ahead, and Sita gazing at her husband. A sense of quiet pervades the painting, which presents a moment of charged interlude in the story. Q.A.

NOTES

1. Pollock, *Ayodhyākaṇḍa,* 170.
2. Ibid., 183 (46:66).
3. Goswamy, *The Spirit of Indian Painting,* 249–251.

19

Rama refuses his brother Bharata's
entreaties to return, page from the
Mewar Ramayana, 1649–1653

By Sahibdin (Indian, active approx. 1625–1660)
Opaque watercolors on paper
H. 30.5 × W. 46.5 cm
The British Library, Add. 15296(1) f.126r

The theme of morally guided kingship runs
consistently and repeatedly through the Ramayana
story. In Ayodhya, we encounter three rulers who
represent different aspects of dharma. Rama's father,
King Dasharatha, keeps a promise to his wife even
though that means sending his favorite son and
rightful heir into exile; Prince Rama stoically accepts
his father's unjust ruling in order to maintain the
bonds of filial duty and prevent strife; and Prince
Bharata, Dasharatha's younger son appointed ruler
in Rama's stead, recognizes his own unintended role
as a usurper and tries to restore justice.

The painting here depicts five successive moments[1]
in Bharata's failed efforts to convince Rama to return
to Ayodhya and accept his place as king. Accompanied
by an impressive retinue of sages, queens, and an army
to lend support to his mission, Bharata had followed
Rama, Lakshmana, and Sita into the forest. He tried
unsuccessfully to persuade Rama to return with him,
but eventually he agreed to accept Rama's sandals as
a symbol of his brother's presence on the throne. In
the left half of the painting, Rama is seen four times
(counterclockwise from bottom left): taking final leave
from the queens and sages, giving Bharata a pair of
gold-trimmed sandals as symbols of kingship, and
entering his ascetic's hut "in tears."[2] The right half of
the painting shows Bharata and his brother (in the
lower chariot, with their heads bowed in grief and
Rama's sandals carried by Bharata on his head), along
with their entourage, returning to Ayodhya. Q.A.

NOTES
1. Dehejia, "Treatment of Narrative," 303–324.
2. Pollock, *Ayodhākāṇḍa,* 309 (104:25).

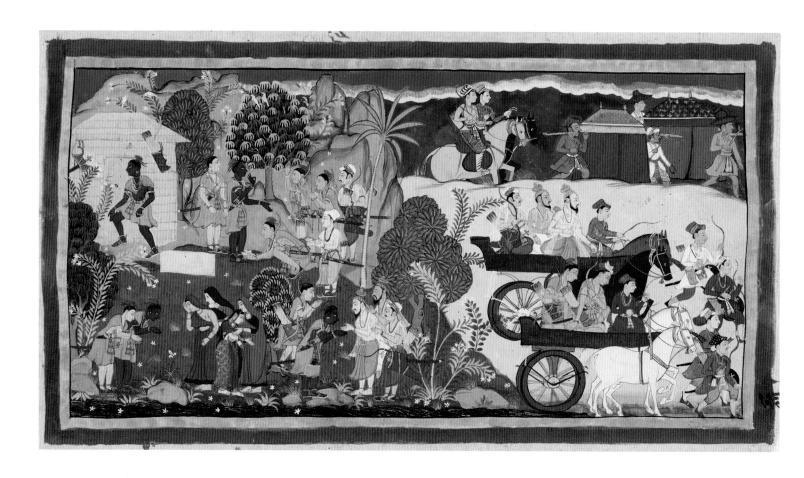

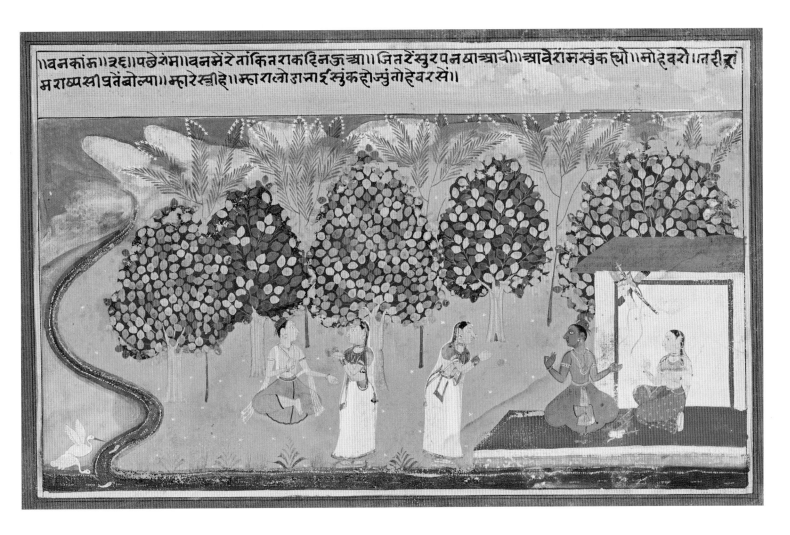

20

The demoness Shurpanakha, in the
form of a beautiful woman, addresses
Rama and Lakshmana, 1675–1700

India; Rajasthan state, former kingdom of Mewar
Opaque watercolors and gold on paper
H. 23.5 × W. 38.4 cm
Asian Art Museum, Gift of George Hopper Fitch, 2001.55

Although the main protagonists of the Rama epic are
male warriors, women—both human and demon—
play important roles in catalyzing the narrative's
action and advancing the story.

In the episode illustrated here, the demoness
Shurpanakha (Ravana's sister), who in some versions
of the story has transformed herself into an attractive
woman, has come upon Rama in the forest.[1] Struck
by his beauty, she tries to seduce him. In the scene
on the right, Rama informs Shurpanakha, who
appears twice in the painting, that he is married and
directs her attention toward his equally handsome
brother Lakshmana (on the left). Not shown in
this painting are the next critical moments of the
story, when the brothers' teasing of the seductress
turns into an exchange of insults. Shurpanakha
proceeds to threaten Sita, which arouses the brothers'

anger. The episode concludes with Lakshmana
disfiguring Shurpanakha by cutting off her nose.
This ill-treatment of his sister angers Ravana, who
subsequently decides to abduct Sita and thus avenge
his family's dishonor.

Shurpanakha's encounter with Rama also
highlights certain secondary aspects of his character:
we learn that Rama is physically beautiful and
irresistible, as befits his status as a god; that he is
devoted to his wife, and thus an ideal husband; and
that he can see through surface appearances to assess
the true nature of things, such as the immorality and
demonic nature of Shurpanakha. Yet this episode
also raises problematic questions about Rama's
conduct when he orders her disfigurement, even if it is
Lakshmana who performs the act of violence. Several
commentators of the Ramayana have attempted to
justify this moment in Rama's story. Q.A.

NOTE

1. The inscription reads, "In the back [or afterward], there is Rama.
He had been dwelling in the woods for many days and nights. Then
Shurpanakha arrived. As she arrived, she said to Rama, 'Marry me.'
Then Rama answered the demoness, 'I have a wife. Speak to my
younger brother, who'll marry you.'" We thank Heidi Pauwels for
kindly translating the text.

21

Two figures, probably Rama and Lakshmana, 400–500

India; Uttar Pradesh state
Terra-cotta
H. 44.5 × W. 42.5 cm
Asia Society, New York: Mr. and Mrs. John D. Rockefeller 3rd Collection, 1979.6

The two male figures here can be plausibly identified as Rama and Lakshmana: their hair is pulled into topknots like those of ascetics; their earlobes are distended in the manner of renunciates; and they have quivers of arrows strapped on their backs, with what looks like a bow in the foreground. The figures engage with each other in a gentle and familiar way. The only comparable narrative moment in the Ramayana to this scene is when Lakshmana pulls a thorn out of Rama's foot (cat. no. 40), a subject that becomes popular in the Punjab Hills (Pahari) region after the 1700s. Are we seeing here a very early representation of this episode?

Depictions of the Ramayana story in Indian manuscript painting are not widely seen until the 1590s, which is a fairly late date given the long history of Indian wall painting and other artistic traditions. However, images that can be associated with narratives or protagonists from the Ramayana, such as this early example (see also cat. no. 64), appear on temples from at least the fifth century onward. Q.A.

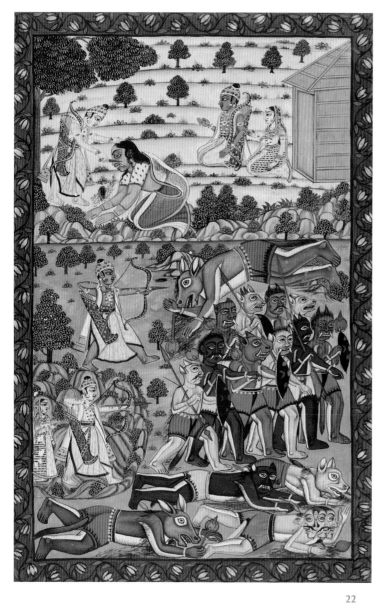

22

22 *also fig. 63*

Lakshmana cuts off the nose of Ravana's sister Shurpanakha, approx. 1780

India; Murshidabad, West Bengal state
Opaque watercolors on paper
H. 32.5 × W. 21.6 cm
The British Library, Add. Or. 5725

23

Rama battles demons, approx. 1700

India; Ajmer, Sawar, Rajasthan state
Opaque watercolors and gold on paper
Image: H. 29.2 × W. 23.8 cm
Los Angeles County Museum of Art, Purchased with funds provided by Dorothy and Richard Sherwood, M.73.34

The two paintings here illustrate the aftermath of Shurpanakha's flirtatious advances toward Rama and Lakshmana, an encounter that led to an unfortunate conclusion for her when Rama, infuriated by her threats to Sita, ordered Lakshmana to cut off her nose (see cat. no. 20). In the upper register of cat. no. 22, Lakshmana is shown fulfilling his brother's command and disfiguring the demoness as Rama and Sita look on.

After leaving Rama's ashram, the distressed Shurpanakha sought refuge with her powerful brother Khara, who was deeply angered by this injurious insult to his sister. He sent fourteen "blood-drinking" rakshasas, "the likes of Death himself," with Shurpanakha, so she could show them where Rama and Lakshmana lived. Rama asked them to turn away, but they attacked him with clubs and spears. He effortlessly rebuffed the onslaught and retaliated by slinging fourteen arrows at once; each arrow found its mark, and thus he killed all the demons (seen in cat. no. 23 and the lower register of cat. no. 22). Then, when Khara attacked with an army of fourteen thousand demons, Rama obliterated them.[1]

Such descriptions of Rama's battles with heavily armed and invincible opponents draw attention to his vulnerable position as a prince in exile, while also emphasizing his bravery and skills as a warrior. An episode such as this one serves as well to foretell of future events in which Rama and his armies will be outnumbered and outpowered by Ravana's demon forces but will emerge as victorious. Q.A.

NOTE
 1. Pollock, *Araṇyakāṇḍa*, 128–149 (18:17–29:28).

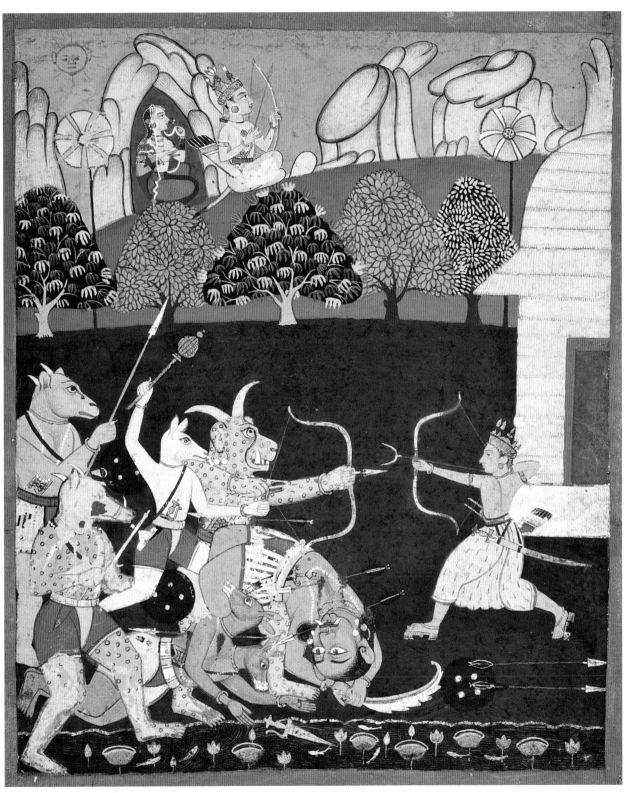

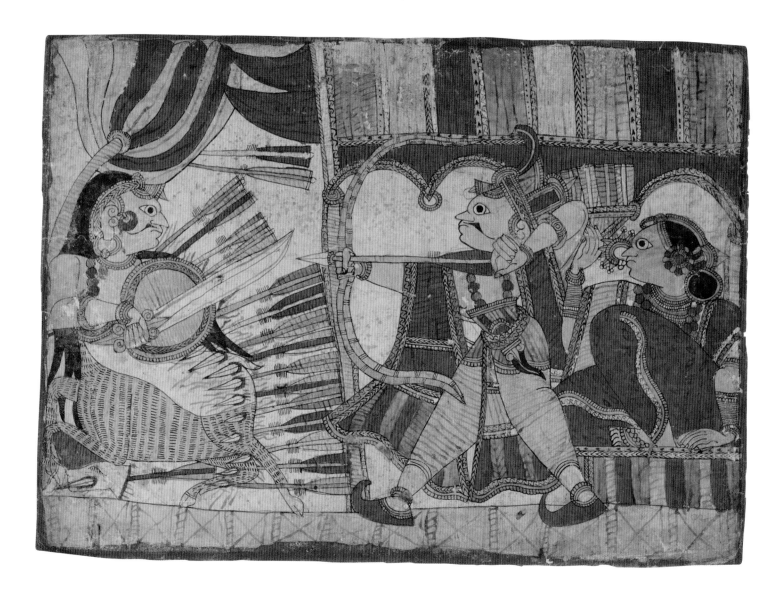

24

Rama slays the golden deer, approx. 1830–1900
India; Karnataka state or Andhra Pradesh state
Opaque watercolors on paper
Image: H. 30.8 × W. 42.5 cm
From the Collection of Gursharan S. and Elvira Sidhu

Rama's skill as a hunter is tested by the golden deer that he pursues on Sita's request. This episode serves also as a commentary on the dangerous consequences of desire and temptation. Following the disfigurement of Shurpanakha described in cat. no. 22, the demon king Ravana persuades his uncle Maricha to assume the form of an alluring deer with a beautiful golden and silvery hide. When Sita sees this lovely animal, she immediately desires it, dead or alive, and begs Rama to bring it to her. Disregarding Lakshmana's warning that the deer may be the demon Maricha and not what it appears, Rama is motivated by desire—to please Sita, to engage in the challenge of the hunt, or, should Lakshmana be right, to rid the forest of a demon. He follows the deer deep into the forest. Maricha successfully eludes Rama for a long time but

eventually falls victim to the hero's arrow that strikes his heart.

The final moment of the deer hunt is depicted in this bold painting. Rama's arrows have pierced Maricha's body (at the left), whose contours are defined by the multicolored arrows. Rama remains recognizable as the intrepid huntsman with his bow poised to release yet another arrow. The moment of "truth," as deception falls away, is signaled by the transformation of the shape-shifting dying Maricha from a deer into his demonic self (the head of the deer is shown in the lower left corner). Interestingly, however, not only has the artist of this storytelling tradition included Sita in the painting (who should have been elsewhere in the forest and alone) but also he has made little distinction between Rama and Maricha. The two are shown with similar features and ornaments, which leaves open the question of whether, in this folk variation, Maricha is presented both as an evil demon and as the saintly renunciate he is sometimes described as. Q.A.

25

Rama and Lakshmana search in vain for Sita, approx. 1680–1690

India; Mewar, Rajasthan state
Ink and opaque watercolors on paper
H. 26 × W. 41.3 cm
The Metropolitan Museum of Art, Purchase,
T. Roland Berner Fund, 1974.148

Rama occasionally expresses human weakness when he gives in to intense love, grief, or anger. Such moments in the story do not undermine his role in the Ramayana as its (divine) hero. Instead, the way in which he responds in such situations provides a model for behavior and enables devotees to feel more closely connected with the god.

Rama's deep love for Sita was conveyed when he agreed to get the beautiful golden deer for her (cat. no. 24). The shape-shifting demon Maricha, with his dying breath, had imitated Rama's voice and called out, "O Sita, O Lakshmana, save me!" This deceptive cry had lured Lakshmana away from Sita's side, leaving her alone and prey to Ravana, who abducted her in Lakshmana's absence. When the brothers returned home, they found Sita gone. Overcome with fear for her well-being and grief over his beloved's loss, Rama searched in vain for Sita. As the text above this painting reads, "Ranging the woods, hills, rivers, and lakes on every side, searching the plateaus, caves, and summits of the mountain, these two sons of Dasaratha could not find Sita anywhere." Seen three times, from left to right, in different landscapes, Rama and Lakshmana are unable to locate Sita. Their poses and gestures express their unsuccessful efforts, and the blue-gray colors that dominate this somber painting suggest a sense of melancholy. Q.A.

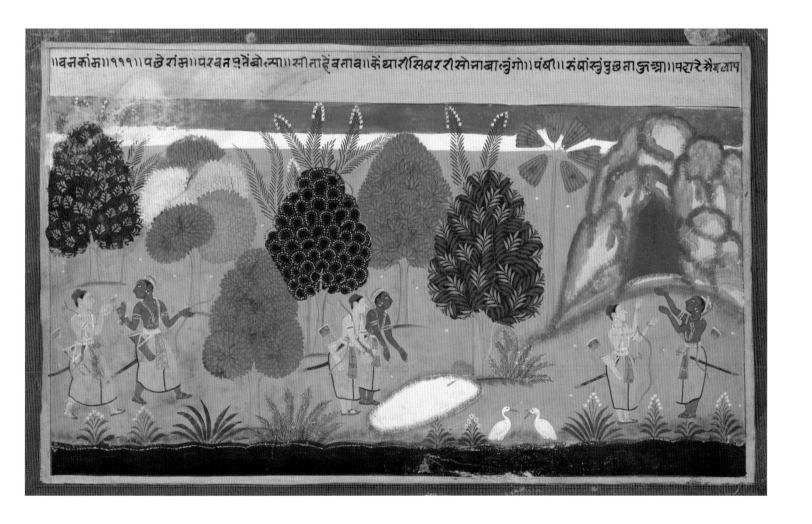

26

Rama pines in the wilderness, approx. 1775–1780

India; Himachal Pradesh state, former kingdom
of Guler or Kangra
Opaque watercolors and gold on paper
Image: H. 20.8 × W. 31 cm
Philadelphia Museum of Art, 125th Anniversary Acquisition,
Alvin O. Bellak Collection, 2004-149-73

As Rama and Lakshmana continued their search
(cat. no. 25), they came upon a mighty broken bow,
armor, a royal parasol, and a chariot: signs of a
battle. They were now convinced that Sita was either
dead or abducted. At this point, Rama gave himself
over to grief, self-doubt, and anger. In one moving
conversation included in Valmiki's Ramayana,
Rama asked Lakshmana if his (Rama's) mild temper,
compassion, and self-restraint had become signs of
weakness and powerlessness, which, through Sita, were
used against him. As if to demonstrate otherwise,
Rama continued passionately with a description of
the terrible destruction he was prepared to unleash
on the universe. Eventually calmed by Lakshmana's
sympathetic and practical advice, he resolved to first
try to find Sita through peaceful means, and to resort
to angry devastation if those efforts failed.

Through this episode, the Ramayana not only
evokes pity—in human terms—for Rama but also
positions him in contrast with the arch villain
Ravana. The demon king's actions, as the story will
soon reveal, are driven by desire and anger; filled
with arrogance, he consistently rejects good counsel
when it is offered to him. Rama, on the contrary,
although subject to the same destructive emotions,
possesses the strength of character to overcome
those weaknesses, be receptive to advice, and make
decisions that are guided by dharma.

This painting depicts Rama in his moment of
vulnerability. Framed by the gentle branches of a
flowering tree, Rama evinces melancholy in his pose
and downcast head; his bow and quiver of arrows—
symbols of his strength—lie abandoned nearby. The
vast landscape, empty of birds and animals, enhances
the sense of Rama's loss and loneliness. Q.A.

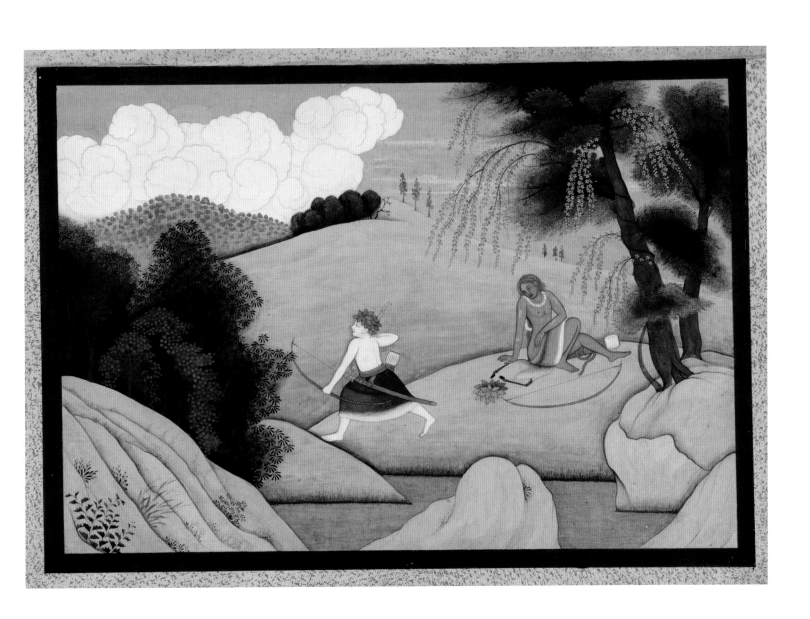

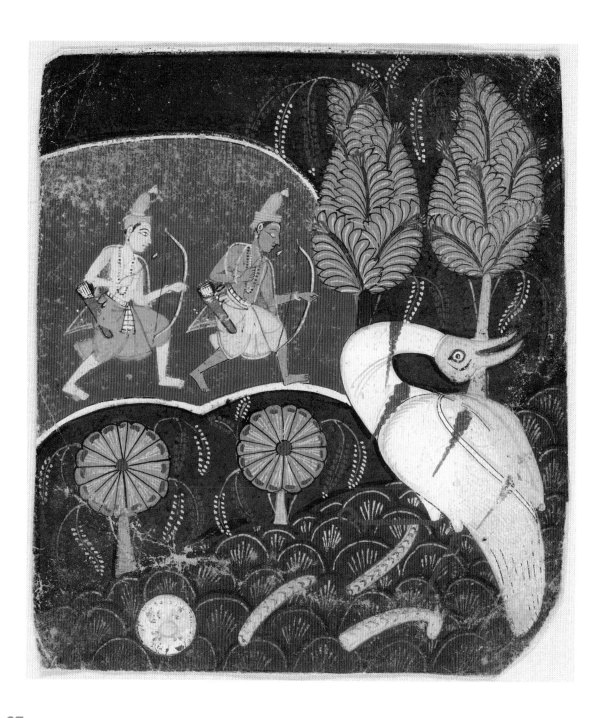

27

Rama and Lakshmana discover the dying Jatayus,
approx. 1640

> India; Malwa, Madhya Pradesh state
> Opaque watercolors on paper
> H. 18 × W. 16.2 cm
> Harvard Art Museums/Arthur M. Sackler Museum,
> Gift in gratitude to John Coolidge, Gift of Leslie Cheek, Jr.,
> Anonymous Fund in memory of Henry Berg, Louise Haskell
> Daly, Alpheus Hyatt, Richard Norton Memorial Funds
> and through the generosity of Albert H. Gordon and
> Emily Rauh Pulitzer; formerly in the collection of
> Stuart Cary Welch, Jr., 1995.70

Running from the red interior of a cavern-like space, the royal brothers Rama and Lakshmana have just arrived on the scene of a gory and obscene slaughter. Amid the cinnabar-colored semicircles of the rocky terrain, each undulation detailed in gold, they witness the aftermath of a tragedy. Neck twisted grotesquely backward, the yellow-beaked king of the vultures Jatayus bleeds from four prominent wounds. Indeed, the Malwa artist has succeeded in conveying that Jatayus is twitching in what must be his death throes.

However, the noble bird survives long enough to tell Rama and Lakshmana of Sita's fate. Here, she is nowhere to be found; only what seem to be fragments of Ravana's donkey-drawn chariot remain to attest to his presence. Sita is already gone.

Rama is both vocal and demonstrative in the face of her loss; according to Valmiki, he was "consumed with grief, helplessly lamenting . . . numb with shock, insensible in the grip of profound stupor."[1] J.D.

NOTE

1. Pollock, *Araṇyakāṇḍa*, 362–363 (62:1).

The heroes Rama and Lakshmana witness the death of the great vulture Jatayus and prepare his cremation, 1830–1840

India; Himachal Pradesh state, former kingdom of Kangra
Opaque watercolors and gold on paper
H. 36.6 × W. 45.7 cm
Asian Art Museum, acquisition made possible
by the George Hopper Fitch Bequest, 2015.40

The only witness to Sita's abduction had been Jatayus, the king of the vultures, who valiantly engaged in combat with Ravana but was mortally wounded when Ravana cut off his wings (cat. no. 66). Rama and Lakshmana, searching for the missing Sita, chanced upon Jatayus as he lay dying and heard from him about Sita. The artist here tells this story as a continuous narrative, from left to right, with the figures of Rama and Lakshmana appearing multiple times.

At the left, and comprising the painting's main focus, we see the brothers approaching the fallen Jatayus, who is shown, sympathetically, with severed wings, bloodshot eyes, and bleeding from the mouth and wings. In the adjacent vignette, the dead Jatayus is carried to the cremation pyre tended by Lakshmana, at the right. The narrative continues behind this register, with Rama and Lakshmana performing ritual ablutions in the river after the cremation, and then advancing on their journey in search of Sita. A divinity, seated on a throne in the clouds above, bears witness to this important and tragic moment in the epic.

The artist expresses the pathos evoked in the text by such subtle details as the sensitive depiction of the bleeding Jatayus and the placement of Rama's hand, which gently cradles the vulture's head. Landscape elements, such as the swell of the hills and the carefully placed trees, serve as framing devices for directing the viewer's gaze to each vignette and for presenting the story's events in a clearly organized progression. Q.A.

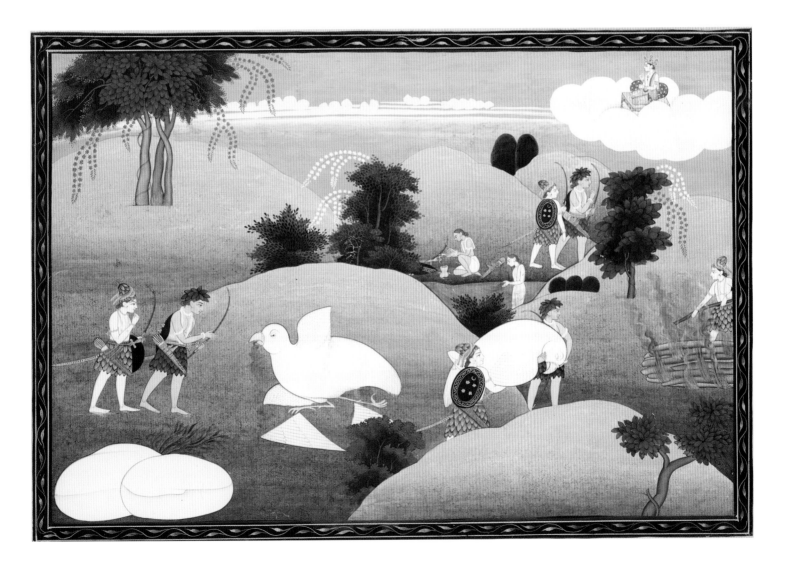

One of the most ethically vexing incidents in the epic involves Rama's intervention in the royal succession of Kishkinda's monkey dynasty. The episode begins when a seer urges Rama to seek the monkey king Sugriva's assistance in locating Sita. Sugriva has recently been dispossessed of his kingdom by his elder brother Valin, who also married his former wife. In the course of their conversation, Rama agrees to help Sugriva regain his throne in return for the monkey's help in finding Sita. Rama does indeed help, going so far as to attack Valin. But since Valin had done Rama no personal harm, and was moreover the sitting monarch at the time, the incident raises questions about whether Rama had or had not performed his duty (dharma) correctly.

J.D.

29

Rama and the monkey king Sugriva form a bond of friendship, 1720

India; Jammu and Kashmir state, former kingdom of Mankot
Opaque watercolors and gold on paper
Image: H. 17 × W. 26.7 cm
Collection of Barbara and Eberhard Fischer,
on loan to the Museum Rietberg Zurich, REF 24

Two mirrored pairs of figures sit face to face in a rocky outcropping. The pair on the left, seated on slightly higher terrain, are Rama, in blue, and his brother Lakshmana behind him. Both are dressed in the leaf outfits they adopted upon exile. Despite the simplicity of their garb, the brothers are adorned with extravagant jewelry, gold, pearls, and gemstones. Across from them sit the crowned monkey king, Sugriva, and his loyal lieutenant, Hanuman, whose jewelry echoes that of the young princes. The four are gathered on Rishyamuka mountain, the home in exile of Sugriva's followers. A ritual fire that Hanuman has built burns between the two parties. In Valmiki's Ramayana, Sugriva is described as taking a human form in this first encounter, but the artist does not illustrate that here.

In this summit of rulers, each takes a turn in tearfully describing his plight. They make a pact of friendship, with Rama agreeing to help Sugriva in his fight against his rival brother and Sugriva agreeing to help search for Sita. The painting deliberately parallels Rama with his faithful brother and Sugriva with his follower Hanuman. Lakshmana's downcast glance emphasizes a sense of sorrow that pervades the painting. During this encounter, Sugriva pleads with Rama to end his mourning and follow his dharma as a great man:

> I, too, have met with great misfortune through the abduction of my wife, yet I do not grieve in this fashion, nor do I abandon my composure.
>
> Nor do I grieve over her, though I am just an ordinary monkey. How much less should you, who are great, disciplined, and resolute?
>
> In misfortune or loss of wealth or in mortal danger, the resolute man deliberates with his own judgment and does not despair.
>
> But the foolish man who always gives way to despair sinks helplessly in grief, like an overloaded boat in water.
>
> Here, I cup my palms in supplication. I beseech you out of affection: Rely upon your manliness. You must not let grief take hold of you.
>
> For those who give way to grief, there is no happiness, and their strength dwindles away. You must not grieve.[1]

N.R.

NOTE
1. Lefeber, *Kiṣkindhākāṇḍa*, 66–67 (7:6–12).

30

The monkey king Sugriva and his army pledge their support to Rama, page from a dispersed series of the Ramayana, approx. 1640–1650

India; Malwa, Madhya Pradesh state
Opaque watercolors on paper
Image: H. 18.7 × W. 27.1 cm
Philadelphia Museum of Art, Purchased with funds contributed by an anonymous donor, 1990-11-1

This painting depicts the significant episode in which Rama forges an alliance with the deposed monkey king Sugriva. Rama and Lakshmana had been advised to offer Sugriva support for regaining his kingdom; in return, Sugriva would pledge his vast army of monkeys to fan out in all directions to search for Sita. Without this crucial assistance, Rama's quest would be unfulfilled and the rest of the story would not unfold.

Valmiki and other Ramayana-tellers describe the moment when the pact between the two exiled rulers, Rama and Sugriva, is consecrated over a ritual fire on the mountaintop where Rama and Lakshmana have made their temporary home (cat. no. 29). In this simple and clear composition, the artist shows the main characters at the top of the peak, flanked on either side by their loyal companions Lakshmana and Hanuman, the monkey general.

Q.A.

29

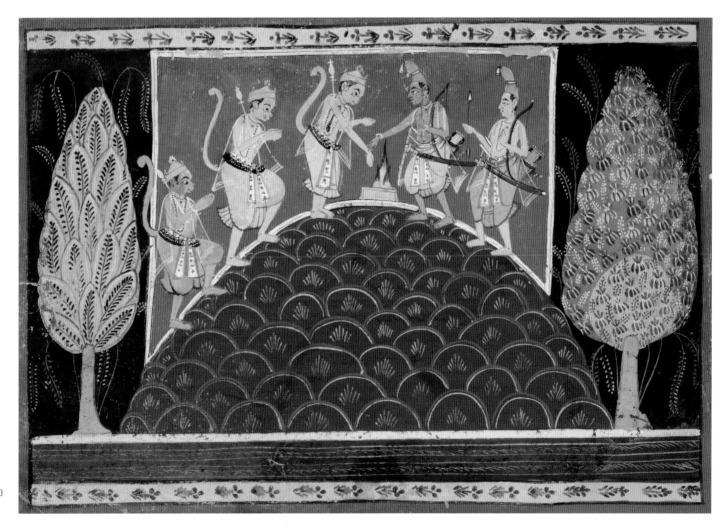

30

31 *also fig. 27*

Valin and Sugriva fighting, from the "Shangri" Ramayana, approx. 1690–1710

India; Jammu and Kashmir state,
former kingdom of Kulu or Bahu
Opaque watercolors on paper
H. 20.3 × W. 31.1 cm
Brooklyn Museum, Gift of
Mr. and Mrs. H. Peter Findlay, 77.201.1

This painting depicts the battle royal between the two rival monkey kings, Valin and Sugriva. As it turns out, Rama's quest for Sita has driven the simians to the point of violence, for Rama had previously been urged by a sage to pursue Sugriva as an ally in his upcoming war with Ravana. In so doing, Rama promised to restore Sugriva to the throne in return for the monkey's aid in finding Sita.

In the first encounter between the two monkeys, however, Sugriva is defeated; since Rama was unable to distinguish one from the other, he could not intervene. He appears here just to the right of the tree, with Lakshmana and Hanuman behind him. All three, but especially Hanuman, appear nonplussed.

In the aftermath of Sugriva's defeat, Rama urges Sugriva to wear a specific vine, so that the next time he can kill the correct monkey. Sugriva follows his advice, and in the second round of the conflict, Rama is able to identify and shoot Valin in the back. Valin then admonishes Rama for failing to live up to the duty (dharma) of a king, for in attacking Valin, who never did him harm, Rama has acted unjustly while appearing to be the very incarnation of justice. Rama defends his violent acts by citing Valin's improper marriage to Sugriva's former wife, which he felt duty-bound to address. Valin admits that Rama's interpretation of duty is accurate, and he expires.

J.D.

32 *also p. viii*

The combat of Valin and Sugriva, approx. 1075–1125

Cambodia; Vat Baset
Sandstone
H. 69 × W. 152 × D. 35 cm
Musée national des arts asiatiques–Guimet, MG18218

Two monkey lords battle with one another at the center of this dynamic and detailed Cambodian frieze, which would have appeared above a temple doorway. The monkey on the right appears to have the upper hand; he bites the left arm and grips the left leg of his opponent. A double-headed serpent stretches from one side of the frieze to the other; it is a standard component of lintels of this period and is not related to the narrative.

The first scene appears at the top left of the frieze; here, the dispossessed monkey king Sugriva kneels at the feet of Rama to make his ethically ambiguous offer of assistance: kill his brother Valin, who has usurped the throne, and Sugriva will help Rama find Sita. Rama accepts Sugriva's offer, and together they go to Valin's city, Kishkinda. Drawing Valin out of his citadel with a mighty roar, Sugriva attacks Valin but gets the worse of the conflict and retreats. When Rama asks why he did so, Sugriva counters that Rama did not defend him. Rama, for his part, states that he couldn't tell the difference between the two monkeys, and he advises Sugriva to don a vine so Rama can tell them apart and intervene.

In the subsequent encounter, Rama identifies Sugriva on the basis of this vine and so is able to shoot Valin surreptitiously from behind. In the aftermath of the shooting, visible at the upper right of the frieze, Valin is in his death throes surrounded by his grieving wife and followers. At this time, Valin delivers in reference to Rama a withering critique of sneak attacks conducted by those who seem to be virtuous. Rama has no rejoinder to the critique and simply falls silent—until he sees fit to cite Valin's taking of Sugriva's wife, as well as his own promise to Sugriva. The fact that Rama, the very embodiment of dharma, is willing to violate his core principles when something he considers important is at stake is one of the more intriguing fault lines in his complex personality.

J.D.

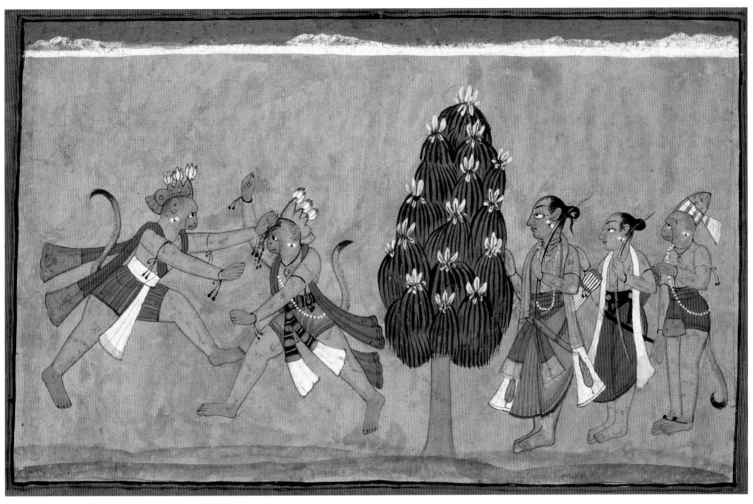

31

32

33

Death of Valin, king of the monkeys, approx. 1820

India; Himachal Pradesh state, former kingdom of Kangra
Opaque watercolors and gold on paper
Image: H. 21 × W. 29.4 cm
Philadelphia Museum of Art, Gift of
Stella Kramrisch, 1975-148-3

At the center of this painting, a large white monkey wearing a crown lies prostrate on the ground, an arrow protruding from his chest. He is Valin, former king of the monkeys, now on his deathbed and deserted by some of his former monkey followers, who have fled to various other places in the painting. Blue-skinned Rama, wearing a leaf hat and carrying his ubiquitous bow, made the deadly shot from behind. Valin's hand is raised and his mouth open, as if engaged in his famous debate with Rama over who has most effectively fulfilled his duty (dharma). In the cave behind him, Valin's wife and her attendants mourn their fallen monarch. At the same time, Rama smiles down at the son of Valin; Sugriva and white Lakshmana stand behind them impassively. J.D.

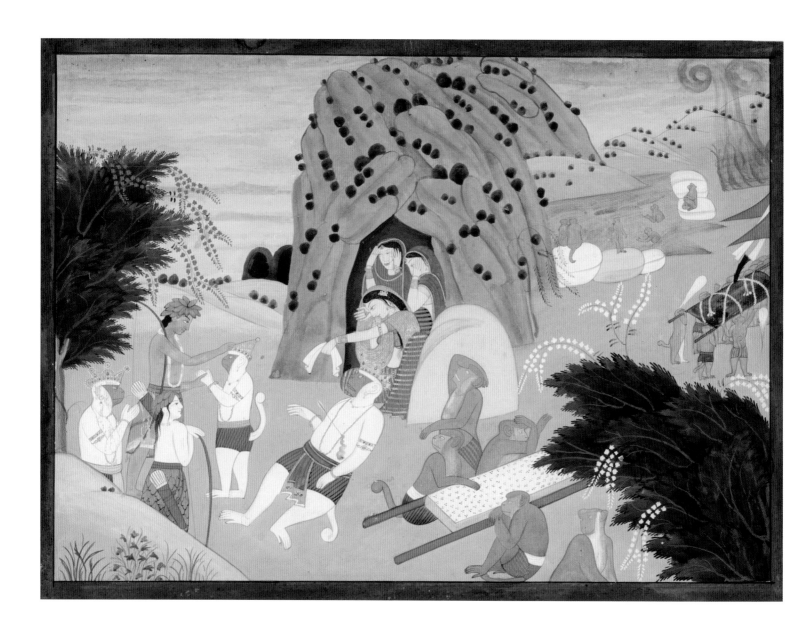

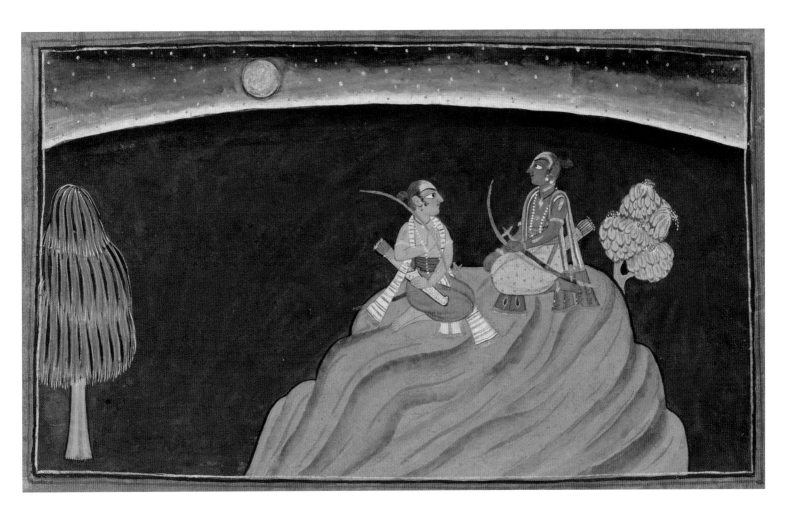

34 *also pp. 20–21*

Rama and Lakshmana on Mount Prasravana,
from the "Shangri" Ramayana, approx. 1690–1710

India; Jammu and Kashmir state, former kingdom of
Kulu or Bahu
Ink, opaque watercolors, and silver on paper
H. 17.8 × W. 30.8 cm
The Metropolitan Museum of Art, Purchase,
Cynthia Hazen Polsky Gift, 1999.400

Rama's sense of loss and loneliness, which recurs
at various moments of the story as he searches for
Sita, has inspired many artists of the Ramayana over
the centuries. In this evocative painting, Rama and
Lakshmana appear in a nighttime scene atop Mount
Prasravana, where they had made their temporary
home. The quietness of the night is expressed through
the empty dark background, the star-filled sky,
and the silver moon. Yet, despite the peacefulness

surrounding them, Rama is unable to sleep, and
Lakshmana, his ever-constant companion, offers
support and solace.

The painting calls to mind Valmiki's poignant
description, "But though the mountain was very
pleasant and full of valuable things, Rama did
not feel the least delight living there, for he was
thinking of his abducted wife, who was more
precious to him than his life's breath. Nor would
sleep come to him when he had gone to bed at night,
especially when he saw the moon rising in the east.
Grieving for Sita, his mind weakened by all his tears,
sorrowful Kakutstha [Rama] was constantly absorbed
in his grief."[1] Q.A.

NOTE
 1. Lefeber, *Kiskindhākāṇḍa*, 110 (26:6–8).

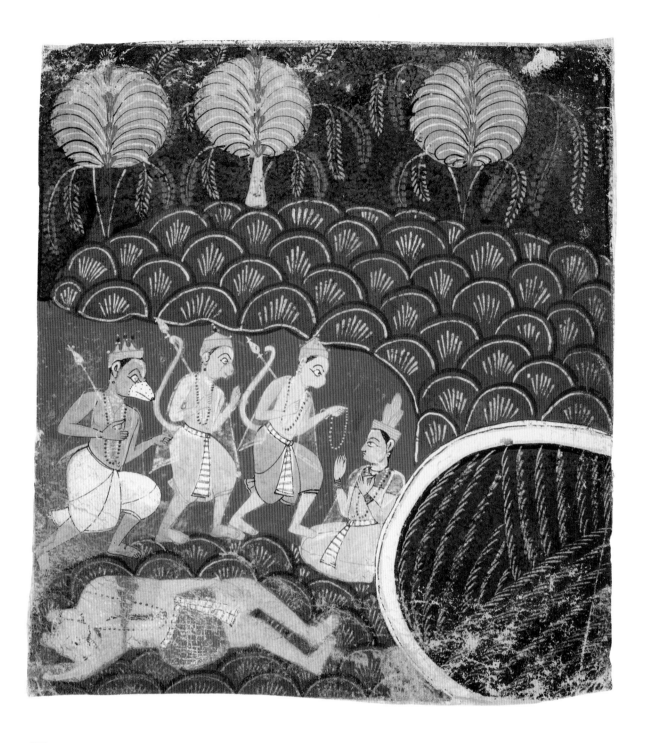

35

The leaders of the monkeys and bears deliver Sita's ornaments to Rama, approx. 1650

India; Malwa, Madhya Pradesh state
Opaque watercolors on paper
H. 17.7 × W. 16 cm
The San Diego Museum of Art,
Edwin Binney 3rd Collection, 1990.953

In some tellings of the Ramayana, as Sita is being taken in Ravana's carriage through the air to Lanka, she drops her jewels to the ground and they are discovered by monkeys, who hide them in a cave. After the alliance is forged between Rama and the monkey king Sugriva, the monkeys retrieve the ornaments and take them to Rama. Upon seeing

them, he realizes that they belong to Sita and falls distraught to the ground. His despair is tempered by a clue as to Sita's fate, and by a bond with friends who will help him find her.

The artist here shows Rama seated outside a red cave set into a hilly landscape. Two monkeys and a bear approach, the first holding a necklace in his outstretched hand. In the foreground is a slain demon.

The paintings of Malwa are known for their bold use of color and pattern. Here the artist divides the scene into four distinct spaces: the round Lake Pampa on the lower right; the blue horizon with exuberantly flowering trees; and the brown rounded hills bisected by the red cave.　　　　　　　　　　　N.R.

Rama and Lakshmana, riding Hanuman
and Angada, set off toward the south, page
from the Mewar Ramayana, 1649–1653

Opaque watercolors on paper
H. 23.3 × W. 38.5 cm
The British Library, IO San 3621 f.14r

"Let the mighty lions among monkeys in their
hundreds and thousands lead the fearsome vanguard
of the army, which resembles the surge of the sea. . . .
He [Rama] set out surrounded by tawny monkeys
resembling elephants. They numbered in the
hundreds, the tens of thousands, the hundreds of
thousands, and the tens of millions. . . . That fearsome
army of monkeys, vast as the ocean's flood, streamed
onwards with a mighty roar, like the ocean in its
dreadful rush."[1] So describes Valmiki the vast army
that sets out with Rama toward Ravana's palace
in Lanka.

 Capturing the spirit of such an account, the artist
fills the painting with monkeys of varied sizes and

shades of "tawny." Rama and Lakshmana ride on
the monkey generals, like "the sun and the moon in
conjunction with the two great planets."[2] In most
Ramayana paintings, regardless of the region or style
in which they were made, the monkeys are human-
like: they stand on two legs, wear contemporary dress
and ornaments, and hold weapons. This example is
unusual in that the monkeys look like the ubiquitous
animals so familiar in the Indian landscape. The
artist appears to have used his personal observations
to populate this painting, depicting the monkeys in
varied poses and giving them individuality. Especially
charming is the monkey near the bottom left of the
picture who turns its head to snarl at another monkey,
as is the one nearby who looks behind him as if to
confirm that others are following. Q.A.

NOTES
 1. Goldman and Sutherland Goldman, *Yuddhakāṇḍa*, 127–129 (4:11,
4:21, 4:35).
 2. Ibid.

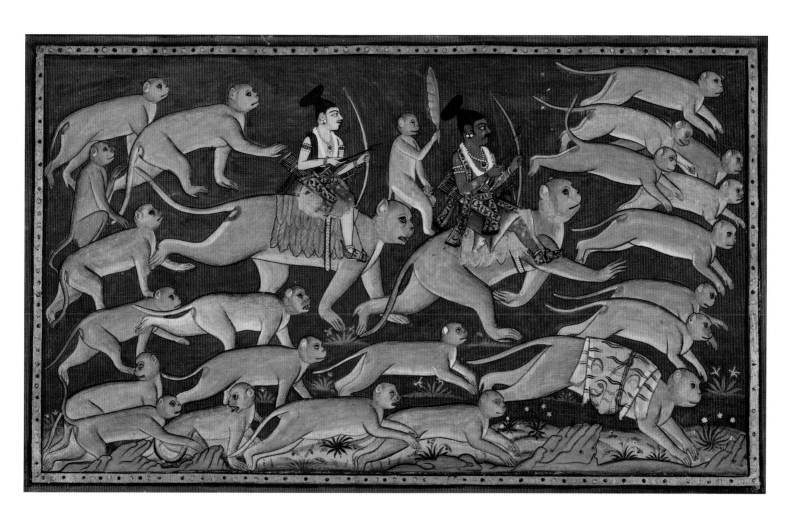

37 *also p. xiv*

Vibhishana offers his service to Rama,
approx. 1675–1700

> India; Malwa, Madhya Pradesh state
> Ink and opaque watercolors on paper
> H. 20.3 × W. 27.9 cm
> Anonymous collection

The contrast between Rama and Ravana is emphasized at various moments in the Ramayana. While the story's hero and villain share certain characteristics, the differences in how they respond to similar circumstances define their respective roles as righteous hero and destructive demon. For devotees, these oppositions provide examples of everyday situations and models for ethical behavior.

The defection of Ravana's brother Vibhishana and his joining Rama's forces brings to attention several polarities. Most obviously, we see two relationships between brothers—Rama and Lakshmana, Ravana and Vibhishana. The former are archetypes for brotherly love, loyalty, support, and mutual respect; the latter are the opposite, as Ravana accuses his brother of being motivated by jealousy and hatred, and in his arrogance harshly rejects the good advice Vibhishana offers. More subtly, the message in this episode is one of redemption and forgiveness: not all demons (or people) are devoid of conscience, they have the potential to change their ways, and they need courage to do so; equally important, when confronted with someone seeking redemption or refuge, one must have an open mind and compassion to offer them trust and aid, as Rama does for Vibhishana.

This painting documents the event in which Rama accepts Vibhishana's valuable offer of service, despite the misgivings of his monkey advisors, who distrust Vibhishana's intentions. The artist has organized the picture space to include a great deal of information in what appears to be a simple painting. The viewer is reminded that Rama and Lakshmana are no longer alone but now have the support of an army of monkeys (seen running, in the lower register, with concern over the presence of the enemy Vibhishana). The painting also shows that Rama's phase as ascetic-in-exile has concluded and he has assumed the role of a warrior and army commander. Wearing a crown and no longer an ascetic's garb, Rama is shown in the upper register surrounded by a group of trusted advisors and holding court. Vibhishana steps into the picture plane at the top right of the painting, dressed as a contemporary royal courtier rather than in the rakshasa's typical form, with fangs, a horned animal or grotesque head, and a corpulent body. Q.A.

38

The demon prince Vibhishana informs
Rama about Ravana's troops, approx. 1594

> India; Agra, Uttar Pradesh state
> Opaque watercolors and gold on paper
> Image: H. 32.6 × W. 21.2 cm
> Museum Rietberg Zurich, Gift of Balthasar
> and Nanni Reinhart, RVI 2169

The same episode as cat. no. 37 is included in the Persian translation of the Ramayana made under the orders of the Mughal emperor Akbar (ruled 1565–1605). Although many versions of the Ramayana story were used as sources for the Persian text, the lines of text on this page and some pictorial details align with the Valmiki version. Here, Ravana's brother Vibhishana appears in his glory as a demon prince, having arrived in Rama's presence in a palanquin carried by demon servants. Valmiki's text describes that Vibhishana flew across the ocean and remained hovering in midair until he received assurances of Rama's protection. It also specifically mentions four rakshasas who left Ravana's court with Vibhishana. The artists of this painting included Vibhishana's companions but left out details of his fantastic mode of travel, replacing it instead with a familiar palanquin. Ravana's brother appears here as a supplicant before Rama but is also shown as a demon with gravitas: he wears a crown to denote his princely status, and his figure is human-like and devoid of an animal head, horns, and fangs; yet the bells around his waist and his open mouth with teeth visible indicate his demonic nature. Rama's position of gracious authority is conveyed through both his pose and gesture and his placement on a platform, framed by a tree.

The importance—and unexpectedness—of this event in the story is marked by the assemblage of sages who stand witness at the top of the painting. The mixed response to Vibhishana, of trust and distrust, is conveyed through the gestures, poses, and human-like expressions of the monkeys. The lines of text on the page state that Vibhishana brings news of the armies Ravana has assembled and of Sita's condition—she is unharmed but in despair. This painting (like cat. no. 12) comes from an illustrated Ramayana made for Hamida Banu Begum, the mother of Emperor Akbar. Q.A.

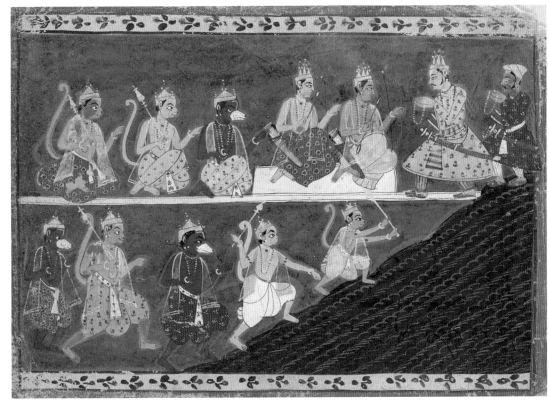

37

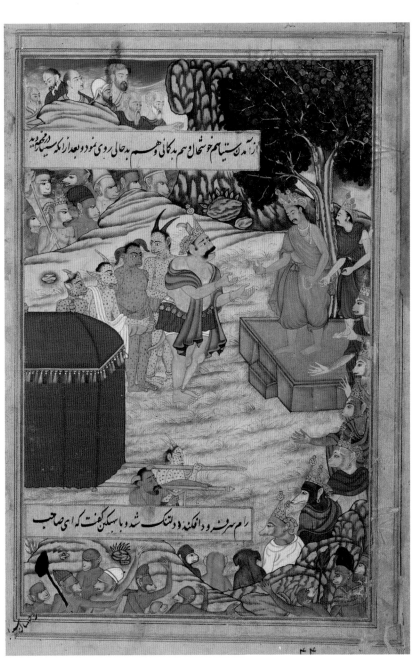

از آمدن سیاه خوشحال شدم یکانه بهم بهم بهم حالی وری نمودو بعدازکه سیاه دید

رام سرغره و دانکنه و دلتنگ شد و باسبکن گفت که ای صاحب

38

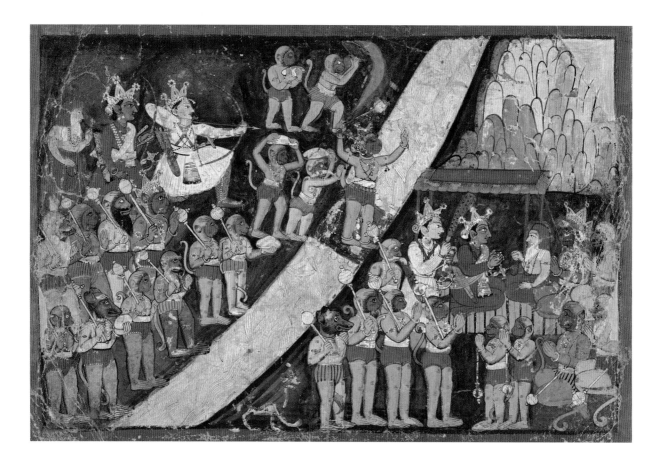

39

Rama and his forces invade Lanka,

approx. 1730–1740

India; Jammu and Kashmir state, former kingdom of Mankot
Ink and opaque watercolors on paper
H. 25.4 × W. 34 cm
Promised gift of Robert J. Del Bontà

While Vibhishana's support of Rama highlights certain philosophical metanarratives and universalisms, from a story point of view, it moves the action forward to the next step. Rama and his allies had arrived at the shore of the ocean but now had to resolve a major logistical barrier: how were the thousands of monkeys to cross the vast and dangerous ocean and get to Lanka? Vibhishana advised Rama to worship the god of the ocean, Sagara, and ask for his assistance. Sagara, who appeared only after Rama raised a storm with his arrow, named Nala as the only monkey capable of the enormous bridge-building task, because of a boon his father had received. Filling the ocean with trees and boulders, the "bounding, bellowing, and leaping" monkeys,[1] under Nala's direction, completed the bridge.

This painting is divided in half by the diagonal ocean, at the center of which Nala stands on the "well-built, smooth-surfaced and beautifully proportioned" bridge, "resembling a dividing line in the midst of the ocean."[2] On both sides of the ribbon-like water are Rama, Lakshmana, and Sagara.

In the absence of text, identifying the artist's source or intention sometimes becomes speculative, as in this case. The challenge is greater when the painting depicts multiple moments of the story but not in their narrative sequence. At the left, Rama and Lakshmana are shown in aggressive poses (Lakshmana is poised to shoot), perhaps after Rama has released his arrows in the water, terrifying sea serpents, raising a gale and massive waves, and prompting the god of the ocean to appear.[3] The sage-like figure in red is probably Sagara, whom Valmiki describes as having a luminous gold body and wearing red garlands and robes.[4] On the right, Rama speaks with the sage, perhaps at the moment when he advises them to build a bridge. The artist here has also depicted the monkeys in an unusual manner; several sport large beards and mustaches that not only give them individuality but also seem to show different age groups.

A similar composition with a diagonally placed body of water is seen in cat. no. 18. The two paintings, produced at different artistic centers and in varied styles, convey entirely different moods. Q.A.

NOTES

1. Goldman and Sutherland Goldman, *Yuddhakāṇḍa*, 155 (15:24). For more on the god of the ocean episode, see cat. no. 2, sections 32–34.
2. Ibid., 156 (15:26).
3. Ibid., 152 (14:1–26).
4. Ibid., 154 (15:2).

40

Rama's brother pulls a thorn from his foot,

approx. 1700–1710

India; Pahari region, Himachal Pradesh state
Opaque watercolors and gold on paper
H. 17.5 × W. 26 cm
Harvard Art Museums/Arthur M. Sackler Museum,
Richard Norton Memorial Fund, 2011.97

This episode, of Lakshmana pulling a thorn from Rama's foot, does not appear in the classic textual versions by Valmiki and Tulsidas. But it is frequently depicted in paintings from the Punjab Hills region (Himachal Pradesh state), suggesting that the artists were responding to local tellings of the story. Here, Lakshmana is seen three times in quick sequence,

cradling and supporting Rama's wounded body and then tenderly pulling the thorn from his foot. Paintings like this one emphasize the strong bond of brotherly devotion and loyalty that Lakshmana displays for Rama, which is a key moral theme in the Ramayana. He willingly left his home and family, undergoing hardship and exile for the sake of his half-brother. Rama's quest for Sita would have been very lonely and difficult without the constant presence of Lakshmana, who continuously provided solace and confidence during moments when Rama lost hope, and sound advice at the time of strategic decision-making. Q.A.

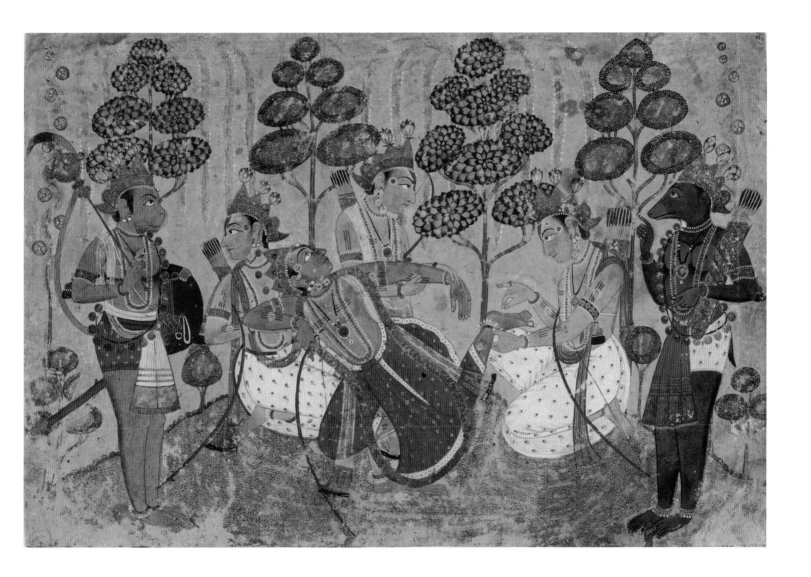

41 *also p. x*

Manuscript cabinet with scenes from the Thai version of the Rama epic, approx. 1800–1850

Thailand
Lacquered and gilded wood with iron fittings
H. 156.2 × W. 96.5 × D. 79.4 cm
Asian Art Museum, Gift from Doris Duke Charitable Foundation's Southeast Asian Art Collection, 2006.27.41

Three sides of this Thai cabinet are elaborately and densely ornamented. Two sides illustrate scenes or characters from the Ramayana, while the third shows a pattern of flame-like foliage interspersed with occasional animals. Along the lower edge of the front doors are chariots bearing, from left to right, Sita, her husband, Rama, his brother Lakshmana, and Vibhishana, a demon prince who is Rama's ally.

On the upper parts of these doors and on the right side of the cabinet are scenes of battle from the climactic war between Rama's forces and those of the demon Ravana. The figures are so ingeniously twisted and turned amid the melee of battle that it is difficult to tell the characters apart. Rama may be one of the royal figures depicted along the top of the side panel, but it is curious why he seems to be battling the monkeys below him. Rama's monkey troops usually have rounded jowls and protruding muzzles, and demons usually have bulbous noses. The major characters of both types are dressed finely and have a pointed aureole around their heads. At the lower border of the panel, the monkeys are depicted more naturalistically and with great humor.

Cabinets such as this one were often donated to temples and were used to hold Buddhist texts, manuscripts, and ritual implements. Donors chose the decorative themes. N.R.

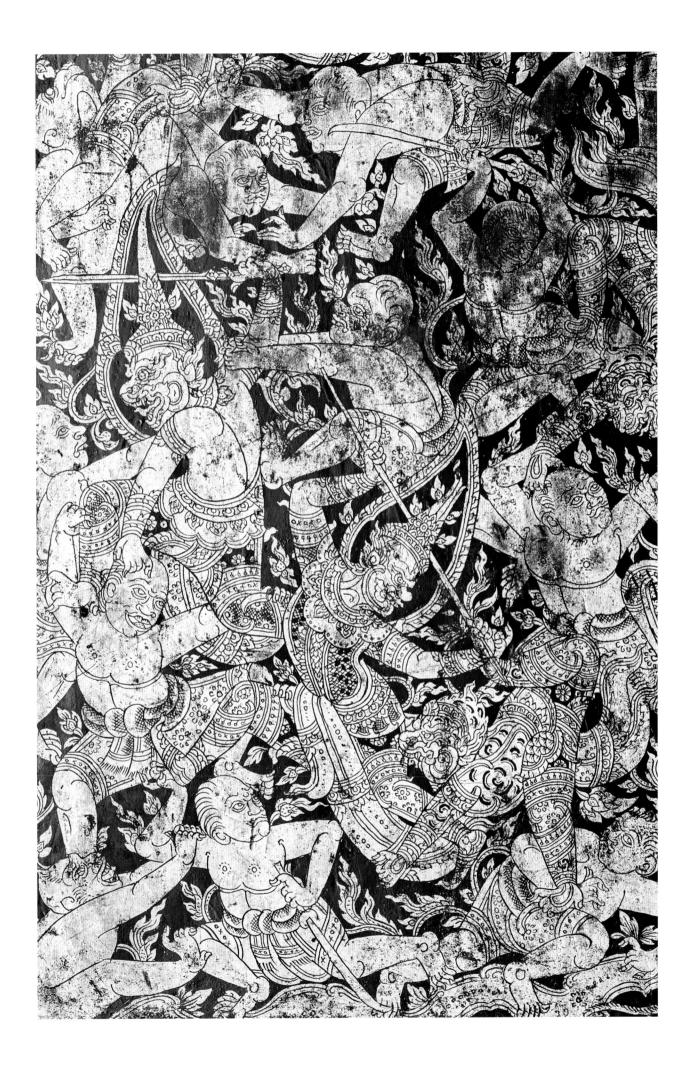

The invisible Indrajit wounds Rama and Lakshmana with his snake arrows; Vibhishana comforts Sugriva, approx. 1800–1810

India; Himachal Pradesh state, former kingdom of Kangra
Opaque watercolors on paper
Image: H. 20.5 × W. 30.5 cm
From the Collection of Gursharan S. and Elvira Sidhu

Rama and his army faced Indrajit, Ravana's formidable son, on two occasions. Both combats left Rama and Lakshmana near death because Indrajit posed a unique threat: he had the ability to become invisible. Their first encounter, depicted here, is described in detail by Valmiki: in the chaos of a fierce nighttime battle, Indrajit became invisible and attacked Rama and Lakshmana with magical weapons, whereby sharp-fanged venomous serpents turned into arrows. The wounded and blood-covered brothers lost consciousness, and their troops took them for dead. The distraught monkey king Sugriva was comforted only after Vibhishana observed that the heroes were unconscious but still alive, and that no one should despair. "When he had spoken in this fashion, Vibhishana dipped his hand in water, and with it wiped Sugriva's lovely eyes."[1]

The artist captures here various key moments of this episode. The story unfolds from right to left, as Indrajit in the background rides toward his opponents. He is seen again as invisible, charging forward and poised for his deadly assault. In central focus, Vibhishana (who is shown as a court-attired royal figure rather than a demon) tenderly wipes the eyes of the grieving Sugriva. The painted narrative concludes with Rama and Lakshmana near the left border. Their fallen bodies—with Lakshmana still unconscious—are framed by the figures of their troops who stand protectively around them. Rama and Lakshmana are not shown "drenched with blood . . . sleeping on the ground . . . completely riddled with arrows";[2] the only indications of their near-fatal injuries are the snakes wrapped around their bodies. The invisible Indrajit, depicted here as a large gray silhouette, gives the painting an unfinished appearance at first glance; but once we recognize the episode, the artistic solution's effectiveness becomes apparent as clever and apropos.

In this episode, Rama also grieves keenly for his brother: "What do I care for Sita or even for my life itself now that I see my brother lying defeated in battle? . . . Damn me, an ignoble evildoer, on whose account Lakshmana lies fallen on a bed of arrows, his life's breath ebbing."[3] Such descriptions remind us of Rama's vulnerability and his deep brotherly love; they testify as well to his loyalty-inspiring qualities. Q.A.

NOTES
1. Goldman and Sutherland Goldman, *Yuddhakāṇḍa*, 216 (36:29). Eventually Rama and Lakshmana were revived by Garuda, the powerful "king of the birds." The sight of Garuda made the serpents flee in fear, while his touch healed the brothers' wounds and restored their vigor. Ibid., 228–230 (40:33–59).
2. Ibid., 227 (40:17).
3. Ibid., 223 (39:5, 7, 12).

43

The demon giant Kumbhakarna battles Rama's armies of monkeys and bears, approx. 1605

India; Possibly Madhya Pradesh state, former kingdom of Datia
Opaque watercolors and gold on paper
H. 26.7 × W. 18.4 cm
Asian Art Museum, Gift of the Connoisseurs' Council with additional funding from Fred M. and Nancy Livingston Levin, the Shenson Foundation, in memory of A. Jess Shenson, 2003.3

The appearance in the Ramayana of Kumbhakarna, Ravana's giant brother, provides a moment of humor (*hasya*) in the overall sobering story. He is larger than life, both literally and metaphorically, with his enormous appetite and ability to sleep deeply.[1] But despite his caricature-like depiction, he surprises the epic's audiences with his fearless and well-reasoned criticism of Ravana's actions. He thus represents yet another type of the brotherly relationships featured in the tale. Like his brother Vibhishana, Kumbhakarna fulfills his filial responsibility by speaking freely and offering sound advice to Ravana; but unlike the former, he remains loyal to his misguided brother out of love and duty. In that respect, Kumbhakarna is like Lakshmana, who stands beside his brother against all odds, willing to give up his own life if necessary.

Kumbhakarna, one of the most unassailable opponents of Rama and his troops, is shown here in all his frightening might: "so huge and extraordinary, diademed and tall as a mountain peak, as if matching the sun itself with his innate splendor . . . [who will] roam the earth with gaping mouth, devouring all creatures."[2] Kumbhakarna is recognizable as a demon by his large size, his fangs, his unkempt hair, and the bells around his waist. The sight of the giant sent the monkeys and bears fleeing in fear; they were calmed only when Vibhishana told them Kumbhakarna was a mechanical man. They returned armed with boulders, although the artist here depicts them using contemporary weapons such as muskets, lances, maces, swords, and arrows. The placement of Kumbhakarna—along the left margin of the painting,

with arrows piercing his chest, and hemmed in by the monkey troops—foretells his impending death at Rama's hand. This episode offers yet another testament to Rama's skill on the battlefield, speaks to the courage and devotion of his monkey allies, and reinforces the righteousness of his cause.

Inscribed on the back of this painting are verses from the Valmiki Ramayana, which read, in slightly abridged form, "Ravana addresses Kumbhakarna: 'O Kumbhakarna, [go] to victory and kill [our enemies]! Having contemplated your going without assistance I am unnerved, so, go flanked by troops, [unconquerable even by the best]. . . .' Kumbhakarna went forth, energy ablaze and full of zeal. With his enormous mouth, Kumbhakarna laughed and spoke these words: 'Rama together with Lakshmana is at the root of the siege on this city! I will kill him in battle; and when he is killed the rest will be, too!' Mighty Kumbhakarna departed from the city gates. All the best of monkeys then, seeing that mountain-like rakshasa, took flight in every direction, like clouds scattered by the wind. And seeing them flee, Prince Angada spoke: 'Where are you going, quaking with fear as if you were regular old monkeys? My dear friends, turn back, all of you! Why just save your own lives?' After they composed themselves with great difficulty, they encouraged one another and [took their places] on the frontlines, rocks and trees [in hand]. [Kumbhakarna], who was more than vexed, tore around like a raging fire ignited in a forest. Many of those bulls among monkeys were just lying there, [for they were encrusted] in blood. Then, those mighty monkeys . . . all together attacked Kumbhakarna."[3] Q.A.

NOTES

1. Goldman and Sutherland Goldman, *Yuddhakāṇḍa*, 263–272 (48:12–49:37).

2. Ibid., 269 (48:86–87), 271 (49:27).

3. The inscription on this painting, in *nagari* script, is an abridged version of verses 53–55 of the critical edition of the Yuddhakāṇḍa. It was read and translated by Kashi Gomez.

44

Hanuman revives Rama and Lakshmana
with medicinal herbs, approx. 1790

India; Himachal Pradesh state, former kingdom of Guler
Ink and opaque watercolors on paper
H. 25.2 × W. 35.4 cm
The Metropolitan Museum of Art,
Gift of Cynthia Hazen Polsky, 1987.424.13

Rama and Lakshmana receive lethal wounds in their
second encounter with the invisible Indrajit (see cat.
no. 42). In the course of a prolonged battle in which
Rama and Indrajit hurl magical weapons against each
other, Indrajit invokes Brahma's divine weapon-spell.
In deference to the god Brahma, Rama decides not to
resist. "How is it possible to kill Indrajit today, when
he is invisible and is wielding his divinely charged
weapons? . . . Wise Lakshmana, with a calm mind you
must endure with me the blows of these arrows here
and now."[1] The injuries inflicted by Indrajit not only
leave the brothers near death but also kill the bravest
of the monkeys and bears, such as Sugriva, Angada,
and Jambavan. Following instructions given by the
dying Jambavan, Hanuman flies to the Himalayas
to pick healing herbs that will revive Rama and
Lakshmana. Unable to identify the herbs and urgent
to return to Lanka, Hanuman breaks off the mountain
peak and brings it back (cat. nos. 96, 97). "No sooner
had the two human princes smelled the fragrance of
those powerful healing herbs than they were freed on
the spot from their arrow wounds. The others, too, the
heroic tawny monkeys, stood up as well."[2]

The moment of revival is depicted in this painting.
In the simple yet charming composition, the
concerned monkeys and bears sit protectively around
the injured Rama and Lakshmana. Hanuman makes
an offering to Rama of the sprigs of healing herbs.
The broken-off mountain peak is visible at the bottom
right corner, diagonally across from the mountain
base that is missing its peak in the top left corner.
Rama and Lakshmana will recover with renewed
vigor from the herbs' aroma, returning to battle
Ravana to the end. Q.A.

NOTES

1. Goldman and Sutherland Goldman, *Yuddhakāṇḍa*, 326
(60:44–45).

2. Ibid., 332 (61:67).

45

Rama kills the demon warrior Makaraksha
in combat, approx. 1790

India; Himachal Pradesh state, former kingdom of Guler
Opaque watercolors on paper
Image: H. 20.3 × W. 30.5 cm
Asian Art Museum, Gift of Margaret Polak, 1992.95

The penultimate (sixth) volume of Valmiki's
Ramayana is devoted almost entirely to the long
battle between Rama and Ravana and their respective
allies. Several individual combats are described in
considerable detail, of which one is represented in this
painting as a continuous narrative.

At the upper right corner, inside the palace, we see
the tiny figures of Ravana commanding the demon
Makaraksha (in blue) to enter the battlefield, and
Makaraksha again outside the gate in his chariot. He
reappears below the ridge at the right margin, riding
into the fray, ready to attack the valiant monkeys who
block his path and hurl tree limbs and boulders at
him. Makaraksha then emerges at the bottom right
corner, now on foot, with his white horses killed
and chariot broken. His strength and aggression
are conveyed through his vigorous figure, stilled in
motion after having thrown a three-pronged lance
at Rama (which lies broken near Rama's feet). His
pose mirrors that of Rama, who appears calmly in
control as he aims his crescent-tipped gold arrow at
Makaraksha. In the final action, Rama's arrow has
pierced his heart and Makaraksha falls to his death.
The intensity of the battle is expressed by the dead
demons in the foreground, the broken tree trunks,
and the scattered boulders. These details emphasize
the power of Ravana's forces, who, despite their
might, stand disadvantaged against their courageous
foes under Rama's command. The loyalty that the
monkeys and bears show for Rama, regardless of
the odds against them, also highlights the charisma
of the morally guided Rama.[1] Q.A.

NOTE

1. Thanks to Pika Ghosh for her help in determining the exact
battle depicted here.

44

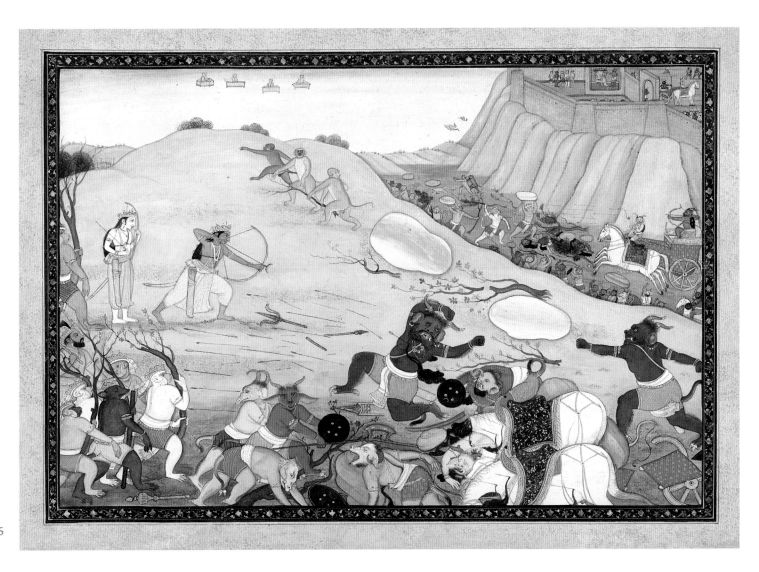

45

46 *also pp. 35, 213, 217, and fig. 26*

Manuscript with scenes of combat from the Thai version of the Rama epic, approx. 1800–1840

Central Thailand
Opaque watercolors and gold on paper
H. 22.2 × W. 49.5 × TH. 6.3 cm
Asian Art Museum, Gift from Doris Duke Charitable
Foundation's Southeast Asian Art Collection, 2006.27.9

Rama and Ravana, and many other pairs of warriors from the Rama epic, struggle on page after page of this manuscript.[1] No other narratives are shown, and there is no text at all; only details of facial features and types of headdress, together with skin color, allow viewers familiar with the conventions of Thai art and theater to identify characters.

In Thailand, both Rama and Ravana traditionally have green skin; Ravana has multiple demonic faces stacked in his crown. Both warriors wield stick-like weapons, which, when used as props on the stage, can represent bows, arrows, or fighting staffs.

Battling pairs include not only Rama and Ravana but also Hanuman and various demon warriors. In addition, Rama's brother Lakshmana grapples with Ravana's son Indrajit, brother Kumbhakarna, and other demons.

Almost always each pair of fighters is shown on three successive double pages at various moments of

Ravana and Rama fight in Thai classical dance-drama.

Rama and Ravana fight.

their clashes. It is as if we see three freeze-frames from a movie.

The function of this manuscript is not at all clear. Certainly it must have had something to do with the Thai classical dance-drama, as its costumes and positions are virtually identical to those seen onstage. It seems not to have been any sort of functional manual, because it shows little wear and is painted in the finest style and materials associated with courtly patronage. One possibility is that, based on comparison with the use of manuscripts on the characteristics of elephants, this manuscript served as an emblem of office for an official in charge of dance troupes.[2]

F.McG.

NOTES

1. All pages of the manuscript can be seen in the collection database on the Asian Art Museum's website. To find them, enter the manuscript's accession number, 2006.27.9. The manuscript is discussed in McGill and Pattaratorn, "Thai Art of the Bangkok Period," 32–33; and McGill et al., *Emerald Cities,* 188–189.

2. This idea comes from Hiram Woodward in a personal communication of July 13, 2015.

47

Rama, his brother Lakshmana, and their monkey allies battle the demon Ravana and his army, 1975–1982

By Krishnanand Jha (Indian)
Ink and colors on paper
H. 76.8 × W. 182.9 cm
Asian Art Museum, Museum purchase, 1999.39.41

Solely featuring key characters, this bold and charming painting represents the long battle between Ravana and Rama, which began with individual demons taking the field. Ravana remained undefeated in his combats with Rama and met his death only toward the end of Valmiki's Yuddhakanda. Here we see Rama and Lakshmana at the right, both identifiable by their halos, bows, and arrows. Ravana, with his multiple heads and arms, stands at the left. The numerous rakshasas surrounding Ravana not only indicate the size of his vast demon army but also emphasize that, despite their numbers and might, they were overcome by the less powerful but courageous monkey troops seen near Rama and Lakshmana. The demons and monkeys are difficult to tell apart in this painting; some demons are shown with fangs and snake-like tongues, but their identification is possible mainly through their relative placement near the heroes or the villain.

Paintings such as this one demonstrate the important place that the Ramayana continues to hold in Indian life and culture. The iconographies of the main subjects have become established over the centuries and are thus easily recognizable with even the slightest visual cues, regardless of the style or medium in which they are represented. This work, in the Madhubani or Mithila style, is distinctively associated with the eastern Indian region of Mithila (Bihar state). The tradition derived from the local practice of mural paintings inside homes that women created for celebratory occasions such as weddings and religious festivals. Since the 1960s, artists have been painting on paper and canvas instead of walls. Among other subjects, the Ramayana is popular in this tradition, perhaps because the Mithila region is believed to have been the kingdom of Janaka, Sita's father.

Q.A.

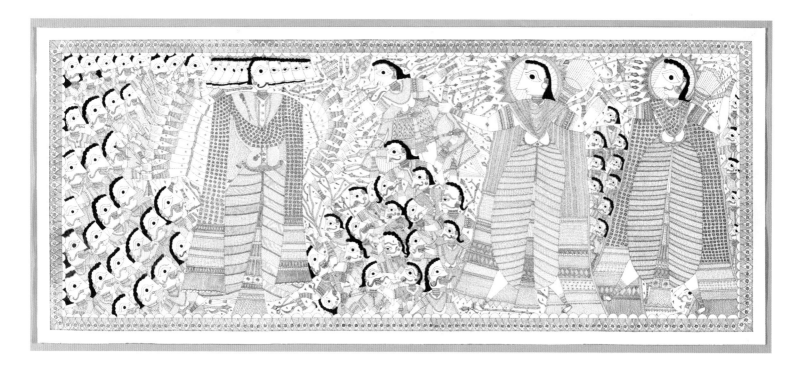

48

The killing of Ravana, approx. 1750–1800

India
Ink and opaque watercolors on paper
Image: H. 17.9 × W. 13.6 cm
Album: H. 28.9 × W. 21.3 × TH. 2.5 cm
The British Museum, 1880,0.2435, donated by
Sir Augustus Wollaston Franks

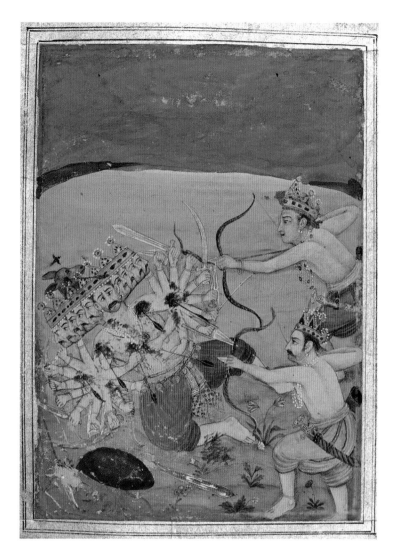

Ten-headed Ravana met his end after an extensive series of combats with Rama. The opponents were so evenly matched that neither was able to gain advantage over the other until, finally, Rama's celestial charioteer suggested that he use Brahma's magical arrow. This weapon was invincible, and its appearance was at once frightful and beautiful. The god of wind resided in its feathers, the fire and sun gods were in its arrowhead, and its shaft was made of Space and given weight by the mountains of the gods.[1] Valmiki mentions Rama's fury and his immense exertion as he released the deadly arrow, which struck Ravana's heart and instantly killed the demon.

The grand finale of a major portion of the Ramayana is represented in this eloquent painting. The focus remains on the main protagonists, with the figure of Ravana taking up most of the picture space. He is shown with his many heads, and his central face expresses defeat. His upper body is pierced with multiple arrows, two of which he tries to pull out while powerlessly holding on to his weapons in the face of the vigorous attack against him. This painting of the dying Ravana is a touching depiction of a fallen anti-hero, despite his villainy and arrogance. Rama's victory over him becomes all the more celebratory because of his adversary's might. In most versions of the Ramayana, Rama and Ravana engage in the final battle alone, but here, another princely figure, presumably Lakshmana, accompanies Rama. Unusual, but also effective in this painting, is the absence of additional details typically included in Ramayana battle scenes. No monkeys, bears, or demons appear; no dead bodies or fallen horses lie on the field. Even the background landscape is plain, leaving the principal action as the main—and only—subject. Q.A.

NOTE

1. Goldman, Sutherland Goldman, and van Nooten, *Yuddhakāṇḍa,*
437 (97:3–13).

Sita's trial by fire, approx. 1630–1635

India; Malwa, Madhya Pradesh state
Opaque watercolors on paper
H. 18.1 × W. 23.1 cm
The San Diego Museum of Art,
Edwin Binney 3rd Collection, 1990.945

At the center of this painting, Sita holds her hands in prayer, surrounded by flames. She has just been accused by Rama of unfaithfulness during her stay in Lanka and is so "deeply wounded" that she demands a trial by fire.[1] Blue Rama looks on from within a pavilion; Lakshmana and Hanuman appear behind him.

In a sky-chariot above Sita, the four-headed deity Brahma surveys the scene, while in a similar vehicle to the right sit two more deities. They are Shiva, with his matted hair and meditation beads, and Indra, identifiable by the eyes on his body. These and other gods implore Rama to stop the travesty, but the trial does not end until Agni, the god of sacrifice, puts out the fire. Sita's virtue is vindicated by the trial, but Rama claims he knew she was innocent all along.[2]

J.D.

NOTES
1. Goldman, Sutherland Goldman, and van Nooten, *Yuddhakāṇḍa*, 456–457 (104:1–19).
2. Ibid., 458–463 (105:1–106:19).

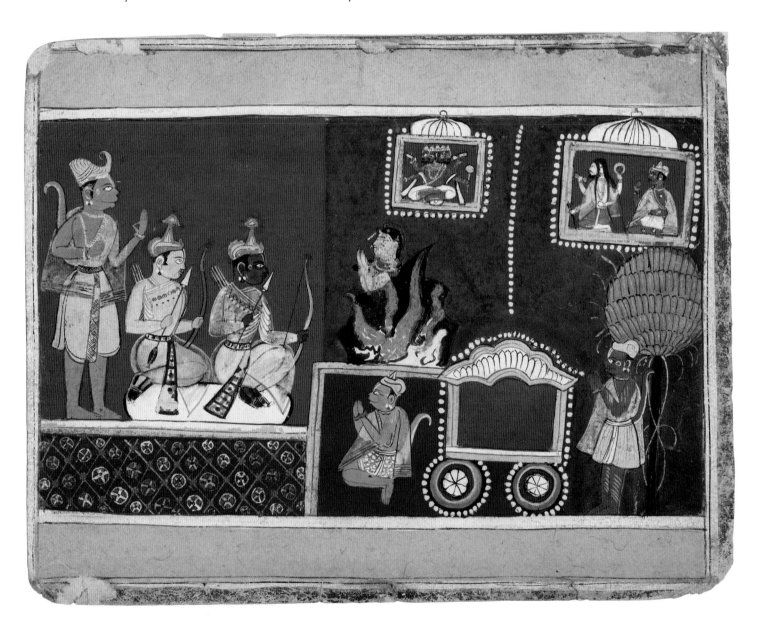

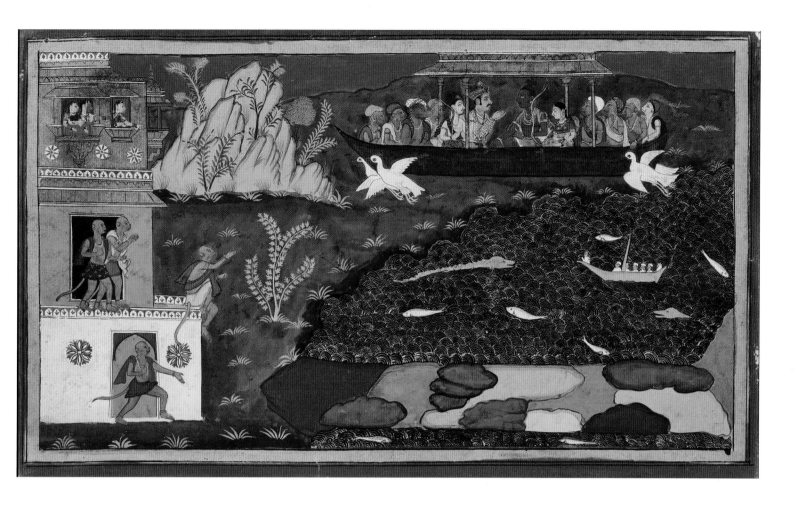

50

Rama, Sita, and their followers fly back from Lanka, page from the Mewar Ramayana, 1649–1653

By Sahibdin (Indian, active approx. 1625–1660)
Opaque watercolors on paper
H. 31 × W. 47 cm
The British Library, Add. 15297(1) f.190r

After the defeat of Ravana, his brother Vibhishana is appointed king by Rama. Rama declines Vibhishana's invitation to stay in Lanka for a while. He instead expresses the desire to return to Ayodhya, and Vibhishana offers Ravana's luxurious flying palace to take Rama and his companions back home. Vibhishana and Sugriva ask to accompany Rama so they can witness his coronation in Ayodhya, and Rama invites the leading generals and all their troops to join him. As they journey back, Rama points out to Sita all the places he passed through in his search for her, encapsulating the various stages of his quest in reverse sequence from the moment of exile.

This painting includes major landmarks that refer to critical moments in the story. Occupying the lower right corner is the bridge the monkeys built across the sea to Lanka. Toward the middle, at the back, stands the verdant mountain where Rama forged an alliance with Sugriva, and at the left is "Sugriva's charming city," the monkey kingdom of Kishkindha. The flying palace Pushpaka—which Valmiki describes in detail as bearing gold mansions, adorned with precious materials such as lapis lazuli, pearls, silver, and crystal[1]—appears here simply as a boat with a golden pavilion, carried aloft by white birds. Traveling in it are the immediately identifiable figures of Rama, Lakshmana, Sita, Vibhishana, and Jambavan; the monkeys are presented more generically and Sugriva is not distinguished from other monkey leaders. Q.A.

NOTE
1. Goldman, Sutherland Goldman, and van Nooten, *Yuddhakāṇḍa*, 473 (111:14), 469 (109:22–27).

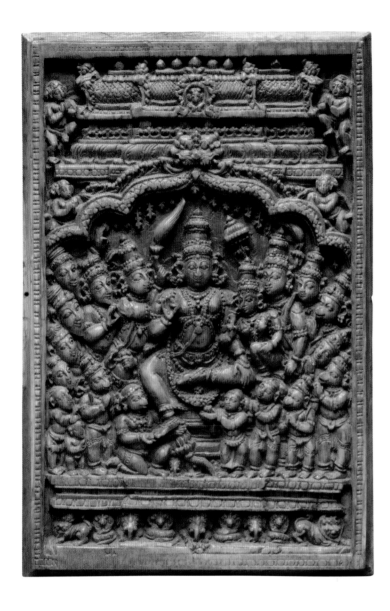

51 *also p. 35*

Rama and Sita enthroned, 1600–1800

India; Tamil Nadu state
Ivory
H. 15.1 × W. 10.2 × D. 1 cm
The Metropolitan Museum of Art, Gift of
Mr. and Mrs. John J. Klejman, 62.34.2

This exquisitely carved ivory plaque represents the triumphal moment of the epic: the coronation of Rama and Sita, which will inaugurate ten thousand years of utopian rule in Ayodhya. The rather static imagery presents an interesting contrast with the dynamic action scenes so prominent in the Rama epic; indeed, it represents the transformation of a narrative episode into a religious icon. Diminutive and deeply detailed, the work was likely used in a domestic shrine for offerings (*puja*); in shrine-like fashion, the central figure is Rama himself, his right leg on a lotus in the posture of royal ease. Such ease is perhaps warranted in this case, for seated next to him is his beloved consort Sita, as well as his faithful brother Lakshmana, who holds a bow.

On either side, two sets of figures are depicted in three-quarter profile, enhancing the three-dimensional quality created by the artist. They include sages (*rishis*) with their telltale pointed beards to his left, while Hanuman's monkey army honors the restored monarch. It would appear that Rama is now safely ensconced in a temple shrine that rises in terraces above his head; a "face of glory" (*kirtimukha*), the symbol of majesty, centers the composition. Along the sides of the miniature shrine fly musicians and garland bearers, all ostensibly to celebrate the return of the king to his rightful place. J.D.

52

Rama and Sita enthroned, 1700–1900

India; Birbhum, West Bengal state
Terra-cotta
H. 21.6 × W. 20.3 × D. 7 cm
Asian Art Museum, The Avery Brundage Collection, B62S43.6

In this terra-cotta plaque from West Bengal, a charming Rama and Sita occupy the elevated platform typical for Indian monarchs. At the center of the image, a rather small Rama holds what is also a seemingly small bow in his left hand. To Rama's side, a dynamically executed Sita swings her right leg off the throne; it is as if her long scarf is responding to the motion of her right hand, raised in a gesture of greeting.

Below the royal couple kneels their devotee, the monkey king Hanuman; his posture expresses his complete surrender to Rama and Sita. To the left of Rama is a large figure wearing a long pleated garment with a thick belt. This figure holds the umbrella of royalty over Rama's head and may be Lakshmana; alternatively, the Valmiki text dealing with this incident specifies that another of Rama's brothers, Shatrughna, held the white umbrella at the coronation.[1] The palpable atmosphere of apparent final triumph, complete with Rama's confidence that his ten thousand years of utopian rule is about to begin, closes this final chapter of the sixth book, the Yuddhakanda.

Many of the details on the garments match those from Bengali temples executed in terra-cotta from about the same time (figs. 10 and 11), and attendant figures such as we see here are often depicted in an oversize manner in these same temples. Similar triads are extant in painting from the same period. J.D.

NOTE
1. Goldman, Sutherland Goldman, and van Nooten, *Yuddhakāṇḍa*, 491 (116:59).

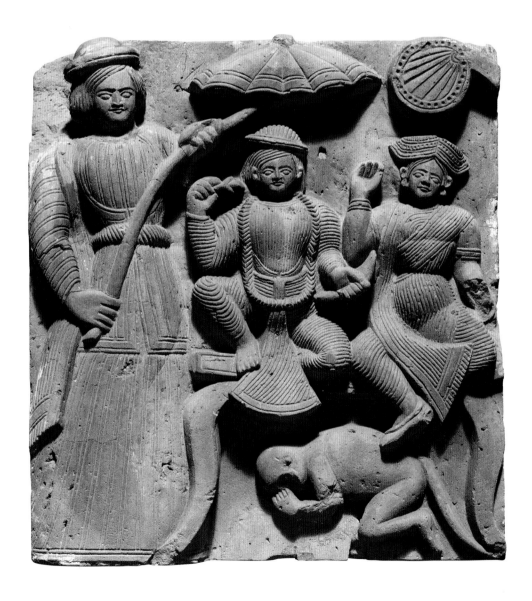

53

Overdoor panel showing the coronation
of Rama, approx. 1850–1920

India; Chettinadu area, Tamil Nadu state
Wood
H. 29 × W. 203.5 × D. 6.3 cm
Asian Art Museum, Gift from
Dr. and Mrs. Joseph Catton, B76S4

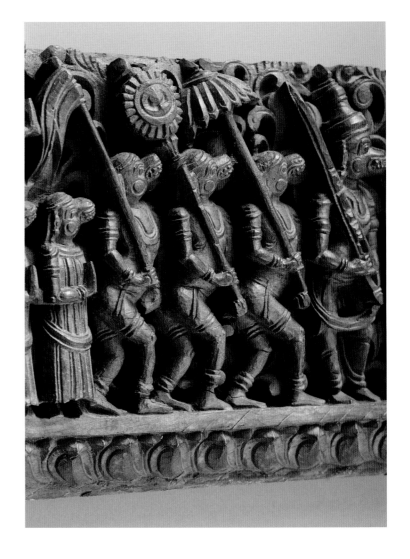

At the center of this lintel presides the victorious
Rama. With a mace in his right hand and his right
leg in the posture of royal ease, he awaits his incipient
coronation. To the left, a sage consecrates the king.
Beyond the sages to the left, a cadre of monkeys
receives a distribution of treasure in gratitude for
their assistance in recovering Sita.[1]

 Sita herself, slightly smaller than Rama, sits to
the right. Around both of them, precisely ordered
ranks of human and monkey warriors celebrate the
occasion. Some of the male monkeys bear umbrellas,
as is appropriate for the festive royal event. Behind
them, female monkeys appear dressed in pleated
gowns. And at the very center of the composition,
just underneath Rama, is his greatest devotee,
Hanuman. The transcendent nature of the entire
scene is framed by the panel's base, which consists
of a series of stylized lotus petals; the lotus is the
symbol of miraculous manifestation in many Asian
religious traditions. J.D.

NOTE

 1. Goldman, Sutherland Goldman, and van Nooten, *Yuddhakāṇḍa*,
488 (116:75).

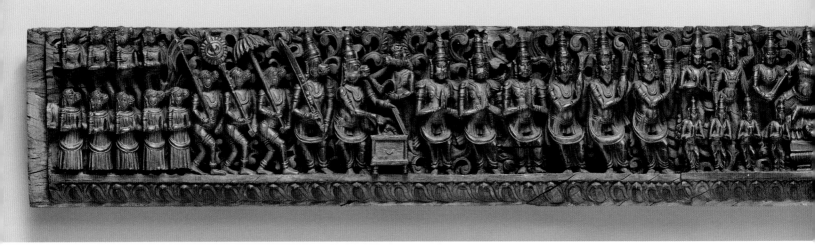

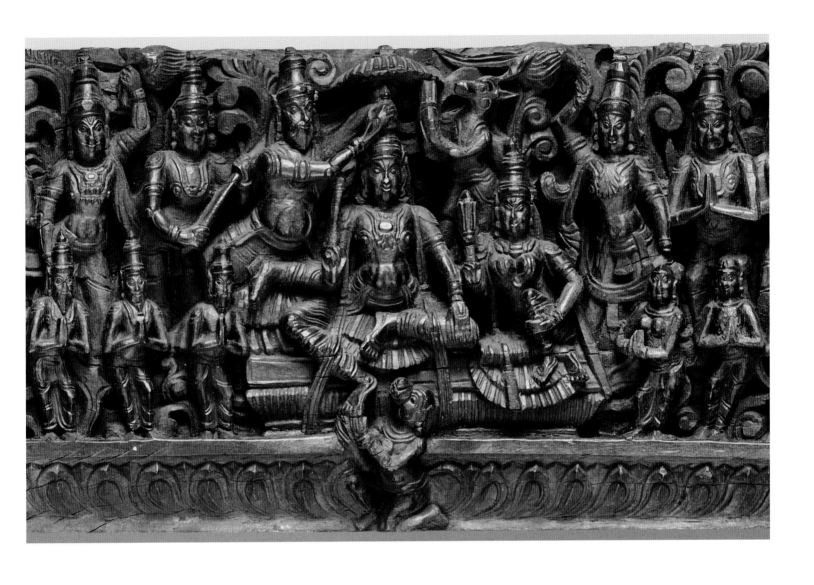

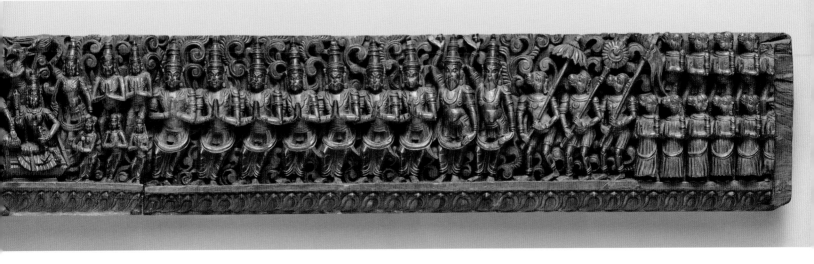

SALLY J. SUTHERLAND GOLDMAN

A Heroine's Journey

Many *Ramayanas* are told . . .
But can anyone name one in which
Rama goes to the forest without Sita?

Sita, the heroine of the Sanskrit epic tale the Ra-
mayana, is the wife of the epic's hero, Rama,
prince of Ayodhya and eldest son of King
Dasharatha. Although many scholars attribute
to her origins that date back to the earliest literary rec-
ords of the Indian subcontinent, it is only with her ap-
pearance in the Valmiki Ramayana that her character
is fully developed. Here she is the daughter of King
Janaka of Mithila and the dutiful wife of Rama, who,
together with her brother-in-law Lakshmana, follows
her husband into exile. The symbol of wifely devotion
and sacrifice in the Hindu consciousness, Sita has con-
tinued to serve as a role model for countless generations
of women in the Indian subcontinent and diaspora.

The Ramayana of Valmiki is, in all likelihood, the
earliest extant version of the story and is the text that
has most consistently been examined for its significant
impact on the religious, literary, and cultural traditions
of South and Southeast Asia. Nevertheless, numerous
additional versions of the narrative are found through-
out these regions, and each of these presents our hero-
ine and her trials and tribulations in ways that are at
once familiar and yet distinctive. These subsequent
versions of the Rama epic render the narrative and the
character of Sita in myriad ways. In
many, the variations of Sita's char-
acter reflect ever-changing cultural

attitudes toward women. In some her role is greatly di-
minished, while in others, both Sanskrit and regional,
it is so enhanced that she has become a powerful god-
dess who defeats a second, more powerful form of the
demon antagonist, Ravana (fig. 28).

However, few who know or study the story in the
majority of its versions would not recognize the epic's
heroine, Sita, as the example par excellence of the tra-
ditional brahmanical construction of ideal woman-
hood, a woman totally devoted to her husband (*pa-
tivrata*). As laid out in the traditional law books, it was
believed that a woman must be under the control of a
man—her father, husband, or son—for her entire life.
She must consider her husband as her god and lord
and must obey and serve him. Regardless of how such
ideas strike us today, we must remember that these
are the attitudes from which the patriarchal world of
traditional Hindu society was constructed. While the
tradition may prescribe such a moral compass, the
Ramayana narrative, especially the version found in
Valmiki, framed as it is in the culture of traditional
India, depicts Sita as both embodying and contesting
these very ideals.

Birth and Marriage (Book I, Balakanda)

The two most important roles for women in premod-
ern India are those of wife and mother; while both take

FACING
Detail of cat. no. 70

101

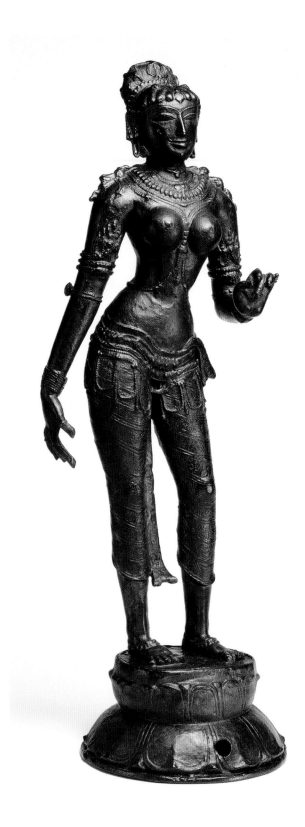

FIG. 28. Eleventh-century bronze Sita
from South India (cat. no. 54).

center stage in Valmiki's epic, the narrative primarily focuses on Sita's wifehood. Book 1 of the Ramayana expends its energy telling of the birth and childhood adventures of the hero Rama, concluding with his marriage to Sita. We know virtually nothing of Sita until near the end of the first book, when the sage Vishvamitra, mentor and guide to Rama, arrives with the young prince in the capital city of King Janaka, Sita's father. Janaka offers to show Rama and Lakshmana a very special bow, that of the god Shiva. First, however, he tells them about his daughter, Sita: Once during a sacrifice, a girl sprang up from the earth. Since she had appeared as Janaka was plowing the sacrificial ground, he called her Sita, "Furrow." Janaka placed a very high bride-price on her; she was only to be given to one of great strength. Janaka had offered his daughter to any who could lift and string Shiva's bow, a test of strength. Many kings had tried, but none succeeded. Rama, though still young, lifts the bow, strings it, fits it with an arrow, and draws it back, but in doing so he breaks the bow, clearly demonstrating his superhuman strength (figs. 29 and 30).

We have not seen or heard Sita prior to this contest and the text has provided no physical description of her. Even during the wedding preparations—the most central of rites for a woman—Sita is largely absent, and there is a marked erasure of virtually all women from the festivities. The wedding ceremony, itself only briefly described, marks the first appearance of Sita in the epic. Upon completion of the ceremony of the sacred wedding thread, Rama takes Sita's hand, and then, according to the ritual injunctions, the couple takes three steps around the sacrificial fire. Those familiar with modern Hindu wedding ceremonies will note the similarity of these important elements: the wedding thread ceremony, the groom's taking of the bride's hand, and the circumambulation of the sacred fire. The number of steps is three, however, and not the expected seven of the present-day rite. At the end of the ceremony, Sita is given lavish gifts by her father, another common current practice.

At the close of the book we learn of the flowering of love between the newlyweds and of Sita's virtue, beauty, and, most especially, her deep and fully reciprocated love for her husband. Valmiki thus establishes his heroine, providing her with an impeccable pedigree and all the virtues of a perfect wife.

While Valmiki spends little energy on either the story of Sita's birth or that of her marriage, numerous subsequent versions have expanded and developed these two episodes significantly. The birth of Sita has,

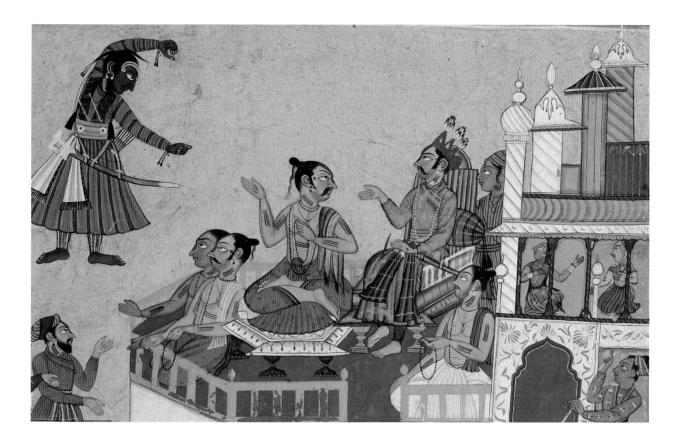

perhaps, given rise to the largest number of variations. While Valmiki provides only a brief account of her origins,[1] other versions tend to provide more elaborate, and in some cases alternative, explanations, generally retaining only Janaka's finding her while performing his sacrifice (fig. 31). The episode as it is basically known to Valmiki is found in a number of later sectarian religious texts, called Puranas, but some, uncomfortable with Sita's lack of a mother figure, provide one. Thus a later Purana, devoted to the worship of the Goddess, has the Earth goddess giving Sita to Janaka during the plowing.[2] The eastern recension of the Valmiki Ramayana introduces the nymph Menaka as her mother, a variant also seen in the fourteenth-century Assamese version of the story.[3] A third-century Jain Prakrit version makes Sita the natural daughter of Janaka and his wife Videha,[4] a motif also seen in a Kannada version dating from the late eleventh century. A Buddhist Jataka has Dasharatha as her natural father.

A fascinating and popular variant has Mandodari, Ravana's chief queen, as Sita's natural mother, or both Mandodari and Ravana as her natural parents. The earliest-known version of this variant is found in an early Jain Prakrit version. Here, Mandodari and Ravana are told that their eldest offspring will destroy their family. Mandodari gives birth to Sita, who is put in a box that is placed where Janaka, plowing a field, discovers it.[5]

FIG. 29 (*top*). Sita watches the bow-bending contest from the palace (detail of cat. no. 15).

FIG. 30 (*above*). Sita garlands Rama after he lifts, strings, and breaks Shiva's bow. Popular print.

FIG. 31. The infant Sita is found by King Janaka. Detail of a nineteenth-century mural at Wat Phra Si Rattanasatsadaram, Bangkok.

A common enhancement of the motif of placing Sita in a box, found throughout South and Southeast Asia, is setting the box adrift in a river or in the ocean.[6] A Telegu version tells us that Sita was born in a lotus in Ravana's garden and then put into a box, which is set adrift. In a Bengali version, Mandodari becomes pregnant, but astrologers predict that the child will destroy Lanka, the capital city of the demons. Mandodari gives birth to an egg, which is placed in a golden chest and thrown into the ocean. The chest is found and taken to Janaka, who opens it and finds a girl. The box motif is also a favorite in Southeast Asia. Thus, in Malay and Lao versions, it is a gold casket that is set on a raft; in a Thai version, she is placed in a glass urn and thrown into the ocean; and in a Burmese version, the box is iron.[7]

The Adbhuta Ramayana, a later Sanskrit version, narrates a unique version of Sita's birth. Ravana demands drops of blood from the forest seers. He puts the blood in a pot and gives it to Mandodari, telling her that it is poison. Mandodari, thinking Ravana unfaithful, drinks it in order to end her life. The potion is not poisonous, but rather is infused with the essence of the goddess Lakshmi. Mandodari immediately becomes pregnant and gives birth to a girl, whom she buries in a field.[8]

Like the birth of Sita, later versions of the Ramayana develop and expand the brief and unromantic marriage ceremony found in Valmiki. For Valmiki, the marriage is clearly a royal alliance, and any premarital meeting between the young couple is avoided. Over time, in addition to the political component, a decidedly romantic one has been added in a number of versions. The eighth-century Sanskrit playwright Bhavabhuti introduces just such an element, allowing Rama and Sita to meet before the breaking of the bow.[9] This romantic interlude is found and developed in some of the best-known and widely dispersed subsequent versions of the story. Thus we see the premarital meeting in the Ramayana of the Tamil poet Kamban as well as in later Sanskrit works.[10] The popular and influential North Indian Ramayana of Tulsidas includes and greatly expands the motif, having the couple meet in a garden before the lifting of the bow.[11] In modernity the popularity of the garden meeting is evidenced by the attention it is given in modern screen versions of the Ramayana, in particular the 1980s TV serialization of the story.[12]

The Exile (Book 2, Ayodhyakanda)

Book 2, the Ayodhyakanda, tells of the court intrigue in Ayodhya, the capital city of Rama's father, and of Rama's fourteen-year exile to the forest. We encounter Sita only when Rama goes to her apartments to inform her of his impending exile. He orders her to remain in Ayodhya, but her reaction is strong and immediate,

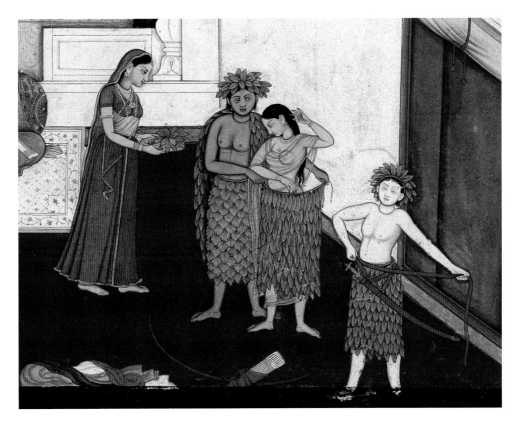

FIG. 32 (*left*). Sita is assisted by Rama in donning ascetic garments for their exile (detail of cat. no. 58).

FIG. 33 (*below*). Rama's concerns for Sita (detail of cat. no. 59).

and somewhat at odds with those of an ideal wife. Before she even speaks, we are told that she is angry. At first her words reflect a traditional understanding of wifehood. Her husband is her lord; she must follow his footsteps and share in his reversal of fortune. However, her very resistance to remaining behind contradicts her husband's desires. Rama is still unwilling to take her, and Sita, in her bitter sorrow at his repeated refusals, responds in words that can only be described as harsh and demanding. Finally, she threatens suicide if he refuses to take her. Rama still refuses. Changing her tactics, Sita reviles him.

> What could my father [Janaka] . . . have had in
> mind when he took you for a son-in-law, Rama,
> a woman with the body of a man?[13]

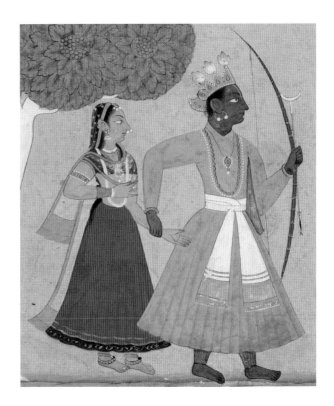

Rama finally relents. Few epic women are allowed such a strong and abusive voice, and Valmiki has carefully crafted the passage to allow Sita to speak these words under very specific circumstances, that is, when her status as an ideal wife is challenged.

Valmiki depicts Sita's public persona far differently, emphasizing her devotion as well as her youth, her position, and her shyness. She has been kept isolated and protected in the confines of the women's quarters. She is innocent and pampered, unused to the harshness of the outside world. This is highlighted during their leave-taking from Ayodhya, when Sita seeks her husband's assistance as she tries to put on the harsh bark cloth garments of exile (fig. 32). The scene, eliciting the pathos of generations of Ramayana audiences, is among the most frequently depicted in dance, drama, and the visual arts.

The Abduction (Book 3, Aranyakanda)

Once Sita reaches the forest, our opportunities to see and hear her increase while, simultaneously, we find her far more vulnerable to myriad dangers. In Book 3, the Aranyakanda, the most central event of the epic occurs. Our heroine is abducted by Ravana, the overlord of the demons, and taken to his island fortress, Lanka.

The events of the abduction of Sita (*sitapaharana*) are well known, but Sita's role in them provides further insight into the complexity of her character. Sita, spying a lovely golden deer, becomes infatuated and desires Rama to fetch it for her. Lakshmana, suspecting that the deer is illusory, tries to dissuade him. Rama departs, arguing that either the deer will provide Sita a delightful hide or, if the deer is truly the rakshasa (demon) Maricha in disguise, he ought to kill him. Lakshmana remains to guard Sita. Rama eventually finds and kills the demon. Maricha, in the throes of death, cries out in Rama's voice. Hearing his call of distress, Sita begs Lakshmana to go to Rama's aid. Lakshmana refuses, and Sita lashes out at him in anger (fig. 34). She accuses Lakshmana of lacking affection for Rama and wishing for his elder brother's demise. Lakshmana is so offended by Sita's accusations that he curses her and makes disparaging remarks on the nature of women. Finally he agrees to go, but not without warning her of the ominous portents that have appeared. Nevertheless Sita, in an even more vicious manner, continues her assault on his character, finally accusing Lakshmana of the unthinkable:

> You treacherously followed Rama to the forest, the two of you alone: You are either in the employ of Bharata or secretly plotting to get me.[14]

These words are the cruelest of all. By accusing Lakshmana both of plotting against Rama with Rama's and Lakshmana's brother Bharata, whom she implies is Rama's rival, and of having secret designs on her, Sita questions Lakshmana's abiding quality, his unwavering devotion to his elder brother. Her words, comparable in intensity to those she utters to Rama in the Ayodhyakanda, similarly end with a threat to kill herself. Lakshmana, unable to withstand her harsh accusations, acquiesces to her demands and departs in search of Rama. Sita's behavior—both her infatuation with the illusory deer and her demand, expressed in such cruel and harsh words—sets the stage for her abduction.

Now alone, Sita is approached by Ravana, who has taken on the guise of a mendicant. Once again deluded by illusory powers, this time Ravana's, Sita greets him with the honor due a revered elder. Ravana at first maintains his disguise but soon begins to seduce Sita. Finally Ravana reveals his true nature and purpose to her, that he desires her as his wife. Sita, although

FIG. 34. Sita lashes out at Lakshmana (detail of cat. no. 63).

frightened, swears her undying fidelity to Rama. Fiercely rejecting the demon king's advances, she engages in a spirited and condescending verbal attack on his character and a heartfelt defense of Rama's valor and power. Sita's rebuff enrages Ravana, and he abducts her. He seizes Sita with his left hand by her hair and with his right hand by her thighs (fig. 35). In this scene we see Sita's first encounter with a male outside the family. Sita's defense and resistance, however, are not physical—she is unable to defend herself against such assaults—but rather verbal. Threatened by Ravana, she once again demonstrates the power of both her voice and her devotion. As she is carried up into the sky by the rakshasa, we hear Sita calling out to Rama. But she is heard only by the vulture Jatayus, who tries to aid her, and by the monkeys.

Later in the book, we hear once more from Sita when Ravana, having taken her to his palace in Lanka, again attempts to seduce her. Sita, now placing a piece of straw[15] between herself and Ravana, an action she repeats in Book 5 (the Sundarakanda), praises the glory and power of Rama and foretells Ravana's downfall.

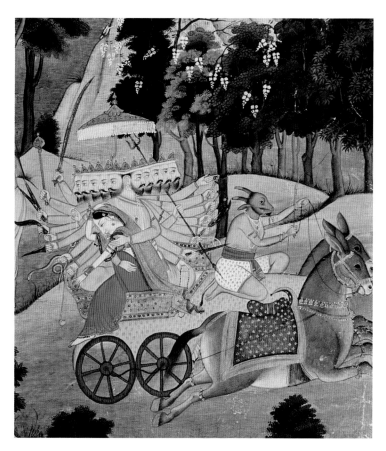

FIG. 35. Sita is abducted by Ravana (detail of cat. no. 61).

> A pariah cannot desecrate an altar in the place of sacrifice, equipped with ladles and other utensils, and sanctified by the hymns of brahmans.
>
> This body of mine has no more feeling; throw it in chains or have it killed. I care nothing about preserving it, or my life either, *rakshasa*. I will not disgrace myself in the eyes of the world.[16]

Here we see Sita's body compared to the ancient fire sacrifice, which stands at the symbolic center of the brahmanical world, and Ravana compared to a pariah. The destruction of the sacrifice, like that of her own body, is preferable to its defilement. The scene ends with Ravana allotting twelve months (the time remaining of Rama's exile) for Sita to submit to him or to face having Ravana's cook "chop [her] into minced meat for my breakfast."[17] Upon his departure, Ravana orders hideous and terrifying rakshasa women to guard Sita. Thus a pattern has emerged wherein Valmiki has Sita defend her husband as well as the patriarchy to the outside world. However, when she is alone and seemingly abandoned, Sita's words challenge her husband and the societal norms that he represents.

The Golden Deer and Lakshmana's Magic Circle (Lakshmana-rekha)

The centrality of the golden deer episode to the narrative is likewise seen in the majority of the other versions of the Ramayana. Most variants retain both Sita's inability to recognize the illusory magic of the rakshasas and her fierce attack on Lakshmana found in Valmiki. An extremely popular innovation has Lakshmana, before leaving to search for Rama, draw a magical circle around Sita. As long as she stays within this circle she is safe, but once she leaves it, she becomes vulnerable. This line, popularly called Lakshmana's magic circle (*lakshmana-rekha*), is known in a number of versions from at least the fourteenth century, where it is found in the Adbhuta Ramayana, the Bhushundi Ramayana, and the Khotanese versions of the story.[18] While the Ramayana of Tulsidas has this motif, it is found not in its Aranyakanda, but rather in its sixth book.[19] The motif is widespread in Southeast Asian versions as well, where it is seen in such texts as the Malay Hikayat Seri Rama.[20] This innovation is so popular that in India the phrase "lakshmana-rekha" is used idiomatically to mean a convention or rule that must not be violated.

The Abduction

One of the most emotionally wrought scenes of the epic is the abduction of Sita. In Valmiki, Ravana physically assaults Sita, coming into direct contact with her body. Such physical contact—as well as the thought that Sita

resides in the garden of Ravana's harem—clearly makes many audiences uncomfortable, and numerous variations have evolved to avoid any suggestion of either. The best known of these modifications is what is commonly called the "illusory Sita" (chayasita or mayasita). Here, a simulacrum of Sita is created, which is then abducted by Ravana. The "real" Sita spends the duration of her exile in heaven or hidden in the sacred fire. After her rescue, during the trial by fire, the "real" Sita once again replaces the simulacrum. Thus the "real" Sita is never touched by Ravana nor does she dwell in his palace or undergo a fire ordeal.[21] Other versions similarly avoid physical contact.[22] A popular motif to avoid contact has Ravana picking up the ground on which Sita stands. This is sometimes expanded to include the hut where Sita is, as, for example, in the Tamil Kamban Ramayana and a number of Southeast Asian versions.

The Ashoka Grove (Book 5, Sundarakanda)

Once abducted and confined within the walls of Ravana's palace, Sita, though she is constantly in Rama's thoughts and is frequently mentioned in the conversations of others, does not actively participate in the epic until Hanuman discovers her in Lanka. In other words, we do not hear from her or see her again until Book 5, the Sundarakanda. The events of this book occur in Lanka, specifically in the ashoka grove attached to the women's apartments of Ravana's palace. Here Valmiki both invokes the sympathy—or other reactions[23]—of his audience toward the forlorn, helpless heroine and creates a situation wherein the heroine's voice is heard at great length. Because of her captivity, Sita must act in ways not often allowed women in patriarchal discourse—she must make her own decisions, interact with males outside of her family, and defend her husband and her virtue.

Much of the book is spent in either describing or hearing Sita. The poet takes us from the depths of Sita's despair to her realization that Rama will rescue her, painting a nuanced and vivid picture of the epic's heroine. We see repeated, developed, and intensified many of the traits that the poet has already associated with her. He evokes varied visual images of Sita, which are projected through the eyes of the monkey Hanuman, Ravana, and the poet. Further, Valmiki lets us hear Sita as she interacts first with Ravana and the rakshasa wardresses and then with Hanuman, and finally as she contemplates her own situation.

Hanuman has been dispatched to search for the abducted princess; before he even finds her, we are given a detailed, highly eroticized description of Lanka, Ravana's palace, its inhabitants—specifically the women of his harem—and the grove where Sita has resided during her captivity. Once he reaches the ashoka grove and prior to his discovery of the princess, Hanuman, reflecting to himself, reminds us of her beauty and her intense devotion to Rama as well as her love for the forest life and its creatures. He anticipates that Sita will come to the nearby stream in time to perform her evening rituals, drawing our attention to the fact that she is a deeply religious woman. The description of Sita as Hanuman first glimpses her in the ashoka grove is one of the most poetic and emotionally wrought passages of the epic:

> Then he saw a woman clad in a soiled garment and surrounded by rākṣasa women. She was gaunt with fasting. She was dejected and she sighed repeatedly. She looked like the shining sliver of the waxing moon.
>
> Her radiance was lovely; but her beauty now only faintly discernible, she resembled a flame of fire occluded by thick smoke.[24]

The poet carefully sets in juxtaposition the contrasts: a once finely clothed and ornamented woman is now garbed in soiled clothing and gaunt. Her beauty is still discernible but barely. The poet continues to develop the pathos of the passage, finally comparing Sita to the most important markers of the preservation of the traditional brahmanic culture, its scriptures:

> As he examined Sita closely, Hanuman's mind was once more afflicted with uncertainty; for she seemed barely discernible, like some [sacred] Vedic text once learned by heart but now nearly lost through lack of recitation.[25]

The elaborate and lengthy descriptions of Sita as delicate, beautiful, forlorn, alone, devoted to Rama, pious, and ascetic stand in stark contrast to that of the enchanting, romantic beauty of the garden and the inner apartments recently described by the poet. The images used to describe Sita are of a different resonance and temper than those seen earlier. Many of the similes focus on asceticism, fire and smoke—perhaps reminiscent of the ritual fire—memory, faith, hope, intellect, and the like. These types of images are not typically associated with women or beauty, and the tone and choice of descriptors can be seen in part as a device to reassure the audience of Sita's chastity and her utter devotion to Rama.

At this point in the narrative, Ravana is introduced, still intent on seducing the lovely Sita (fig. 36). The poet, through Hanuman's eyes, describes the king of the rakshasas in terms that emphasize his sexual nature. In Sita, Ravana sees only a sexualized object:

> But as for Ravana, in his urgent desire to see
> that fair-hipped woman with her black hair, her
> full breasts crowding one another and her dark,
> darting eyes, he advanced toward her.[26]

This highly eroticized picture is immediately countered by yet another chapter-long description of Sita, which highlights once again her blamelessness, isolation, ascetic mien, devotion to Rama, and misery. Through another series of highly descriptive similes—some reflective of earlier ones, others entirely new—Valmiki evokes the pathos of Sita's condition. Again a number of these figures map the ancient brahmanic tradition and sacrifice onto her, reinforcing that the danger is not just to Sita but an entire way of life as the poet envisions it.

Finally Ravana departs after repeating his threat that if she does not willingly come to his bed, he will have her served as his breakfast. Alone, except for the disfigured rakshasa women who are ordered to guard her, Sita begins to lament. Unlike her spirited defense of her husband in her confrontation with Ravana, we now are presented with a woman filled with doubts about her future. Alone and abandoned, Sita gives up all hope of rescue and resolves to end her life. Depressed and forlorn, Sita concludes that her beloved husband has been killed or has found other women with whom to make love. Unable to procure poison or a weapon, Sita finally decides to hang herself with her long black braid (fig. 37). In the poet's depiction of this remarkable passage we finally discover the emotional complexity, intensity, and depth of our heroine. Here we see no stereotypical woman but a nuanced depiction of a woman both faithful to her husband and defensive of her world, yet still subject to self-doubt and introspection.

At this most critical juncture, Hanuman reinserts himself into the narrative. He reveals his presence and eventually convinces Sita, who originally thinks he is a rakshasa in disguise, that he is Rama's messenger, offering her as proof the token ring that Rama had given him for her:

> Taking her husband's ring and examining it,
> . . . [Sita] was as joyous as if she had rejoined her
> husband.[27]

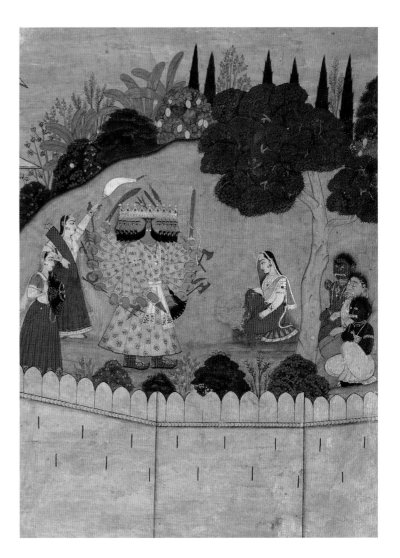

FIG. 36 (*top*). Ravana approaches Sita in the ashoka grove (detail of cat. no. 71).

FIG. 37 (*above*). Sita, in despair, tries to hang herself (cat. no. 69).

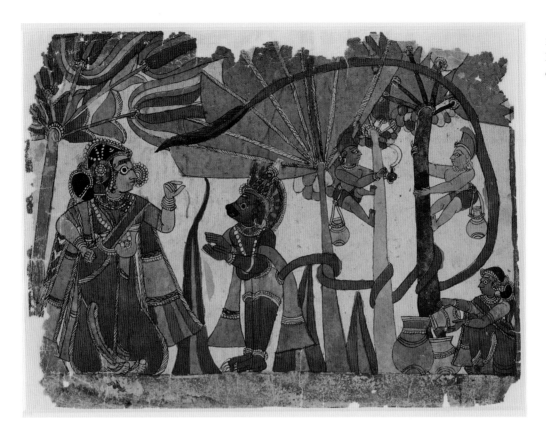

FIG. 38. Sita gives
Hanuman a hair
ornament (cat. no. 91).

The verse, considered one of the most important of the epic, marks the moment that the downward spiral of tragic events that have haunted the couple reverses its course. Hanuman, in yet another iconic moment in the epic, offers to carry Sita back. She refuses his offer, first questioning his ability to do so because he is a mere monkey, and then offering a number of additional excuses, the most famous of which is that she would not willingly touch another's male body. Sita gives Hanuman her hair ornament to give to Rama, and Hanuman leaves her (fig. 38).

The encounter between Hanuman and Sita offers yet another window into this complex heroine. With Hanuman's arrival we first encounter a skeptical and defensive woman, one wary of the illusory powers of the rakshasas. Ironically, what Sita at first understands here as illusory—a talking monkey—is, in fact, real. The episode is the inverse of the previous one in the forest, where both the golden deer and Ravana in the guise of an ascetic appeared to her as real, but were illusory. Once convinced that there is hope of her rescue, Sita is depicted as articulate, insightful, and virtuous. Additionally, the poet describes for us a woman who is used to giving orders. First she insults Hanuman, rejecting his plans for her rescue, and then tells him what he must do.

Thus it is only in the Sundarakanda that the full depth and complexity of our heroine's character is manifested. Valmiki has carefully constructed this book to allow us a varied portrait of his heroine, providing us a rare opportunity to explore a full range of human emotions through her.

Trial by Fire (Book 6, Yuddhakanda)

The next book, the Yuddhakanda, relates the long and fierce battle between Rama and his monkey troops and Ravana and his rakshasa armies. The book is about male aggression and revenge and rarely allows space for other concerns. Nevertheless, as the object of that aggression, Sita looms large in this book, although she rarely appears or speaks in it.

The first encounter we have with Sita is early in the book, where Ravana, using his illusory powers, attempts to delude her into thinking that Rama has been killed. He tells her an elaborate but fabricated story of how his army defeated Rama's troops in the night and shows her Rama's bow and his severed head, both illusory. Believing the illusion real, Sita laments the loss of her beloved and wishes for her own death (see chapter frontispiece). Ravana is summoned away, and as he departs the illusory head and sword disappear. The passage reminds us once again how susceptible Sita is to the illusory magic of the rakshasas.

Sita appears again only at the end of the book, in what is perhaps one of the most controversial moments of the epic. After the culminating battle of the book,

the duel between Rama and Ravana, in which the rakshasa overlord is slain, Rama orders Sita to be brought to him in full view of the assembled court, much to the queen's humiliation and embarrassment. The reunion between Rama and Sita is anything but happy. Rama, claiming that he only undertook this mission to avenge the insult to himself and his family, rejects her:

> Since, however, your virtue is now in doubt, your presence has become as profoundly disagreeable to me as is a bright lamp to a man afflicted with a disease of the eye.
>
> Go, therefore, as you please, daughter of Janaka. You have my permission. Here are the ten directions. I have no further use for you, my good woman.[28]

Regardless of Sita's devotion to her lord, her abduction by Ravana and her period of captivity in the residence of the rakshasa lord has rendered her polluted, unfit as a wife for Rama. For, as he cruelly reminds her:

> What man of good family would take back again a woman who has lived in another man's house?
>
> How can I, boasting of my great lineage, take you back after you have sat on Ravana's lap and have had his lustful gaze upon you?[29]

The fear of sexual transgression is so clearly at the forefront of the poet's, and by extension the culture's, concerns that even Sita, the most devoted and faithful of wives, cannot escape its net. Thus, the harshness of these words is real but not unexpected. Sita, devastated, again speaks in defense of herself while condemning her husband's behavior.

> How can you, heroic prince, speak to me with such cutting and improper words, painful to the ears, as some vulgar man might speak to his vulgar wife?
> . . .
> You harbor suspicion against all women because of the conduct of the vulgar ones. If you really knew me, you would abandon your suspicion.
>
> If I came into contact with another's body against my will, lord, I had no choice in this matter. It is fate that was to blame here.
>
> My heart, which I do control, was always devoted to you. But I could not control my body, which was in the power of another. What could I have done?[30]

She then orders Lakshmana to build a pyre, as she can no longer bear to live. Lakshmana, first seeking Rama's approval, does so. In one of the most poignant moments of the epic, Sita, in her final words of the book, swears her fidelity to her husband and asks for the protection of Agni, the god of fire. She then enters the flames but is not consumed by them (fig. 39). Agni, assuming human form and taking hold of Sita, emerges from the pyre with the princess unharmed and testifies to her purity. Rama finally accepts her, arguing that he knew that Sita was untainted, but even so she had to be tested. Rama's public rejection of his wife ensures the priority of the masculine concerns of the narrative and the patriarchy it defends.

This episode, commonly called "the trial by fire" (*agnipariksha*), has not been universally well received by audiences of the Ramayana. Rather, it has served as a focal point of numerous critiques and counternarratives from early times. These critiques focus on Rama's treatment of Sita both here and later in the last book, where he banishes her. The innovation, discussed above, of the "illusory Sita" (*chayasita*) is one popular mechanism through which the tradition seeks to diffuse the unease caused by Rama's actions. Other versions of the story express the discomfort differently. Some omit the trial by fire entirely, while others, like the Malay Hikayat Seri Rama, have Sita undergo an ordeal by fire from which she emerges on her own when the fire has burned itself out.[31]

FIG. 39. Sita's trial by fire (*agnipariksha*) (detail of cat. no. 49).

The Banishment and Vow of Fidelity
(Book 7, the Uttarakanda)

Once Rama has returned to Ayodhya and is conse-
crated in the kingship, the epic turns its attention to
the history and lineage of the epic's antagonist, Ravana,
giving, at least for the first half of the book, little space
to any of the epic's other characters. However, when the
narrative's attention once again turns to the concerns
of Rama's kingship, Sita emerges as a central, although
largely silent, figure. Having dealt with the matters of
the court, Rama finally turns his attention to his wife.
In the ashoka garden adjacent to their royal apart-
ments, Rama and Sita engage in a romantic moment, at
the end of which we are told that Sita displays the aus-
picious signs of pregnancy. Following this, Rama hears
that there are rumors in the city questioning Sita's fi-
delity. Rama decides that he must abandon Sita, who is
now in the final stages of pregnancy. He orders Laksh-
mana, under the pretext of fulfilling her own desire to
visit the sages, to take her to the forest and abandon
her. Lakshmana does so, and Sita is discovered and res-
cued by Valmiki (now appearing as a participant in the
story he is telling), who gives her protection in his own
ashram, where she eventually gives birth to her twin
sons, Lava and Kusha. This powerful scene, commonly
called "the abandonment of Sita" (*sitatyaga*), is another
of the most controversial moments in the epic.

Sita's reaction to her husband's rejection is yet an-
other emotionally powerful moment. Years later—
after Rama's two sons have been raised by the epic poet
himself—Rama, during a performance of a ritual horse
sacrifice, hears them sing the story of his own adven-
tures. Rama is so moved by the power of the singing
that, seeking reunion with Sita, he once again sum-
mons her and orders her to take an oath of fidelity.
Valmiki leads her in front of Rama, verifying her pu-
rity yet again. But Sita, in a final act of resistance, uses
her very oath of fidelity to defy her husband. Invoking
her mother, Sita swears:

> As I have never even thought of any man other
> than Raghava [Rama], so may . . . , the goddess
> of the earth, open wide for me.[32]

With these words, her mother, the goddess of the earth,
arises from a fissure in the earth's surface and, taking
Sita, descends once more to her subterranean abode
(fig. 40). Thus Sita, who had emerged as an infant from
the sacrificial ground during her father's sacrifice, re-
enters the earth during her husband's. Sita's devotion

to her husband provides her with the very power to re-
sist his wishes and yet remain within the confines of
normative, prescribed behavior for women.

In Sita, Valmiki has created a powerful, complex,
and very human character. Her devotion to her lord
and husband is real and lies at the heart of both Valmi-
ki's portrayal of her and the culture's infatuation with
her. But, as we have discovered, Valmiki has created a
much more complex and nuanced figure, one through
whom the epic audience is able to experience a full
range of emotion. Nevertheless, she is still a woman,
and as such her purity and fidelity are always in ques-
tion. Thus, for Valmiki, Sita's final words demonstrate
both her unwavering adherence to the cultural ideal of
a devoted wife and her resistance to this very construc-
tion of womanhood.

Like the trial by fire, the abandonment of Sita (fig.
41) and its aftermath are deeply disturbing to many au-
diences, so much so that numerous popular versions
omit them altogether.[33] Nevertheless, other versions re-
tain these episodes or even expand upon them. Thus we
have the *Padma Purana,* a popular sectarian work in
Sanskrit, which devotes a great deal of attention to the
latter days of Rama's career, focusing on and enhancing
the role of Lava and Kusha, the twin sons of Rama and
Sita. Some of these versions show evidence of a grow-
ing unease with Valmiki's story. This discomfort is ex-
pressed in a number of ways in the various renderings,
in particular, with innovations rationalizing the cause
of Sita's abandonment. Among these rationalizations
are a curse on Rama and/or Sita, Sita as the instiga-
tor or cause of her own "banishment," the malicious
gossip of a washerman, and Sita's drawing of Ravana's
portrait.[34]

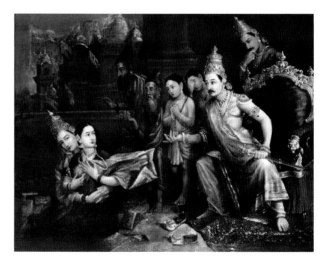

FIG. 40. Sita reenters the earth in the arms of the earth
goddess. Raja Ravi Varma, nineteenth-century painting,
Maharaja Fateh Singh Museum, Vadodara.

FIG. 41. Sita is led into the forest by Lakshmana and told that she has been banished (detail of cat. no. 76).

While Valmiki himself expresses some discomfort, introducing the idea of a previous curse, some later poets express their unease through a critique of Rama by an elder.[35] The *Padma Purana* offers several rationalizations. One merely has Rama saying that Sita has abandoned him. In another, Sita blames herself for her banishment. Sita captures a pair of parrots, which she overhears talking about her future marital joy. They promise to tell Sita's future in full if Sita will set them free once the story is concluded. Sita refuses, vowing instead to keep the pregnant female parrot until the prediction proves true. Separated, the two birds cannot survive. The female dies, cursing Sita to suffer separation from her husband. The male bird drowns himself in the Ganges, vowing to be reborn in Ayodhya as a washerman. The washerman, introduced here, becomes the voice of gossip concerning Sita and is a popular motif in eastern Indian versions of the Ramayana as well as in the Tibetan version.[36]

Another popular and widespread motif similarly places the blame on Sita. Here Sita, typically urged on by other women, draws a picture of Ravana (fig. 42). Rama then discovers the picture and banishes Sita. Similar accounts are known in a number of later Jain versions[37] and are also found in some later Sanskrit versions,[38] as well as in many regional versions, such as the Bengali, Assamese, Telegu, and Malayalam. This popular motif is also known throughout Southeast Asia—in Thailand, Malaysia, Myanmar, Cambodia, and Sri Lanka.

Contested Traditions

In addition to the numerous versions of the Rama epic that follow and reinforce the cultural dictates articulated by the main narrative, a long and continuing history of counter-Ramayanas contests and even subverts these very norms. A large number of these counter-Ramayanas focus on Sita. Thus Sita has become the subject of numerous literary and artistic endeavors

as well as a popular focus of feminist scholarship and activism. So popular a figure is she in such alternative narratives that V. Narayana Rao has questioned at what point the Sita of these various alternative versions ceases to be Sita or the heroine of the Ramayana.[39] Rao's question is an important one. Many modern representations of Sita have been and continue to be extremely controversial. For example, the great disruption caused by various showings of several of M. F. Husain's paintings of Sita effectively forced the artist to go into self-imposed exile in Qatar before his death; and Nina Paley's cartoon film *Sita Sings the Blues* has also given rise to protests (fig. 43).

Conclusion

While for many Sita stands as a silent representative of ideal Hindu wifehood, she emerges in the modern day as a significant, multidimensional, and complex marker of womanhood for millions of women throughout the world. She is the devoted and subservient wife of Rama and yet a goddess in her own right, the very source of her husband's power. An abused wife and yet a feminist heroine, she possesses a voice that continues to be heard as a powerful index to cultural norms, anxieties, and resistances.

FIG. 42 (*above*). Sita is tricked into drawing a portrait of Ravana. Detail of a nineteenth-century mural at Wat Phra Si Rattanasatsadaram, Bangkok.

FIG. 43 (*below*). The abduction of Sita, still from Nina Paley's 2008 film *Sita Sings the Blues*.

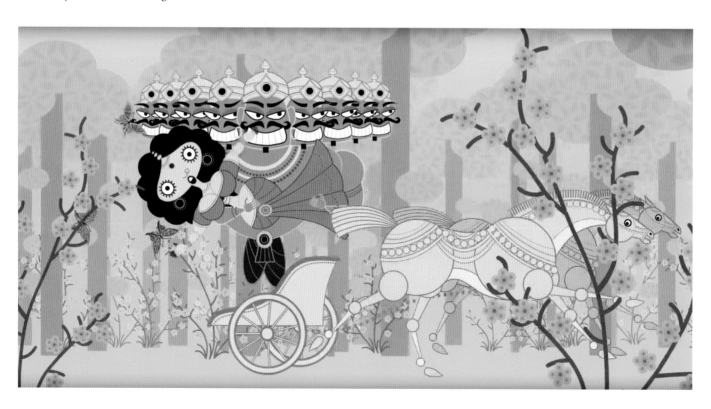

NOTES

Epigraph. From the *Adhyātmarāmāyaṇa*, an ancient Sanskrit devotional text, verses 4.77cd–78ab.

1. Sita's birth is told once again at the end of Book 2.

2. The text in question is the fourteenth-century *shakta* work, the *Kalika Purana*; see Brockington, *Righteous Rāma*, 241, 257.

3. Smith, *Rāmāyaṇa Traditions in Eastern India*, 70; Brockington, *Righteous Rāma*, 278–279.

4. The work referred to is the third-century *Paumacariya*; see Kulkarni, *Story of Rāma in Jain Literature*, 129.

5. The reference is to the third-century Jain work called the *Vasudevahindi*; see Brockington, *Righteous Rāma*, 267; Smith, *Rāmāyaṇa Traditions in Eastern India*, 70.

6. The Tibetan version (late eighth–early ninth century) makes Sita Ravana's daughter. Ravana places Sita in a copper box and puts her in the ocean; she is found by a peasant. The ninth-century Khotanese version is similar. See Brockington, *Righteous Rāma*, 265; Smith, *Rāmāyaṇa Traditions in Eastern India*, 21.

7. Smith, *Rāmāyaṇa Traditions in Eastern India*, 21 (Telegu), 73 (Bengali), and 21 (Malay, Lao, Thai, and Burmese).

8. Ibid., 72.

9. Bhavabhuti, *Mahāvīracarita*, Act 1.

10. The reference is to the Bhushundhi Ramayana; see Brockington, *Righteous Rāma*, 256.

11. Pauwels, "'Only You'" and *The Goddess as Role Model*, 50.

12. Ramanand Sagar, *Ramayan*; and see Pauwels, "'Only You'" and *The Goddess as Role Model*, 68–75.

13. Pollock, *Ayodhyākāṇḍa*, 139 (27:3).

14. Pollock, *Araṇyakāṇḍa*, 178 (43:22).

15. Typically a piece of straw is a symbol of insignificance. Another common interpretation is that the straw symbolically stands for a curtain.

16. Pollock, *Ayodhyākāṇḍa*, 206 (55:18–19).

17. Ibid., 206–207 (55:22).

18. Brockington, *Righteous Rāma*, 265.

19. Lankakanda (doha 35, chaupais 1).

20. Brockington, *Righteous Rāma*, 297.

21. Perhaps the earliest known version is found in the *Kurma Purana* (2.33.110–140); similar variants are known in both the *Brahmavaivarta Purana* and the Adhyatma Ramayana (Brockington, *Righteous Rāma*, 253). The motif is also found in many popular versions, such as the Bhushundi Ramayana (ibid., 258) and Tulsidas's *Ramcaritmanas* (ibid., 282).

22. For example, see the Jain *Uttara Purana* (Brockington, *Righteous Rāma*, 268) and the Tibetan version (de Jong, "An Old Tibetan Version of the Rāmāyaṇa," 195).

23. See Kakar, *Intimate Relations*, 32–35, for a discussion of male reaction to rape in Hindi films.

24. Goldman and Sutherland Goldman, *Sundarakāṇḍa*, 154 (13:18–19).

25. Ibid., 155 (13:36).

26. Ibid., 164 (16:28).

27. Ibid., 207 (34:3).

28. Goldman, Sutherland Goldman, and van Nooten, *Yuddhakāṇḍa*, 455 (103:17–18).

29. Ibid., 455 (103:19ab–20).

30. Ibid., 455 (104:7–19).

31. For example, *Bhagavata Purana*, Ramopakhyana of the Mahabharata, *Vasudevahindi*, and Pampa Ramayana all omit the episode. For Sita emerging on her own, see Brockington, *Righteous Rāma*, 298.

32. Goldman and Sutherland Goldman, *Uttarakāṇḍa*, 421 (88:10).

33. For example, it is not found in the Ramopakhyana, the Adhyatma Ramayana, or the *Ramcaritmanas*, and so on.

34. Smith, *Rāmāyaṇa Traditions in Eastern India*, 94–99.

35. Kalidasa in his *Raghuvamsha* and Bhavabhuti in his *Uttaramacarita*.

36. See Smith, *Rāmāyaṇa Traditions in Eastern India*, 96–97, for eastern Indian versions; and Brockington, *Righteous Rāma*, 265, for the Tibetan version.

37. Smith, *Rāmāyaṇa Traditions in Eastern India*, 95; Brockington, *Righteous Rāma*, 257, 268.

38. Ananda Ramayana 5.3.38–39.

39. V. N. Rao, "When Does Sita Cease to Be Sita?"

What Does Sita Look Like?

Among the main characters of the epic, Sita has the
fewest special aspects of appearance to identify her.
She is a princess of wondrous beauty and virtue and,
like Rama, takes the appearance that various cultures
in various periods attribute to such a figure [1, 2, 3].

Often Sita is easy to pick out because she is the only
(human) woman onstage.

A special aspect of her appearance is that, while
Rama, the monkeys, and Ravana are sometimes
shown dejected or grieving, artists seem to have
responded particularly strongly to Sita's sense of
isolation and despair [4]. F.McG.

[1] *Detail of cat. no. 61.*

[2] *Detail of cat. no. 64.*

[3] *Detail of cat. no. 121.*

[4] *Sita collapses on hearing that she is to be abandoned (detail of cat. no. 75).*

Sita, 1000–1100

India; Tamil Nadu state
Chola period (880–1279)
Bronze
H. 66 × W. 20 cm
Linden-Museum Stuttgart, SA 33610L

This image of Sita was created during the Chola dynasty of southern India, an era when bronze production in the subcontinent was reaching an apogee. Far lighter than the stone sculptures that would occupy a Chola temple, bronzes like this were used as processional images; they would be brought out of the temple to be seen on important festival days. Such a visual encounter with the divine, called *darshan,* is one of the most important aspects of Hindu religiosity. Along with images of Lakshmana, Rama, and Hanuman, this sculpture most likely was originally part of a set of four figures who together comprise the standard complement of a temple to Vishnu.

Aesthetically, this Sita sculpture is fascinating. Her lips are slightly upturned at the edges, revealing a beatific smile. Elegant details, such as the fine line of her eyes and the subtle motion of her hands, create a sense of both motion and precision. Such work conveys a sense of transcendence, as if Sita were aware of the entire scope of the story, assured that the events taking place are all in conformity with an overarching intent.

J.D.

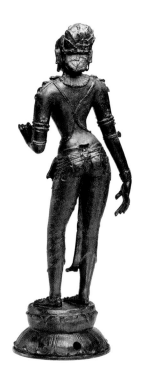

55

Sita, approx. 1893

> By Odilon Redon (French, 1840–1916)
> Pastel, Conté crayon, and charcoal on paper
> H. 53.6 × W. 37.7 cm
> The Art Institute of Chicago, Joseph Winterbotham
> Collection, 1954.320

During the last half of the nineteenth century, the symbolist school of European art used representations of this-worldly phenomena to reveal a mystical message thought to transcend the boundaries of culture and language. European artists were discovering the literary worlds that newly translated Sanskrit and Greek texts had revealed. In particular, they discovered that certain mythical motifs occurred across cultural traditions. This important symbolist work by Odilon Redon reveals just such a motif: the encounter of a cosmic female with an equally cosmic egg.

At the top right of the work, the bust of a golden-haloed figure floats on a cloud, gazing in profile at an egg-like shape. She wears a head ornament from which a golden rain of radiance descends. Here, the imagery recalls Sita's dropping of her jewelry after being kidnapped by Ravana; for its part, the golden egg is in fact an element of Hindu religious literature. However, this "golden embryo" (*hiranya-garbha*) plays no role in the Ramayana. It is possible to see how Redon might interpret the drawing as referencing Sita, but the connection relies on association rather than any precise textual parallels.

Another possibility is that this painting also represents the Greek version of the cosmic egg and the female divinity Sophia who interacted with it at the dawn of creation. Redon himself wrote, in reference to his design for the work, that "a title is only justified when it is vague, and even aims confusedly at the equivocal."[1] Thus Sita's interpretive multidimensionality, along with a cosmopolitan, syncretistic approach to religious imagery, makes this work an archetypal example of the symbolist philosophy precipitated into form.[2] J.D.

NOTES

1. Goldwater and Treves, *Artists on Art*, 440.
2. See also Hauptman, *Beyond the Visible*, for a selection of Redon's works.

56

Ted Shawn and Ruth St. Denis in
"The Abduction of Sita," 1918

By Lou Goodale Bigelow (American, 1884–1968)
Photograph
H. 34.9 × W. 26.7 cm
The Jerome Robbins Dance Division, The New York
Public Library for the Performing Arts, Astor, Lenox,
and Tilden Foundations, DEN_0771V

In the early part of the twentieth century, comparative
religion was in the air—and so were a number of
innovations in modern dance. Among the greatest
exponents of both were Ted Shawn and Ruth St.
Denis. For Shawn especially, dance traditions were a
spiritual tonic, restoring a healthy sense of movement
that he felt had been choked out of him by an overly
repressive Methodist background. Accordingly, the
couple created a series of dance performances based
on such biblical stories as those of Joseph and Job.
They also developed an interest in performing the
Ramayana. This photograph depicts the two dancers
in a pose from their work "The Abduction of Sita."
Their costumes are related to those seen in Thai and
Cambodian art (see cat. nos. 46 and 121). J.D.

57

Ted Shawn as Rama, Lenore Scheffer as Sita,
Charles Weidman as Ravana, and George Steares
as Hanuman in Shawn's Siamese Ballet, 1922

By Nickolas Muray (American, 1892–1965)
Photograph
H. 25 × W. 20 cm
The Jerome Robbins Dance Division, The New York
Public Library for the Performing Arts, Astor, Lenox,
and Tilden Foundations, DEN_1268V

In the 1920s, the modern dancer Charles Weidman
joined Ted Shawn and Ruth St. Denis for a summer
stint at their school. Shortly thereafter, he was hired
as a replacement dancer. Here, he appears in his mask
in the role of Ravana. Also in this photograph are
Ted Shawn as Rama, who holds a horizontal Sita in
his arms. This time, however, Sita is portrayed not by
Ruth St. Denis but by Lenore Scheffer; Shawn and
St. Denis's marriage was tempestuous, and Shawn
would eventually separate from her and establish his
own dance company.[1] J.D.

NOTE
1. For background, see Shelton, *Divine Dancer*.

56

57

58 *also p. 35 and fig. 32*

Rama, Sita, and Lakshmana prepare for exile, 1780

India; Himachal Pradesh state, former kingdom of Guler
Opaque watercolors and gold on paper
Image: H. 19.7 × W. 30.5 cm
Museum Rietberg Zurich, Collection of
Eva and Konrad Seitz, A 07

The opening conflict of the Ramayana focuses
on Queen Kaikeyi's plot to place her son Bharata
on Rama's rightful throne. This painting reveals
the results of her machinations. In an example of
continuous narration, the artist has depicted the
succession of events driven by Kaikeyi in a single
frame. However, the events must be read in a specific
order for the imagery to reveal its story.

First, at the upper right, three figures enter the
capital city of Ayodhya. The lead figure, recognizable
by his blue skin, is Rama. Sita in her red sari follows
behind, while white Lakshmana brings up the rear.

Then, toward the left of the painting, an aged figure
in pink robes sits disconsolate on a green cushion.
He is Dasharatha, father of Rama and husband to
devious Kaikeyi. Behind him in a palace room stand
four women; the one in the red robe on the far right

is Sita—and she is not going to be happy with the
next turn of events. For King Dasharatha had once
granted a boon to Kaikeyi, and now she demands
in fulfillment of her boon that the old king send his
beloved son Rama into exile. In his stead, he must
place Kaikeyi's own son Bharata on the throne.

To conform to the strictures of his promise
and thus with the principle of duty (dharma),
Dasharatha reluctantly agrees to send Rama into
exile. Accordingly, just to the right of Dasharatha,
three figures remove their royal finery and instead
put on garments of leaves. Again, the blue figure is
Rama, and his brother Lakshmana is the white figure
on the right. Between them Sita dons a leaf skirt, too;
although Rama had expected her to remain behind in
Ayodhya, Sita nonetheless insists on going with him,
in conformity with her own dharma.

In the final scene, at the far right of the painting,
Rama, Sita, and Lakshmana are fully dressed in leaf
clothing; they sit in a chariot just outside the city
gates. Surrounded by grieving crowds of well-wishers,
the three companions are about to embark on their
sojourn in the forest. J.D.

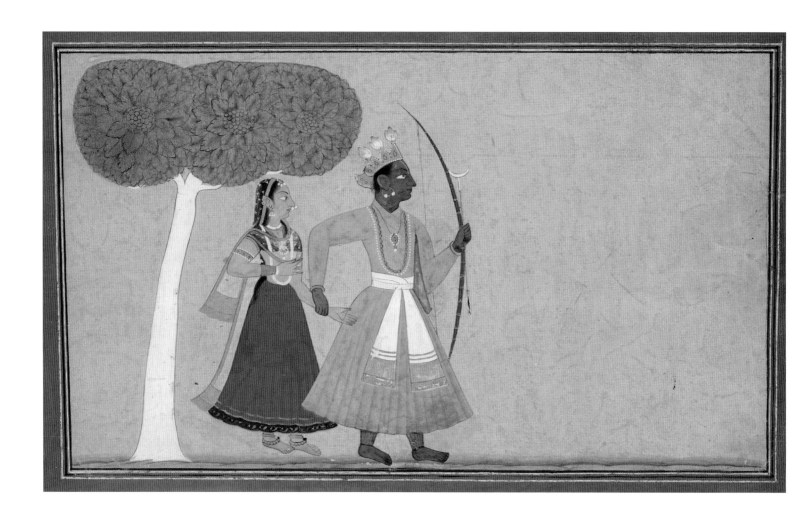

59 *also pp. 98–99 and fig. 33*

Rama's concerns for Sita, from Bhanudatta's Rasamanjari, approx. 1720

India; Jammu and Kashmir state, former kingdom of Jammu
Opaque watercolors on paper
H. 21.9 × W. 33.7 cm
Victoria and Albert Museum, London, IS.116-1960

Indian literary theorists have long analyzed the various types of lovers. To systemize them, a theoretician of aesthetics named Bhanudatta created a typology in the form of a lengthy Sanskrit poem called the Rasamanjari.

This painting uses the imagery of Rama and Sita to illustrate the type of male lover known in the Rasamanjari as the *nayaka:* the man who is devoted to one woman in the person of his spouse. Accordingly, blue Rama calmly leads his devoted spouse toward their shared future; for her part, Sita seems equally at peace with her companion. The kind of lover that Rama illustrates in these paintings is deemed to be "in conformity" (*anukula*) with the ethical principles of duty (dharma). The question of whether a given action is or is not in conformity with duty often drives the dialogue and action of the Ramayana. J.D.

60

Rama and Lakshmana converse with a sage while Sita talks to his wife, approx. 1630–1635

India; Malwa, Madhya Pradesh state
Opaque watercolors and gold on paper
H. 17.3 × W. 23 cm
Harvard Art Museums/Arthur M. Sackler Museum,
Gift in gratitude to John Coolidge, Gift of Leslie Cheek, Jr.,
Anonymous Fund in memory of Henry Berg, Louise Haskell
Daly, Alpheus Hyatt, Richard Norton Memorial Funds
and through the generosity of Albert H. Gordon and
Emily Rauh Pulitzer; formerly in the collection of Stuart
Cary Welch, Jr., 1995.69

After leaving Ayodhya, Rama, Sita, and Lakshmana travel to the confluence of the Ganges and Yamuna Rivers. Since the location proves too close to Ayodhya for real isolation, they journey onward. First they arrive at the beautiful "Painted Mountain" (*Chitra-kuta*), but their presence attracts demonic attention; Rama therefore decides to visit the figure at the center of the painting. He is the sage Atri; Rama and Lakshmana sit to his right. In the hut to the left, the sage's wife Anasuya converses with Sita. With ten thousand years of austerity behind her, Anasuya is able to recognize how Sita's spiritual merit is reflected in her devotion to her husband, for "to a woman of noble nature, her husband is the supreme deity."[1] The two find themselves in such complete agreement that, as a parting gift, Anasuya gives Sita a garland, jewelry, and a jar of beauty cream that will never run out. These gifts will prove of great value in the future, since they will allow Rama to trace Sita to Lanka. J.D.

NOTE
1. Pollock, *Ayodhyākāṇḍa*, 597–599 (109:15–25).

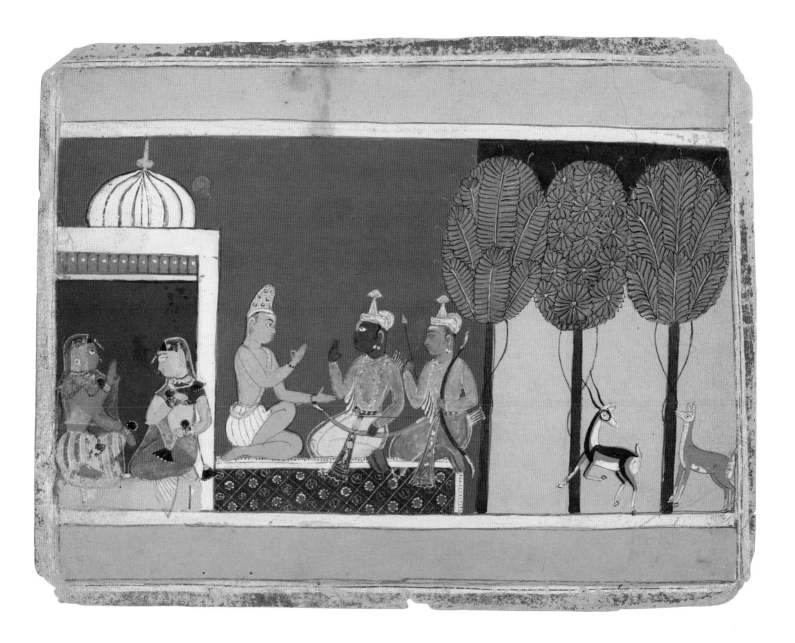

Full of lies, sexuality, magic, and foolish bravado, Ravana's abduction of Sita is at every turn a compelling story of illusion and misdirection. Small wonder, then, that it is one of the most often depicted episodes in the Ramayana.

The episode begins when the demoness Shurpanakha, the sister of Ravana, encounters Rama, Sita, and Lakshmana at their home in the forest. Impassioned by the charms of the exiled prince, Shurpanakha professes her love for Rama. He responds by mocking her and suggests that she instead pursue Lakshmana, which she does. Lakshmana expresses his own disinterest in the demon princess by cutting off her nose—along with either her ears or her breasts, depending on the tradition (see cat. nos. 20, 22).

Shurpanakha reports the violation to Ravana; at the same time, she tells her brother of Sita's incomparable beauty (cat. no. 118). At that point, Ravana determines to kidnap Sita, and to do so with the help of a magical diversion. He compels his fellow demon Maricha to transform himself into a golden deer, who lures first Rama and then Lakshmana away from the now-defenseless Sita.

Ravana then travels to Rama and Sita's home in the forest, taking his donkey-drawn sky-chariot for the journey. Once there, he transforms his appearance into that of a harmless ascetic, whom Sita is duty-bound by dharma to welcome. The demon king resumes his natural form, drags Sita into his chariot, and flies away. No trace is left of Sita but her hut.

On the way to Lanka, Ravana is accosted by the vulture king Jatayus, but the latter is unable to stop him. Rama and Lakshmana find the noble bird in his death throes, but before he dies, Jatayus names the criminal who has abducted Sita: Ravana himself. Rama will now raise the monkey army that will help him take Ravana's golden city of Lanka. J.D.

61 *also pp. 116, 212, and figs. 35, 62*

Ravana abducts Sita, approx. 1810

India; Himachal Pradesh state, former kingdom of Kangra
Ink, opaque watercolors, and gold on paper
H. 34.7 × W. 48.4 cm
Harvard Art Museums/Arthur M. Sackler Museum,
Gift of Philip Hofer, 1984.478

In this painting of the abduction of Sita, two deceptions drive the action. At the upper left, Rama draws his bow and shoots at what he thinks is a golden deer—but when Rama's arrow strikes the deer, the beast reverts to his actual, demonic form, which is visible beneath the deer. The slain deer-demon is Maricha, whom Ravana previously sent to lure Rama away from Sita. (Maricha's name translates as "mirage.") Meanwhile, Sita, worried about Rama, commands Lakshmana to look for his brother; Lakshmana can be seen searching the mountains at the upper right. To protect Sita in his absence, Lakshmana has used his arrow to draw a magical protective circle around Sita's hut; this detail is not contained in Valmiki's version of the epic but can be found in other tellings. The discrepancy reflects the multiplicity of traditions that inform artistic interpretations of key narrative episodes.

Both hut and magic circle appear at the center of this painting, which reveals the second deception upon which Ravana's success in his enterprise depends. Note the bearded sage; he is none other than Ravana in disguise, who is now, in the absence of Rama and Lakshmana, able to approach the defenseless Sita.

In response to the seeming sage's visit, Sita emerges from her hut, graciously bowing to the holy man. While the painting does not show Sita crossing Lakshmana's magic circle, she must have, for just to the right, Ravana, in his actual ten-headed, twenty-handed form, lifts Sita into his chariot to depart for his island fortress on Lanka. An additional possibility exists as to how the disguised Ravana breached the magic circle: with his ascetic's staff, which clearly appears within Sita's magic circle.

J.D.

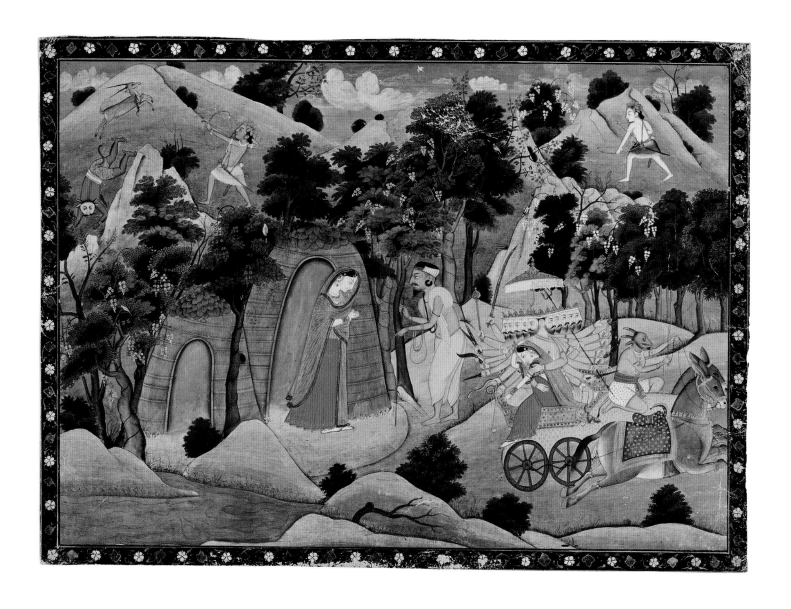

62 *also fig. 65*

The abduction of Sita, 1000–1200

Indonesia; East Java
Volcanic stone
H. 39.3 × W. 77.4 cm
Museum of Fine Arts, Boston, 67.1005

Perhaps the single most pivotal episode in the Ramayana is the abduction of Sita by Ravana. Without it, there would have been no vindication of righteous Rama, no vanquishing of wicked Ravana, no apotheosis of chaste Sita. Given its importance, it is not surprising that many Asian cultures have created imagery of the abduction. However, they have done so using their own artistic idioms. This plaque, executed in the volcanic tufa so abundant on Java, uses high relief to create a sense of perspective. It also uses recognizably Javanese architecture to suggest a division between the two phases of the episode depicted here.

In the first phase of the story, depicted at the far left, an unidentified figure sits in a forest hermitage. But in the courtyard to the immediate right, a figure who is clearly Sita is approached by a man bearing

the aspect of an ascetic—his matted hair, staff, and large begging bowl mark him as such. Sita is simply but charmingly carved, her coiffure moving in the opposite direction from her legs and belt, thus suggesting a sense of motion.

Little does Sita know what's about to happen just outside the articulated temple precincts to the right, which echo the architecture of many structures built in Java's Majapahit period. Here, Ravana has seized lithe Sita, whose head and arms swing loosely to her right, and pulled her into his flying vehicle.[1] In a depiction specific to Java, the chariot appears personified and bears a cudgel in its left hand; in India, the chariot Ravana employs to abduct Sita is usually depicted as drawn by a team of donkeys. The varying depictions of Ravana's vehicle are but one of the many ways that artists in different Asian traditions visually interpret the version of the story prevalent in each cultural milieu. J.D.

NOTE
 1. For more information on this relief, see Fontein, "Abduction of Sītā."

Sita sees the illusory golden deer and asks Rama to hunt it down.

63 *also figs. 34, 67*

Scenes of the Rama epic, approx. 1870

Myanmar (Burma)
Manuscript; opaque watercolors and gold on paper
H. 53 × W. 22 × TH. 5 CM
The British Library, Or. 14178

This accordion-folded manuscript illustrates, in a highly condensed way, episodes of a Burmese version of the Rama epic from the bow-bending contest in which Rama wins Sita's hand all the way into the siege of Ravana's capital by Rama and his forces, stopping at the moment when the monkey prince Angada is sent by Rama to persuade Ravana to return Sita and avoid a devastating war.

The pages shown here depict the stages of Sita's abduction beginning with Rama's being lured away by the illusory golden deer and moving on through Rama's returning to find Sita gone, and hearing from the dying vulture Jatayus what has become of her. Then we see the alliance of Rama with the deposed

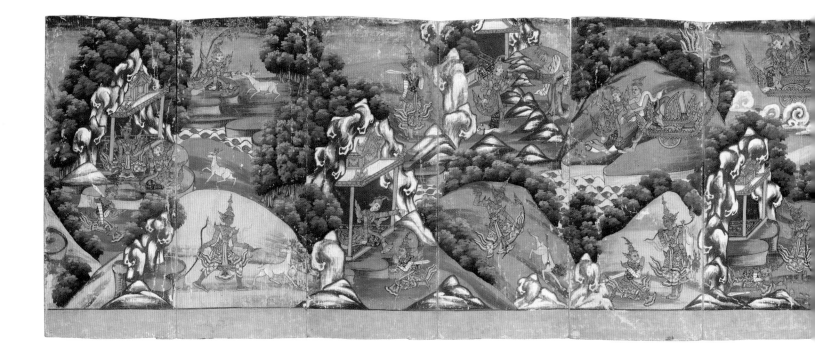

monkey king Sugriva and Rama's intervention to kill Sugriva's rival and restore Sugriva to the throne. Finally, the monkey army builds the bridge to Lanka, and Rama's forces cross over to begin the rescue of Sita.

In the enlargement, the action begins at the upper left. Here, Jatayus, the rainbow-hued king of the vultures, is locked in mortal combat with fierce green Ravana in his golden flying chariot. Just beneath, green Rama with his bow and gold Lakshmana with his sword find the now-wounded Jatayus, who has failed in his attempts to stop Ravana from carrying out his crime. Jatayus then tells an oddly circumspect Rama about Ravana's capture of Sita.

In the upper right, Ravana flies off with Sita in his chariot, which lacks the customary team of donkeys that usually appears in Indian paintings. In a tree below, the monkey king Sugriva catches the ornaments that Sita cleverly drops to mark her trail.

Moving to the bottom right, Rama lies depressively on the ground, while his still-valiant brother Lakshmana, noted as a bowman at this point in the narrative, menaces Sugriva, who sits in the trees.

In the scene at the bottom, Rama receives from the kneeling monkey Sugriva the telltale ornaments that Sita had dropped to help Rama trace her course to Lanka. The stage is now set for the divine-simian alliance that will eventually defeat the demon Ravana.[1]

The previous panel in this book depicts Ravana in the form of an ascetic, tricking Sita into trusting him. He seizes her and flies off with her in his golden chariot; on Rama's return from hunting the golden deer, he finds Sita gone.

In the subsequent panel, we see the combat of Sugriva and Valin, one of the most ethically interesting episodes in the Rama epic. J.D.

NOTE
1. Ohno, *Burmese Ramayana*, 120–123.

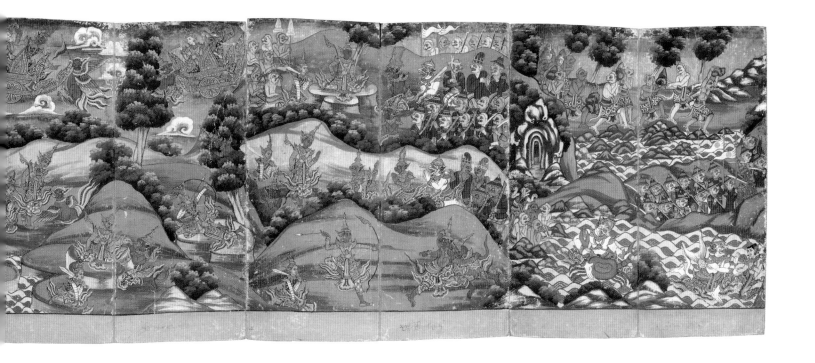

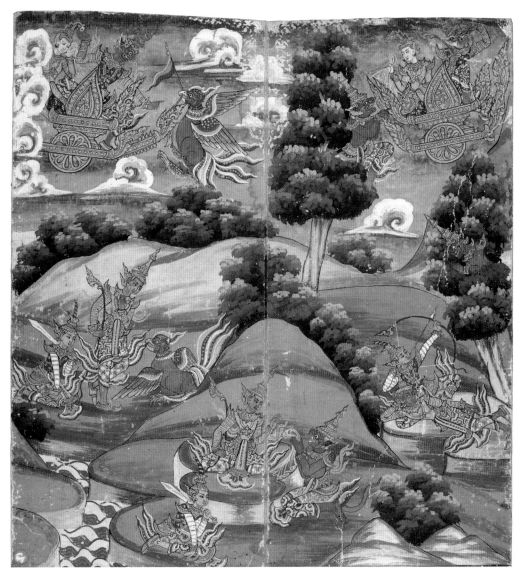

Sita is abducted; Rama encounters Jatayus and then Sugriva.

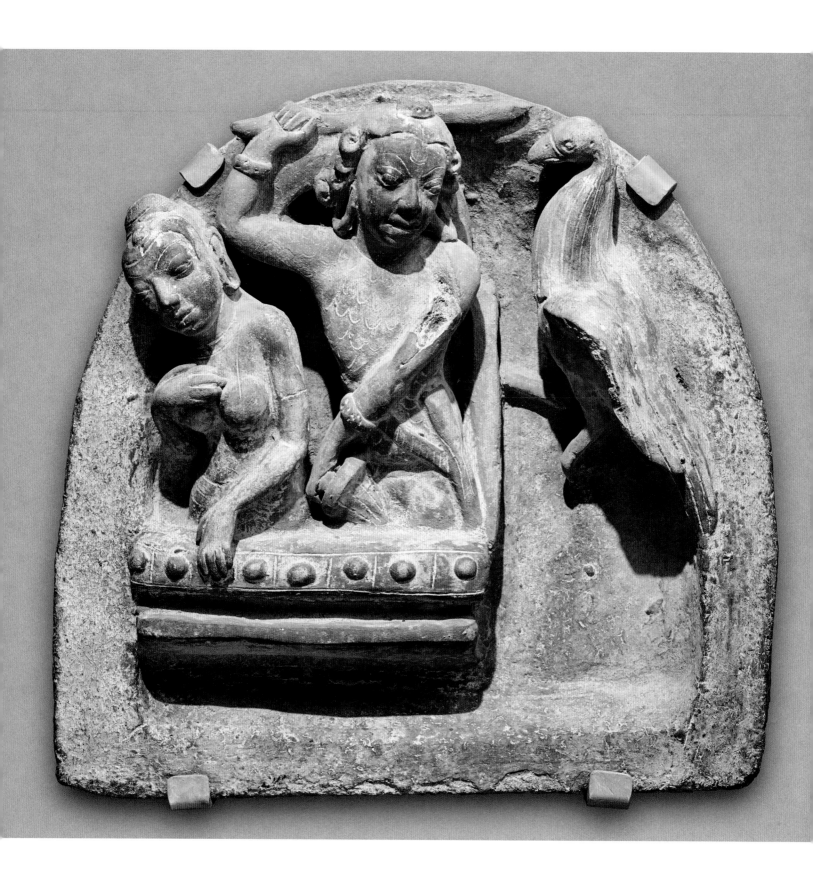

64 *also pp. 117, 212, and fig. 66*

Jatayus, the heroic king of the vultures, attempts to prevent Ravana from abducting Sita, approx. 400–500

India; probably Uttar Pradesh state
Terra-cotta
H. 38.7 × W. 41.9 × D. 7.6 cm
Asian Art Museum, Gift of the Connoisseurs' Council, 1988.40

One of the earliest artworks in the exhibition, this terra-cotta plaque depicts the scene that occurs immediately after what is arguably the most pivotal event in the Rama epic: Ravana's abduction of Sita and the subsequent attempt of the vulture king Jatayus to prevent their aerial passage to Lanka.

Interestingly, many of Ravana's supernatural attributes are absent in this fifteen-hundred-year-old relief, including his multiple heads and fierce, demonic appearance. He can be decisively identified only by context rather than by the characteristics that were later standardized in the visual arts. In this dynamic depiction of the incident, Ravana has reached across his body to unsheathe his sword. He holds it above his head ready to strike the noble vulture king, who seems about to beat his wings—albeit to little effect—against the lord of Lanka.

Underneath Ravana's sword arm, a sensitively executed Sita looks downward, her right hand to her chest as if she is in despair. Her left hand reaches toward the platform on which both she and Ravana are seated; decorated with a horizontal series of raised lozenges, it is Ravana's flying chariot, this time depicted without its customary team of donkeys.

J.D.

65

Sita is abducted by Ravana;
Rama and his brother learn of her fate
from the dying Jatayus, 1675–1700

India; Mewar, Rajasthan state
Opaque watercolors on paper
Image: H. 20 × W. 37.5 cm
Los Angeles County Museum of Art,
Gift of Paul F. Walter, M.86.345.3

The dismembered wings and multicolored feathers of
Jatayus, king of the vultures, fall in heaps at the center
of this painting. Behind his ruined form lies Ravana's
equally ruined flying chariot. Jatayus has destroyed
the magical vehicle in his combat with Ravana, but
he has failed to prevent the abduction, for Ravana
grips Sita in his arms, each of which also bears the
very weaponry that the demon king used to tear apart
Jatayus.

In the painting's final scene, Ravana flies back
to Lanka with Sita just as Rama and Lakshmana
encounter the wounded Jatayus. As he dies, the
vulture relates the grim news regarding the exiled
and now abducted queen. J.D.

66 *also fig. 69*

The abduction of Sita, approx. 1775

India
Opaque watercolors, silver, and gold on paper
H. 24.8 × W. 35.7 cm
Brooklyn Museum, Anonymous gift, 78.256.3

After Ravana departs in his magical chariot for Lanka,
he and Sita encounter the vulture king Jatayus. The
regal bird, a longtime ally of Rama's dynasty, attempts
to stop Ravana. The two begin a fierce and protracted
battle, which unfolds in several phases.

First, Jatayus destroys Ravana's weaponry and
chariot. At this point, the ten-headed, twenty-armed
Ravana seizes Sita and leaps out of his broken vehicle;
one of its donkeys appears splay-legged at the bottom
center of the painting. Jatayus then rips off Ravana's
arms, but they grow back. Ravana counters by slicing
Jatayus's wings, finally dealing the bird a mortal
wound. Victorious, Ravana resumes his journey to
Lanka with Sita in his arms.

Unbeknownst to the demon king, however, Sita
spots a group of monkeys on the ground. She bundles
her jewels in her scarf and drops them, with Ravana
none the wiser. Later, Sita's ornaments become an
important clue in Rama's search for his wife. J.D.

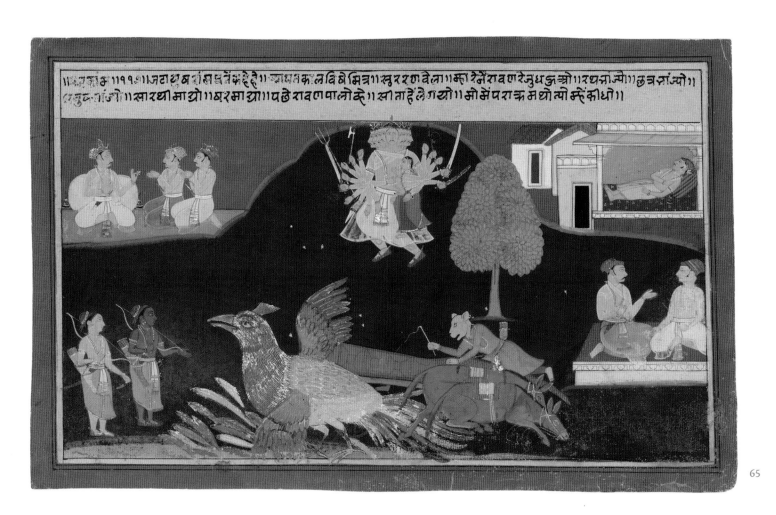

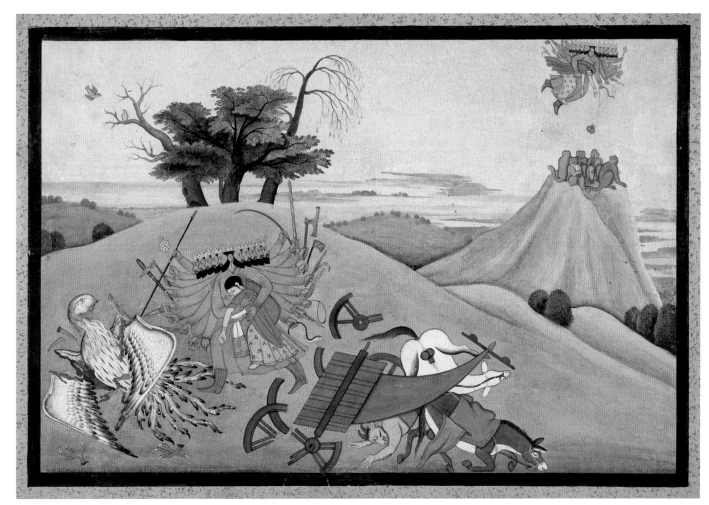

67

Ravana abducts Sita, rubbing of a nineteenth-century relief at Wat Phra Chettuphon, Bangkok, approx. 1960

Thailand
Ink on paper
Image: H. 47.5 × W. 45.7 cm
Asian Art Museum, Anonymous gift, F2015.31.1

68 *also fig. 70*

Sita rejects Ravana's advances, rubbing of a nineteenth-century relief at Wat Phra Chettuphon, Bangkok, approx. 1960

Thailand
Ink on paper
Image: H. 45.7 × W. 45.7 cm
Asian Art Museum, Anonymous gift, F2015.31.2

69 *also fig. 37*

In despair, Sita attempts to hang herself, rubbing of a nineteenth-century relief at Wat Phra Chettuphon, Bangkok, approx. 1960

Thailand
Ink on paper
Image: H. 47 × W. 47 cm
Asian Art Museum, Anonymous gift, F2015.31.3

These three rubbings of stone reliefs at a nineteenth-century Buddhist temple in Bangkok sum up Sita's situation as portrayed in a classical Thai telling of the Rama epic.[1]

In the first rubbing (cat. no. 67), the demon king Ravana, having tricked Sita into allowing him to approach her, seizes her and carries her off. Sita holds tight to the post of her hut, but she will be torn away.

The second rubbing (cat. no. 68) depicts a later scene, when Sita is being held captive in the garden of Ravana's palace. The demon king visits her and appeals to her to submit to him, but she recoils in disgust. Ravana is now the one clinging to a post.

> The heat of his desire was like the Cataclysmic Fire. . . . He smiled while he said, "You are the center of my life. As for Rama, this husband of yours, he is a poor man wandering in the forest. . . . How can he still be alive? So extinguish your love. I am inviting you, lovely one, to enter the sandalwood palace. I will keep you as chief queen."
>
> Lovely Lady Sita couldn't suppress her anger. "Why do you come and insult the Arrow-bearer,

the Summit of the World [Rama]? Your body is an evil one. Its ten heads and ten faces will be cut off. The day you stole me and brought me here you survived only because you fled."[2]

Ravana responds,

> "Beautiful lady, whom I love, even if you curse me I don't take your words seriously; don't reject my love. Queen, have mercy. Be my well-being forever."

Then Sita

> turned her face from him and looked away. She spit and said, "Oh, you wooden devil, you beg and use false words."

When Ravana leaves, Sita, forlorn and feeling abandoned, decides on suicide, as shown in the third rubbing (cat. no. 69). She is saved by Hanuman.

> She was so hurt she couldn't suppress it any longer. She lamented, "O King [Rama], I tried to protect myself and wait for you. I didn't have a chance to say good-bye. From now on, I'll be gone." She took her garment and tied her neck firmly. Then she bound it around the branch of the big *sok* tree. She closed her eyes and made her decision. Then the woman jumped down.
>
> Then the son of the wind [Hanuman, who is hiding in a tree], when he saw the woman, was shocked. When he reached her, he untied the royal garment and lowered her to the earth. He saw that she wasn't dead. He ran to her and paid obeisance at her feet.[3]

F.McG.

NOTES

1. For photos of the reliefs themselves, see Niyada, *Ramakian Bas-reliefs*, 22–23, 72–73, and 74–75.

2. All the quotations here have been shortened and slightly adapted from Bofman, *Poetics of the Ramakian*, 115–132, where the Thai texts are also given. Beautiful recitations of these and adjacent verses can be heard at a Northern Illinois University Thai literature website, http://www.seasite.niu.edu/thai/literature/ramakian/ramakian14.htm.

3. In the Valmiki Ramayana, the scene of Sita's resolving on suicide is found in Goldman and Sutherland Goldman, *Sundarakāṇḍa*, chapter 26.

67

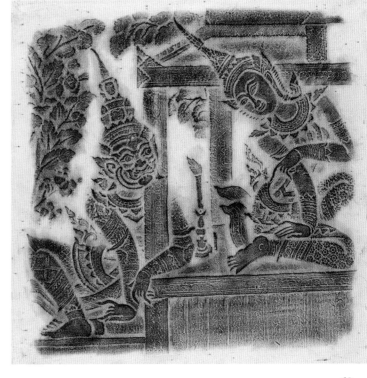

68

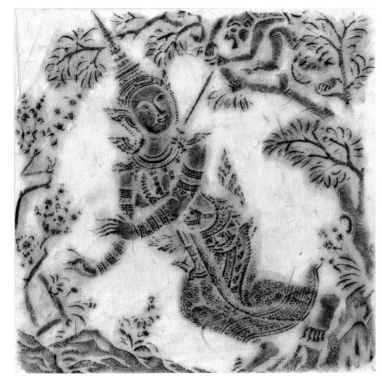

69

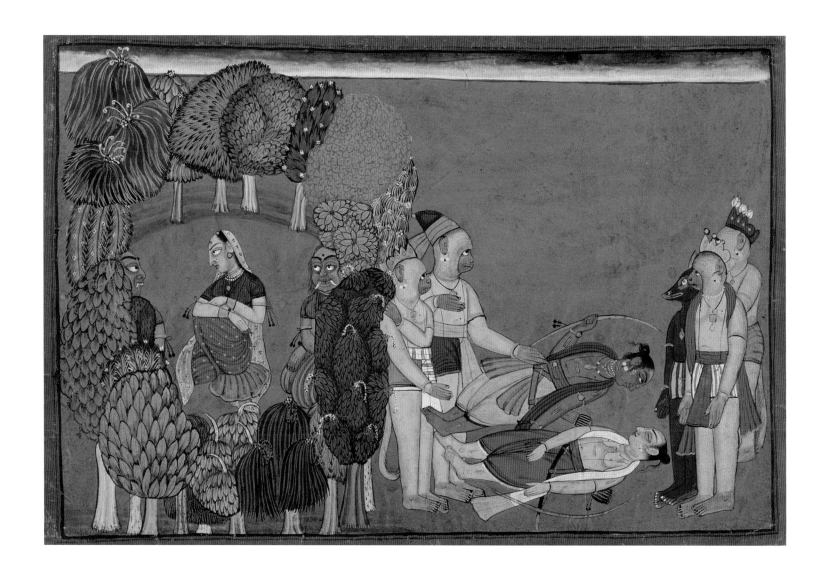

70 *also p. 100*

Sita in captivity in the ashoka grove (left);
Rama and Lakshmana stricken (right), from
the "Shangri" Ramayana, approx. 1690–1710

India; Jammu and Kashmir state,
former kingdom of Kulu or Bahu
Opaque watercolors on paper
Image: H. 19.7 × W. 29.2 cm
Los Angeles County Museum of Art,
Gift of The Walter Foundation, M.91.348.2

This painting reveals two closely connected episodes
from the Rama epic, but a key player doesn't even
appear here: Indrajit, the warrior son of Ravana.
When commanded by his father to confront Rama
and Lakshmana in battle, the demon prince Indrajit
had been confident of success, and with good reason—
he had the power of invisibility, plus three of the
deadliest weapons ever fashioned by the gods. Indeed,
although the invisible Indrajit cannot be seen here,
the results of his valor are all too evident.

On the right of the painting, Indrajit has already
dispatched Rama and Lakshmana, who lie as if slain
in the midst of a grieving group of monkeys, including
Sugriva and Angada. Indrajit has already returned to
Lanka to report his victory to Ravana. Gleeful at the
news, the demon king put Sita in his sky-chariot and
flew off to show her the prostrate brothers.

The second episode depicted here takes place
after Ravana and Sita's flight over the battlefield. This
scene, on the left side of the painting, shows Sita's
lamentations following the sight of her fallen heroes;
two fanged demons grin maliciously at Sita and her
apparent tragedy.[1] J.D.

NOTE

1. Goldman, Sutherland Goldman, and van Nooten, *Yuddhakāṇḍa*,
214–222 (36:1–38:37).

71 *also fig. 36*

Sita in captivity in the ashoka grove, approx. 1725

India; Himachal Pradesh state, former kingdom of Guler
Color and gold on paper
Image: H. 55.5 × W. 79 cm
The Cleveland Museum of Art,
Gift of George P. Bickford, 1966.143

The impregnable golden ramparts of Lanka, the island city of Ravana, rise above a silver sea filled with jumping fish. Having just defeated the vulture Jatayus and with Sita in his possession, the demon king has returned from the mainland flush with victory.

In the leftmost scene, Ravana occupies a luxurious chamber on a flooring inlaid with floral designs. From his golden throne encrusted with precious gems, he confers with his allies. These warriors can be recognized as demons (rakshasas) by their hybrid animal-human constitution and often vibrant coloration.

In the scene to the right, Ravana approaches Sita as she sits in captivity in the grove outside his palace; "at that very moment," Sita begins to "tremble like a banana plant in a gale."[1] First, Ravana tries to persuade Sita that he would be an ideal husband for her. When this approach fails to move the "afflicted and dejected"[2] Sita, Ravana resorts to bravado, going so far as to threaten to eat her.[3] When even this stratagem fails, Ravana commands his female demons to keep applying pressure to Sita; this grotesque entourage crouches behind Rama's beloved. Like their male counterparts in the palace, they are human-animal hybrids of diverse color. J.D.

NOTES
1. Goldman and Sutherland Goldman, *Sundarakāṇḍa*, 164 (17:1–2).
2. Ibid., 169 (19:1).
3. Ibid., 172 (20:9).

Sita's trial by fire, approx. 1940

By Jamini Roy (Indian, 1887–1972) or workshop
Opaque watercolors on cardboard
H. 36.9 × W. 43.8 cm
Victoria and Albert Museum, London,
Given by Mr. J. C. Irwin, IS.49-1979

This painting depicts one of the most controversial episodes from the epic: Sita's trial by fire. Suspected by Rama of infidelity, Sita has been "deeply wounded" by his accusations and has entered the fire to prove her purity.[1] Now she sits unscathed in the midst of the fire, the crackling heat emphasized by the angular execution of the tongues of flames.

Jamini Roy was one of the most important Indian modernist painters. Although his early efforts are related to European painting traditions, Roy's later and more famous works represent a decisive turn away from his early training.

Perhaps Roy's most ambitious work was a series of seventeen paintings based on key scenes from the Ramayana. The series, which begins with a depiction of the sage Valmiki, was quite popular, for Roy and his studio continued to create new versions and copies long after the original set was completed.

Here the trial by fire has been executed in the folk-inspired style that Roy developed in his more characteristic works. Vibrant colors and bold lines highlight the stylized figures. Roy's grass-roots, popularizing imagery was part of his project to discern and articulate what he conceived as basic "Indian" artistic forms, as differentiated from the European styles he learned early in life.　　　J.D.

NOTE
1. Goldman, Sutherland Goldman, and van Nooten, *Yuddhakāṇḍa*, 456–457 (104:1–19).

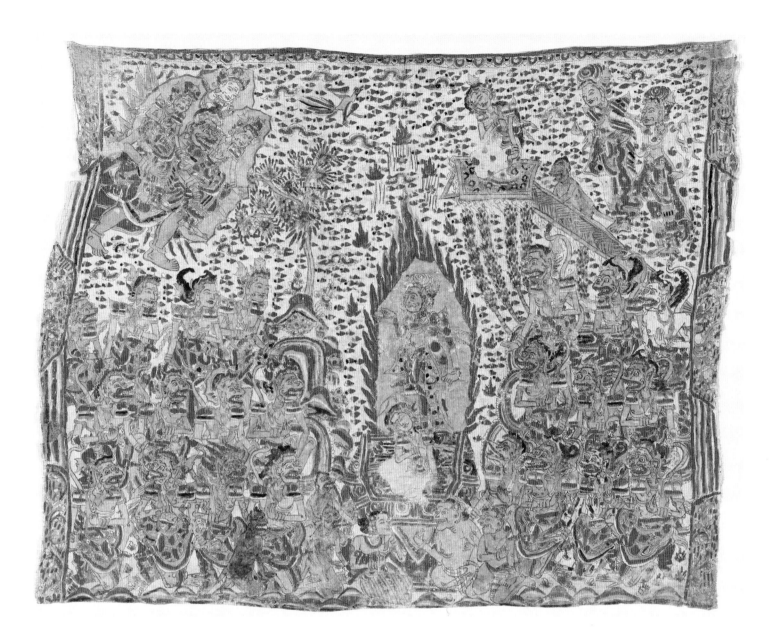

73

Sita's trial by fire, 1850–1900

Indonesia; Kamasan, Bali
Paint on cotton
H. 124.5 × W. 154.9 cm
Asian Art Museum, Gift of Mrs. B. W. Kirshenbaum, B78M1

This Balinese painting depicts Sita's trial by fire with a predominantly red-tinged palette that seems to blaze with energy. It depicts at least two moments in Sita's trial, which she demands in the face of Rama's accusations that "Ravana would not have left you unmolested."[1]

At the top right, a dejected Sita, her arm and neck tilted to the right in a gesture of helplessness, sits atop a woven platform. She has just demanded that Rama allow her to enter the fire to prove her innocence, since her "husband is not satisfied with her virtues."[2] Below the platform she appears again in almost the same posture. Around her blaze red tongues of flame as if it were a halo—yet she is not consumed. For

behind her stands Agni, the Hindu deity of fire, who has just rescued her, both proving her innocence and saving her life.[3]

An army of monkeys surrounds the scene, while a rather inconspicuous pale green Rama and his brother Lakshmana sit to the left, both apparently impassive. At the top right of the image, two sages recognizable by their spiral coiffures look on behind Sita on her platform, while a gleeful demon spouting a flame of gold and carrying three gods—each with three eyes—flies through the air to observe the events. The deity-carrying demon is an iconographic convention peculiar to Balinese imagery. J.D.

NOTES

1. Goldman, Sutherland Goldman, and van Nooten, *Yuddhakāṇḍa*, 456 (103:24).

2. Ibid., 457 (104:18).

3. Ibid., 461 (106:1).

Stringed instrument (tanpura) with Rama
and Sita enthroned, approx. 1800–1900

India; probably Gwalior, Madhya Pradesh state
Wood with ivory inlay and painted decoration
H. 93.3 × W. 23.5 × D. 17.1 cm
Asian Art Museum, Gift of David L. and Merel P. Glaubiger,
2015.68

The front of the sound chamber of this instrument is
painted with Rama enthroned on one side, attended
by Hanuman, and Sita, attended by Vibhishana, on
the other. Above them in the middle is Ganesha, and
below them stands a pair of cows of the sort usually
associated with Krishna as cowherd.

The back is painted with a famous scene of Krishna
dancing with the young cowherd women, the *rasalila*.
In the story, Krishna has gone out into the forest at
night and is playing his flute. Hearing the alluring
sound, the young women of the village leave their
homes to find Krishna and join him in dance. To
prevent any of the women from being disappointed,
Krishna multiplies himself so that each may have
him as a partner. Here, on either side of the circle of
dancers, stand Shiva and Brahma.

Exactly why these scenes and figures are shown
together on a musical instrument is not known.
In the nineteenth and twentieth centuries, it was
not uncommon for scenes and characters of Hindu
mythology to be depicted on luxurious utilitarian
objects ranging from silver teapots to sandalwood
stationery boxes.

Instruments of this type typically had four or five
strings and provided a drone accompaniment rather
than playing a melody. Tanpuras come in various
sizes. This one is of the smaller so-called female

type. The elaborate painting on this tanpura is well
preserved, and the lack of signs of wear suggests the
instrument was seldom played.

A related tanpura with quite similar painting is
in the collection of the Victoria and Albert Museum,
London (IM.238-1922). The Asian Art Museum's
instrument was missing its bridge, strings, and tuning
pegs. These components have been replicated on the
model of those on the V&A instrument. F.McG.

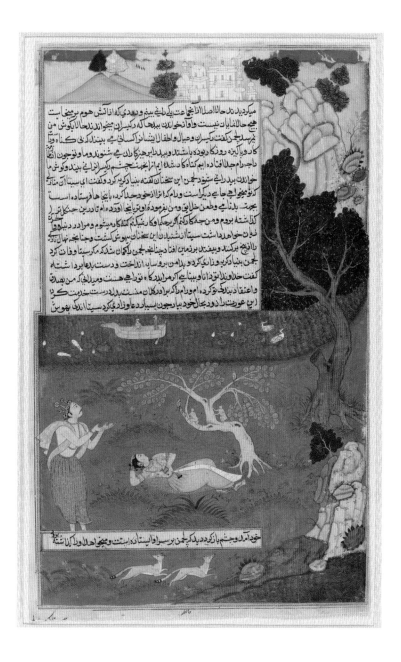

75 *also p. 117*

Sita faints after being told that she is to be exiled and abandoned, from an illustrated manuscript of the Razmnama, approx. 1616

Attributed to Fazl (Indian)
Ink, opaque watercolors, and gold on paper
H. 38.5 × W. 23.5 cm
Harvard Art Museums/Arthur M. Sackler Museum,
The Stuart Cary Welch Collection, Gift of Edith I. Welch
in memory of Stuart Cary Welch, 2009.202.250

A scene of utter desolation dominates this Mughal painting. On the ground beneath a monkey-filled tree lies yellow-robed Sita, her hand to her head. She has fainted at the news Lakshmana, wearing a red outfit and royal crown, has just delivered: Rama has decided to abandon her so as to thwart suspicion that she had been intimate with Ravana during her captivity. Above them, a boat sails on the Ganges, while Ayodhya, from which they recently departed, is visible at the top center.

The Persian text in the center clarifies the dire nature of the situation—Sita faints in despair, and Lakshmana cries in sympathy, protesting his loyalty to the unfairly accused queen. Now she will again have to spend many years exiled to the forest. This time, however, she is pregnant; during this period of exile, Sita will reside with Valmiki, raising Rama's sons Lava and Kusha as a single parent.

This painting comes from the Razmnama, or "Book of War," the Persian-language translation of India's other great epic, the Mahabharata. Commissioned by the ecumenically minded emperor Akbar, the translation includes an abbreviated version of the Ramayana.[1]

J.D.

NOTE

1. Thanks to Qamar Adamjee for reading the inscription and discussing it with me. Seyller, "Model and Copy," 64.

Scenes from the story of Sita in the last book of the Ramayana, 1981

By Shashi Kala Devi (Indian)
Ink and colors on paper
H. 151.4 × W. 153 cm
Asian Art Museum, Museum purchase, 1999.39.50

The unfolding lotus is one of the richest and most psychologically powerful symbols in Asian thought. In this painting, episodes from the last book of the Ramayana, the Uttarakanda, are depicted from above, in a kind of bird's-eye perspective that allows the unfolding lotus to function as a tableau in which multiple moments in linear narrative time appear simultaneously in artistic space. It tells the story of Rama's abandonment of Sita and her subsequent vindication, one of the most ethically problematic episodes in the Ramayana. The accompanying diagram identifies each sector of the lotus by corresponding number.

1. The center of the lotus encloses a front-facing, beaming Rama; he is one of only three figures presented frontally rather than in profile. Rama and Sita's greatest exponents are here, too; Hanuman with his simian characteristics kneels, while to Rama's right is Lakshmana, who (like Rama) carries his customary bow over his shoulder. Note that the square at the top right of the frame contains the number "one" in Indian script, indicating that the story depicted in the painting begins here. But there will be no happy ending, for gossip regarding Sita's suspected infidelity will soon reach Rama's ears. Bowing to pressure, Rama will banish Sita; instead of attending to this matter himself, Rama appoints his brother Lakshmana to abandon Sita in the wilderness.

2. The result is the episode seen in lotus frame 2, just to the left of the central circle; here, Lakshmana invites Sita on an excursion.

3. Sita follows Lakshmana into the wilderness.

4. After Lakshmana tells her that she is to be exiled, Sita faints.

5. Sita meets the sage Valmiki at his hermitage.

6. Sita has given birth to Lava, the small figure who sits on her carpet just to the right; Valmiki sits slightly behind them.

7. Sita teaches Lava and Kusha the bow.

8. Lava and Kusha wander in the forest.

9. Lava and Kusha engage Rama's warriors in battle; two figures lie on the ground amid spent arrows.

10. Hanuman is bound by Lava or Kusha as the other brother looks on.

11. Lava and Kusha are greeted by Sita.

12. The sage Valmiki brings Lava and Kusha to Rama's horse sacrifice.

13. In the bottom register, Valmiki has just vouched again for Sita, but Rama insists on a further oath. This time, Sita sits face-forward, just as Rama does in the central lotus. To her left, Rama—followed by Lakshmana and Hanuman—raises a hand to his face in astonishment. To her right, Lava and Kusha follow Valmiki. Between them, Sita smiles as she sinks into the earth, vindicated.

14. Shiva

15. Brahma

16. Vishnu

17. Valmiki

J.D.

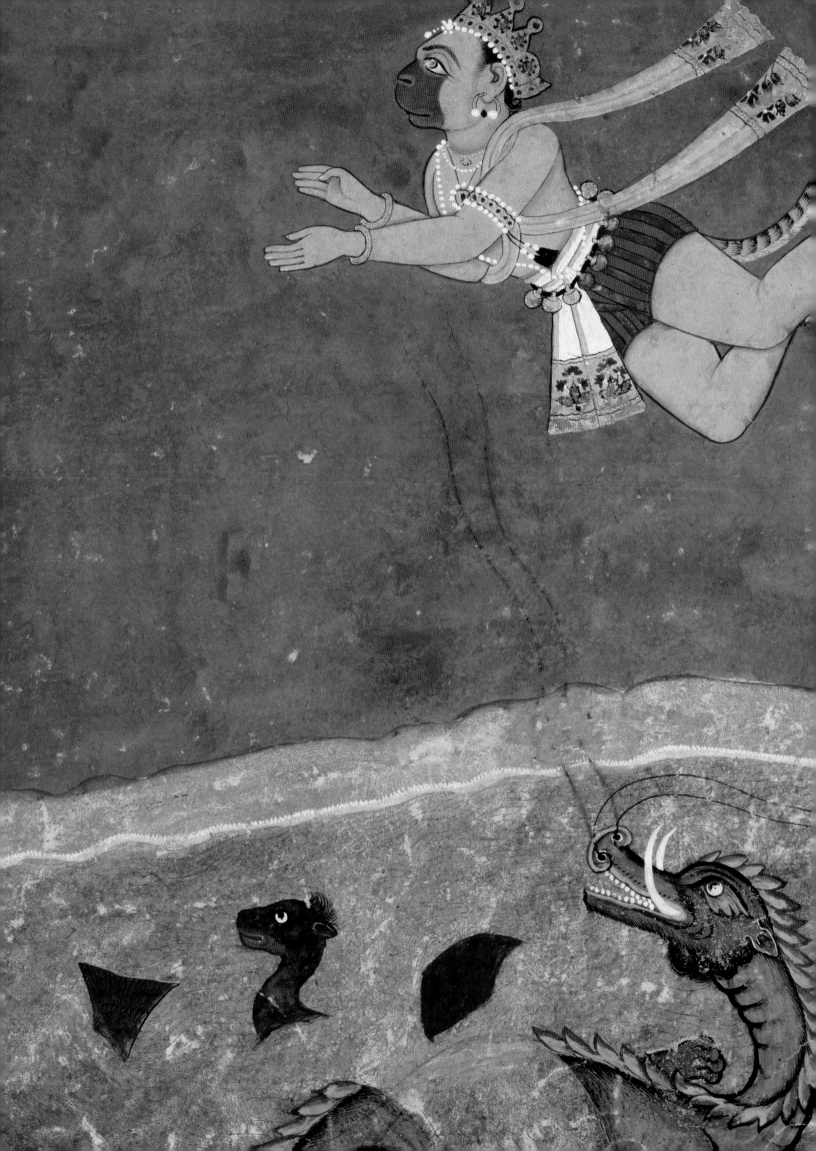

HANUMAN

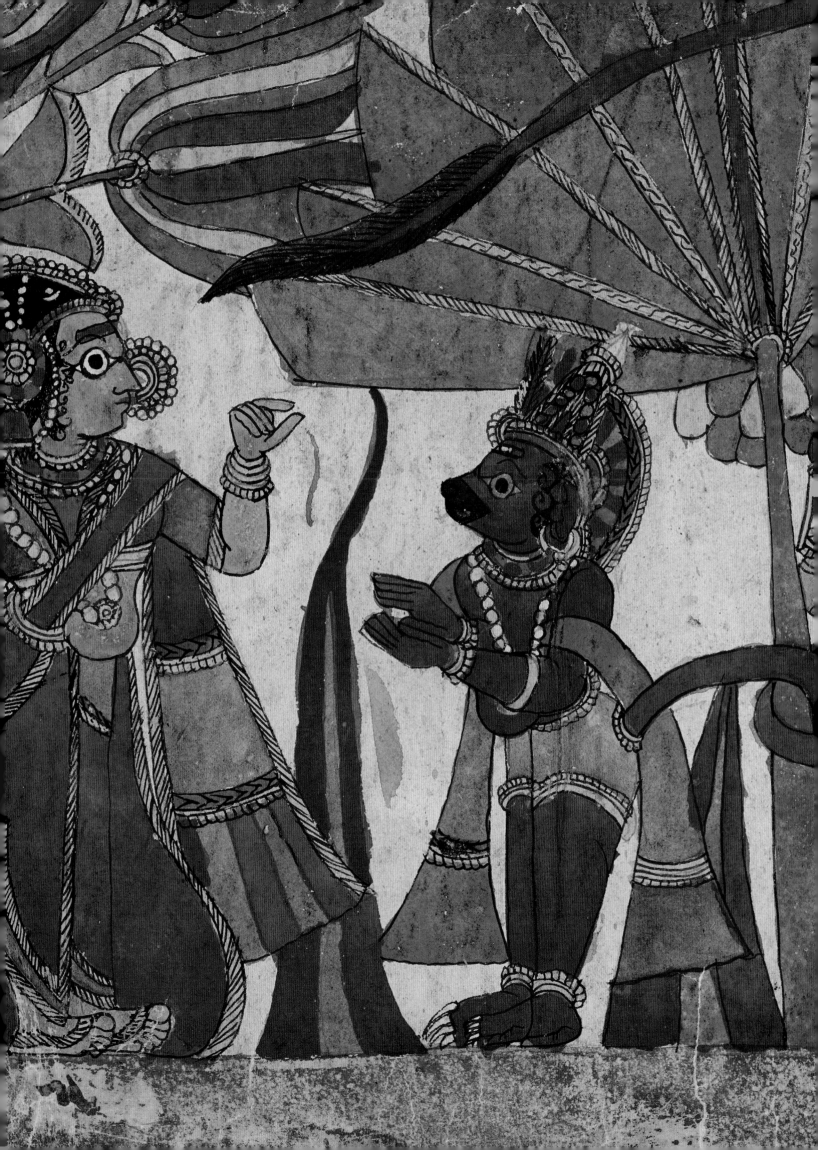

Ally, Devotee, and Friend

Without a doubt, Hanuman is Rama's most important ally in his quest to recover Sita, his kidnapped wife. Born in a forest-dwelling race of monkeys (*vanaras* in Sanskrit) with supernatural powers, including that of human speech, Hanuman becomes allied with Rama when the monkeys' once and future king, Sugriva, seals a pact of friendship with the human hero. But Hanuman's role goes far beyond the welcome assistance he so often provides. If one surveys the myriad stories—written, oral, and visually and dramatically performed—that collectively comprise the great Ramayana epic of South and Southeast Asia, one may easily conclude that Hanuman is their most universally beloved character. Unblemished by the lapses of judgment and ethical choice that even devoted audiences sometimes impute to the saga's hero Rama and heroine Sita, or by the deep but fascinating flaws that mar the character of their demonic foe Ravana, Hanuman leaps—often literally—from the pages and picturings of the Rama epic as an exemplary figure of exuberant energy tempered by profound humility and devotion (fig. 44). Known by many epithets, of which the several most common mean "son of the wind," this shape-shifting monkey with a penchant for expanding his powerful body comes to tower like a superhero over the

FACING
Detail of cat. no. 91

FIG. 44. Hanuman (cat. no. 85).

ranks of faithful simians and bears who, through the alliance made by Sugriva, constitute Rama's unlikely yet ultimately triumphant army.[1]

In one telling battle scene found in Valmiki's Sanskrit epic, the magical serpent-weapon of Ravana's son Indrajit has mortally wounded Rama, his brother Lakshmana, and the better part of their vast army of "six hundred and seventy million swift monkeys," who all lie unconscious and seemingly beyond rescue on the nighttime battlefield. Wandering with torches in hand through this scene of carnage and despair, Hanuman and Ravana's brother Vibhishana, who are miraculously uninjured, come upon an aged general named Jambavan, the king of the bears and a character renowned for his wisdom. When Vibhishana hails him, the old warrior, who has been temporarily blinded by the serpent venom, immediately poses a single question:

> O *rākṣasa,* son of chaos, does the foremost of the monkeys Hanumān . . . still live?

Vibhishana is taken aback; why doesn't the great bear first inquire about Rama, or even Lakshmana or the monkey king Sugriva? Vibhishana frankly poses this question, and Jambavan gives an equally frank reply:

> So long as Hanumān is alive, then our army will survive, even if it should be massacred. But if that hero has lost his life, then, even though we survive, we are as good as dead.[2]

Hanuman soon confirms Jambavan's wisdom by undertaking an extraordinary mission: leaping to the high Himalayas and bringing back a mountain peak covered with medicinal herbs that reinvigorate the human brothers and their entire army. This triumphant feat (which, in Valmiki's version, he will repeat twenty-eight chapters later when Lakshmana is mortally wounded by Ravana, and Rama himself becomes desperate with grief for his fallen brother) forms the subject of one of his most popular and ubiquitous icons, both in sculpture and in painting: the mighty monkey poised to take off into the sky (or flying through it), with his mace in one hand and with the peak of a mountain resting, seemingly without strain, on his other, outstretched palm (fig. 45). In such scenes, Hanuman manifests his incredible power—in Sanskrit, *shakti,* a feminine word that connotes the very life-energy of the cosmos.

Yet Hanuman's appeal does not rest merely on his

FIG. 45. Hanuman carrying the mountaintop. Popular print.

bravery and heroic deeds on the battlefield; as Rama's messenger to Sita during her imprisonment in Lanka, Ravana's island fortress, he is an embodiment of heartfelt compassion and solicitude. Finding the princess at her emotional nadir and resolved to commit suicide, Hanuman first cheers her with a recounting of Rama's life story—becoming one of the first narrators of the Ramayana, another of his celebrated roles—and then thrills her with the presentation of Rama's signet ring, in a Valmikian verse so portentous that traditional commentators have identified it as the very "seed" and heart of the entire epic: the moment when its hero and heroine's fortunes take a decisive turn for the better.

> Taking her husband's ring and examining it, Jānakī [Sita, daughter of King Janaka] was as joyous as if she had rejoined her husband.[3]

Sita will soon hail and bless Hanuman as her "son," and in Hindu India, his self-effacing and filial service to her and to her husband—further inspired by his recognition of them as supreme God and Goddess—is regarded as an epitome of *bhakti:* the cherished religious stance of loving "devotion" to an often personal god. Embodying both *shakti* and *bhakti*—nicely, they rhyme—Hanuman emerges, in Robert Goldman and

Sally Sutherland Goldman's words, as "a kind of normative ego-ideal for South Asian society that is perhaps more compelling than even that of his omnipotent master."[4] Indeed, Hanuman's primacy for devotees was already recognized by the great sixteenth-century poet-saint Tulsidas, author of the beloved Hindi epic of Rama, *Ramcaritmanas* ("sacred lake of Rama's noble deeds"), who, in one of the poem's final passages, has one of his narrators declare:

> My heart, lord, holds this conviction: greater than Rama is Rama's servant.[5]

In contemporary India, this conviction gives Hanuman a perhaps unequaled status as a divine messenger, intercessor, and middle man in the cosmic hierarchy; he is a go-to god for all occasions and for every strata of society. This is confirmed by the multitude of shrines and temples to him, great and small, that have proliferated in recent centuries, sponsored by such diverse patrons as sadhus, wrestlers, students, housewives, merchants, and politicians. An elderly and learned Ramayana scholar in Banaras once remarked to me, "There are so many more temples to Hanuman than to Rama!" His observation was both visibly and statistically correct, for worshipers evidently find the divine monkey more readily approachable than his master. Since many of them regard him not just as the doorkeeper and right-hand man of an incarnation of Vishnu, preserver of the universe, but also as an avatara or incarnation of Shiva, another deity hailed as both destroyer and creator of the world and known as much for his generous and easygoing disposition as for his awesome power, Hanuman appeals to worshipers inclined toward two of the dominant streams—Vaishnava and Shaiva—in contemporary Hindu practice. His icons are found in tiny street-corner or wayside shrines sheltering roughly carved images coated with *sindur,* an auspicious lacquer made of oil and vermilion, as well as in formal temples that in recent years have grown in scale. Their icons, too, have grown, especially during the last decades of the twentieth century, to include numerous colossi that tower imposingly over the Indian landscape—and beyond it, for a twenty-six-meter-high Hanuman now stands in the village of Carapichaima in Trinidad (figs. 46 and 47). Hindus who came to that island as indentured laborers in the nineteenth century brought the Tulsidas Rama epic as their chief scripture and, like Sita, found Hanuman to be a messenger of hope and courage in their "captivity" in an initially alien land.[6]

FIG. 46 (*top*). Colossal Hanuman, Delhi.

FIG. 47 (*above*). Colossal Hanuman, Carapichaima, Trinidad.

FIG. 48. Hanuman carrying a lady, perhaps Benyakai (detail of cat. no. 101).

In Southeast Asia, too, Hanuman enjoys a special popularity in the literary renditions and performances of the Rama cycle, whether as the "white monkey" of the royal Khmer dance-drama or the mischievous and indeed licentious Hanuman so beloved in Thai art and legend. Freed, in this Buddhist cultural context, from the constraints of celibacy that Hindu ideology came to impose on most Indian literary representations of Hanuman, the Thai monkey hero is a veritable Don Juan, who supplements his feats of espionage and warfare with multiple seductions in the service of Rama's cause, enjoying himself thoroughly in the process—as when he romances Benyakai, Ravana's niece, who was sent on a secret mission to weaken Rama's resolve to fight (fig. 48).

The Biography of Hanuman

Hanuman's common epithets meaning "son of the wind" immediately identify him as a "second-generation" deity—one who has a father (and a mother, too, for he is also the "son of Anjani," a celestial nymph cursed to live on earth in a simian body) and who takes birth at a specific time to fulfill a mission.[7] Since he enters the Rama narrative as an adult monkey—the faithful lieutenant and minister of the deposed king Sugriva—early epic audiences may have clamored to know more of his background. This is already reflected in the Sanskrit Ramayana of Valmiki by two accounts, one short and one much longer, of his birth and early life.[8] And since Hanuman is (repeatedly) blessed with the boon of physical immortality and ultimately charged by Rama to remain in this world for as long as his own story endures, Hanuman's life goes on and on.[9] Revered as one of the seven or eight "immortals" of Hindu mythology (literally "long-lived ones," since even gods have allotted life spans, though these may be *very* long), he is believed to be physically present, albeit perhaps in disguise or invisible, whenever the Rama tale is recounted. Equally important, he often appears in response to the needs or prayers of devotees, and such miraculous interventions form the basis for a great number of tales that carry Hanuman down through the ages, from the Treta Yuga (the second age of a cosmic time cycle, in which the Rama avatara occurs) to the present Kali Yuga—our dark era of individual moral decay and societal discord. In recent decades, such stories have coalesced into an impressively large cycle of tales presented in published anthologies, a Hindi epic poem, and even two reputed "autobiographies," as well as an animated film and a television serial, that I have collectively (and only a bit playfully) dubbed the Hanumayana.[10] Even though it contains much of the Rama story as its kernel, this epic cycle expands beyond it on either temporal end with lively tales that cast Hanuman as their main character—a narrative expansion that mirrors the physical growth of his icons in public space. Although some of these adventures are rarely depicted in visual media, a few of the best-known stories indicate the immense popularity of Rama's most important ally (fig. 49).

Hanuman's birth story—in which he is conceived by his mother after she has been secretly "embraced" by the Vedic wind god Vayu—occurs twice in the Valmiki epic, with minor variations. But in the later Sanskrit Puranas and regional-language Ramayanas

it grows into a profusion of tales in which Anjani is variously impregnated by the seed of Vayu or Shiva; in one significant variant, she conceives from a morsel of the miraculous rice-sweet produced from King Dasharatha's sacrificial fire in Ayodhya, by means of which Rama and his three brothers are likewise produced, thus making Hanuman a half-sibling to his adored master. But some tellers wanted their relationship to be even closer, and in one Malay variant Hanuman is born from the love-play of Sita and Rama, who have been temporarily changed into monkeys by bathing in an enchanted forest pool.[11] The popular Hindi-language texts in my collection of Hanuman lore rarely seem troubled by the multiplicity of his birth stories, and some even celebrate them (one book includes six, calling them simply "various causes of the Hanuman avatara"[12]); clearly, each divine father and mother contributes important "genetic material" to this wonderful protean being.

Hanuman's first great adventure occurs soon after his birth and is equally celebrated: his attempt, when left alone as a hungry infant, to leap into the heavens and devour the rising sun, which he mistakes for a ripe, red fruit (fig. 50).

When the sun god calls for help in fending off the voracious infant, Indra, king of the gods in the Vedic pantheon, assaults the baby with his thunderbolt, stunning, wounding, or even killing him (in various versions) and causing him to fall to earth, his jaw permanently disfigured—this is often said to explain his unusual Sanskrit name, which seems to connote "one with a [prominent or unusual] jaw" (*hanu*). But Hanuman soon gets the better of Indra and his cohorts, as he will of any later adversary foolhardy enough to take him on. When the wind, mourning for his stricken son, goes on a sympathy-strike, the whole cosmos, gods included, begins to suffocate, and the celestial powers are compelled to heal or revive the infant, after which they gift him with boons that make him yet more powerful as well as virtually immortal.

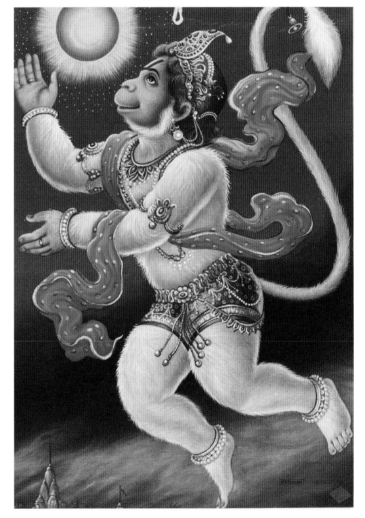

FIG. 49 (*above left*). Hanuman, with episodes of his life. Popular print.

FIG. 50 (*above right*). The infant Hanuman reaching for the sun to devour it. Popular print.

When demonic beings like Ravana get such boons, they go on a rampage of universal conquest, and Hanuman (who throughout his biography, with his shapeshifting, awesome destructive capabilities, and immense appetites, displays more than a little resemblance to Rama's demonic adversaries) soon grows into an unruly monkey youth whose depredations and pranks in the forest ashrams of sages finally make them curse him to forget his own strength until he is reminded of it by another. Thus the sages buy themselves a bit of peace; Jambavan is prompted for the pep talk with which, later in the saga, he will launch Hanuman's leap to Lanka; and latter-day devotees gain assurance that their own prayers, conveyed through such texts as the very popular "Forty verses to Hanuman" (*Hanuman chalisa*, attributed to Tulsidas), will be able to awaken the great monkey's dormant powers. Absent from Valmiki, but much cherished by modern devotees, are further anecdotes of Hanuman as an adorable monkey-child, including the tale of his accompanying Shiva (of whom he is a "portion," or *amsha*) to Ayodhya to adore, Magi-like, the toddler Rama. Shiva is disguised as an itinerant entertainer and Hanuman is his dancing monkey, whose antics so delight the little prince that he asks King Dasharatha to buy him as a pet—thus granting Hanuman a long stay at his Lord's side.[13]

No such intimacy precedes Hanuman's first meeting with Rama and Lakshmana in the standard Valmiki narrative, wherein a nervous Sugriva, hiding from his angry brother Valin on a hilltop, sends Hanuman to find out who the two bow-bearing young passersby may be. Yet this first encounter is likewise specially charged: disguised as a young Brahman student, Hanuman charms Rama with his flawless diction (a trait that would endear him to Sanskrit grammarians and rhetoricians and eventually inspire a book, *The Monkey Grammarian,* by Mexican Nobel Prize–winner Octavio Paz). Realizing that the princes pose no danger (and, in many later versions, overwhelmed by his recognition of Rama's divinity), Hanuman reveals his true form and carries the brothers on his back to Sugriva's hiding place, where Rama and Sugriva, man and monkey, swear a pact of friendship before a sacred fire.

Hanuman plays little role in the controversial event that follows—Rama's assassination of Valin from a place of hiding—but he soon counsels the re-enthroned Sugriva, who has become drunk and debauched after returning to power, to fulfill his promise to Rama to launch an all-out search for Sita. When teams of monkeys and bears at last set out in the four directions, Rama summons Hanuman, who is to accompany the southbound party, and gives him his own signet ring as a token of recognition, again signaling Rama's special relationship to Hanuman and prefiguring the latter's successful mission.

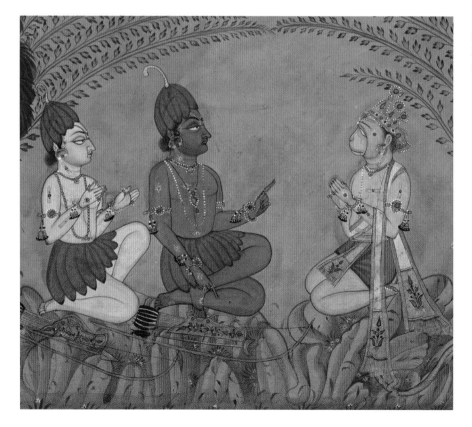

FIG. 51. Hanuman with Rama and Lakshmana (detail of cat. no. 86).

FIG. 52. Hanuman leaps across the ocean (detail of cat. no. 93).

As Valmiki's fourth book of the Ramayana, the Kishkindhakanda, ends, the search party stands disconsolate on the shore of the southern ocean, gazing at its vast expanse and pondering who among them has the power to leap across it to Lanka. As already noted, the wise bear Jambavan awakens Hanuman's latent powers, leading to the transformation with which the fifth book, the Sundarakanda, will open.

And what an opening! In the introduction to their translation, Robert Goldman and Sally Sutherland Goldman describe the book's first chapter—which, at 190 couplets, is the single longest in Valmiki's entire poem—as "a sort of epic within an epic and a kind of epiphany of Hanumān . . . to the status of a divinity."[14] In it, Hanuman, having climbed a coastal mountain, grows to colossal size and crouches in preparation for his leap, pulverizing the mountain and ter-

rifying its many denizens. When he finally takes off with the propulsive thrust of a multistage rocket, the poet presents a Cinemascope sequence that is heavy on special effects:

> So great was his speed that as he leapt up, the
> trees that grew on the mountain flew up after
> him on every side with all their branches
> pressed flat. . . .
>
> Drawn powerfully upward by the force of
> his haunches, the trees followed the monkey for
> a while, just as people follow a kinsman who is
> setting out on a long journey. . . .
>
> The largest of the trees soon plunged into the
> salt sea, just as the mountains themselves had once
> plunged into the ocean, the abode of Varuṇa, in
> their fear of Great Indra. . . .

And as he followed the path of the wind, his eyes, shining like lightning, blazed brightly like twin fires on a mountain.

The great, round, yellow eyes of that foremost of yellow-eyed monkeys blazed like the moon and the sun. . . .

With his white fangs and encircling tail, the great and wise son of the wind god looked like a haloed sun.[15]

Beyond its first chapter, the whole fifth book feels like a mini-epic that recapitulates the greater Ramayana's heroic quest and romance, but with the role of hero shifted from Rama (who is offstage for nearly the whole of it) to Hanuman, whose complexity and appeal as a character are now fully displayed. His encounters with a series of menacing female figures when he is en

route to Lanka have received a wide range of interpretations—for example, as a mystical allegory of initiatory trials along the spiritual path, or as a psychoanalytic study of a boy-child's response to the threatening sexuality of a "bad mother."[16] After tricking Surasa, the "mother of snakes" sent by the gods to test him, by swelling and then quickly shrinking his body to avoid her devouring maw, Hanuman lets himself be swallowed by the monstrous Simhika, a marine she-demon, only to slay her by bursting forth from her belly (fig. 53).

His most extended interaction is with Lankini, the demonic female gatekeeper of Ravana's city of Lanka, who is often considered to embody its bloodthirsty patron goddess. Ramayana tellers themselves offer a range of interpretations of Hanuman's triumph over her, after she announces that her charge is to devour

FIG. 53. Hanuman encounters a demoness (detail of cat. no. 89).

any intruder to the city. Commonly, he knocks her unconscious, and when she comes to, she is transformed, as in Tulsidas's text of approximately 1574 CE:

> The great monkey hit her with one punch
> that sent her sprawling and spitting blood.
> But when she recovered a little and arose,
> Lankini joined her palms and addressed him
> in awe:
> "Back when Brahma gave the boon to Ravana,
> the creator told me, as he departed, of a portent—
> 'When a monkey's blow renders you senseless,
> know it to signal the night-stalkers' doom.'
> Now, son, I realize my great fortune—
> seeing with my own eyes the emissary of Rama."[17]

Extolling the glory of Rama and the merits of holy companionship (for in Tulsidas's view, even demons can become pious devotees), Lankini then blesses Hanuman to fulfill his mission. Other lore maintains that she soon abandons her post and city, spelling Ravana's doom (and permitting Hanuman's later incendiary attack); in some accounts, she then takes up residence elsewhere—for example, in the Kashmir valley, where she is said to be enshrined in a temple and where Hanuman serves (as he does at many other goddess sites) as her faithful bodyguard and doorkeeper.[18] But Jain storytellers would have none of this: their Hanuman—a princely demigod who bears a heraldic monkey on his shield and who is an incarnation of Kamadeva, the Indian Eros—slays the (male) gatekeeper of Lanka and then enjoys a one-night stand with his voluptuous daughter. Such seduction is also how the "white monkey" tames Lanka's female guardian in many Southeast Asian narratives, which may have been influenced by Jain tales popular in port cities of southern India as well as by indigenous folklore about simian sexuality.

Hanuman's nocturnal reconnaissance of Lanka, in tiny size, offers a voyeuristic peep into the cruel but luxurious lifestyle of its urbane rakshasas and especially of their king, whom Hanuman finds asleep, post-orgy, on an enormous bed surrounded by his vast harem. Momentarily supposing a beautiful woman, asleep on a bed nearby, to be Sita, Hanuman (in Valmiki's words) "clapped his upper arms and kissed his tail. He rejoiced, he frolicked, he sang, he capered about. He bounded up the columns and leapt back to the ground, all the while clearly showing his monkey nature."[19] But Valmiki's *vanara* is also sagacious and reflective; he soon concludes that Sita would never stoop to this

state, and his quest continues. It ends in the ashoka grove, where he finds the beautiful woman, now pale and emaciated, imprisoned, and where, concealed in a tree, he witnesses Ravana's vain efforts early the next morning to win so much as a glance from her.

The scene that follows, which includes the crucial turning point of Hanuman's presentation of Rama's ring, is one of the emotional highlights of the epic. In his role as messenger, Hanuman repeats the most tender speech that we ever find attributed in the Sanskrit Ramayana to its hero (though, in fact, we never actually witnessed Rama communicating it to the monkey), and Sita drinks it in, receiving new hope. She also presents Hanuman with an ornament of her own to take back to her husband and in some accounts blesses him with immortality and freedom from disease (p. 146). His main mission complete, Hanuman then decides to undertake another: to assay the strength of Ravana's forces and of Ravana himself. He does this by trashing the king's pleasure park in a hyperbolic vision of simian depredations (while, in some accounts, appeasing his hunger with its choice fruit). He easily annihilates its guards and, later, a legion of troops led by one of Ravana's sons. Only when the king's eldest son, Indrajit, attempts to bind him with the weapon of Brahma (to which Hanuman is, in fact, immune thanks to the childhood boon he received from that god) does he allow himself to be dragged before the throne. He is quickly sentenced to death, but when gentle Vibhishana reminds his elder brother that emissaries can only be mutilated and not killed, the sentence is changed to having his cherished and luxuriant tail set on fire. When this is done, the resourceful Hanuman again shrinks and grows, freeing himself from his bonds and turning his apparent misfortune into an aerial attack on Ravana's golden city. The burning of Lanka—another special-effects extravaganza—became a celebrated set piece in visual and performance art. The subject of one of Indian cinema's earliest hit films (1917), it also figures in popular posters, such as that by artist P. Sardar, a bodybuilder and Hanuman devotee (and, incidentally, a Muslim) who is said to have used a full-length mirror to model his subject on his own trim and muscular physique (fig. 54).[20]

Once Rama has received Hanuman's encouraging report, and his forces have built a marvelous bridge over the sea (in some accounts, Hanuman's devoted inscription of the name "Rama" on each boulder allows them to float), the siege of Lanka begins, and the great monkey's heroic exploits continue. Fighting (in older

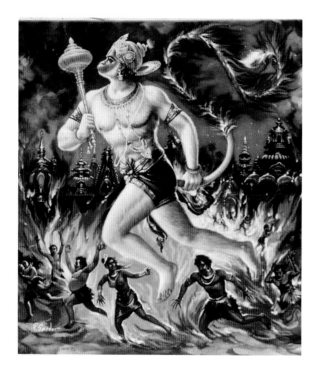

texts) with teeth, claws, tail, and hefted rocks and tree limbs, and (in later accounts) with an enormous club or mace—his preferred weapon in modern visual art— Hanuman slays a number of prominent demon warriors. He also becomes Rama's mount during certain forays, bearing the chariot-less prince (and sometimes Lakshmana, too) on his back or shoulders (fig. 55).

But his most celebrated adventure is his flying journey to the Himalayas to bring back a magical herb that alone can save the mortally wounded Lakshmana. Once more, poets could not resist turning this quest into a mini-epic in which Hanuman must outwit and slay demons who have been placed along the route to waylay him. His ultimate success involves the long-distance transport of an entire mountain peak covered with rare herbs, since either he cannot remember which one the physician requested or the herbs have mischievously hidden themselves from his sight. This feat establishes him as a healer and a patron deity of Ayurvedic medicine—as well as the mascot and logo of a modern Indian courier company (fig. 56).

Another celebrated exploit is Hanuman's rescue of Rama and Lakshmana from the clutches of a subterranean Ravana (generally known in India as Ahiravana, "snake-Ravana," or Mahiravana, "earth-Ravana") who is even more terrible than his earthly counterpart—

FIG. 54 (*top left*). Hanuman sets fire to Lanka with his burning tail. Popular print.

FIG. 55 (*top right*). Hanuman carries Rama into battle (detail of cat. no. 124).

FIG. 56 (*above*). Hanuman carrying the mountaintop, as the logo of the ABT Parcel Service.

sometimes his brother, son, or double—and who comes to the latter's aid when he has nearly lost the war. Kidnapping the two princes from a fortress formed of Hanuman's coiled tail, Ahiravana carries them to the underworld and prepares to offer them as human sacrifices to his tantric tutelary goddess. In the numerous versions of this tale, some as old as the eighth century CE, Hanuman often must assume disguises to outwit the demon sorcerer, as well as encounter and defeat his own doppelganger—a monkey bodyguard to Ahiravana. This character identifies himself (much to Hanuman's surprise) as the great monkey's "son," spawned when a drop of Hanuman's sweat impregnated a female fish. Characteristically, in Southeast Asian versions, she was a voluptuous mermaid, it was not sweat that did it, and the impregnation wasn't accidental. The bloodthirsty goddess, too, is bested (and, like Lankini, sent elsewhere—in one version, to goddess-loving Bengal, where she still has a temple[21]), and Rama and Lakshmana are rescued and carried back to the earth's surface to resume their struggle.[22]

The vision of Hanuman's victory in this tale is common in modern temple sculpture and folk and poster art (fig. 57), and the story contributes to his sometime role as an exorcist and shamanic healer, capable of retrieving lost souls from dark netherworlds, as in the thriving therapeutic shrine of Balaji (a local name for Hanuman) in Mehndipur, Rajasthan.[23]

Hanuman's triumphs on the battlefield, no less than his earlier mayhem in Ravana's ashoka grove, have also endeared him to athletes and practitioners of martial arts. He is the patron deity of traditional Indian wrestlers, and their gymnasia and clubhouses usually feature a small shrine to him where he receives group worship before every workout or bout. More recently, the militant monkey has been adopted by equally militant Hindu nationalists as a symbol of the power they crave and the monolithic, intolerant "Hinduness" (*Hindutva*) they seek to impose on Indians of all religious persuasions. Sadly, it is a group styling itself as "Hanuman's army" (*Bajrang Dal,* drawing on his folksy Hindi epithet *Bajrangbali*—"the iron-limbed hero") that is often

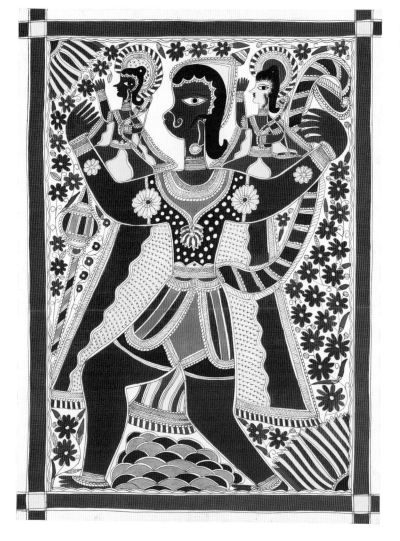

FIG. 57. Hanuman carries Rama and Lakshmana (cat. no. 98).

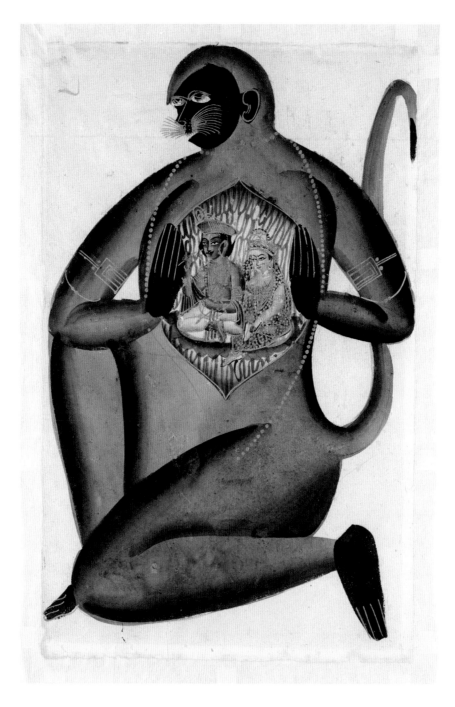

identified in news stories as being responsible for horrific attacks on religious minorities.

Once Ravana has been slain, Sita tested and restored, and Rama and she enthroned back in Ayodhya, Hanuman plays little part in the Valmiki epic, though he ultimately receives his Lord's blessing to remain on earth as the special patron of Rama's story. But other storytellers saw it differently and crafted many charming tales of Hanuman's ongoing service to Rama and Sita, as well as of his exploits in successive ages. The one most celebrated in visual art has its roots in Valmiki's mention of Queen Sita presenting Hanuman with a priceless jewel necklace in token of his aid.[24] According to later tellers, Hanuman soon begins systematically

destroying the gift by breaking its beads (diamonds or huge pearls, in most accounts) between his teeth, and then peering at the fragments as if looking for some edible kernel. When horrified courtiers (some of whom scoff in resignation, "Well, he's a monkey, after all!") ask him why he is doing this, he says simply that he is looking for "Rama," since he believes that things are only of value if they contain the Lord. When it is pointed out to him that his own body, surely, is a thing of value, and yet it has no such tangible content, Hanuman proceeds to tear open his chest with his nails, revealing, within the gaping wound, a divine epiphany—in various versions, Rama, Rama and Sita, or simply the name *Rama* (fig. 58).[25]

This story occurs in the fifteenth-century Bengali Ramayana attributed to Krittibasa, and it may have originated in Bengal; several centuries later, it was a favorite subject for the artists of the Kalighat neighborhood in Kolkata, who regularly painted Hanuman as a black-faced, long-tailed monkey of the species commonly known as "Hanuman langur" (*Semnopithecus entellus*). A visceral encapsulation of Hanuman's dominant traits of *shakti* and *bhakti*—raw power and heartfelt devotion—the image of Hanuman opening his chest is today another of his most ubiquitous icons, especially in bazaar posters, in which a broken necklace lying at his feet alludes to the well-known story.

Scholars of folklore, in quest of the recurring motifs of human narrative, long ago identified that of the "helpful animal"—a magical, talking beast who befriends a hero and assists him in achieving his goals—as a nearly worldwide phenomenon, from the innumerable Native American legends of Raven and Coyote, to Puss-in-Boots of European fable, to the Monkey King Sun Wukong of the classical Chinese novel *Journey to the West*.[26] Hanuman and his forest-dwelling companions likewise figure in the folklorists' motif-directories; in predictable fashion, they meet our human hero when he is wandering in the forest, and in return for a favor (here, Sugriva's restoration to his throne) become his devoted servants and the facilitators of his quest to recover his beloved wife. But in the immense body of narrative, visual representation, performance, and religious practice that has grown up around the greatest of these *vanaras,* we witness the apotheosis of the "helpful animal" as an unparalleled and multifaceted divine figure. At once comical and awesome, beguiling and deeply moving, Hanuman presents humankind with both a mirror image of our own complex nature (as simian species are so often understood to do) and an inspiring exemplar of our highest ideals of courage, loyalty, service, and devotion.

NOTES

1. Although scholars of ancient Sanskrit have concluded that the word in the Valmiki epic that is assumed to mean "bear" (*ṛksha*) originally referred to yet another species of monkey, visual artists and audiences have for centuries only pictured them as the former, and I retain this usage throughout my essay (on the older meaning, see Lefeber, *Kiṣkindhākāṇḍa,* 37–39). Incidentally, I never use "ape" for Hanuman's cohorts, since, although popular usage treats this word as a synonym for "monkey," zoologically the terms refer to distinct families of anthropoid primates, and apes are not found in South Asia.

2. Goldman, Sutherland Goldman, and van Nooten, *Yuddhakāṇḍa,* 328 (61:18, 22).

3. Goldman and Sutherland Goldman, *Sundarakāṇḍa,* 207 (34:3).

4. Ibid., 86.

5. Tulsidas, *Ramcaritmanas,* 7:120:16.

6. For more on colossal Hanuman images, see Lutgendorf, *Hanuman's Tale,* 3–9.

7. Popular epithets meaning "son of the wind" include *pavanaputra, pavanasūta,* and *māruti.* The name Āñjaneya, "son of Anjani," is often given to Hanuman in southern India.

8. Lefeber, *Kiṣkindhākāṇḍa,* 189–190 (65:1–28); Goldman and Sutherland Goldman, *Uttarakāṇḍa,* 7:35–36.

9. Goldman and Sutherland Goldman, *Uttarakāṇḍa,* 108:33–35. Note that he has already, as an infant, received boons that make him effectively immortal (see Lefeber, *Kiṣkindhākāṇḍa,* 190 [65:25–28]; Goldman and Sutherland Goldman, *Uttarakāṇḍa,* 36:12–40); in the *Ramcaritmanas* of Tulsidas, he received a similar boon from Sita in the ashoka grove (*Ramcaritmanas* 5:17:2–3).

10. See Lutgendorf, *Hanuman's Tale,* 125–235.

11. Govindacandra, *Hanumān ke devatva tathā mūrti kā vikāsa,* 258.

12. Dikshit, *Hanumān upāsanā,* 11.

13. For sources, details, and variants of this charming story, see Lutgendorf, *Hanuman's Tale,* 136–137, 192–194.

14. Goldman and Sutherland Goldman, *Sundarakāṇḍa,* 40.

15. Ibid., 104–105 (1:41, 43, 46, 54–55, 58).

16. For the mystical interpretation, see Din, *Mānas rahasya,* 308; for the psychoanalytic, see Goldman and Sutherland Goldman, *Sundarakāṇḍa,* 52.

17. *Ramcaritmanas* 5.4.2–4 (my translation).

18. On Hanuman's link to goddesses, see Lutgendorf, *Hanuman's Tale,* 197, 310–316.

19. Goldman and Sutherland Goldman, *Sundarakāṇḍa,* 138 (8:50).

20. Jain, "Muscularity and Its Ramifications," 6.

21. Sen, *Bengali Ramayanas,* 50–51.

22. On the history, popularity, and numerous variants of this tale, see Lutgendorf, *Hanuman's Tale,* 149–153, 211–216.

23. See ibid., 262–270.

24. Goldman, Sutherland Goldman, and van Nooten, *Yuddhakāṇḍa,* 492 (116:70–73).

25. For additional notes and variants, see Lutgendorf, *Hanuman's Tale,* 156, 218–220.

26. On motifs of the "helpful animal," see Thompson, *Motif-Index of Folk Literature,* 1:422–60. On Sun Wukong's postulated but controversial link to Hanuman and the Ramayana story, see Lutgendorf, *Hanuman's Tale,* 354–357; and Mair, "Suen wu-kung = Hanumat? The Progress of a Scholarly Debate."

What Does Hanuman Look Like?

What does Hanuman look like? The freedom that poets and dramatists have exercised in recasting the Ramayana in literally hundreds of retellings, often with significant variations in plot and character, has been mirrored by South Asian visual artists in depicting all of its prominent characters, including the hero's feral allies.[1] The epic's *vanaras,* like its demonic rakshasas, are said to be able to alter their appearance at will (literally, they are "enformed according to desire," *kamarupin*). But "taking on a form" is a strategic choice that implies abandoning or concealing another. Valmiki's text leaves no doubt that Hanuman's "own form" (*svarupa*) is simian—for example, when Hanuman transforms himself into a brahman student for his first meeting with Rama and Lakshmana, and then reverts to monkey form when he is convinced they mean Sugriva no harm.[2] The poet's verses abound in references to "monkeyness" (*kapitva* is the Sanskrit word, from *kapi,* "a monkey, a tawny-colored animal") and describe the animals' red or black faces and rumps, yellow eyes, luxuriant fur, waving tails, and their habit of baring or chattering their teeth when aroused. Yet these are no ordinary simians; the offspring of celestials and monkey women, they possess the key human trait of speech as well as superhuman strength, and they live in a human-like society in the forest. Accordingly, artists in India have often anthropomorphized them to varying degrees but have nearly always retained a simian lower face and jaw (often rendered in red or black to encode the two dominant monkey species on the subcontinent: the rhesus macaque and the Hanuman langur) and, of course, the trademark tail. In later Mughal and Rajput art, specific simian species are sometimes recognizable among the troops in Rama's army, though its leaders—Hanuman, Sugriva, Angada, and others—may receive more humanized treatment, with clothing, crowns,

and a more upright (though still simian) posture; traditionally, a red loincloth singles out Hanuman. Jambavan and his brethren usually appear as black, with the tapering snouts of Himalayan black bears [1].

Diversity in representation continues to characterize the treatment of Hanuman in modern popular art. Devotional posters variously show him as fully furred or nearly humanized—the latter representations, reflecting the popularity of circus strongmen in the 1920s and then of bodybuilders after

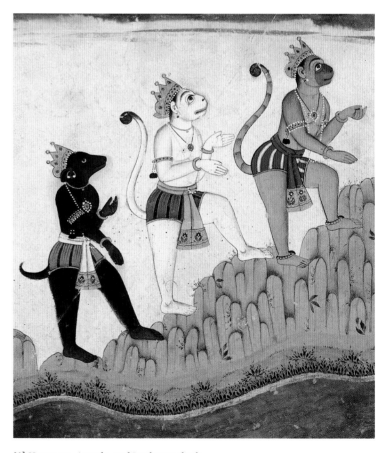

[1] *Hanuman, Angada, and Jambavan climb Mount Mahendra (detail of cat. no. 88).*

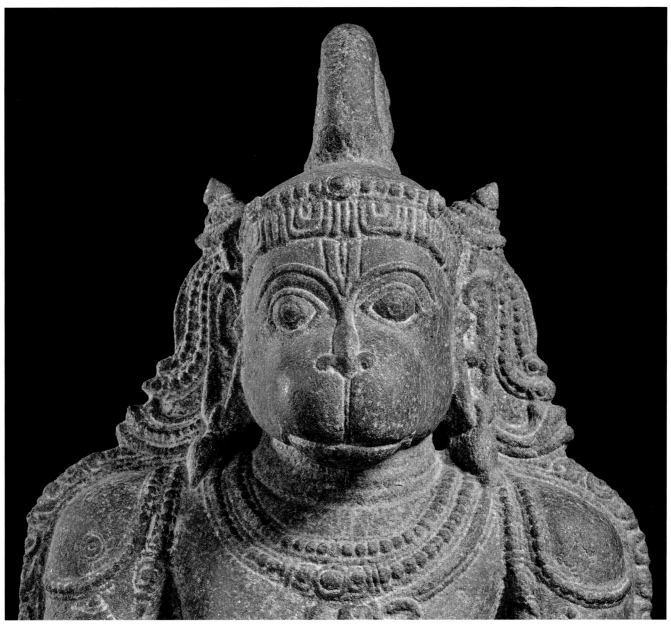

[2] *Hanuman (detail of cat. no. 78).*

about 1990, often feature the exaggerated musculature of "pecs" and "abs," so alien to earlier Indian art, that now evokes an international body image of desirable male power (cat. no. 85).

The hairless, humanized Hanuman also gestures toward another body of discourse: a popular belief that the monkeys of the Ramayana are in fact the poetic transposition of a forest-dwelling tribal people, or perhaps of some "missing link" in the human evolutionary chain. This view was fostered in part during the colonial period by the international sensation created by the publication of Charles Darwin's *On the Origin of Species* (1859), and also by the desire of English-educated Hindus to historicize the Ramayana narrative in order to counter British

assertions that (unlike the supposedly historical scriptures of Christianity) venerated Hindu texts were merely grotesque and childish fairy tales. Although claims that primitive humans underlie the epic's monkeys continue to be periodically advanced in India today (for example, in some Tamil nationalists' insistence that the North Indian author of the Ramayana denigrated the inhabitants of the South by turning them into monkeys, bears, and demons), they coexist with the continued enjoyment, by audiences of all ages, of the *kapitva* of Hanuman and his friends, with the use of simian descriptors in religious praise poems, and with the obligatory visual code of snout and tail from which—even in a 2007 animated feature film that toyed with Hanuman

incarnating as a human child—the divine monkey could not escape [3].[3]

The twin themes of "power" and "devotion," so prominent in Hanuman's lore and religious worship, have their visual counterparts as well, as both devotees and artists regularly affirm. Paintings and statues of the son of the wind are said to be coded to exemplify one of two predominant moods: the "servile" (*dasya,* or *das bhav* in Hindi) and the "heroic" or "martial" (*virya,* or *vir bhav*). The former is characterized by an immobile and often prayerful stance and drooping tail, the latter by an active or militant pose, with tail erect—once again, "monkeyness" asserts itself, since real simians, especially langurs, drop their tails when at rest and raise them when aroused or excited [4, 5].

"Servile" Hanumans are likely to be seen in settings in which the monkey's humility before Vishnu/Rama is stressed, as when he appears as a door guardian of temples of the Shrivaishnava sect of southern India. The famous Chola bronze of a standing Hanuman (cat. no. 77), with its sedate pose of possibly worshipful wonder or dutiful reporting, is similarly thought to have been part of a temple tableau, in which he stood as an attendant to larger icons of Rama, Sita, and Lakshmana. "Heroic" Hanuman, on the other hand, predominates in contexts in which he is the primary object of worship and where devotees are appealing for his aid and protection. His mountain- and club-wielding icons conform to this type, as do hundreds of distinctive images in profile, with tail artfully arching over his head and one hand raised to deliver a slap, characteristic of the popular art of the Vijayanagara kingdom in South India (thirteenth to sixteenth centuries CE). In this mood, he is also often shown crushing a demon underfoot. A martial stance is likewise evident in the genre of *pataka* paintings

[3] *Hanuman resembling a human child.*
Poster for the movie Hanuman Returns.

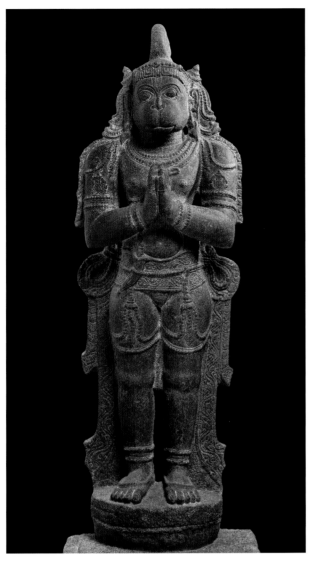

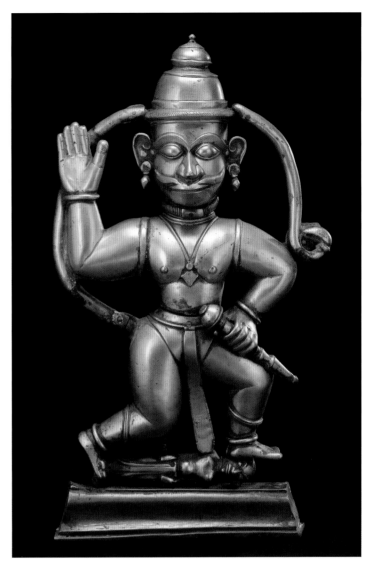

[4] *Hanuman in "servile" mood (cat. no. 78).*

[5] *Hanuman in "heroic" mood (cat. no. 80).*

produced in eighteenth- and nineteenth-century Rajasthan and probably meant for use in rituals intended to create verbal "shields" to protect the worshiper from demonic or earthly adversaries. In these paintings (a magnificent example of which appears as cat. no. 81), the monkey's body is commonly surrounded by, imprinted with, or sometimes actually formed of mantras—spiritually charged word-formulas—of which the most important, of course, is the "great mantra" of Rama's and Hanuman's devotees: the holy name *Rama*.[4] P.L.

NOTES

1. For a survey of visual representations of Hanuman, see Aryan and Aryan, *Hanumān in Art and Mythology.*

2. Although the critical edition text of *Kiṣkindhākāṇḍa* omits mention of Hanuman's second metamorphosis until he has

brought Rama and Lakshmana into the presence of Sugriva, many manuscripts include it after 4.3.25 (see Lefeber, *Kiṣkindhākāṇḍa,* 61 and 209, note on verse 25). As Lefeber notes, Hanuman carrying the brothers up the mountain on his back became a popular subject for visual artists.

3. Directed by Anurag Kashyap and originally called *Hanuman Returns,* the film was released in 2007 with its title changed to *The Return of Hanuman.* Its poor box-office performance was in contrast to the great success of a previous animated film by the same production company, Percept Pictures, *Hanuman,* released in 2005. Whereas the earlier film recapitulated the standard "Hanumayana" narrative, the sequel boldly attempted to craft an independent storyline, in which Hanuman, bored in heaven (the writers apparently ignored his physical immortality), petitions Brahma to grant him an earthly incarnation in order to help a human child combat environmental degradation and global warming. Brahma permits this but ordains that Hanuman must retain an odd-shaped jaw and a tiny tail, which remains visible under his shorts.

4. For examples of *pataka* drawings of Hanuman, see Aryan and Aryan, *Hanumān in Art and Mythology,* plates 50–65.

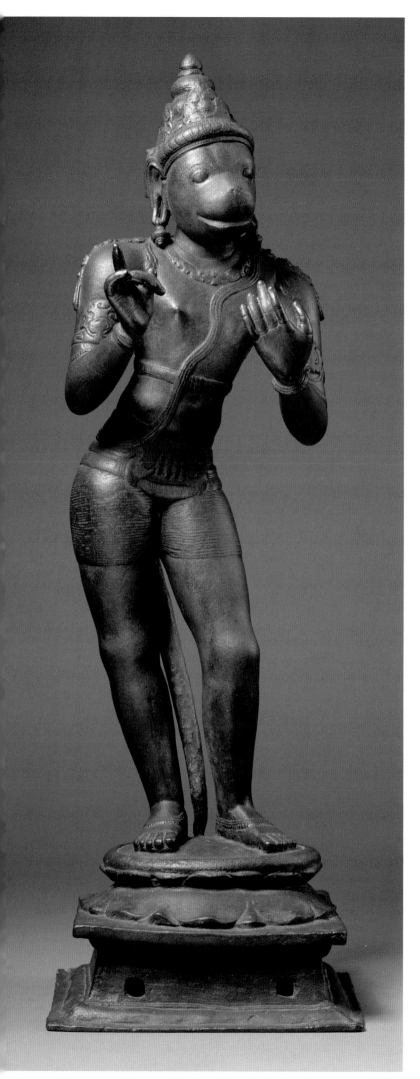

Hanuman conversing, 1000–1100
India; Tamil Nadu state
Chola period (880–1279)
Copper alloy
H. 64.5 × W. 18.4 cm
The Metropolitan Museum of Art, Purchase, Bequests of
Mary Clarke Thompson, Fanny Shapiro, Susan Dwight Bliss,
Isaac D. Fletcher, William Gedney Beatty, John L. Cadwalader
and Kate Read Blacque, Gifts of Mrs. Samuel T. Peters,
Ida H. Ogilvie, Samuel T. Peters and H. R. Bishop, F. C. Bishop
and O. M. Bishop, Rogers, Seymour, and Fletcher Funds,
and other gifts, funds, and bequests from various donors,
by exchange, 1982.220.9

Little betrays the monkey nature of this statue of
Hanuman besides his long tail and sweet simian
snout. This figure was likely once part of a quartet of
bronze statues, including Rama, Sita, and Lakshmana,
which would have resided in a South Indian temple.[1]
The sockets on the base of the sculpture indicate
where poles would have been placed to lift the image
in procession during temple festivals.

The artists of the Chola dynasty in southeastern
India were remarkable sculptors. Metalworkers were
able to achieve in bronze what is often difficult in
stone: supple bends and curves of the body, delicate
lines of fabric, and details on the surface of the skin.
Hanuman's body leans slightly forward, bending in
submission before Rama. Other Chola bronze images
of Hanuman show him with his hand raised to cover
his mouth in a gesture of humble devotion, but here
he seems to be speaking as he gestures with a single
raised finger. N.R.

NOTE
1. See Nagaswamy, *Masterpieces*, 157, for references to sets of these
statues in Indian temples and museums.

Hanuman, 1600–1700

South India
Granite
H. 145 × W. 45 × D. 47 cm
The British Museum, 1880.298

Statues of Hanuman standing with his hands clasped before his chest in the gesture of honor and reverence are popular throughout India, especially in the south. In some cases he stands in a quartet with Rama, Lakshmana, and Sita, and other times he stands alone.

While many images of Hanuman emphasize his strength, like those in which he carries the mountain of healing herbs, this statue emphasizes Hanuman's role as the devoted servant of Rama. Hanuman is thought to personify *bhakti* (worshipful devotion) and in this pose emphasizes this aspect of his character.[1]

The Y-shaped mark on Hanuman's forehead is a marker worn by a caste of Hindu Vaishnava worshipers of Tamil origin, indicating this statue may have come from the state of Tamil Nadu. It bears some iconographical resemblance to statues from the Adi Narayana temple in Pazhaverkadu, Tamil Nadu.[2]

N.R.

NOTES

1. See Philip Lutgendorf's discussion of *bhakti* and *shakti* in relation to Hanuman. Lutgendorf, *Hanuman's Tale,* 388–390.

2. Photos of this temple and some of its images can be seen at http://templesrevival.blogspot.com/2006/04/pazhaverkadu-adi-narayana-vishnu.html.

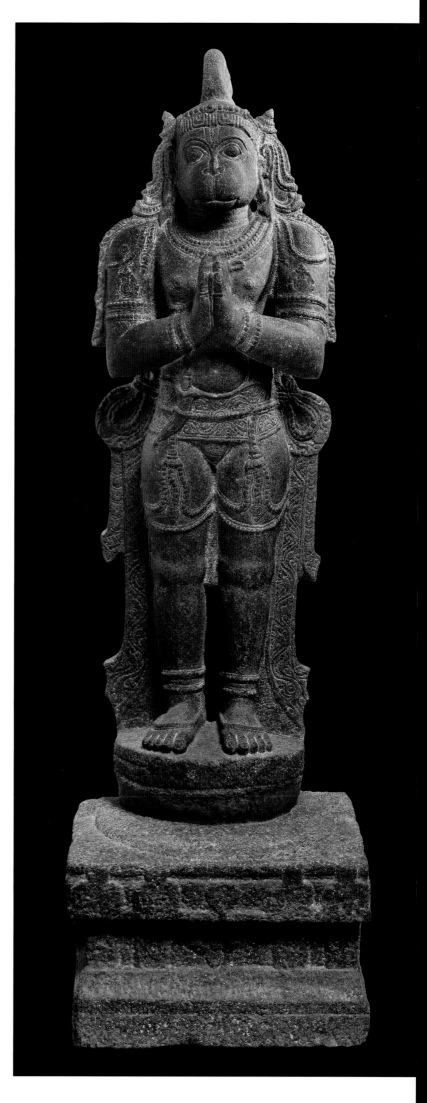

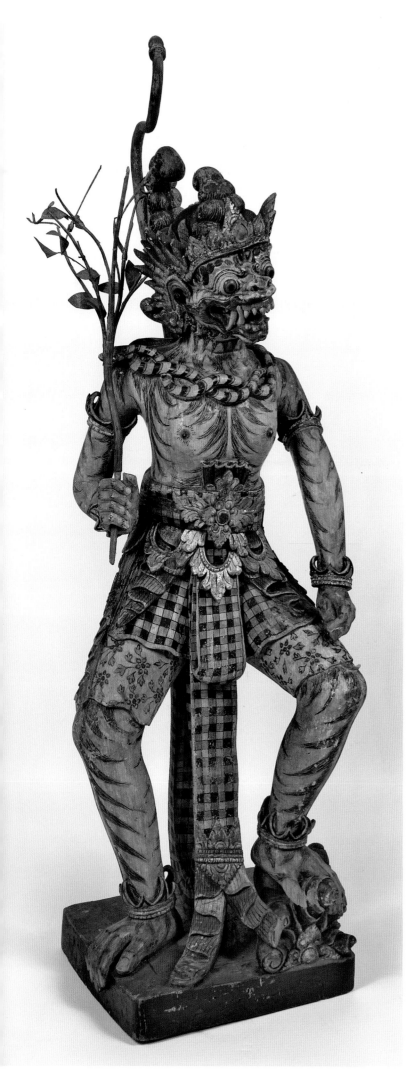

Hanuman, 1899

Indonesia; Bali
Painted and gilded wood
H. 117 × W. 33 × D. 44 cm
Nationaal Museum van Wereldculturen,
Coll. no. TM-15-182b

The fierce and ferocious aspects of Hanuman's
character are emphasized in this statue. He confronts
the viewer, his body tense with energy, legs bent and
hands clenched. Although most of his body looks
much like a human's, his long monkey toes grip the
base of the statue. The monkey's eyes bulge and his
mouth gapes, exposing prominent canines. Yet at the
same time he is finely dressed, wearing a crown and
jewelry and beautiful textiles.

With a few exceptions, it seems that large wooden
statues of deities did not play a role in Balinese
religious practice.[1] This sculpture of Hanuman was
commissioned for the Dutch colonial pavilion of the
Paris World Exposition of 1900 for the purpose of
spreading knowledge about Hindu-Balinese culture.[2]
It was among a group of about thirty statues of
divinities and other figures that were made by artists
in Bali for export. Of works in this group, some were
clearly modeled after stone statuary from temples in
northern Bali; others may have been inspired by the
performing arts. Stylistically, many of the statues
diverge from images typically found in Bali, with
unusual attributes and skin colors.

Various features of this statue of Hanuman are
similar to those found on Indonesian shadow puppets
and dance drama costumes, especially the black-
and-white checked sash, the distinctive upturned
headdress, and the positioning of the tail rising
behind the body. Other features are unusual but
can be seen on shadow puppets from northern Bali,
including the snake-like necklaces and the distinctive
treatment of the fur. The branches in Hanuman's
hand are a puzzling attribute. Perhaps they indicate
his strength; some episodes of the Ramayana refer to
Hanuman's physical power and his ability to uproot
trees. (Monkey warriors use branches as weapons in
cat. no. 45.) N.R.

NOTES

1. Animal-shaped "vehicles for the gods" made of wood are used in
processions during temple festivals and ceremonies. Wooden statues
that functioned as holders for daggers were also carved but served no
religious purpose. Other wooden statuary seems to have been made
for decorative purposes.

2. See Reichle, Brinkgreve, and Stuart-Fox, *Bali*, 322–331.

80 *also p. 163*

Hanuman, 1500–1800

India; Maharashtra or Karnataka state
Copper alloy
H. 62.2 × W. 35.6 × D. 8.9 cm
Peabody Essex Museum, Gift of Leo S. Figiel, MD,
and family, 2006, E303502

Images of Hanuman in this pose can be found
throughout the Indian state of Karnataka, especially
in Hampi, a village that has long been an important
place for the worshipers of Hanuman. Between the
fourteenth and sixteenth centuries, this area was the
capital of Vijayanagara, a powerful and prosperous
empire in southern India. The region is closely
associated with the Ramayana. The monkey kingdom
of Kishkindha, where Rama meets the monkey king
Sugriva, is believed to be located here. Several other
sites are now identified as places where important
events from the story took place: Hanuman's
birthplace, the cave in which monkeys hid the jewels
dropped by Sita as she was carried off by Ravana, and
the hill where Rama waited for Hanuman to return
from Lanka. The rulers of Vijayanagara compared
themselves to Rama, and the Ramachandra temple
with reliefs depicting the Ramayana was built in the
heart of the royal enclave of the city (see cat. no. 6).[1]

During the fourteenth to sixteenth centuries,
sculptors carved hundreds of stone images of
Hanuman; smaller images in brass continued to be
made in the centuries that followed. In Karnataka's
neighboring state of Maharashtra, Hanuman is
considered a village protector, and images like this one
are found in village temples dedicated to the deity. In
many of these images, Hanuman is depicted striding
forward with one hand raised by his head and with
his tail forming a large loop over his head. In some
cases, his raised hand is equated with the do-not-fear
gesture (*abhaya mudra*); in other cases, it is described
as ready to deliver a blow or a slap.[2] In this region,
Hanuman is often depicted with a conical cap and a
large mustache. Sometimes, as in this work, a demon
lies trampled beneath his feet. This "heroic" pose
emphasizes Hanuman's strength and valor. N.R.

NOTES
1. Dallapiccola et al., *The Ramachandra Temple.*
2. Lutgendorf, *Hanuman's Tale,* 60–61.

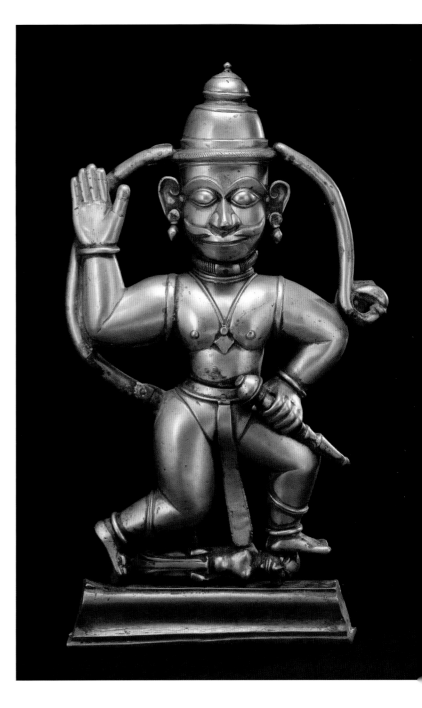

Relief of Hanuman, Hampi, Karnataka.

81

Hanuman bearing the mountaintop
with medicinal herbs, approx. 1800

India; Rajasthan state
Ink and opaque watercolors on cloth
H. 130.2 × W. 116.2 cm
The Metropolitan Museum of Art,
Gift of Edward M. Bratter, 57.70.6

The artist of this *pataka* ("flag" or "banner") presents a bold, dynamic depiction of Hanuman and also fills the painting with delicate and delightful details.

Grasping a flag in one hand and balancing a mountain on the other, Hanuman strides forward, framed by his encircling tail. When Rama's brother Lakshmana is struck ill, Hanuman is sent to the Himalayas to retrieve herbs to heal him. Because he is unsure of which herbs to bring (or, in some tellings of the story, because the herbs hide from him), he breaks off the entire top of the mountain and returns with it. Creatures of all sorts cavort on the craggy hilltop, including a running elephant along its peak. Below the mountain, perched on Hanuman's shoulder, is a tiny depiction of Rama, with bow and arrows in hand. Rama did not accompany Hanuman on this mission but is always spiritually with him.

Perhaps the most remarkable aspect of Hanuman is his long, coiling tail. In the video produced for the Metropolitan Museum's *The Artist Project* series, the artist Nalini Malani notes with amusement the small sleeve in Hanuman's shorts that his tail must fit in, and imagines the effort necessary to pull its entire length through the small opening. Underneath the tail and curving below it, the artist has painted a parade, with carriages, horses, elephants, and marching men. As the hundreds of characters march forward toward the curled tip of Hanuman's tail, the crowd compresses, so at the tip, the elephants turn, moving from profile to face the viewer head on.

Pataka were used as ritual aids and were often covered with mantras (sacred utterances) or yantras (symbolic diagrams).[1] This image is full of letters or words, which cover and surround Hanuman's body as well as emerge from his mouth (see detail p. 170).[2] Hanuman's body is outlined with the letter "ra," र, the first letter of Rama's name. The mountain is bordered with "la," ल (possibly referring to Lakshmana?). The text on his body may be a mantra, a narrative, or a praise poem. The line of letters surrounding Hanuman's long, coiled tail consists of the letters of the Devanagari alphabet, in alphabetical order, written over and over, possibly invoking their power as "seed mantras" for all speech. N.R.

NOTES
1. For other *pataka* of Hanuman, see Aryan and Aryan, *Hanumān in Art*, figs. 50–65.
2. Thanks to Philip Lutgendorf for identifying the elements of the text on this *pataka*.

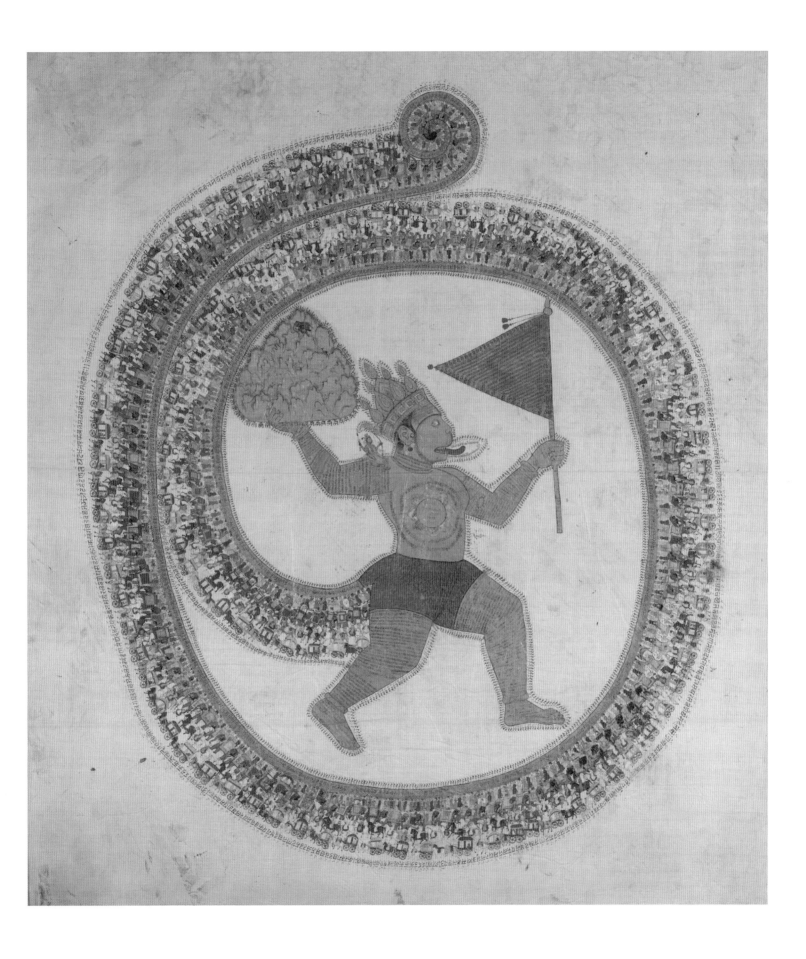

Details of cat. no. 81.

82

Theatrical mask of Hanuman, 1876

Thailand
Papier-mâché, paint, mirrors, and glass
H. 22 × W. 24 × D. 25 cm
Smithsonian Institution, National Museum of Natural History,
Gift of King Chulalongkorn, 1876, USNM #27378

Although the majority of the inhabitants of Southeast Asia today are Buddhist or Muslim, Hindu epics from the region's past remain a favorite subject for many forms of theater throughout the region. The Ramayana is the most popular subject for the Thai classical court dance-drama known as *khon*.

In *khon* performances, Hanuman is depicted as a white monkey who can wear any of at least seven different masks, depending upon the scene enacted. These masks are highly standardized, with distinct identifying features that have not changed for decades. Hanuman in his form of a warrior wears this white mask with green and pink accents. He is depicted with open mouth baring four canine teeth and displaying a jewel on the top of his palate. A simple diadem

encircles his forehead. Because the actor's face is completely covered, he must use his gestures and body to convey emotions.

Masks like this one are made by layering papier-mâché over a clay mold. After drying, the mask is split, the clay is removed, and the halves are resealed with thread and more papier-mâché. Black sap of the *lak* tree as well as acrylic paints decorate the mask, which is then ornamented with mirrors and glass. A cord is sewn in the back of the mask, which the actor grips with his teeth to hold the mask in place during Hanuman's energetic leaps, somersaults, and cartwheels. The role of Hanuman is so exhausting that sometimes four actors are used to play him in a single performance.

This mask was given by King Chulalongkorn of Thailand to the United States after the completion of the Centennial Exposition in Philadelphia in 1876. More than nine hundred objects from Thailand were displayed, including many associated with traditional theater. N.R.

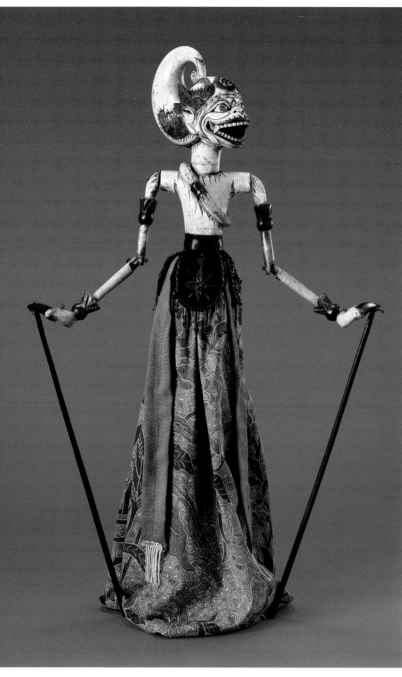

83

83

Rod puppet of Hanuman, approx. 1960
Indonesia; West Java
Wood, cloth, and mixed media
H. 67.3 × W. 25.1 × D. 15.9 cm
Asian Art Museum, from The Mimi and
John Herbert Collection, F2000.86.160

84

Shadow puppet of Hanuman, 1819
Indonesia; Central Java
Hide with pigments, gilding, and horn
H. 76 × W. 60 cm
Nationaal Museum van Wereldculturen,
Coll. no. RV-264-54

In Java, episodes of the Ramayana are enacted
in shadow-puppet theater (*wayang kulit*) and in
rod-puppet theater (*wayang golek*). Hanuman is
depicted in both as a white monkey with bulging
eyes, sharp teeth, and the elongated fingernails of
his spiritual father Vayu, god of the wind. Another
identifying characteristic of puppet representations of
Hanuman are his distinctive bracelets, which are also
worn by his father and by Bhima, another son of the
wind. An Old Javanese story of the birth of Hanuman,
the Kapiparwa, describes Hanuman as also being
the son of Shiva. It is possible he is depicted as white
because that is how Shiva is portrayed in wayang
performances in Indonesia.[1]

One of the most popular stories concerning
Hanuman in Indonesia is his initial journey to
Lanka in search of Sita. This story is the focus of
the narrative reliefs of the fourteenth-century east
Javanese temple Candi Penataran. In the puppet
theater, this popular episode is called *Anoman Duta*
(Hanuman as envoy). In these performances, several
aspects of Hanuman's character are emphasized: his
resourcefulness, bravery, and loyalty.

Cat. no. 83 shows a late innovation of the monkey's
tail carved from wood and looped across the chest.
Earlier puppets had a tail made from a tube of cloth
that would have been pulled up and sewn to the back
of the headdress, in the manner seen in cat. no. 84.
Cat. no. 84 is part of a group of puppets dating from
the early nineteenth century. Collections of wayang
with such a relatively early documented date are rare.

N.R.

NOTE
1. Vickers, "The Old Javanese Kapiparwa," 127–128.

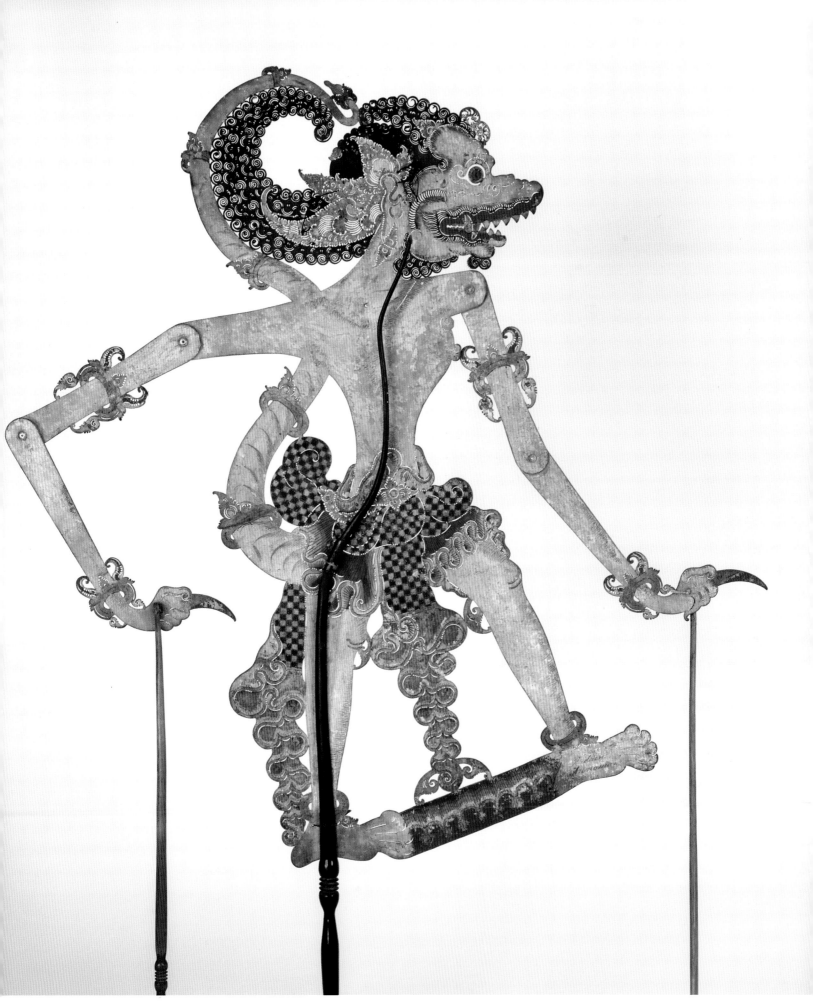

85

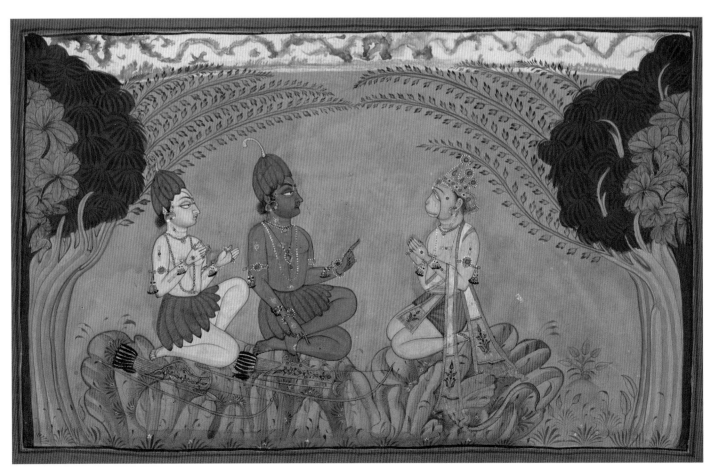

86

85 *also fig. 44*

Hanuman, approx. 1920–1950

> Published by Anant Shivaji Desai (Indian, 1853–?)
> Chromolithograph
> H. 50.2 × W. 35.2 cm
> Robert J. Del Bontà Collection

Hanuman is portrayed here as a muscled strongman, with only his protruding muzzle and long, curling tail indicating his simian nature. Mass-produced printed images of this sort have been popular in India since the late nineteenth century and are still prevalent today. Sometimes called "calendar art" or "bazaar art," these lithographed images of deities, movie stars, and landscapes decorate calendars, advertisements, and many homes.

In this image, Hanuman appears on a rock amid the waters, the buildings of a village silhouetted in the background. In another similar lithograph, Hanuman stands on a globe over the region of India, where he is a nationalist symbol, ready to fight for India, as he fought for Rama.[1] He holds a club (*gada*), his signature weapon, and stares straight ahead. The name of Rama is written on his armlets and necklaces, and a pendant portrait of him is slung low across his chest. Marks in red (known as *tilak*) on his arms and chest indicate a Vaishnava affiliation.

Hanuman is considered the conduit to a spiritual connection with Rama. But for many, Hanuman himself is the object of religious devotion. Far more shrines are devoted to him than to Rama, and he is worshiped in a wide variety of settings.[2] He draws devotees especially from the community of wrestlers, who look to him for both his spiritual and his physical power. One of the tools used for exercise is a heavy stone attached to a bamboo stick, which resembles Hanuman's club.

Many people describe the dual aspects of Hanuman's personality with the Sanskrit terms *bhakti* and *shakti*.[3] *Bhakti* refers to Hanuman's dedication to Rama, a spiritual devotion that can encompass an experience of divine love. *Shakti*, in contrast, refers to extraordinary and divine power.　　　　　N.R.

NOTES
1. Cummins and Srinivasan, *Vishnu*, fig. 170.
2. Lutgendorf, *Hanuman's Tale*, 11.
3. Alter, *The Wrestler's Body*, 198–213.

86 *also p. ii and fig. 51*

Hanuman before Rama and Lakshmana, approx. 1710–1725

> India; Jammu and Kashmir state, former kingdom of Mankot
> Ink and opaque watercolors on paper
> H. 20.3 × W. 30.8 cm
> The Metropolitan Museum of Art, Seymour Fund, 1976.16

Three figures meet on a rocky outcropping under a verdant bower. The brothers Rama and Lakshmana are dressed in leaf garments, indicating that they are already living in exile. To their right sits the great monkey hero Hanuman, with his hands pressed together in a sign of respect. We come upon this scene in the middle of a conversation. Although their faces are impassive, Rama and Lakshmana's gestures indicate they are explaining something to Hanuman, who quietly listens. The trees enclose a peaceful moment, but the tumultuous skyline above suggests turbulence in the future. The artist frames the scene with delicate branches that reach across the painting and lightly touch at the center. This first encounter leads to the joining together of Rama and the monkey forces and Hanuman's important role in helping Rama rescue his kidnapped wife.

In Valmiki's Ramayana, when Rama and Lakshmana appear in the Rishyamukha forest, the monkey king Sugriva is alarmed, thinking that his brother (and enemy) Valin has sent them as spies.[1] Sugriva sends Hanuman to seek out the brothers and ascertain their intentions. Hanuman changes his form into that of a mendicant, approaches the brothers, and praises them extravagantly. Yet he questions why they are adorned in bark garments.

> Who are you in these bark garments, best of men, strong, steadfast, bright as gold, enhancing the beauty of this river of auspicious waters, you splendid warriors with the gaze of lions, courageous and strong as lions, majestic, handsome, with the gait of fine bulls, with arms like elephants' trunks, great arms holding bows like Śakra's [Indra's]?[2]

Rama does not reply directly but urges Lakshmana to explain their situation to Hanuman, who then tells them that the monkeys will help with their search for Sita. Unlike in this painting, in the text, Rama never speaks directly to Hanuman and Hanuman does not resume his monkey form until the end of this encounter, when he has led the brothers back to Sugriva.　　　　　N.R.

NOTES
1. Lefeber, *Kiṣkindhākāṇḍa*, 59 (2:20–22).
2. Ibid., 60 (3:6–8).

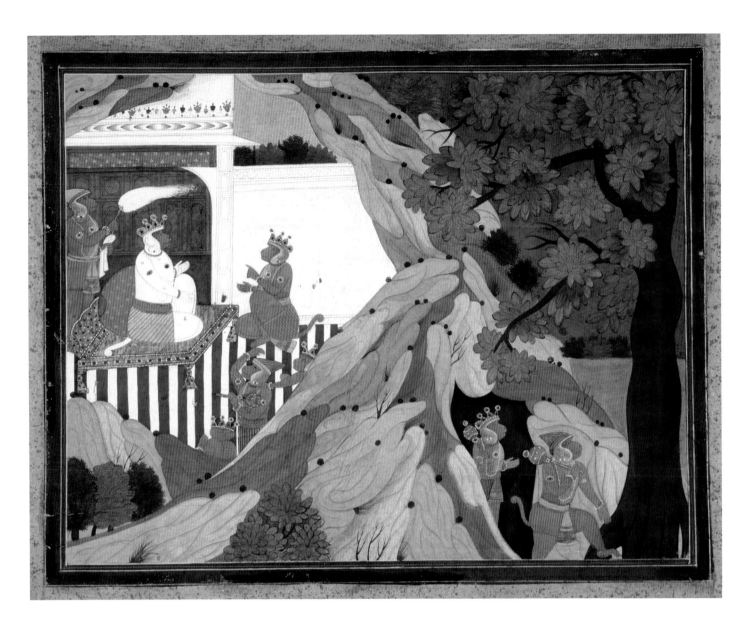

87

The monkey king Sugriva sends Hanuman to find Sita, approx. 1820

India; Himachal Pradesh state,
probably former kingdom of Kangra
Opaque watercolors and gold on paper
Image: H. 20.3 × W. 26.5 cm
Philadelphia Museum of Art, Gift of the
Board of Trustees in honor of William P. Wood,
President from 1976 to 1980, 1981-3-1

With Rama's help, Sugriva defeats his brother Valin and assumes the throne of the monkey kingdom (see cat. nos. 30–33). After celebrating, he joins forces with Rama, gathering the mighty monkey princes from throughout the land to help him. A different group is dispatched in each of the cardinal directions to search for the kidnapped Sita. In this painting, the king of the monkeys sits on a throne conversing with a number of his subjects. This depiction could represent the scene in which Hanuman and his companions are assigned the task of searching to the south.

The artist lets us peek within a fantastic cave at a splendid palace that in every way mirrors a palace in the human world. The strong diagonals of the rocky outcropping frame the space, and their dynamic lines bring energy to the scene. Sugriva sits on a jewel-encrusted golden throne, while a servant waves a fly-whisk behind him. Another monkey (perhaps Hanuman) sits on bended knee, deep in conversation with the monkey king.

Monkeys (both in slightly different garb) are shown again at the bottom right of the painting departing the cave to bravely begin their mission. The one leading the way is bearing a club, a weapon associated with Hanuman. Confusingly, the second monkey also carries a club. Three monkeys, all in different dress, are shown holding such a weapon. If they are all supposed to represent Hanuman, it is difficult to tell what the narrative purpose of the repetition of this figure could be. N.R.

88 *also p. 160*

Hanuman, Angada, and Jambavan climb Mount Mahendra, approx. 1720

Attributed to the workshop of Pandit Seu of Guler (d. 1740)
Opaque watercolors and gold on paper
Image: H. 17.5 × W. 26.5 cm
Museum Rietberg Zurich, RVI 847

When Hanuman planned his jump to Lanka, he realized that the earth might not withstand the power of his leap. So he first climbed Mount Mahendra, hoping that the solid rock would absorb the force of his departure. The mountain is depicted with the conventions of Pahari painting: pinkish fingers of rock extend vertically, with delicate tufts of greenery emerging among them.

The artist of this manuscript shows Hanuman at the front of a line of animals ascending a rocky landscape.[1] Two royally dressed followers are at his heels; the first is the monkey prince Angada, and the second is the bear Jambavan (sometimes described in texts as a monkey). At the back of the line trail two more naturalistic monkeys, walking on four feet.

Although texts emphasize the size and strength of Hanuman, this painting provides few physical characteristics besides his tiger tail, perhaps a reference to the epithet "a tiger among monkeys."

N.R.

NOTE
1. For more of this manuscript, see Goswamy, "Leaves from an Early Pahari Ramayana Series," 153–164. Also see Britschgi and Fischer, *Rama und Sita*.

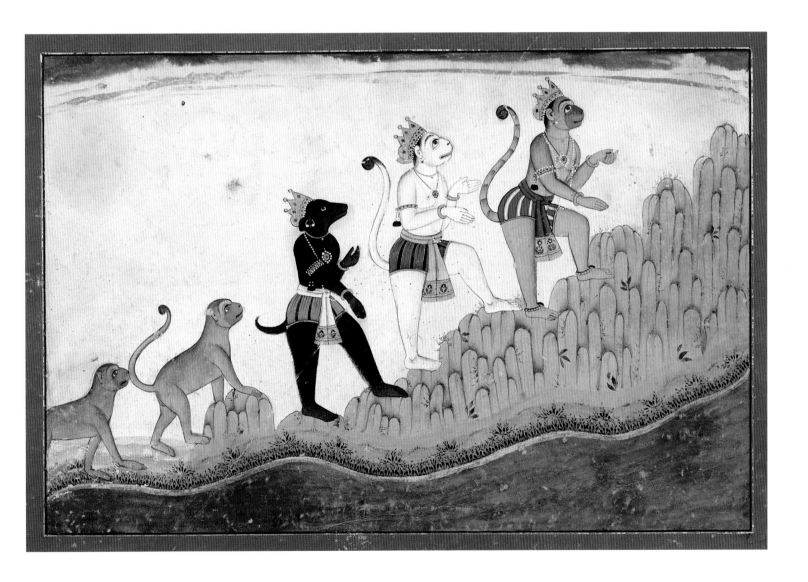

Hanuman's encounters with demons on his journey to Lanka,

approx. 1900–1950

By I Gusti Nyoman Lempad (Indonesian, 1862?–1978)
Ink on paper
H. 51.4 × W. 39.1 cm
Asian Art Museum, Gift of Karen A. Signell, 1998.90

This Balinese drawing illustrates a scene during Hanuman's initial mission to Lanka, where Sita is held in captivity. As the son of the wind god, Hanuman is capable of flying and thus is able to traverse the ocean to Lanka. This image focuses on obstacles Hanuman faces en route in a Balinese retelling of the story.[1]

In some Indonesian versions of the story, Hanuman meets two demons who guard the oceans in front of Lanka. The first, called Kataksini, sucks Hanuman into his mouth, but Hanuman is able to tear the creature's mouth open and escapes.[2] The second demon, Tatakini, also swallows Hanuman, but the monkey is able to expand and burst from his captor's stomach.[3] This drawing may depict only the second incident or may be an amalgamation of the two episodes, showing Hanuman twice but with a single demon. Hanuman is known as a shape-shifter, but Lempad does not emphasize this ability, instead showing the monkey twice at relatively the same size.

Indian versions of the tale also contain stories of Hanuman's brave adventures, but the demons are slightly different. In some Indian versions, Hanuman encounters a serpent goddess, Surasa, who has been asked by the gods to test Hanuman by taking the form of a giant demoness and obstructing his journey. She challenges him to enter her mouth, and by transforming himself into a tiny size he is able to dart in and out. He then meets a demoness, Simhika, who grows to an enormous size. Hanuman flies into her mouth and kills her by ripping open her internal organs. The episodes illustrate Hanuman's bravery and quick-wittedness.

Other features of this illustration may have been inspired by versions of the epic as performed by Balinese shadow-puppet theater (*wayang kulit*), or they may be purely from the artist's imagination. Such innovation is not unusual for I Gusti Nyoman Lempad, one of the most famous Balinese artists. Over Lempad's very long lifetime, he saw tremendous changes in the development of modern art in Bali. Lempad worked in many mediums but is most well known for his distinctive ink drawings.[4]

Hanuman is depicted according to the conventions of Balinese shadow-puppet theater, with his face mostly in profile and his body in three-quarter view. In Indonesian depictions of Hanuman, he often has a curving headdress, wears a checkered cloth around his waist, and has long, pointed thumbnails. As he enters the demon's mouth, he is shown with four arms. This characteristic is sometimes found in portrayals of Hanuman in East Java and Thailand. N.R.

NOTES

1. Pandey, "Surasa, Simhika and Lanka," 227–244.
2. Holt, *Art in Indonesia*, 301.
3. Sudibyoprono, *Ensiklopedi wayang purwa*, 342, 538.
4. For more information on Lempad's career, see Carpenter et al., *Lempad of Bali*; and Gaspar et al., *Lempad*.

90

Hanuman meets Sita, overcomes Ravana's forces, sets fire to Lanka, and extinguishes his burning tail, approx. 1775–1810

India; Himachal Pradesh state,
former kingdom of Guler or Kangra
Opaque watercolors on paper
H. 24.1 × W. 35.6 cm
Collection of Judy Wilbur

Here we see Hanuman meeting Sita in Lanka, where she is living in captivity within Ravana's walled palace. Sita sits regally on a throne in a neatly ordered garden, while Hanuman kneels submissively at her feet. Whereas this scene in the center of the painting emphasizes Hanuman's humility and devotion, the surrounding scenes demonstrate his strength, ingenuity, and quick-wittedness.

In this painting, Hanuman is either meeting Sita for the first time or returning to check on her, after he has destroyed much of Ravana's kingdom. Beyond the enclosure of flowering trees we see a scene of chaos— the slaughtered demons being eaten by birds.

Outside the walls of the palace, Hanuman is depicted three other times from other points in the narrative. While in Lanka, Hanuman is captured by Ravana's forces and his tail is lit on fire. He escapes his captors, and, using his burning tail, he sets the buildings of Lanka aflame. On the top right of the page, Hanuman is running, tail blazing, toward the water. After dousing the fire, he returns to make sure Sita is safe before he flees. On the lower left he energetically runs from the scene, leaving the island to return from his reconnaissance mission. N.R.

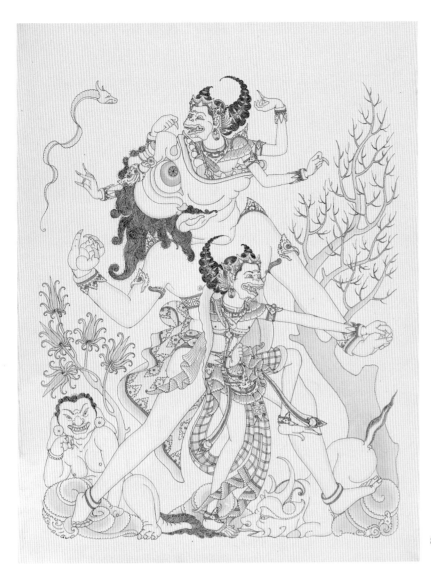

89

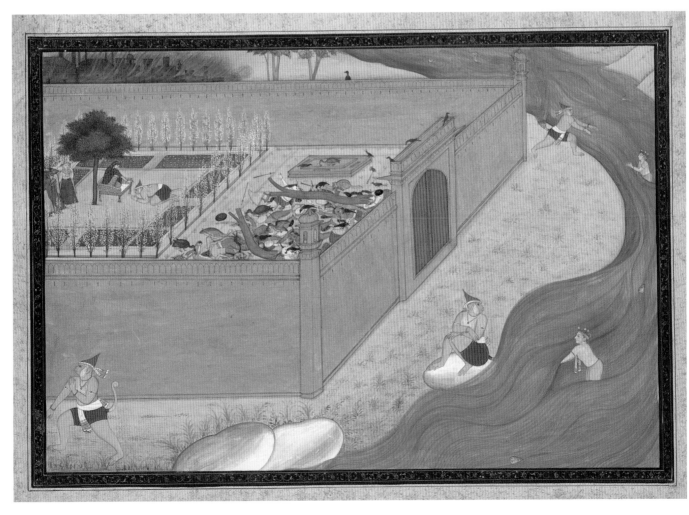

90

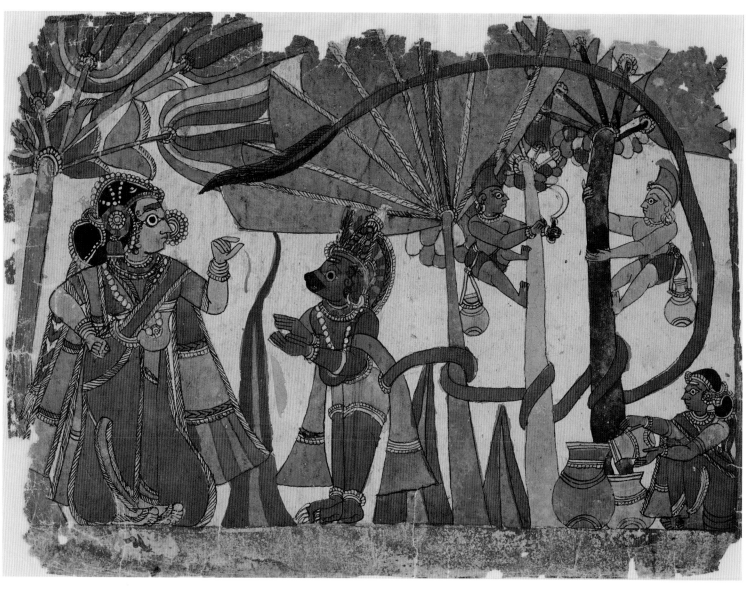

91

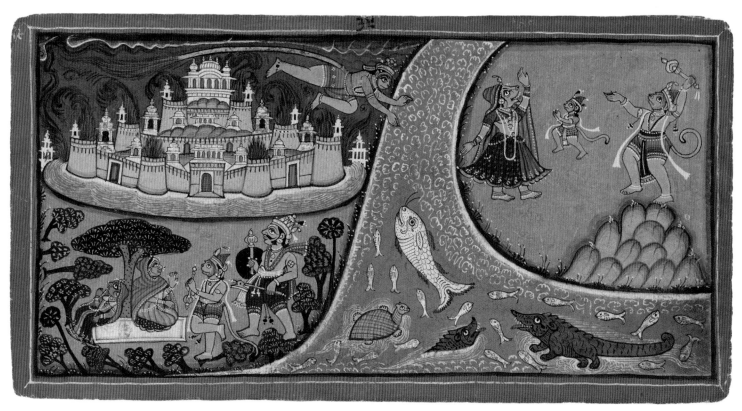

92

91 *also p. 146 and fig. 38*

Hanuman and Sita in the grove, 1800–1900

India; Karnataka or Andhra Pradesh state
Opaque watercolors on paper
H. 31.6 × W. 42.1 cm
The British Museum, 2003,1013,0.11, purchased with
assistance from Brooke Sewell Permanent Fund

Sita is probably handing a hair ornament to Hanuman
as a token for Rama. While these two figures fill the
left side of the painting, the right side is dominated
by Hanuman's exuberant tail, which snakes its
way around the trunks of three palm trees before
twisting around to point directly at Sita. This scene
probably illustrates Hanuman's initial meeting with
the kidnapped Sita on the island of Lanka. When
Hanuman departs from Lanka, he will use his tail
to set fire to Ravana's kingdom (see cat. no. 90).

Indian artists likely based their depictions of
Hanuman on gray langurs, the most common monkey
species in South Asia. A particular characteristic
of this type of monkey is the way that the tail tip
loops toward the head, especially when the animal
is walking. The long and looping tail of Hanuman is
featured in this depiction as well as in many other
images of the monkey hero.

Paintings such as this one were used in storytelling
performances; a different scene would have been
attached to the back. The bold colors, striking
patterns, and conventions for depicting bodies seen
here are also found in the shadow-puppet theater
and textiles of the southern Indian states of Karnataka
and Andhra Pradesh.[1] This region is known for its
palm wine, and the artist of this painting integrates
a local scene of toddy tappers collecting palm sap as
a background to the narrative. N.R.

NOTE
1. Dallapiccola, *Die "Paithan"-Malerei.*

92

Hanuman's visit to Sita in Lanka and other adventures, approx. 1775–1800

India; Gujarat state
Opaque watercolors and ink on paper
H. 16.5 × W. 31.8 cm
Los Angeles County Museum of Art, Purchased with
funds provided by Christian Humann, M.72.11

The artist repeats the figure of Hanuman four times in
this painting of the great monkey's initial journey to
find Sita in Lanka. On the right of the page, he stands
with club raised on a hill facing a demoness, probably
one of the three female demons that Hanuman meets
and defeats during his adventure. Between the two
figures is a much smaller monkey, which may also
represent Hanuman. In his confrontations with these
demonesses, Hanuman uses his special powers to
shrink himself to a much smaller size to fool them.

On the lower left, he has crossed the ocean to
Lanka and meets with Sita in Ravana's garden.
A royal figure, perhaps Ravana himself, stands
behind Hanuman. In many accounts of this episode,
Hanuman remains hidden in a tree and observes
Ravana threatening Sita. This may be a local variation
of the story.

At the center of the painting, Hanuman is shown
flying through the air, his tail lighting fire to the
buildings of Lanka. Consistency in the depiction of
Hanuman was not a priority of the artist or artists of
this page; Hanuman is dressed differently as he flies
above Lanka than he is in the other two scenes.

One senses a playfulness in the depictions of the
creatures in the ocean and in Hanuman's exuberant
pose on the right side of the painting. N.R.

93 *also pp. 144–145 and fig. 52*

Hanuman leaps across the ocean, approx. 1720

Attributed to the workshop of
Pandit Seu of Guler (d. 1740)
Opaque watercolors and gold on paper
Image: H. 19.5 × W. 26.5 cm
Museum Rietberg Zurich, RVI 840

"Tireless Hanuman sailed across the lovely, shining, and boundless sky."[1]

Effortlessly flying across the night sky, Hanuman departs from Lanka after finding Sita and lighting the kingdom on fire. The artist emphasizes the power of his jump, which is so forceful that the tip of Hanuman's crown breaks through the border of the painting. In many written versions of the Ramayana, Hanuman's initial leap over the ocean is given prominence; in Valmiki's Ramayana, it is the center of the epic, and one hundred ninety Sanskrit verses are dedicated to this feat. Hanuman's ability to fly through the air is associated with traditions that describe him as the son of the god of the wind.

In this painting, Hanuman appears suspended against a brilliant blue background. Valmiki's text draws metaphors between the planets, stars, and winds of the night sky with the features of the ocean below.

The monkey's calm demeanor and purposeful forward-facing gaze contrast with the tumultuous ocean below, its churning waves filled with fish and sea creatures. Although they have been painted over, traces of paint seem to indicate streams of water that shoot from the dragon's nostrils toward the flying monkey. Hanuman's golden sashes and tiger tail float behind him, and one can imagine the jingling of the bells on his belt as he speeds through the air. N.R.

NOTE

1. Goldman and Sutherland Goldman, *Sundarakāṇḍa*, 262 (55:1).

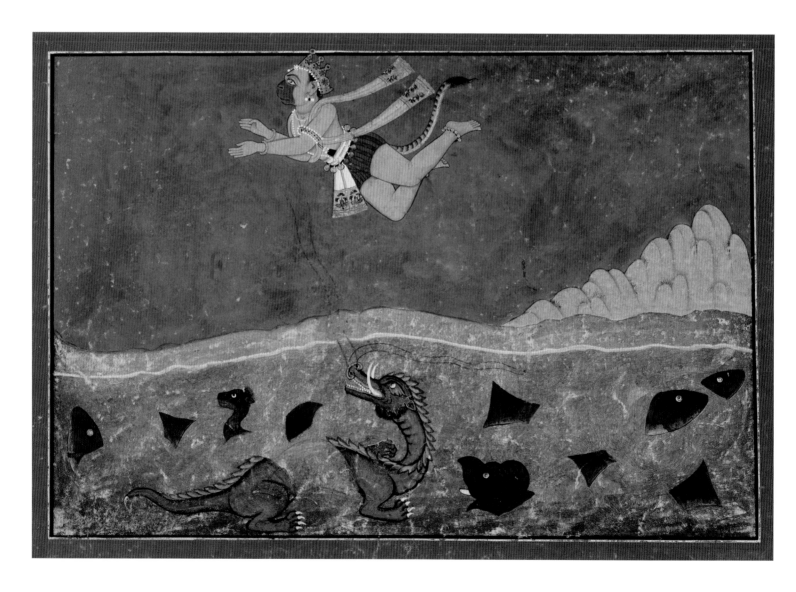

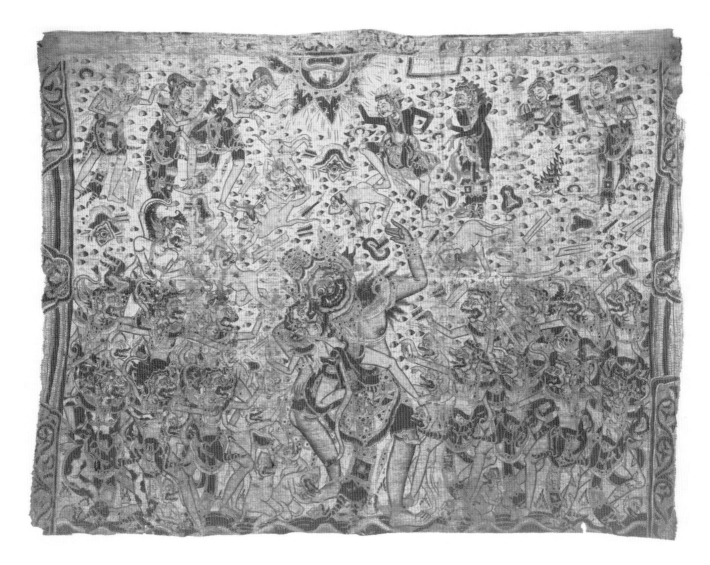

94 *also fig. 72*

Hanuman and the monkeys battle
demon giant Kumbhakarna, 1800–1900

Indonesia; Bali
Cotton plain weave with natural dyes
and mordants, and mordant painting
H. 132.7 × W. 177.2 cm
Philadelphia Museum of Art, Gift of
Miss Mary K. Gibson, 1952-60-2

The large figure in the center of the painting is
Kumbhakarna, the giant brother of the demon
king Ravana.[1] Despite his personal reservations,
Kumbhakarna is drawn by familial loyalty into the
battle against Rama's forces. Here he is besieged by the
monkey troops, who swarm in tangled masses around
him. In his arms he clutches Sugriva, the king of the
monkeys, whom he has captured. The artist portrays
the moment when Sugriva has regained consciousness
and bites Kumbhakarna's face, temporarily shocking
the giant, which allows the monkey to escape. Other
characters from the epic appear along the top register
of the painting. An inscription in the center mentions
the sun god Surya, and a second inscription may
indicate a date, but it is difficult to read.

Hanuman is shown in white on the left side of
the painting, floating above the melee with a weapon
in his hand. In Valmiki's Ramayana, Hanuman
contemplates saving Sugriva but then decides that
the king's honor might be tarnished if he does so.[2]
This consideration of dharma (correct behavior)
is the same in the monkey world as it is in the
human one.

The carnage of the battlefield is captured in a
background filled with injured monkeys, broken
arrows, and the ubiquitous eye-shaped filler motif
found on traditional Balinese paintings. This painting
is made in the so-called Kamasan style, named after
the village in southern Bali, where painting on cloth
with natural pigments continues today. Paintings like
this one are used in Bali to decorate temple pavilions
during religious festivals. N.R.

NOTES
 1. For an examination of the role of Kumbhakarna in Valmiki's
Ramayana, see Goldman, "To Wake a Sleeping Giant," in Goldman
and Tokunaga, *Epic Undertakings*, 119–138.
 2. Goldman, Sutherland Goldman, and van Nooten, *Yuddhakāṇḍa*,
292–293 (55:54–62).

95

The invisible Indrajit fires arrows
at Rama and his allies; end panel
from a box, approx. 1500–1600

Sri Lanka
Ivory
H. 12.1 × W. 13.7 cm
Virginia Museum of Fine Arts, Friends of Indian Art
and the Robert A. and Ruth W. Fisher Fund, 2004.16

On this panel, which once belonged to an ivory box used to hold precious objects, Ravana's demon son Indrajit is shown in the clouds in the central niche. In the battle between Rama and Ravana's forces, Indrajit was one of the fiercest warriors in his father's army. Given weapons with special powers by the gods, he is able to wreak havoc on Rama's forces. Through magical illusion that renders him invisible, he floats in his chariot above the invading troops and shoots arrows down at them (cat. no. 128). He is finally defeated by Rama's brother Lakshmana. Many tellings of this episode describe days of battle between Indrajit and Lakshmana. After much bloodshed, Lakshmana kills Indrajit with an arrow, in some versions severing his head and in others piercing his chest.

On the right in this plaque is a man on a monkey, a pairing often associated with Rama and his loyal follower Hanuman.[1] If this is the case, the figure in the center might be Lakshmana, falling after being injured by Indrajit. On the left, another monkey fights an enemy. The monkeys are portrayed here as sturdy supporters and brave warriors in the battle against Ravana.

The finely carved panel includes small details on the upper right and left corners that may be the marks of one of the Hindu sects of the Tamil Iyengar caste, the Thenkalai.[2] These marks are often drawn with powder or paste on worshipers' foreheads. See, for instance, the mark on the forehead of Hanuman in cat. no. 78. N.R.

NOTES

1. In a Tamil telling of the Ramayana, Lakshmana also is described riding on Hanuman's shoulders. Kamban and Jagannathan, *Kamba Ramayana*, 314, 364. For an eighteenth-century painting that depicts Lakshmana on Hanuman's shoulders, see *Lakshmana Fights Indrajit*, Walters Art Museum, accession number W.902.

2. Thanks to John Henry Rice for bringing these details to my attention.

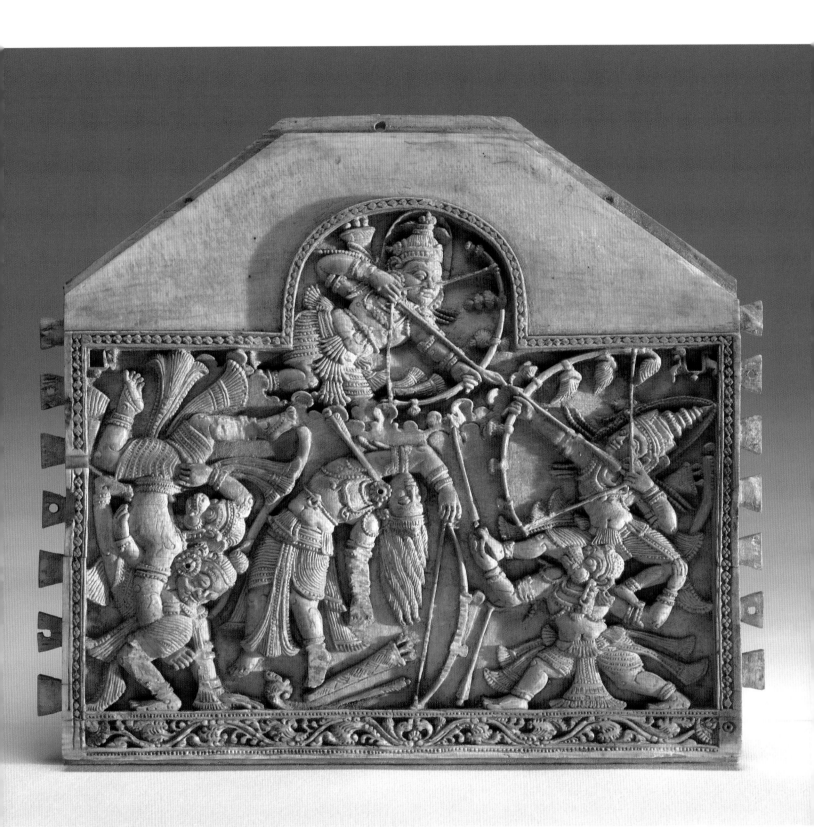

96

Hanuman flies to the Himalayas for magical herbs, page from the Mewar Ramayana, 1649–1653

By Sahibdin (Indian, active approx. 1625–1660)
Opaque watercolors on paper
H. 27.2 × W. 46.5 cm
The British Library, Add. 15297(1) f.100r

97 *also p. 258*

Hanuman returns with medicinal plants, 1775–1780

India; Himachal Pradesh state, former kingdom of Guler
Opaque watercolors and gold on paper
Image: H. 24.5 × W. 31 cm
Museum Rietberg Zurich, Collection of
Eva and Konrad Seitz, B40

These two paintings offer radically different conceptions of the same episode of the Ramayana. After the heroes Rama and Lakshmana are struck by magic arrows, Hanuman is sent to a mountain in the Himalayas to retrieve life-restoring herbs. Unable to identify the specific plant needed, Hanuman lifts the entire mountain and returns it to the battlefield. The works' palettes, constructions of space, and depictions of nature seem worlds apart, and yet both images effectively relate this dramatic scene.

In the Mewar painting, the landscape's fecundity is emphasized with bright colors of flora contrasting with the multihued hills. Streams pour down from each mountain into a fish-filled river that forms the lower border of the painting. The artist uses continuous narration, showing Hanuman three times within the panel. On the left he springs into the air, on the far right he lands on the mountain, and in the center of the painting he returns, his arms cradling the peak and his tail gently wrapping around it.

The painting from Guler is as elegantly understated as the Mewar painting is exuberant. The landscape is dominated by a white mountain that slants across the page, taking up almost half of the image. Hanuman is shown twice, once on the left grappling with the plant-covered peak and again flying with it held above his head as he returns to the battlefield. Below him lie green hills and meandering rivers, and awestruck denizens of both small huts and fine palaces stand and look upward. Just as Sahibdin drew from his familiarity with the red, rocky hills of Rajasthan, one senses in the Guler painting the artist's knowledge of the snow-covered peaks of Himachal Pradesh. N.R.

96

98 *also fig. 57*

Hanuman carries Rama and Lakshmana,
December 14, 1977

By Baua Devi (Indian, b. 1944)
Ink and colors on paper
H. 76.2 × W. 57.2 cm
Asian Art Museum, Museum purchase, 1999.39.21

Hanuman dominates this painting, striding forward with small figures of Rama and Lakshmana perched on his shoulders. Two interpretations of this scene are popular. In one, Hanuman is thought to be carrying the brothers to meet Sugriva for the first time. In another, he has rescued the brothers from the underworld, where they were captured by Mahiravana/Ahiravana (Ravana's brother). The latter scene is found in tellings of the Ramayana in numerous South and Southeast Asian languages, although it does not appear in Valmiki's version.[1]

Using a simple palette and bold black lines, the artist depicts the characters amid a background of flowers. The monkey hero is distinguished by the faint hint of a monkey's muzzle, the club that seems to float in front of him, and the long, striped tail that flows behind him like a scarf.

Sita's father, King Janaka, is said to have once ruled the Mithila region of Bihar state along the border of India and Nepal. According to popular belief, the regional style of painting originated when village women were asked to decorate the mud walls of the town's buildings in celebration of Rama and Sita's wedding. That wall painting developed into works on paper in the mid-1960s when the Indian Handicrafts Board encouraged women to help support their families with this new enterprise. Baua Devi was one of the youngest women to begin painting on paper and has become one of the best-known artists of the Mithila region. N.R.

NOTE
 1. Lutgendorf, *Hanuman's Tale*, 151, 211–216.

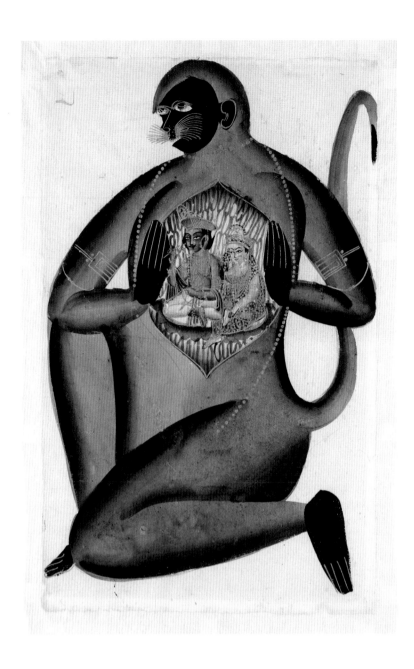

99 *also fig. 58*

Hanuman revealing Rama and Sita in his heart, approx. 1865–1870

India; Kolkata, West Bengal state
Opaque watercolors and tin alloy on paper
H. 44.5 × W. 27.7 cm
Victoria and Albert Museum, London, Given by the University
Museum of Archaeology and Ethnology, Cambridge, IS.231-1953

Here we see Hanuman opening his chest to show Rama and Sita within his heart. According to a popular tale, Rama gives Sita a valuable pearl necklace, which she presents to Hanuman to thank him for his bravery and loyalty.[1] Hanuman begins biting the pearls to crack them open and peer inside. Members of Rama's court tease him, but he counters their derision by noting that everything of value must contain the divine. Someone then asks if Hanuman's own body has value, and the monkey rends his chest apart to expose the divine couple seated within. Although this act is shockingly violent, the artist depicts Hanuman kneeling gently, his head bent and his hands seeming to cradle the figures within him.

The scene depicted here gained popularity in the nineteenth century; it is not mentioned in Valmiki's or Tulsidas's telling of the Rama epic. It was painted in Kolkata (formerly Calcutta), the center of the British empire in India from 1833 to 1912. A distinctive style of painting developed when narrative scroll painters from West Bengal migrated into the city and began to sell single works on paper. Because of Calcutta's position as a trading center, paper and watercolors were available to artists; these materials replaced traditional cloth and gouache or tempera. Trade in these works was centered near temple complexes, where pilgrims and foreign travelers would buy paintings as mementos. N.R.

NOTE
1. Lutgendorf, *Hanuman's Tale,* 156, 218–220.

100

Hanuman revealing Rama and Sita in his heart, 1982
By M. F. Husain (Indian, 1915–2011)
Photolithograph on paper
H. 61 × W. 45.7 cm
Los Angeles County Museum of Art, Gift of
Mr. and Mrs. Chester Herwitz, M.91.315.4

This image refers to the same story as that of cat. no. 99. In an act illustrating his devotion, Hanuman tears open his chest to reveal Rama and Sita within his heart.

Here the artist M. F. Husain alludes to iconic portrayals of the comic superhero Superman, who is often depicted at a similar diagonal, leaping into the air in flight. In Husain's lithograph, Hanuman's brown head contrasts with his yellow body and red shorts, which evoke Superman's colorful bodysuit. His act of tearing open his chest calls to mind Clark Kent's ripping open his business shirt to reveal the "S" beneath it.

Throughout his career, Husain drew inspiration from Indian culture. In 1968 the artist began to produce paintings and drawings inspired by the Ramayana. Within eight years he created between eighty and one hundred fifty works on the epic,[1] a subject he returned to over the years. Between 1980 and 1982 he completed a series of ink and watercolor paintings, which were then turned into prints. This lithograph was part of a series focusing on the character of Hanuman. Others in the series included an image of Sita riding on Hanuman's tail, and another contained a naked Sita on the thigh of Ravana.

These works and others have been criticized by fundamentalist Hindus, who consider his depictions of deities sacrilegious. Husain's house was vandalized, and works on display in galleries in India as well as London were destroyed. Husain eventually left India to live in Doha and London. The controversy surrounding his work points to both the power of Husain's imagery and the fervency of belief in certain Hindu communities.

Husain has talked about the importance of the Ramayana and Hindu culture in his life and work:

As a child, in Pandharpur, and later, Indore, I was enchanted by the Ram Lila. My friend, Mankeshwar, and I were always acting it out. The Ramayana is such a rich, powerful story, as Dr Rajagopalachari says, its myth has become a reality. . . . Later, in Hyderabad, in 1968, Dr Ram Manohar Lohia suggested I paint the Ramayana. I was completely broke, but I painted 150 canvases over eight years. I read both the Valmiki and Tulsidas Ramayana (the first is much more sensual) and invited priests from Benaras to clarify and discuss the nuances with me. . . . Would I insult that which I feel so close to? I come from the Suleimani community, a sub-sect of the Shias, and we have many affinities with Hindus, including the idea of reincarnation. . . . It is people in the villages who understand the sensual, living, evolving nature of Hindu gods. They just put orange paint on a rock, and it comes to stand for Hanuman.[2]

N.R.

NOTES
1. Ramaswamy, *Barefoot*, 35.
2. Chaudhury, "In Hindu Culture."

101 *also fig. 48*

The monkey hero Hanuman carries a lady, perhaps Punnakay (Thai: Benyakai), approx. 1900–1950

Cambodia or Thailand
Paint and gold on cloth
H. 238.8 × W. 85 cm
Asian Art Museum, The Avery Brundage Collection,
B60D30+.a

This painting comes from a series representing characters from the Ramayana. Numerous retellings of this tale exist, not only in the Cambodian and Thai languages but also in many other Southeast Asian languages. Scenes from the Ramayana have long been enacted in courtly dance drama; in less formal, popular drama; and in puppet theater. Such episodes are also frequently depicted in sculpture and painting.

In Cambodian and Thai versions of the Ramayana, Ravana's niece Punnakay (Benyakai) is forced to disguise herself as Rama's wife, Sita. Punnakay pretends to be dead and nearly tricks Rama into abandoning the true Sita, but the ruse is discovered. After learning that Punnakay has been an unwilling pawn in Ravana's plans, the heroic monkey Hanuman returns her to the kingdom of Lanka. The female figure riding a white monkey shown here may represent Punnakay on the shoulders of Hanuman. However, in mainland Southeast Asia, Hanuman is not celibate, as he usually is in India, but has many romantic interests. Thus it is difficult to identify which lady love of Hanuman's is depicted here.

This work is unusual because it was created on cloth spread on a stretcher, unlike traditional paintings from the region. It may have been used to decorate a building such as a theater, college, or hotel.

N.R.

102

Shadow puppet of Hanuman wooing Ravana's niece Punnakay (Thai: Benyakai), 1973

Cambodia
Hide with pigments and bamboo
H. 146 × W. 103 cm
Musée national des arts asiatiques–Guimet, MA3708

In Thai and Cambodian dramatic performances, Hanuman's character is quite different from the heroic monkey of many South Asian tellings of the epic. This puppet depicts a scene emphasizing Hanuman's amorous nature, which is emphasized in mainland Southeast Asian versions of the Ramayana.

In Valmiki's Ramayana, we do not hear much of Hanuman's relationships. As a reward for his

service, Bharata offers Hanuman "sixteen maidens of excellent character, adorned with earrings, to be your wives. These are women of excellent caste and family, adorned with every ornament. Their complexions are like gold, their faces as lovely as the moon, and their noses and thighs perfect."[1] We do not hear if Hanuman accepts them.

By the sixteenth century, many texts in India highlighted Hanuman's celibacy and his sole devotion to Rama and Sita. This treatment stands in marked contrast to Khmer and Thai tellings of the Ramayana,

in which Hanuman has at least three wives, plus other female friends.

This puppet is said to depict Hanuman and Ravana's niece Punnakay (known as Benyakai in Thailand). Similar puppets show him wooing other female characters, including a mermaid and several celestial maidens. N.R.

NOTE

1. Goldman, Sutherland Goldman, and van Nooten, *Yuddhakāṇḍa*, 478–489 (113:40–42).

103

Cambodian dancers portraying Hanuman and a lady, 1934

By Thomas Handforth (American, 1897–1948)
Lithograph
H. 34.9 × W. 23.5 cm
Asian Art Museum, Museum purchase, 2014.44

This lithograph shows two characters from a dance drama depicting a Khmer telling of the Ramayana. The standing figure wears a mask of a monkey, and the kneeling figure is a female character. If the lithograph were accurate, it would show the placement of the armlet on her right arm and the fold of the top of her lower garment to the left, but this likely was reversed in the printing process.

It is difficult to determine which scene is portrayed. The monkey is Hanuman, but the female character could be one of Hanuman's romantic interests. In South Asia, Hanuman is portrayed as being single-mindedly devoted to Rama and Sita; in Southeast Asia, though, he romantically pursues several female characters.

When this lithograph was reproduced in a magazine in 1934, it was described as being based on the American illustrator Thomas Handforth's observations of dancers at the famous Cambodian monument Angkor Wat.[1] Photographs from the first few decades of the 1900s record performances by the royal dance troupe at the temple, and Handforth most likely observed them. During Handforth's six years of living in Beijing, he had the opportunity to visit many parts of Asia, including Cambodia. N.R.

NOTE
 1. "Cambodian Dancers," 49–51.

"A visit to the ruins of Angkor by [King] S.M. Sisowath—the dancers of the king dance in honor of the guests." Probably 1909.

104

Standing Buddha flanked by two disciples,
supported by the monkey hero Hanuman,

approx. 1825–1875

> Thailand
> Paint and gold on cloth
> H. 207.6 × W. 88.9 cm
> Asian Art Museum, Gift of John Kerry Little, 2015.28

Why are the Buddha and his disciples shown held
aloft by Hanuman, while two ordinary monkeys
caper nearby?

This question has no clear answer. The subject is
rare and seems not to have been studied by scholars.[1]
But episodes and figures from the Rama epic turn
up often in Thai Buddhist contexts (as is discussed
on p. 41). Rama was associated with the Buddha,
either as a rebirth-precursor or as a more general
analogue.[2] So, if Rama is sometimes shown supported
or conveyed by Hanuman, then perhaps the Buddha
can be, too.[3] The question of what creatures can be
shown conveying the Buddha is complicated, though,
and needs more study. In a gilded lacquer panel in
the Asian Art Museum's collection, an array of forty
Buddhas is carried by a flying demon.[4]

At the lower edge of this painting is a damaged
inscription that follows the pattern of dedicatory
inscriptions on such works. It says that the painting
of the Buddha is given by Mother So-and-so for the
Buddhist religion. She hopes that the donation will
contribute to her reaching Nirvana in the future.

<div align="right">F.McG.</div>

NOTES

1. Only a few other known paintings show Hanuman supporting
the Buddha. One at the Metropolitan Museum of Art (59.179.2) is
rather similar in configuration to this one. In another, also at the
Asian Art Museum (B60D106), the structure on which the Buddha
and disciples stand is shouldered by two demons as well as Hanuman;
below them is an apparently unrelated scene of an encounter between
the powerful monk Upagupta and the demon Mara (McGill et al.,
Emerald Cities, 130–131). A painting at the Walters Art Museum also
shows Hanuman and two demons supporting the Buddha and his
disciples; Ginsburg, "Thai Painting in the Walters Art Museum," 116.

2. See Reynolds, "Holy Emerald Jewel," 185; and Reynolds,
"*Rāmāyaṇa, Rāma Jātaka*, and *Ramakien*," 58–59.

3. A famous early depiction of Rama standing on the shoulders
of Hanuman is in the bas-reliefs of the west gallery of Angkor Wat.
(It can be seen by searching images online for "Angkor Wat Rama
Hanuman.") A later example is a wooden relief in the National
Museum, Phnom Penh, no. Gha.443, which can be seen in the
museum's online collection database. An Indian example is cat.
no. 124.

4. Acc. no. 2006.27.48. See McGill et al., *Emerald Cities*, 110.

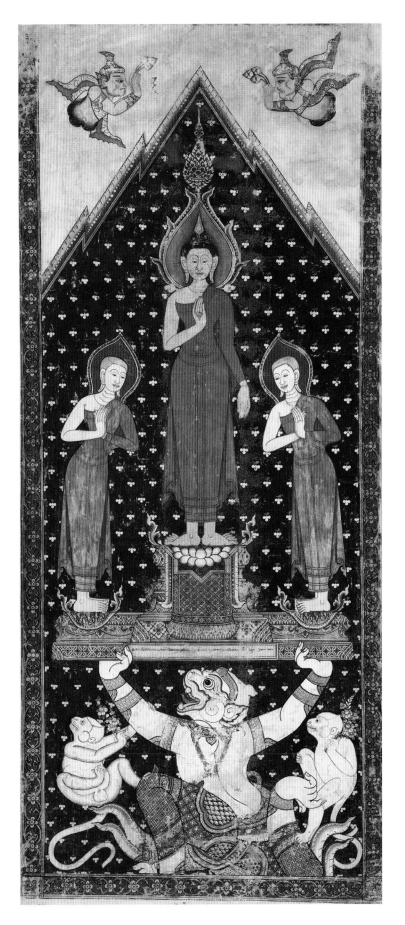

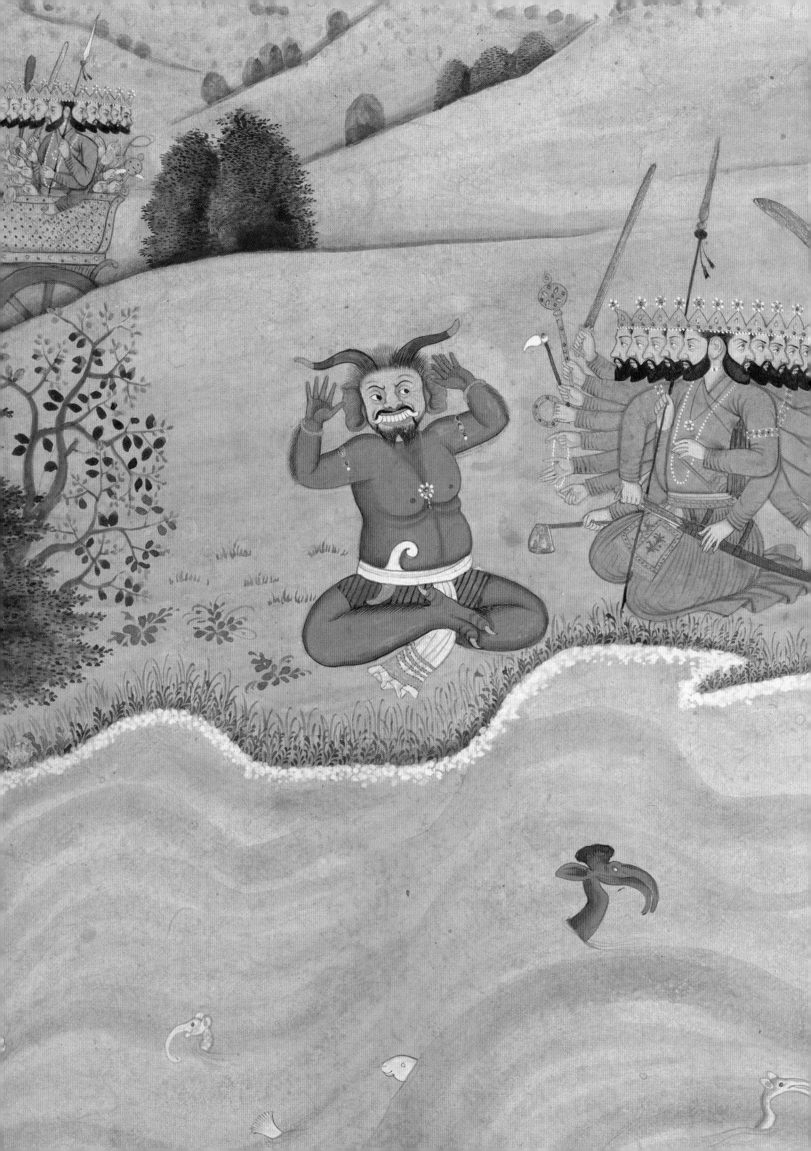

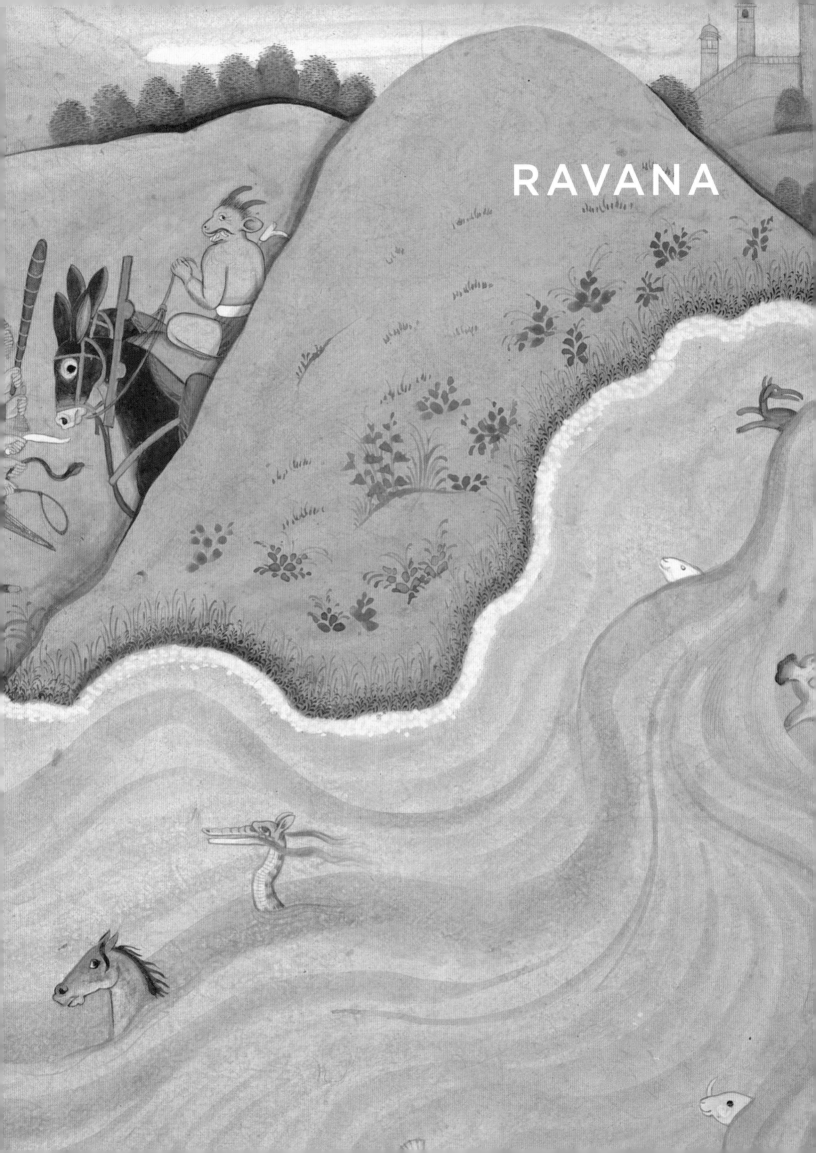

RAVANA

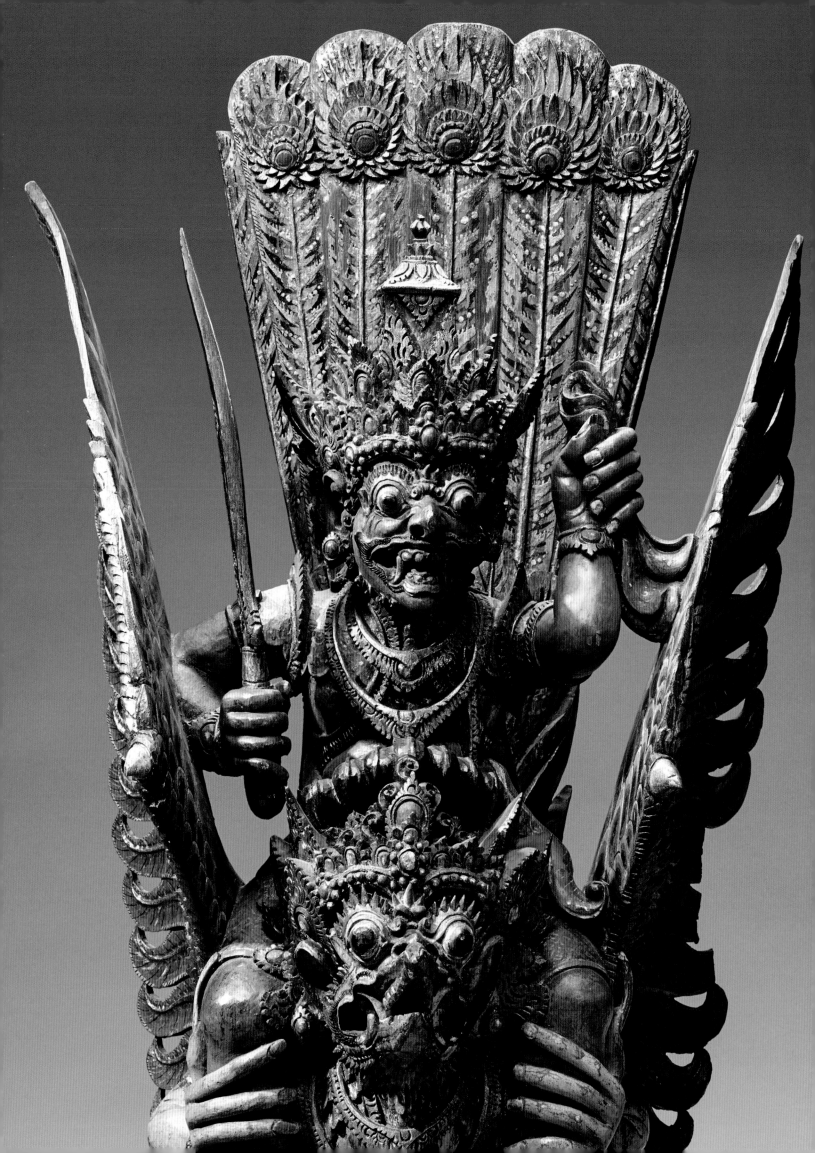

FORREST MCGILL

Picturing Ravana

On most points about Ravana there is no possible doubt whatever. He has ten heads, or fewer, or one. He is red, or green. He fathers Sita, or he doesn't. He is a symbol of cataclysmic cosmic evil, a stock music-hall villain, a tragic antihero, or a damnation-defying embodiment of self-will and unrestrained aggressiveness and lust to whom we react with a mixture of attraction, envy, dread, and nervous laughter reserved for the likes of Don Giovanni.[1] How could a picture created, recreated, or retouched for over two millennia by countless artists, performers, and poets in a dozen countries be expected to be more distinct or less layered and inconsistent?

The back story of Ravana's life before the main events of the Rama epic is told at length in the final book of the Valmiki Ramayana, the Uttarakanda. With one exception, though, the episodes of the back story are not often depicted by artists and so will not be discussed in detail here.[2]

Suffice it to say that Ravana is born a ten-headed, twenty-armed child of mixed ancestry, who counts among his forebears brahmans, celestial musicians, and members of the race of demons known as rakshasas. At a certain point while growing up, egged on by his mother, he becomes envious of his half-brother,

FACING
Detail of cat. no. 108

the king of Lanka, and resolves to gain the power to surpass him.

To do so he begins the sort of extreme austerities that in Indian tradition gain the attention of the gods and encourage them to give rewards. He fasts for a thousand years, and then cuts off one of his heads and gives it as an offering; these fasts and offerings he repeats until he has only one head left. Now the great god Brahma favors him and suggests he ask for a boon. Ravana requests immortality, but when Brahma is unwilling or unable to comply, he then asks to be invulnerable to being killed by a god or any of the other classes of beings he lists. He intentionally does not mention humans or animals, because he believes that such creatures are not a mortal threat. Brahma grants the boon, restores his sacrificed heads, and adds that Ravana will have the ability to assume any form he wishes.[3]

Ravana now claims his right to the throne of Lanka, and his half-brother assents. Ravana marries Mandodari, who becomes his chief queen. While the prosperity of his kingdom suggests that Ravana rules effectively, he exercises his demonic nature in violent and disruptive acts elsewhere, killing sages, laying waste the landscape, and making the gods themselves apprehensive. Rejecting appeals to reform, he pursues universal conquest and domination. The stability and righteous order of the world are endangered.

FIG. 59. Relief of Ravana shaking Mount Kailasa in Cave 29, Ellora (detail of cat. no. 115).

Now comes the episode that is frequently represented in the arts. Ravana, having completed an attack, flies homeward toward Lanka in the aerial palace he has wrested from its owner. Passing over a mountain, the palace comes to a halt. On the slopes below, the deity Shiva and his wife are engaged in love play, and no overflight is permitted. Ravana, enraged as usual, descends, grasps the mountain, and struggles to uproot it, disturbing its inhabitants (fig. 59). Shiva, whose might is infinitely beyond the demon king's, moves his foot and pins him beneath the mountain's weight. Advised to appeal for Shiva's mercy, Ravana worships the great god for a thousand years. Shiva, pleased, releases him.

Ravana's warlike violence toward gods and men is matched by more intimate violence toward women. He abducts those who catch his eye and adds them to his harem. How far his transgression goes is a contentious matter. In Book 5 of the Valmiki Ramayana we are told that Ravana does not force himself on the women he kidnaps, and that during the time Sita is his captive he threatens to impose himself on her sexually, but refrains.[4] In Book 6, when he is killed, his wives mourn him as though they feel truly bereft, and there is no

suggestion that they are relieved to be rid of him. In Book 7, the Uttarakanda, however, the extremity of Ravana's sexual violence against women is pronounced. He assaults a pious young female ascetic named Vedavati, seizing her by the hair. Though the text does not say explicitly that he rapes her, there seems little doubt.[5] A rare painting of the scene from the Mewar Ramayana is graphic to a degree unprecedented in the manuscript, showing Ravana penetrating the young woman with his penis (fig. 60).

Vedavati, enraged at Ravana's actions, throws herself into the fire. Drawing on the power she has gained through asceticism and sacrifice, she promises to be reborn as a noble-minded woman who will bring about Ravana's destruction. In her reincarnated form as Sita, she will make good the promise.

In the Uttarakanda, we learn more of Ravana's violent and hateful deeds in the past, and of the consequences they will have (or will have had, since the Uttarakanda comes after the main action of the epic and is told in retrospect). Ravana, again inflamed with lust, rapes another young woman, the wife of his half-nephew. Her husband issues the baleful curse that if

Ravana forces himself on any other unwilling woman, his head will split and he will die. This curse, we are given to understand, is why Ravana did not rape Sita when he held her captive.[6]

Ravana continues his campaigns of territorial conquest, killing numberless opponents and challenging the gods (fig. 61). It is in this context that the deity Vishnu eventually agrees to descend to earth in the form of a great hero, Rama, to overcome Ravana and restore righteous order.

This outline of Ravana's life and career before the main action of the epic is based on the Ramayana of Valmiki because its incidents are not often recounted in detail, or at all, elsewhere. It is worth underlining,

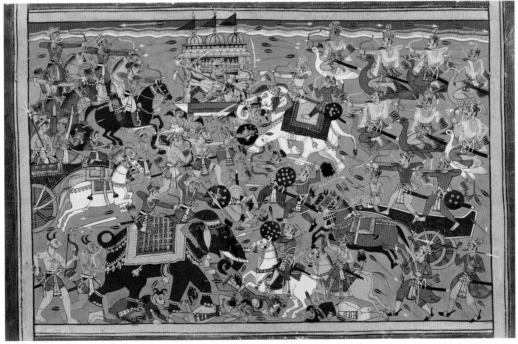

FIG. 60 (*top*). Ravana rapes Vedavati. From the Mewar Ramayana, 1649–1653. The British Library Add. MS 15297(2), f.30r (painting).

FIG. 61 (*above*). Ravana and his forces battle the gods. From the Mewar Ramayana, 1649–1653. The British Library Add. MS 15297(2), f.60r (painting).

though—as discussions elsewhere in this catalogue suggest—how varied are the interpretations of Ravana's personality and character in different places and periods of time. Everywhere, though, one point is emphasized: Ravana has titanic powers of intellect, of charisma, of physical strength, of magic, and, above all, of will. He must have, to be an antagonist worthy of the sustained efforts to crush him on the part of the gods and Rama.

According to Valmiki, Hanuman himself, in one encounter with Ravana, says of him,

> Oh what beauty! What steadfastness! What strength! What splendor! Truly, the king of *rākṣasas* is endowed with every virtue! If this mighty *rākṣasa* lord were not so unrighteous, he could be the guardian of the world of the gods, Indra included.[7]

Of course *if he were not so unrighteous* is a big qualification, as Ravana's victims would, and sometimes do, protest.

The contradictions and ambiguities of Ravana's character, even in just the Valmiki Ramayana, may result in part from changing attitudes during the centuries of its compilation. (The first and last books are thought to be somewhat later than the central ones.)[8] But artistic and psychological factors also seem to have a role in his complexity. Rakshasas have the power of shape-shifting and, as mentioned earlier, Brahma has reaffirmed this power in Ravana.

The most famous instance of Ravana's shape-shifting is when he takes on the appearance of an ascetic to deceive Sita into letting down her guard before he abducts her (fig. 62). In a discussion of the nature of rakshasas, the scholar Sheldon Pollock notes that "there is something profoundly threatening about the absence of a stable, perdurable personality; one's interlocutor may never be what one believes him to be."[9] Poets and other artists have generally allowed us to predict how Rama or Sita will act or react in a situation. From Ravana we can usually expect fury and lust, but not always; besides, who is that ascetic who just wandered up?

Oppositional interpretations of the Rama epic have seen, and continue to see, Ravana as an admirable figure, or at least as the object of slander and misrepresentation. One such interpretation is that of the twentieth-century social reformer E. V. Ramasami. He championed the rights and cultures of southern Indian speakers of Dravidian languages, such as Tamil, and of lower-caste people against what he saw as oppression by high-caste northern Indian speakers of Indo-European languages such as Hindi. In his view, Ravana was a great Dravidian king resisting the hegemonic encroachments of northern Indian forces represented by Rama and his allies.[10]

Ramasami considers the portentous interaction of Ravana's sister with Rama and his immediate family and its aftermath. These episodes are well worth pondering. How they are interpreted and what their significance is taken to be depend very much on whose point of view—whether narrator's, character's, or reader's—they are seen from. In Valmiki's narration of the story, Ravana's sister Shurpanakha—like him a member of the rakshasa race—sees Rama, is consumed with desire

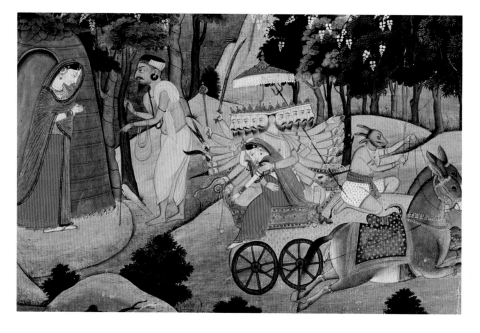

FIG. 62. Ravana assumes the form of an ascetic and then reverts (detail of cat. no. 61).

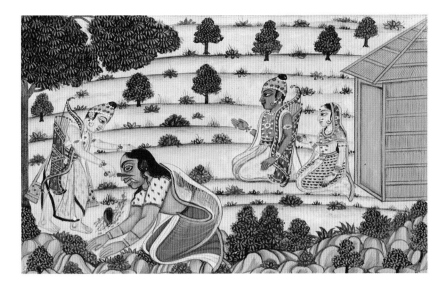

FIG. 63 (*left*). Lakshmana cuts off the nose of Shurpanakha (detail of cat. no. 22).

FIG. 64 (*below*). Ravana's sister reports to him of her maltreatment by Rama and Lakshmana, and of Sita's beauty (detail of cat. no. 118).

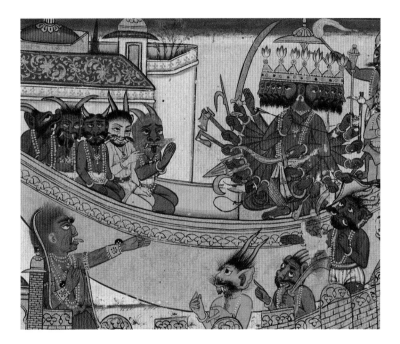

(according to the narrative) or love (as she herself says), and proposes marriage, promising to devour Sita to get her out of the way. Rama deflects her toward his brother Lakshmana, who makes fun of her. Spurned, Shurpanakha again threatens Sita. Rama directs Lakshmana to cut off her nose and ears in punishment (fig. 63).[11]

Shurpanakha describes her ill-treatment to another of her brothers, and, when he and his forces attack Rama, Rama kills them all, fourteen thousand strong. Now Shurpanakha reports these events to Ravana and rebukes him for his inattention to protecting his people (fig. 64). As a further spur to action, she also tells Ravana of Sita's incomparable beauty. Thus is set in motion the central action of the epic, Ravana's seizure of Sita and the long efforts of Rama and his allies to get her back.

From a certain conventional perspective of the story, blame ultimately falls on Shurpanakha. She did not control her sexual urges as she should and then committed the outrage of threatening Sita. The fact that she is a hideous demoness, self-deluded and uncomprehending of the effect her threats to devour Sita will have, gives a shade of uncomfortable ridiculousness to the situation and distances it from us. Rama "was young, attractive, and well mannered, she ill mannered, repellent, an old hag," Valmiki reminds us.[12]

But in Ramasami's view, Shurpanakha's mutilation at the hands of Rama and Lakshmana justifies—indeed necessitates—retaliation by Ravana.

It is worth thinking more about the situation from Ravana's point of view. First, though, envision the episode of Shurpanakha's report to Ravana as if it were a scene in a performance. It has already been a long evening, and we have not yet glimpsed Ravana. After an intermission the curtain rises: Shurpanakha "found Rāvaṇa in his splendid palace, radiant in his power, his advisors sitting beside him. . . . He was seated on a golden throne radiant as the sun, and he looked like a fire on a golden altar blazing with rich oblations. A hero invincible in combat with gods, *gandharvas,* spirits, or great seers, he looked like Death with jaws agape. . . ." (Valmiki's description of Ravana goes on for fifteen more verses).[13]

Revealed to us in such majesty, what does this "broad-chested mighty king" do or say? Nothing. His sister launches into her scena:

Drunk as you are on sensual pleasures,
So licentious and unbridled,

You overlook the one thing you must not,
The presence of terrible danger. . . .
But, consumed with lust, negligent,
And no longer your own master, Rāvaṇa,
You are unaware of the danger present in your
 own realm.
In times of trouble
No one runs to aid a king
Who has been cruel and ungenerous,
Negligent, haughty, and treacherous.

The deluded, ridiculous Shurpanakha has become a Fury of truth-telling, and Ravana must endure it. He "paid heed as she recited his failings in this fashion, and for some time afterward the lord of nightstalkers, with all his wealth and pride and power, sat lost in thought."[14]

The news Shurpanakha has brought him is dire indeed. She, his royal sister, has been humiliated and cruelly disfigured. His royal brother, retaliating, has been massacred, along with another brother and fourteen thousand soldiers. All this has been the responsibility of one man. Wouldn't anyone seek revenge?

Rama must be punished. He has a supremely beautiful and virtuous wife, to whom he is devoted. If she is taken from him, he will both suffer her loss and be shamed, his masculinity impugned. Ravana will gain vengeance—and the most desirable woman in the world as his prize.

Ravana (presumably reasoning that, since Rama has just single-handedly killed fourteen thousand demon soldiers, a direct attack is not the best course) sets in play a stratagem. One of Ravana's henchmen, the de-mon Maricha, is required to turn himself into a jeweled deer and lure Rama away from Sita's side long enough for Ravana to kidnap her (see cat. nos. 63 and 119).

The kidnapping is another of those famous scenes that audiences wait for. In the visual arts the successive moments are represented sometimes together and sometimes separately. First, Ravana, in the guise of a seer, tricks Sita into allowing him to approach her; second, he flies off with her in his aerial chariot (fig. 65); third, he battles the heroic vulture Jatayus, who tries to rescue Sita, and deals the bird a mortal blow.

In his encounter with Jatayus, Ravana is again subjected to an extended condemnation, but this time from a wholly admirable creature whom we immediately respect. Jatayus is a sixty-thousand-year-old friend of Rama's father. He proudly announces himself to Ravana, saying, "I am Jatayus, the powerful king of vultures, who keeps to the ancient ways of righteousness and puts his trust in truth." As Ravana tries to flee with Sita, Jatayus accosts him, enumerating his faults at length and warning him (correctly, of course) that "carrying her off will lead to the slaughter of the *rākṣasas*. . . . You are caught in the noose of Doom." Jatayus is just one of many enemies and friends who caution Ravana and attempt to dissuade him from stealing Sita and later refusing to return her, even though his obstinacy will bring death and destruction on him and thousands of his followers. As usual, Ravana rejects the advice and, "blind with rage," strikes back.[15]

In the aerial dogfight that follows, Jatayus succeeds in destroying Ravana's flying chariot and the brutish donkeys that pull it, but eventually he tires and is

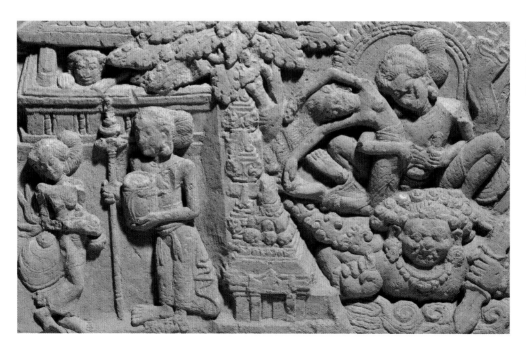

FIG. 65. Ravana tricks Sita and then flies off with her (detail of cat. no. 62).

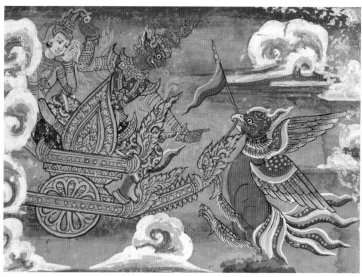

FIGS. 66–68 (*clockwise from left*). The combat between Ravana and the vulture Jatayus in fifth-century India, nineteenth-century Myanmar, and twenty-first-century America (details of cat. nos. 64, 63, and 122).

bested (figs. 66–68). Ravana cuts off his wings and feet, and Jatayus falls, slowly dying.

Everything about the scene evokes our anger toward Ravana and sympathy for the wise and stouthearted ancient vulture. When he fell, "Sita, daughter of Janaka, took him in her arms and wept." Later, when Rama and Lakshmana return to find Sita gone and the old family friend about to breathe his last, Rama caresses him, "showing all the affection of a son for his father,"[16] and carries out a respectful cremation (see cat. no. 28).

An eighteenth-century painting from the north of India shows the handsome Ravana at his worst:

clutching the helpless Sita, his hand across her breast, he hacks at the already dismembered Jatayus (fig. 69). Next to his smashed chariot his dead donkeys sprawl; the artist has positioned one to expose and emphasize its genitals. Donkeys were associated not only with stubbornness but also with uncontrolled sexual desires.[17] Here are summed up the charges against Ravana: brutal violence, rapine, and rampant lust.

What we think Ravana "really" feels for Sita in any artistic or literary context is, of course, a matter of our personal reactions. While he has her in captivity in a grove near his palace, he repeatedly pleads with her and threatens her. How do we assess what he says? Is all

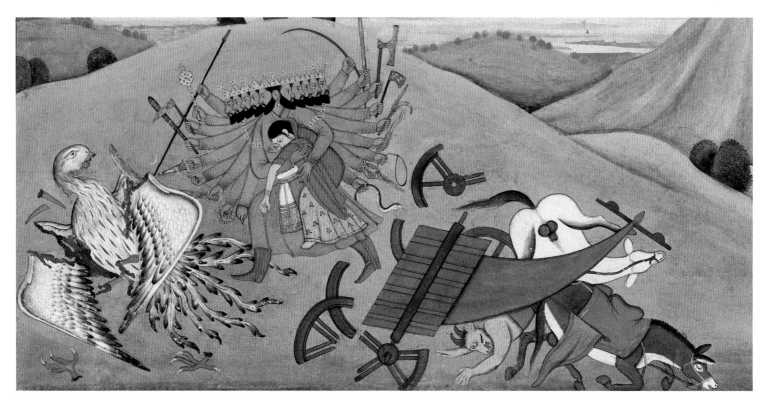

FIG. 69. The abduction of Sita (detail of cat. no. 66).

the pleading simply the sweet talk of the seducer? Are the threats entirely serious or partly playful?

In the Valmiki Ramayana we hear,

I long for you, wide-eyed lady. Dear lady, you are endowed with every bodily perfection. Stealer of all men's hearts, please look upon me with favor. . . . I will never touch you unless you desire it, though Kāma, the god of love, may rage through my body to his heart's content. You must trust me, dear lady. . . . Give me your true love.

You must be my wife. . . . You will be the chief queen. . . . All of the choice things I have taken by force from all the worlds will be yours, timid lady, as will my kingdom and myself.[18]

Or in Kamban's Tamil language Ramayana,

"Accept me, the ruler of the three worlds, as your slave," he pleaded, falling at her feet, unmindful of the scandal and shame of such unmanly abasement.[19]

But (Valmiki again),

Whenever a man treats a woman gently, he ends up being humiliated. The more I speak sweetly to you, the more I am rejected. Nonetheless, the desire for you that has arisen in me reins in my anger, as a

skilled charioteer reins in his speeding horse on the road. Truly, desire is one of man's perversities; for it gives rise to compassion and affection in whomever it is aroused. That is the only reason I do not kill you, my pretty one. . . . Once the two months have passed, if you still do not want me for your husband, then they will slaughter you in the kitchen for my breakfast.[20]

Now, I am picking and choosing verses, of course, but what they present is pretty typical of many tellings of the story. I confess I am at a loss to reach a firm sense of what is going on. Would an ordinary seducer kneel and beg to be accepted as a slave? And what about "desire is one of man's perversities; for it gives rise to compassion and affection in whomever it is aroused"? That sounds serious and important, not like a commonplace pickup line. We seem to be once more in Mozart territory, where lying and truth-telling, seriousness and parody, are going on simultaneously, even in the same utterance, and are too interwoven—too integral—to be unraveled.[21]

Artworks, too, may be ambiguous. A nineteenth-century Thai relief shows Ravana coming to plead with Sita (fig. 70). Verses of the classical Thai Rama epic say, "His love had bound him and kept a hold on his heart. He felt a desire to sleep with her. The heat of his desire was like the Cataclysmic Fire." And then "He smiled while he said, 'You are the center of my life. I feel great affection for you, beautiful lady.'"[22] How do we read

the artwork itself? The facial expressions of demons are not very familiar. To my eye it is at least conceivable that Ravana's expression here comes from love as much as lust. And that cataclysmic fire? In this relief it is not some inferno but a candle flame flickering toward Ravana. Maybe Ravana is merely feeding Sita a line. I cannot help thinking, though, that we are meant to have more complicated reactions here, and to feel a degree of empathy for Ravana.

Another relief in the same series raises more questions about how we are to understand Ravana's personality. The demon king has a domestic life, of course, though it is not often depicted. Works in this publication picture him sitting with two senior wives and again quietly playing a board game with one of them (see cat. nos. 107 and 117). What the relief shows is altogether more intimate. Hanuman, having reached Lanka, is searching high and low for Sita. He investigates one part of Ravana's palace and then another, eventually reaching the king's bedchamber. He looks in and sees a woman sleeping with Ravana, and momentarily jumps to the conclusion that this must be Sita being unfaithful to her husband. Hanuman quickly grasps that he is mistaken, and that it is Mandodari, Ravana's chief wife, who sleeps with him.

Hanuman's spying on the slumbering Ravana is described at length in the Ramayana of Valmiki. Ravana's wives cluster around him—"the great *rākṣasa* lord was fond of his wives"—though he does not embrace a particular one; he has "ceased his dalliance for the night." The descriptions of what Hanuman sees have an extraordinary sensuousness. Of Ravana we are told that "with his red eyes, great arms, garments shot with gold, and his precious dazzling earrings, he resembled a great storm cloud. His body smeared with fragrant red sandalpaste, he truly resembled a cloud laced with streaks of lightning and reddened in the sky at twilight. He was handsome.... His shoulders were muscular, symmetrical, well-knit, and powerful . . . ," and so on. The account of the women is equally lush: "Yet another young woman, overcome by the power of sleep, lay sleeping, her breasts—like golden pitchers—cupped in her hands. Exhausted by passionate lovemaking, one woman—her eyes like lotus petals, her hips beautiful, and her face like the full moon—slept embracing yet another."[23]

Representations of this scene in the visual arts are rare, making the Thai relief particularly interesting. Ravana and Mandodari doze cuddled together; he gently clasps her bare nipple (fig. 71).[24] There is no suggestion

FIG. 70 (*above left*). Ravana pleading with Sita (detail of cat. no. 68).

FIG. 71 (*above right*). Hanuman finds Ravana asleep with his wife. Detail of a rubbing of a nineteenth-century relief at Wat Phra Chettuphon, Bangkok. Asian Art Museum F2008.49.

of any coercion here, or anything but tender affection. Mandodari, we know from elsewhere in the epic, is no fool and no shrinking violet. There are limits to what she would stand for. But here she seems enveloped in the warmth of marital contentedness.

We do not hear or see much more of Ravana's personal life. As his end approaches, though, he is increasingly shaken by doubts and wrenched by the loss of many of those closest to him.[25] Two of his brothers were killed, it will be remembered, when they attacked Rama to avenge Shurpanakha. Another brother, the upstanding Vibhishana, defects to Rama's side after too much abuse from Ravana himself (see cat. no. 37). Vibhishana repeatedly tries to help his brother see reason, act responsibly in various situations, and return Sita before it is too late. Ravana not only rejects his advice over and over but does so in insulting, hurtful ways. "If a man is a leader, competent, learned, righteous in his conduct, and valiant, *rākṣasa,* then his kinsmen will malign him and bring him down," spits Ravana, doing exactly what he accuses his brother of.[26]

The later losses take a grave toll, both directly and indirectly. Another brother, the vast (and usually sleeping) giant Kumbhakarna, also tries to talk sense into Ravana, but, like all the others who can see what is coming, he fails. Dutifully, though, he goes into battle when ordered and, after a gargantuan struggle with monkey soldiers, is killed by Rama (fig. 72). Ravana blacks out when he hears the news. Coming to, he grieves, "I have no further use for kingship, and what good is Sita to me now? Without Kumbhakarna, I can take no pleasure in life." Then, his loss compounded with bitter self-knowledge, he cries, "This has befallen me because, in my folly, I failed to heed the beneficial

FIG. 72. Ravana's brother Kumbhakarna battles Rama's monkey allies (detail of cat. no. 94).

advice of great Vibhīṣaṇa. . . . The words of Vibhīṣaṇa have put me to shame."[27]

Worse is to come. Having already lost six sons in the battle against Rama, now Ravana must endure the death of his last and greatest son, Indrajit. Ravana is devastated. Many tellings of the story describe his

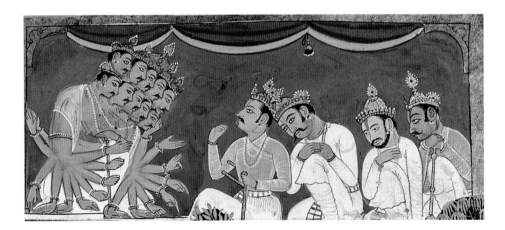

FIG. 73. Ravana grieves at the news of his son Indrajit's death (detail of cat. no. 131).

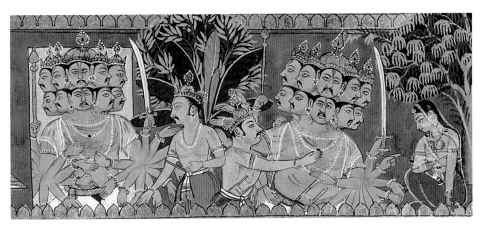

FIG. 74. Ravana, maddened with grief, resolves to kill Sita (detail of cat. no. 131).

collapsing, weeping, and frenzied pacing. In a painting from the Mewar Ramayana in this publication, though, Ravana's anguish is shown with moving restraint (fig. 73). The king slumps forward, bracing himself on several arms. He cups two hands together in a gesture of supplication. With another hand he wipes away tears.

Shortly his great sadness turns to rage. He storms out to find Sita and kill her on the spot, and is prevented only when a trusted advisor intervenes, arguing that to murder Sita would, in effect, be beneath Ravana's dignity (fig. 74).

Now Ravana, unable to gain the release of either possessing Sita or killing her, seems driven forward as much by momentum as by directed determination. The ultimate battle must be fought; in contest after contest Ravana struggles fiercely, jealous of his honor. Grim omens darken the scene, "but, heedless of these terrible portents that appeared before him, Rāvaṇa, in his delusion, marched forth, impelled by his own impending doom, to seek his own destruction."[28]

When Ravana is slain no one, probably least of all he himself, is much surprised. In the Valmiki Ramayana the dispatching occupies barely five verses, and one of those has to do with housekeeping: "Once the arrow had accomplished its purpose in killing Rāvaṇa, it dutifully returned to its quiver, glistening with its still-wet blood."[29]

Rama is hailed by his monkey army and the gods themselves. Ravana's wives run onto the gory field and, finding their dead husband, mourn and remonstrate (fig. 75). Rama orders that his adversary be given a proper funeral.

How we feel about the conquest of Ravana depends, of course, on our point of view. For centuries Ravana has functioned as an all-purpose villain, standing for the Mughal emperor, the British governor-general, the king of Burma, or whoever leads our enemies or contradicts our values.[30] If this is all he is, then when he dies we cheer, like the crowds at the annual Ramlila enactments in many North Indian cities. Multiday public performances of versions of the Rama epic are staged, with amateur actors portraying the well-known characters. Performances culminate when Rama shoots a powerful arrow at a huge effigy of Ravana; the effigy explodes into flame and everyone exalts the triumph of good over evil (fig. 76).

FIG. 75. "One of them embraced him in her devotion and wept, . . . while yet another clung to his neck" (Yuddhakanda 99:8; detail of cat. no. 135).

FIG. 76. An effigy of Ravana is destroyed in a Ramlila.

In other traditions, however, the death of Ravana may be more complicated, or at least more fraught. In some Southeast Asian performance traditions, the final battle and Rama's victory are enacted, but not Ravana's death. A controversy on this subject is testimony to the continuing power and relevance of the Rama epic in numerous cultures. In 2006 a Western-style opera titled *Ayodhya* (after the name of Rama's capital) was created by Thai-American composer Somtow Sucharitkul to mark the sixtieth anniversary of the reign of the present king of Thailand, known as Rama IX in Western languages. Just before its premiere in Bangkok the Thai government threatened to disallow it, supposedly on the grounds that it showed the death of the character "Ravan" onstage. *The Guardian* (London) reported that "in a country still jittery after September's military coup, officials from the Ministry of Culture, an Orwellian body charged with protecting Thailand's heritage and morals, claimed that the opera, a retelling of the Ramayana epic, would bring bad luck."[31] The production eventually went ahead, but apparently disagreement remains over whether changes were introduced to satisfy the officials.

In the Valmiki Ramayana, Ravana's funeral is hardly described. We are told only that the demon king was cremated "according to the prescriptions of the ritual texts."[32] Once again, things are different in Thailand (and no doubt elsewhere).

The cloister walls of Bangkok's royal Buddhist temple Wat Phra Si Rattanasatsadaram ("The Temple of the Emerald Buddha") are covered with extensive murals of the Rammakian, the canonical Thai telling of the Ramayana. Three large panels of the murals depict the elaborate ceremonies for the funeral of Ravana (fig. 77). In Thai tradition Ravana is as much a demonic villain as he is elsewhere, but his elevated status as a king is never forgotten.[33]

The Thai Buddhist Ravana of yesterday or two centuries ago is obviously not the same as the Hindu Ravana of two millennia ago. The scholar A. K. Ramanujan famously spoke of three hundred Ramayanas, so it is not surprising if we find three hundred Ravanas. In this sketch yet another has been created, like the earlier ones assembled from what has been read, heard, and seen in all sorts of picturings and tellings, and, no doubt, colored by the outlook of the portrayer.

If this sketch is at all successful it will create in the mind's eye an intriguingly complex character, both magnetic and brutal. In his vainglorious ambition, Ravana wreaks vast damage to the larger world, yet he has long ruled his own kingdom creditably. He is seized by an obsession: he, whom no one has ever successfully resisted either on the battlefield or in the bedchamber, will conquer the unconquerable Rama and will win the unattainable Sita. He is utterly arrogant, stubborn, and headstrong but, having lost, through his own agency, his closest siblings, his six brave sons, and numberless allies and supporters, he has aching moments of self-awareness and doubt.

The last words on Ravana come from my respected gurus Robert Goldman and Sally Sutherland Goldman:

> In his towering stature, megalomania, pride,
> and power, vitiated only by his mad and self-
> destructive passion for the one thing in the
> universe he cannot possess, he comes as close
> as any figure in the epic to an approximation
> of a classic tragic hero.[34]

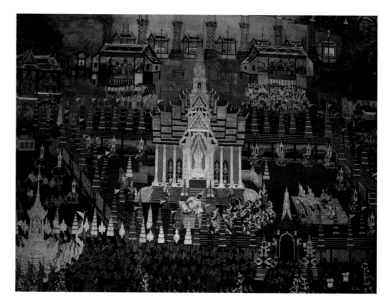

FIG. 77. Third section of a mural depicting the funeral of Ravana at Wat Phra Si Rattanasatsadaram (The Temple of the Emerald Buddha), Bangkok.

NOTES

1. On the character of Ravana: "For does it not seem that we are here confronted with yet another incarnation of the pirate or gypsy of that archetypal female fantasy of seduction—or, more properly no doubt, of the male construal or rendering of such a fantasy?" Pollock, "Rākṣasas and Others," 279. On Ravana as Sita's father: Though it is not the case in the Valmiki Ramayana and a number of other texts, in some Jain, Thai, and other tellings, Ravana is in fact Sita's father. See the discussion and references in Lutgendorf, *Hanuman's Tale,* 51; and Ramanujan, "Three Hundred *Rāmāyaṇas,*" 37.

2. I have surveyed only a score of the hundreds of the South and Southeast Asian temple reliefs and murals with scenes of the Rama epic, but this generalization seems to hold. Branfoot and Dallapiccola note that some sixteenth-century southern Indian temples have reliefs illustrating some episodes of the Uttarakanda, such as Sita's banishment. They do not mention depictions of Ravana's early career (Branfoot and Dallapiccola, "Temple Architecture," 300–301). The most comprehensive known set of paintings of Ravana's early life and career is in the great Mewar Ramayana of about 1650. Its illustrations of the Uttarakanda are held by the British Library; though few have been published, they can be seen in full at the joint British Library–CSMVS site called "Turning the Pages" at http://www.bl.uk/turning-the-pages/?id=68b0d8eb-787f-4609-9028-8cd17ff05c96&type=book. About these illustrations, J. P. Losty wrote, "The *Uttarakāṇḍa* had very possibly never been illustrated before in any depth." From the undated essay "Art Historical Overviews of the Mewar *Rāmāyaṇa* Books" at www.bl.uk/ramayana. Losty further notes that "preceding Mughal ones are not illustrated in detail." Several Mughal depictions of scenes from Ravana's earlier life as described in the Uttarakanda, including some from the Freer Ramayana, may be seen in vol. 7 of Vālmīki, *Rāmāyaṇa de Vālmīki illustré par les miniatures indiennes du XVIe au XIXe siècle.*

3. Brahma's giving Ravana the power to change form at will is odd because Ravana, like other rakshasas, presumably already had this power; see Goldman and Sutherland Goldman, *Uttarakāṇḍa,* note to 10:21. I appreciate the Goldmans' help in understanding the issue.

4. "Despite Rāvaṇa's reputation elsewhere in the epic as an abductor and ravisher of women, including those already married, the poet here claims that with the exception of Sītā alone all the women of the *rākṣasa's* harem were there of their own free will, won over by the virtues of Rāvaṇa, and had, moreover, no attachments to other men." Goldman and Sutherland Goldman, *Sundarakāṇḍa,* 68, where they also cite relevant verses.

5. My understanding of the importance of this scene is based on the discussion in the section called "The Major Characters of the *Uttarakāṇḍa*" in the introduction of Goldman and Sutherland Goldman, *Uttarakāṇḍa.* The Goldmans were most generous in allowing me to read the prepublication draft of this introduction.

6. Uttarakanda, chapter 26. On the rarity of accounts of penetrative rapes in the epic literature, see the introduction of Goldman and Sutherland Goldman, *Uttarakāṇḍa,* and several of its notes.

7. Goldman and Sutherland Goldman, *Sundarakāṇḍa,* 248 (47:17–18). These verses are discussed in Whaling, *The Rise of the Religious Significance of Rāma,* 70–71; and Pollock, "Rākṣasas and Others," 278.

8. On the notion that Ravana (like Rama) "has undergone a significant process of exaltation in the [Uttarakanda]," see Goldman and Masson, "Who Knows Rāvaṇa?," 95.

9. Pollock, "Rākṣasas and Others," 273.

10. For more on such oppositional readings in general, see Richman, introduction to *Many Rāmāyaṇas,* 15, and the sources she cites. On Ramasami's interpretation in particular, see Richman, "E. V. Ramasami's

Reading," 185–187, and the discussion in the section called "The Controversial Episodes" in the introduction of Goldman and Sutherland Goldman, *Uttarakāṇḍa.* A treatment of Ravana's character that is sympathetic, if not heroizing, is found in an eighteenth-century *kathakali* play discussed by Richman, "Looking at Ravana," 66–68.

11. Pollock, *Araṇyakāṇḍa,* 123–126 (16:4–17:21).

12. Ibid., 123 (16:8–10). In some tellings of the story—but not Valmiki's—Shurpanakha shape-shifts into the form of a beautiful woman to carry out her seduction.

13. Ibid., 150 (30:4–6).

14. Ibid., 152–153 (31:2–14, 23). To heighten the theatrical effect, I have taken the liberty of breaking the translated lines into the semblance of verse.

15. Ibid., 115–117 (13:3–35), 190–195 (48:3–49:40).

16. Ibid., 226 (63:25).

17. For more on the negative association of donkeys in general, and their association with Ravana, see Mokashi, "The Ass Curse Stele Tradition," 67–69.

18. Goldman and Sutherland Goldman, *Sundarakāṇḍa,* 166–167 (18:3–7 and 18:16–17).

19. Kamban, Sundaram, and Jagannathan, *Kamba Ramayana,* 230.

20. Goldman and Sutherland Goldman, *Sundarakāṇḍa,* 171–172 (20:2–9).

21. Robert Goldman, in an e-mail of September 29, 2015, says, "Don't forget the position of some Śrivaiṣṇava commentators that R[avana]'s appeals to Sītā are actually that of a devotee to the goddess and have no carnal intent."

22. Slightly adapted from Bofman, *Poetics of the Ramakian,* 115, 121.

23. Goldman and Sutherland Goldman, *Sundarakāṇḍa,* 135–136 (8:5–15), 138 (8:43–44).

24. Images of the relief have been published in Cadet, *The Ramakien,* no. 24; and Niyada, *Ramakien Bas-reliefs,* no. 24.

25. Goldman and Sutherland Goldman discuss Ravana's "progressive mental and emotional disintegration" in *Yuddhakāṇḍa,* 71.

26. Goldman, Sutherland Goldman, and van Nooten, *Yuddhakāṇḍa,* 141 (10:4).

27. Ibid., 300 (56:12, 56:16–17).

28. Ibid., 400 (83:37).

29. Ibid., 438 (97:19).

30. On the identification of rakshasas in general and Ravana in particular with our geopolitical enemies, see Pollock, "Rāmāyaṇa and Political Imagination in India," 283, 287.

31. Bill Condie, "Thailand's Culture Police Turn an Opera into a Censorship Battle," *The Guardian,* November 25, 2006. The performance is available on DVD and can be seen full-length on YouTube. The original performance was reviewed by Robert Markow, "Ayodyha," *Opera News,* November 16, 2006, at http://www.operanews.com/Opera_News_Magazine/2007/3/Review/BANGKOK_%E2%80%94%C2%A0 Ayodhya,_Bangkok_Opera,_11/16/06.html.

32. Goldman, Sutherland Goldman, and van Nooten, *Yuddhakāṇḍa,* 445 (99:42).

33. On the Rama epic in Southeast Asian Buddhist contexts, see page 41. The murals showing the preparations for Ravana's funeral (which were painted at the end of the eighteenth century and have since been extensively restored several times) are so detailed that they have been studied for information on traditional Thai royal funerals; see Pattaratorn, "Funeral Scenes." On the murals in general, see *The Ramakian (Rāmāyaṇa) Mural Paintings;* and Nidda Hongvivat, *The Story of Ramakian.*

34. Goldman and Sutherland Goldman, *Yuddhakāṇḍa,* 75.

What Does Ravana Look Like?

Heads and Arms

Ravana is said to have ten heads and twenty arms, and several of his alternate names have meanings such as "ten-faced" or "ten-necked." The question artists face is how to depict a being with ten heads. They have used several strategies: arranging the heads in a single row or stacking them in clusters. The challenge of a single-row arrangement is that if the heads are divided five on each side, then there is no face in the middle to be the focal point [1]. Putting a face in the middle, though, requires an asymmetrical arrangement with four faces to one side of the middle one and five to the other (cat. no. 48).

Artists opting for the stacked-heads strategy usually present the heads in a 4-4-2 arrangement (cat. no. 114), though once in a while a 5-5 arrangement is chosen (cat. no. 128).[1] In two-dimensional mediums such as painting or shadow puppets, fewer than ten heads are sometimes shown because some are understood to be at the back (cat. no. 113).

Occasionally (in Indian depictions) Ravana's heads are surmounted by a donkey's head, apparently an indication of Ravana's obduracy and unwillingness to control his animal impulses. The donkey head is

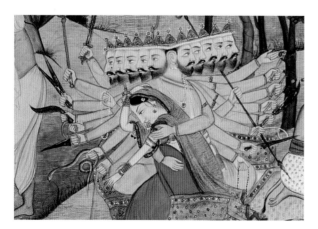

[1] *Handsome Ravana with ten heads and twenty arms (detail of cat. no. 61).*

sometimes counted among the ten and sometimes not (cat. nos. 127 and 123).

In Indonesia and rarely elsewhere, Ravana is shown with only one head (cat. no. 110). An unusual Indian example with a sole head is one of the earliest art objects in this catalogue [2].[2] Single-headed Ravanas normally have only two arms but in exceptional instances have twenty (cat. no. 133).

Other arrangements of heads appear at various times and places. For example, in a well-known relief of Ravana shaking Mount Kailasa at the late sixth-century Cave 29 at Ellora, we see Ravana from the back with five visible heads. Presumably if the figure were visible from the front we would find five more heads (cat. no. 115).

[2] *Ravana with one head and two arms (detail of cat. no. 64).*

Facial Features

As a rakshasa, a demon, Ravana may be expected to have demonic facial features, and so he often does, in both Indian and Southeast Asian art. Bulging eyes, a prominent nose, and fangs or even tusks are among the most common (cat. nos. 105, 108, and 109).

In other instances, however, all from India, Ravana has the facial features of an ordinary, or sometimes quite handsome, human (cat. nos. 64 and 71).

Skin Color

In Thailand and Myanmar, Ravana usually has green skin, and in Indonesia, red or maroon [3]. In India, Ravana's skin is in a range of tones of human complexions or, exceptionally, another color such as blue (fig. 3, cat. no. 2) or red (cat. no. 109).

[3] *Ravana with red skin, from Indonesia (detail of cat. no. 111).*

Garments

Ravana usually wears the finery and crown that would be associated with a king in whatever time and place the representation was made. For example, in Mughal and Rajasthani paintings, Ravana often wears the sort of robe, or *jama,* that would have been worn by a contemporary king, and in Thai shadow puppets he wears the elaborate tight-fitting jacket of an aristocrat. Occasionally what he wears is perhaps armor or a padded coat for protection in battle (cat. no. 113).

Sometimes, in both South and Southeast Asia, Ravana is shown bare-chested except for necklaces and perhaps a sort of scarf. He may wear shoes or boots, or be barefoot. It might be expected that he would go barefoot indoors and wear shoes outdoors, but this seems not to be the case (compare a barefoot battle scene such as cat. no. 125 with a shoe-wearing indoor scene such as cat. no. 128 or cat. no. 107).

Very rarely is Ravana seen without a crown, except occasionally when he is in the guise of an ascetic (cat. no. 116). An unusual crownless example is cat. no. 64, where Ravana's locks flow free. Here he might also be thought to be bare-chested, but in fact he wears a short-sleeved tunic, indicated by looping incised lines perhaps intended to represent chain mail.

And Who Does Ravana Look Like?

In mainland Southeast Asian Buddhist contexts it is notable that Ravana and Mara, the demonic personification of delusion and death whom the Buddha-to-be must conquer on the way to achieving enlightenment, often look so similar as to be indistinguishable [4, 5]. It seems likely that a set of parallels was understood, if not made explicit: the Buddha was the conqueror of Mara, as Rama was the conqueror of Ravana, as the king was the conqueror of worldly enemies. (See the section "The Rama Epic in Buddhist Contexts in Thailand and Neighboring Countries" on p. 41.) F.McG.

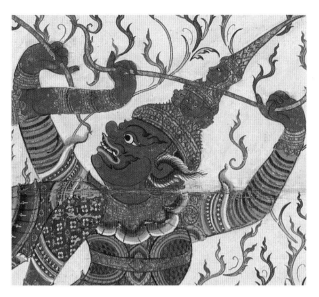

[4] *Ravana (detail of cat. no. 46).*

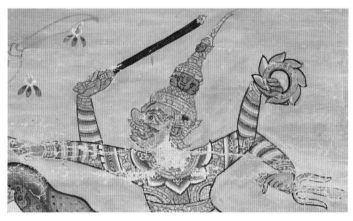

[5] *Mara (detail of Asian Art Museum 2006.27.71).*

NOTES

1. An interesting question is the origin of the stacked-heads arrangement. It is rare in Indian art, appearing seldom outside the seventeenth-century Mewar Ramayana, but it is common in mainland Southeast Asia. There, the 4-4-2 arrangement is found at least as early as the Angkorian temple of Banteay Srei, consecrated in 967. In India, multiple heads stacked in a similar way occur earlier in certain rare Buddhist images, such as an eleven-headed Avalokiteshvara, probably of the sixth century, in Cave 41, Kanheri.

2. The Goldmans note that "in his descriptions of Rāvaṇa as a monarch and a lover the poet [Valmiki] represents him consistently in a normal, if exceedingly handsome, form. That is to say, he is pictured with one head and two arms instead of the monstrous ten and twenty with which he is often represented. Several of the commentators note this seeming discrepancy and observe that Rāvaṇa has in fact two fundamental forms, the ten-headed being his wrathful, battlefield form." Goldman and Sutherland Goldman, *Sundarakāṇḍa*, 68 n. 268. This distinction does not always hold in the visual arts, as can be seen in the examples here and elsewhere in this catalogue.

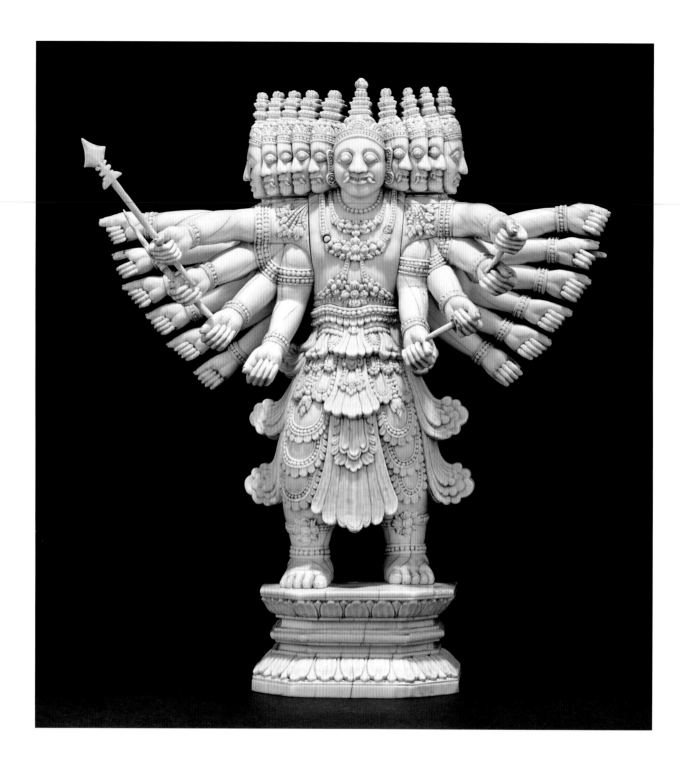

105

Ravana, approx. 1800–1875

South India
Ivory
H. 26.5 × W. 23 × D. 12 cm
The British Museum, 1878,1101.329,
donated by Lt-Gen. Augustus W H Meyrick

Ravana strides forward in his classic fanged, bulging-eyed, multiheaded, multiarmed form, attired in elegant royal garments and jewelry.

Statues of Ravana are not common. What was the purpose of this one, of such a precious material as ivory? Was it made as a curio, to appeal to the taste of a well-to-do colonial officer such as Lieutenant General Augustus Meyrick, who donated it to the British Museum along with a number of Indian figurines of ivory and other materials, as well as other curios? Or might it have been part of a tableau such as a well-known set of ivories of Vishnu's ten incarnations in the National Museum, New Delhi,[1] or an ivory shrine of the goddess Durga in the Victoria and Albert Museum?[2] F.McG.

NOTES

1. http://nationalmuseumindia.gov.in/prodCollections.asp?pid=1&id=6&lk=dp6, accessed May 31, 2015.

2. http://collections.vam.ac.uk/item/O67518/shrine-of-goddess-durga-carving-unknown/, accessed May 31, 2015.

106

The court of Ravana, approx. 1605

India; possibly Madhya Pradesh state, former kingdom of Datia
Opaque watercolors and gold on paper
Image: H. 27.6 × W. 18.9 cm
The Metropolitan Museum of Art, Cynthia Hazen Polsky
and Leon B. Polsky Fund, 2002.505

107

Shadow puppet of Ravana in his palace
(*Le royaume de Reap* [Ravana]), 1973

Cambodia
Hide with pigments and bamboo
H. 176 × W. 138 cm
Musée national des arts asiatiques–Guimet, MA3645

Ravana is a demon but, equally important, a king. To be a worthy antagonist of Rama, Ravana must be of great stature, and indeed he is known for his learning, musical prowess, pious devotion to Shiva, and capability as a ruler, as well as for the grandeur of his court.

A seventeenth-century painting from India, but in a Persianate style (cat. no. 106), suggests this grandeur. Ravana sits in regal state clasping the hand of a high-ranking noble, probably his son Indrajit.[1] His faces are human and quite refined, rather than demonic. Around and below, demon courtiers, dressed more or less sumptuously according to their status, kneel or stand in respectful attendance. If all these figures had human features instead of their array of amusingly grotesque (but characterful) features, the scene could be of any royal audience.

Ravana is shown with only about fourteen arms and eight, rather than ten, heads. Instead of having multiple headdresses, he wears a single capacious royal helmet.

A large Cambodian shadow puppet (cat. no. 107) also shows a scene of Ravana in his palace. He is attended not by male nobles but by two beautiful women, presumably his wives. One wears a serpent headdress; she is probably the naga princess given to Ravana, in Cambodian and Thai tradition, when he defeated her father.[2] (She can also be seen in one of the famous Rama epic reliefs at Wat Phra Chettuphon [Wat Pho] in Bangkok.[3])

Here the king has demonic facial features, and his ferocious side is further suggested by his holding a sword at the ready even in his palace, and by the emphasis on the monstrous face on the chest of his armor. (Monstrous faces appear on armor in many parts of Asia, but seldom is attention called to them so strongly.)

Another detail foretokens Ravana's eventual fate. In a gable of the palace appears Rahu, the inauspicious creature that causes eclipses by swallowing the sun or moon. In a classic sixteenth–seventeenth-century Cambodian Rama epic, Ravana's horoscope is read: "There was an unfortunate conjunction of signs, utterly horrifying: the Moon and Sun, with Rāhu seizing hold of them! There were clearly divine portents of evil."[4]

This shadow puppet is one of a newly made set acquired in 1973 for the Musée Guimet in Paris by curator Jeannine Auboyer as part of an effort to preserve traditional arts that were disappearing in Cambodia. Subsequently, years of war and turmoil further endangered the arts and artists of Cambodia. In a moving affirmation of the importance of the

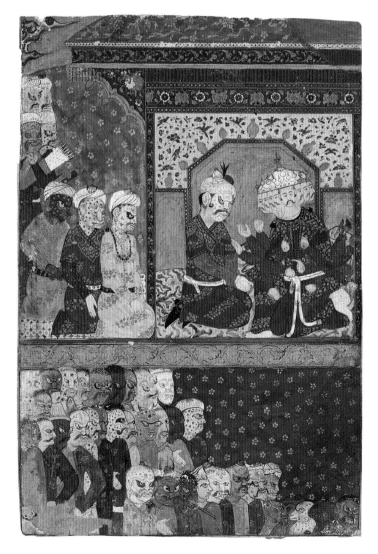

106

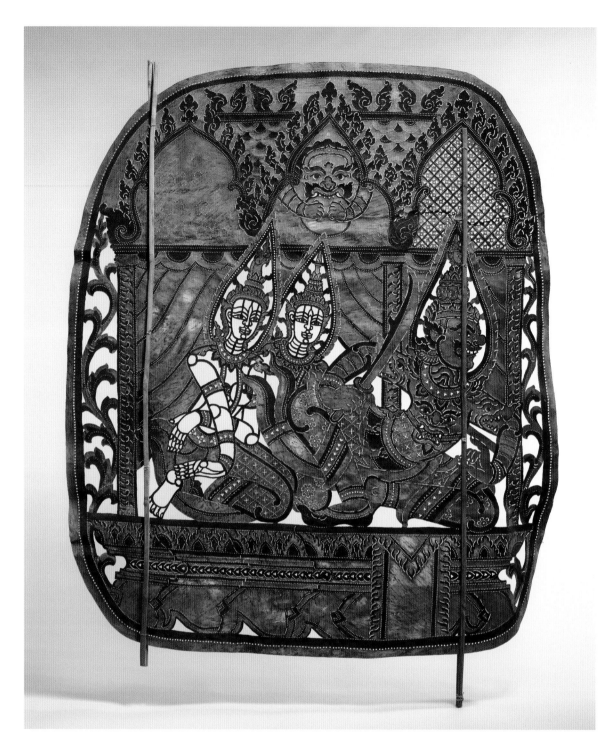

large shadow-puppet theater to Cambodia, the author of a 1995 book on the subject, Pech Tum Kravel, writes,

> This incredible loss happened so fast, as fast as a vicious tornado. . . . The war destroyed the customs, the traditions, the moral precepts of a compassionate, tolerant, and empathetic society. . . . Proceeding from the point of view that "something small or inadequate is better than nothing," I have compiled this book in the hope that it will help to rehabilitate Cambodian culture.[5]

F.McG.

NOTES

1. This painting and three others from the same set (which also included cat. nos. 43 and 123) are discussed in Ekhtiar et al., *Masterpieces from the Department of Islamic Art,* 356–357. Navina Haidar suggests that the figure sitting before Ravana is Indrajit in this book and in Topsfield, *In the Realm of Gods and Kings,* 364. In the latter, she briefly discusses the text on the back of the painting.

2. Singaravelu, "Rama Story," 58.

3. Niyada, *Ramakien Bas-reliefs,* 108–109; and Cadet, *The Ramakien,* 97, 101.

4. Jacob and Kuoch Haksrea *Reamker,* 140.

5. Pech, *Sbek Thom,* 1. A puppet nearly identical to the one included here is illustrated in *Sbek Thom* as no. 100. For more on the Musée Guimet's set of large shadow puppets, see Sunseng Sunkimmeng, "Une importante série."

THE PUPPET THEATER AND OTHER ARTS

For centuries, various forms of puppet theater have had an important place in the arts of Southeast Asia. Puppet dramas were not intended primarily for an audience of children and could continue for many hours, alternating boisterous scenes of combat or bawdy comedy with quieter scenes of romance, intrigue, or ethical and philosophical discussion.

Shadow puppets are flat and usually made of hide. Some, such as the Thai *nang yai* and the Cambodian *sbek thom,* are very large and have no movable parts. Others, such as Javanese and Balinese *wayang kulit,* are smaller and have jointed arms (and occasionally other parts) that can be moved by attached sticks. Three-dimensional puppets come in two main types, "rod puppets" that also have arms movable by attached sticks and stringed marionettes.

Interaction between the puppet theater and other arts seems to have been constant. Puppets' costumes and faces relate to the costumes and masks of actors or dancers portraying the same characters, of course. In addition, though, actors' and dancers' movements may derive from puppets' movements. Burmese dancers, for example, sometimes explicitly imitate marionettes and may perform duets with them. Furthermore, painters and even sculptors sometimes draw on puppet theater for inspiration, creating works in which the emphasis on emphatic stances and gestures in strong silhouette on a shallow or flat picture plane recalls shadow puppets against a screen. F.McG.

Balinese shadow puppet of Ravana (cat. no. 110).

Ramayana relief at Penataran Temple, East Java, fourteenth century.

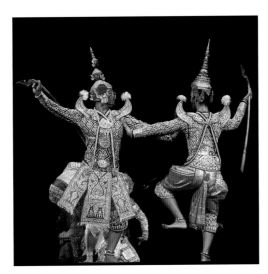

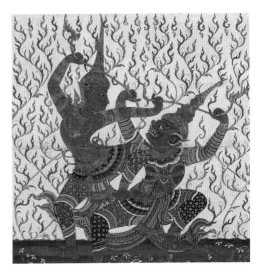

ABOVE LEFT Shadow puppet of Ravana riding a chariot into battle (cat. no. 113). ABOVE CENTER Thai classical dancers portraying Ravana and Rama. ABOVE RIGHT Rama and Ravana in combat (detail of cat. no. 46).

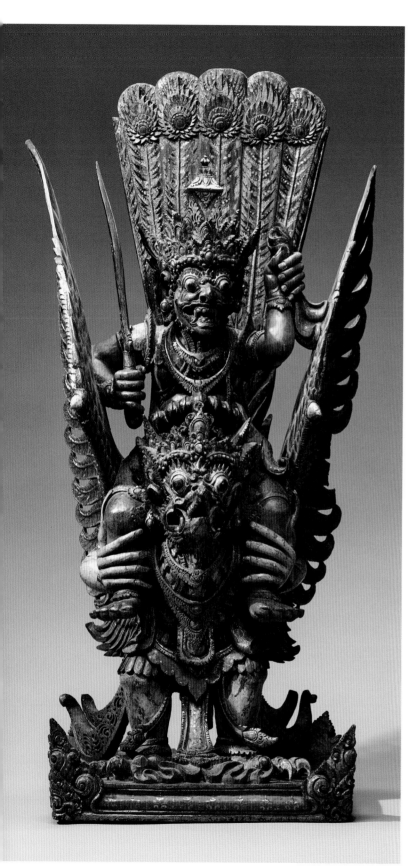

108 *also p. 198*

The demon king Ravana riding a mythical bird, approx. 1800–1900

Indonesia; North Bali
Colors and gold on wood
H. 96.5 × W. 46.4 × D. 45.7 cm
Asian Art Museum, Acquisition made
possible by the Connoisseurs' Council
and the estate of K. Hart Smith, 2010.18.2

If we expect Ravana to have multiple heads and pairs of arms, and to ride a donkey-drawn chariot, as he often does in India, we will not recognize him here. In Bali he is usually shown with a single head and riding a demonic creature with the wings and tail, and sometimes other features, of a bird. This creature is called "Wilmana," a term that has been thought to derive from the Sanskrit *vimana*, a flying chariot or palace.[1] This winged demon can be seen carrying Ravana as he abducts Sita in the Ramayana reliefs of the ninth–tenth-century temple of Prambanan in central Java.

Here Ravana's mount is, except for its hands, very birdlike, and the sculptor has gone to great effort depicting the textures and colors of Wilmana's splendid plumage.

Ravana carries a fabled sword he received from Shiva, which he used, during the abduction of Sita, to slice off the wings of the heroic vulture Jatayus, who was trying to protect her.

This sculpture forms a pair with a sculpture thought to be of Vishnu riding Garuda. Little is known about how such figures were used in nineteenth-century Bali.[2] F.McG.

NOTES

1. For more on this matter, see Reichle et al., *Bali*, 243; and Fontein, "Abduction of Sitā," 29–30.

2. See Reichle et al., *Bali*, 241–243, for a photo of the Vishnu and for discussion of other sculptures comparable to this pair.

Ravana should be easy enough to represent or recognize. He is a rakshasa, or demon; he has ten heads and twenty arms; and he is a king, and so he should be garbed and jeweled as a king. True, he has the power of shape-shifting, but in his normal form he should be identifiable.

But the issues are obvious. Artists from different places and periods may have quite different notions of what demons look like, and the royal finery of an Indian king of the seventeenth century may be very different from that of a Balinese king of the nineteenth. (See "What Does Ravana Look Like?" on pp. 212–213.) Then, what if ten heads seem to look too crowded, or twenty arms—ten on each side!—don't look right or are too tedious to depict? For example, what if Ravana needs to shoot an arrow? Doing so requires two arms; what occupies the other eighteen?

The Indian shadow puppet (cat. no. 109) shows all ten heads and has, dangling from its main arms, a number of miniature arms—enough to suggest twenty. Its eyes bulge and its mouths have demonic fangs, as is frequently the case in representations of Ravana, but its heads have two unusual features: pointed beards and the triple lines painted on the forehead that indicate a devotee of the great god Shiva, as Ravana was. The royal finery is there, including fancy shoes. Ravana's skin is red, but it turns out that his color varies across cultures.

On one of the miniature arms are inscribed the Telegu words *Shri Rama*. Possibilities of why a Ravana puppet's arm would be inscribed with Rama's name are that the holy name served to affirm that the entire puppet performance was in homage to Rama, or as a reminder that because Ravana was so focused on and absorbed with Rama, even as an adversary, Ravana was in some sense Rama's devotee.[1]

The faces of the Balinese and Javanese shadow puppets (cat. nos. 110 and 111) are also red, and the puppets are decked in royal attire, but of course following Indonesian rather than South Indian styles. Their facial features are large and coarse, as those of Indonesian demons are expected to be, but they have only single heads and pairs of arms. The fact is that even those somewhat familiar with the Indonesian shadow theater may have trouble distinguishing Ravana from other kingly demons in other epics.

Because of the Netherlands' centuries of involvement with Indonesia during the colonial period, Dutch museums often have superb selections of Indonesia's theatrical arts documented from an early period. An example is the Javanese puppet of Ravana here, which is known to have been in the Netherlands by 1839.

In contrast to the shadow puppets just discussed, the three-dimensional West Javanese puppet (cat. no. 112), with its multiple heads (though a sole pair of arms), is unmistakable. Other puppets of Ravana from this West Javanese tradition have only one head, so perhaps here Ravana is manifesting himself in his fullest, most terrible, form.

The Thai puppet and theatrical mask (cat. nos. 113 and 114) follow a strong mainland Southeast Asian tradition of showing Ravana's multiple heads stacked in tiers. (Usually the main head is understood to have three smaller heads at the back.) The main faces, with their popping eyes, bulbous noses, and grimacing mouths, are grotesque, but all the refinement of the Thai court is shown in the sumptuous garments and jeweled ornaments. Ravana's face is not red but—following mainland custom—green. F.McG.

NOTE
1. These helpful thoughts come from Professor Blake Wentworth in an e-mail of August 17, 2013.

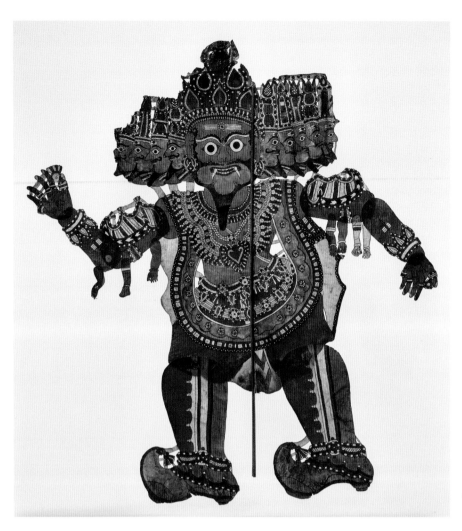

109

109

Shadow puppet of the demon king Ravana,
approx. 1875–1925

India; Andhra Pradesh state
Hide with pigments
H. 144.8 × W. 94 cm
Asian Art Museum, Gift of Joyce Roy, 2013.40

110 *also p. 217*

Shadow puppet of Ravana, before 1900

Indonesia; Bali
Hide with pigments and horn
H. 68 × W. 30 cm
Nationaal Museum van Wereldculturen,
Coll. no. TM-15-954-27

111 *also p. 213*

Shadow puppet of Ravana, 1839

Indonesia; Central Java
Buffalo hide with pigments and buffalo horn
H. 97.5 × W. 75 cm
Nationaal Museum van Wereldculturen,
Coll. no. RV-264-10

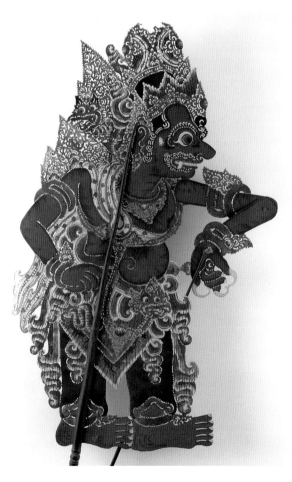

110

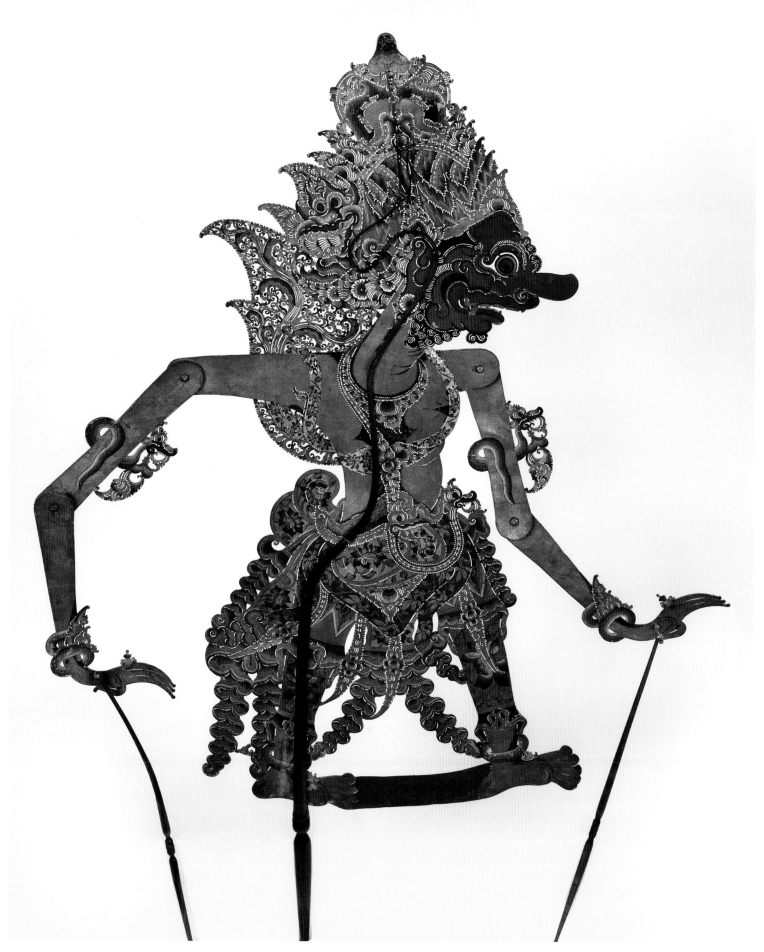

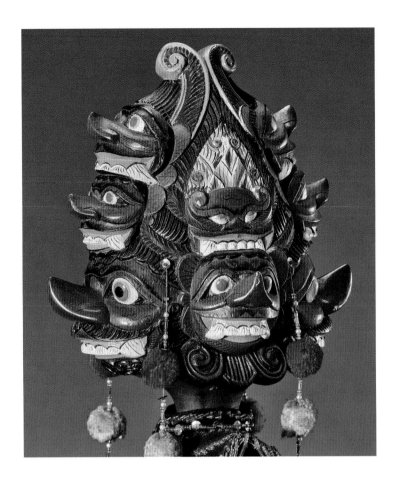

112
Stick puppet of the demon king Ravana,
approx. 1950–1980

Indonesia; Bandung, West Java
Wood, cloth, and mixed media
H. 81.3 × W. 28.6 × D. 12 cm
Asian Art Museum, from The Mimi and
John Herbert Collection, F2000.86.31

113 *also p. 217*
Shadow puppet of the demon king Ravana
riding a chariot into battle, approx. 1850–1900

Thailand
Hide with pigments and bamboo
H. 193.5 × W. 142 cm
Asian Art Museum, Gift from Doris Duke Charitable
Foundation's Southeast Asian Art Collection, 2006.27.115.2

112

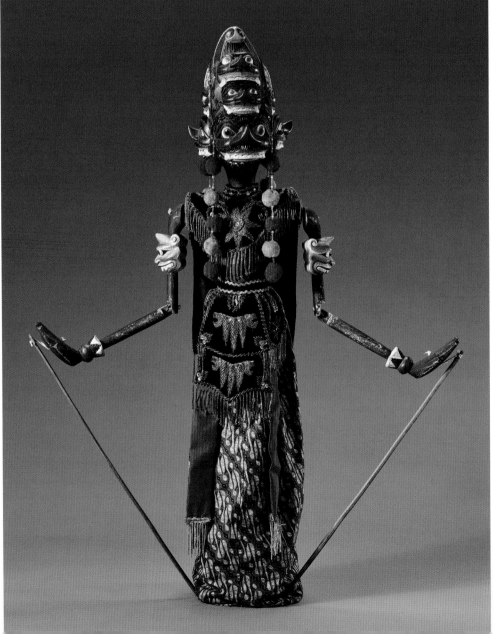

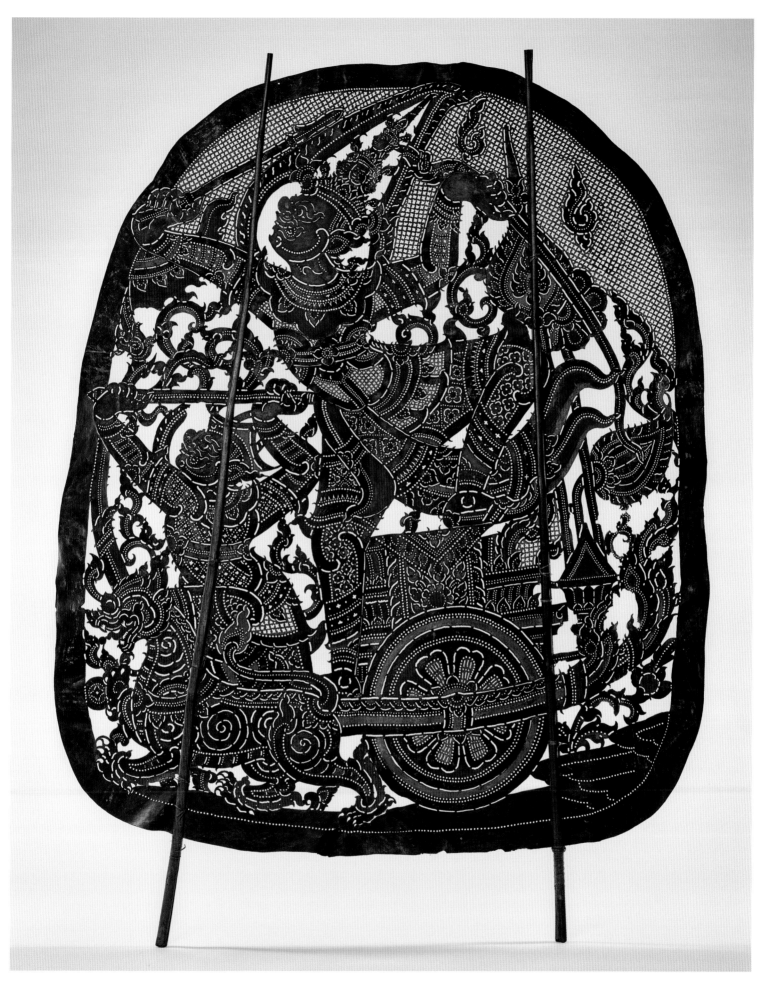

114

Theatrical mask of Ravana, 1876

Thailand
Papier-mâché, paint, mirrors, and glass
H. 57 × W. 28 × D. 23 cm
Smithsonian Institution, National Museum of Natural History,
Gift of King Chulalongkorn, 1876, E54232

115 *also fig. 59*

Relief of Ravana shaking Mount Kailasa in Cave 29, Ellora, approx. 1868

Attributed to Henry Mack Nepean (British, 1829–1914)
Albumen silver print
H. 34.9 × W. 28.3 cm
Asian Art Museum, from the collection of
William K. Ehrenfeld, M.D., 2005.64.558

The sculpture that appears in this photograph comes from the rock-cut temples of Ellora in central India; it depicts the culmination of an episode that accounts not only for Ravana's name but also for his inability to defeat the monkey host of Hanuman. The retrospective story occurs only in the seventh book of the Ramayana, the Uttarakanda, which was probably added to the earlier books of the epic to address doubts and apparent inconsistencies.

The Hindu deity Shiva is the large figure at the center of the composition. To Shiva's left is his wife Parvati; both of them are sitting on a slab of rock that represents Shiva's abode, the mountain Kailasa. But the most important figure here crouches beneath Shiva and Parvati. He is Ravana, who has just stolen the flying chariot Pushpaka from his stepbrother Vaishravana, the god of wealth. What is he doing here?

Immediately prior to this scene, Ravana's stolen chariot had inexplicably stopped at Mount Kailasa. Nonplussed, Ravana encountered Nandi, the bull companion of Shiva, who told Ravana the reason for the delay: Shiva and Parvati were in residence on Kailasa and could not be disturbed. In a pique, Ravana ridiculed Nandi, who had assumed the face of a monkey. For his contumely, Nandi cursed Ravana, affirming that he would eventually be defeated by an army of monkeys.

Enraged, Ravana then lifted the mountain and shook it. Parvati was terrified, but Shiva responded by suppressing Ravana with no more than his big toe. Agonized, Ravana cried out so loudly that the worlds "reverberated," earning Ravana his proper name—the "Reverberator."

Urged by his advisors to propitiate Shiva with hymns, Ravana will sing to the god for a thousand years. In return, Shiva releases the demon, setting the stage for Ravana's decisive encounter with Rama. J.D.

116

Ravana receiving a powerful weapon from Shiva, approx. 1850–1900

India; Himachal Pradesh state,
probably former kingdom of Kangra
Opaque watercolors and gold on paper
H. 23.2 × W. 27.9 cm
Los Angeles County Museum of Art,
Gift of Robert Shapazian, M.2009.148.2

At the center of this painting, a one-headed form of Ravana brandishes twenty weapons in his twenty arms. According to the epic, at least some of these weapons are divine, which raises one of the most intractable problems in the story: how unruly Ravana—king of the demons—gained powers that would ordinarily be understood as holy.

The resolution of the dilemma lies in the fact that Ravana's supernatural powers and weaponry derive from forces that are ethically neutral, in this case penance (*tapas*). In the first, competing with his brother Vaishravana to amass the greater amount of spiritual power, he receives from his grandfather Brahma not immortality but invulnerability. In the second, he secures Shiva's powerful weapons, again "attained from Rudra [Shiva] by virtue of his rigid penances."[1] Indeed, to the right of Ravana, the supreme deity Shiva sits under a tree, a cobra uncoiling toward the lord of the demons. This cobra may represent a weapon obtained by Ravana as a result of his penances.

Above Ravana and Shiva, the sage Narada appears from within a roiling mass of dark clouds. He bears his Indian lute, called a *vina*. Narada is important in the Ramayana because he was instrumental in convincing Ravana that humans were no threat and so should not be included in the list of beings that cannot kill him. It could thus be argued that Narada's counsel to Ravana set the stage for the rakshasa's final undoing. J.D.

NOTE
1. Shastri, *Ramayana of Valmiki*, vol. 3, 449.

117

Ravana and one of his wives play a game of chaupar, 1801–1805

India; Pune, Maharashtra state
Opaque watercolors on paper
H. 25.6 × W. 40.3 cm
The British Museum, 1940,0713,0.160,
donated by Mrs. A G Moor

A rare scene of Ravana's domestic life shows the king playing a quiet evening round of the board game chaupar with one of his wives, perhaps his queen Mandodari. A serving woman offers refreshments, and two amusing demons fan the couple and stand ready to whisk away insects.[1]

No source has yet been found for Ravana playing chaupar with another character. F.McG.

NOTE
1. Appreciation is due Professor Vidyut Aklujkar for help in identifying this scene.

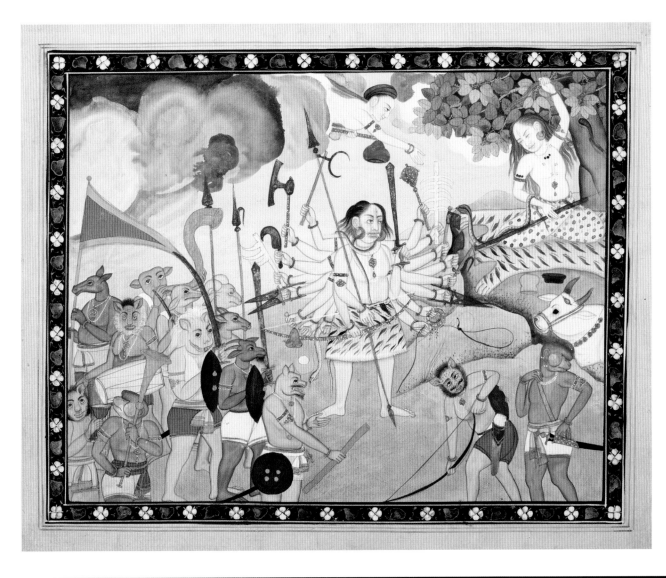

116

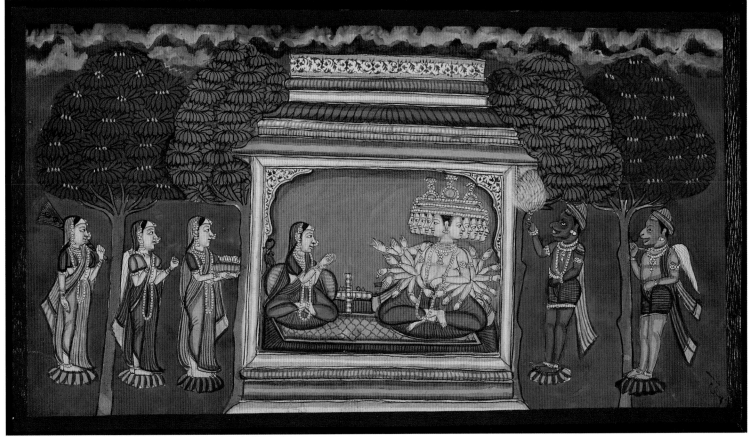

117

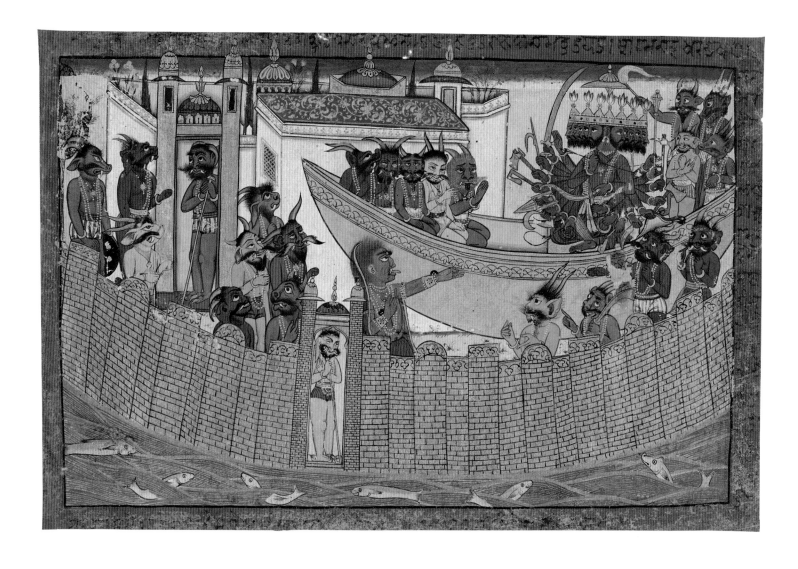

118 *also fig. 64*

Ravana's sister reports to him of her maltreatment by Rama and Lakshmana, and of Sita's beauty, from the "Shangri" Ramayana, approx. 1690–1710

India; Jammu and Kashmir state,
former kingdom of Kulu or Bahu
Opaque watercolors on paper
Image: H. 18.4 × W. 28.9 cm
From the Catherine and Ralph Benkaim Collection

The main action of the Rama epic—Ravana's abduction of Sita and the long, brutal war for her return—is ignited by the episode shown here. Ravana's sister Shurpanakha, like him a rakshasa or demon, has come upon Rama, Lakshmana, and Sita in their forest exile. Struck by Rama's beauty and overcome by desire, she proposes marriage and offers to eat Sita to free Rama from his ties to her. Rama and Lakshmana make fun of Shurpanakha, and when she threatens Sita, Lakshmana cuts off her ears and nose. She enlists

the aid of two other brothers, who attack Rama but are killed along with their army of thousands of demon warriors.

All this Shurpanakha is here seen reporting to Ravana, calling for revenge. She goads him by berating him for letting his sensual indulgences distract him from protecting his family and kingdom. Well knowing her brother's capacity for lust as well as rage, she describes Sita as the most beautiful and desirable woman in the world, a perfect wife for him. Ravana is ensnared and immediately sets in motion a plan to kidnap Sita.

In the painting, Ravana's demon courtiers witness Shurpanakha's testimony and exhortation with an amusing variety of quizzical expressions. The artist seems to find a degree of grotesque humor in a moment that will kindle a protracted war that destroys many lives and causes untold suffering.

F.McG.

119 *also pp. 196–197*

The demon Maricha tries to dissuade Ravana,

approx. 1780

India; Himachal Pradesh state, former kingdom of Kangra
Ink, opaque watercolors, silver, and gold on paper
H. 24.8 × W. 35.6 cm
The Metropolitan Museum of Art, Gift of
Cynthia Hazen Polsky, 1985.398.14

Ravana's sister has told Ravana of her disfigurement at the hands of Rama and Rama's brother, the incomparable beauty of Rama's wife Sita, and the destruction Rama has brought to Ravana's brothers and their army.

Ravana decides on a plan of revenge to kidnap Sita. He will travel across the sea to visit his relative the demon Maricha and enlist his help. He proposes that Maricha turn himself into a golden deer and lure Rama away from Sita's side. Then Ravana will seize her. Rama will be so undone by the loss that he will be easily overcome and slain.

In the center of this painting we see Maricha's reaction. He offers wise counsel: "What can you possibly gain, overlord of *rākṣasas*, by this futile adventure? For the moment you face him in battle your life is finished—your life, your every pleasure, your hard-won kingship." But Ravana rejects all efforts to dissuade him, retorting, "What utter nonsense you are telling me, Mārīca."[1] Maricha persists, and faces rebuff after rebuff.

At last, Ravana harshly threatens Maricha if he does not do as he is commanded, and the two ride off, at top left, to find Rama and Sita.

The painter shows Ravana's donkey-drawn flying chariot twice, arriving and departing, but—amusingly—cuts off the back part one time and the front half the other.

The lower half of the painting is taken up with the sea and its array of wondrous creatures, from a sort of narwhal to a sea-goat. F.McG.

NOTE

1. Pollock, *Araṇyakāṇḍa*, 161, 166 (35:20, 38:3).

Ravana, his passions aroused by reports of Sita's
supreme beauty, uses trickery to lure away Rama and
Lakshmana and leave Sita unprotected. Disguising
himself as an ascetic, he manages to deceive and seize
her. He resumes his demonic form and flies off with
her in his aerial chariot toward his city.

The heroic vulture Jatayus, an old friend of Rama's
father, observes the abduction and tries to intervene.
Bird and demon engage in a fierce midair battle.
Finally Ravana succeeds in delivering a devastating
blow, and Jatayus falls to the ground dying.

120

The battle of Ravana and Jatayus, approx. 1605

India, possibly Madhya Pradesh state, former kingdom of Datia
Opaque watercolors on paper
H. 26.5 × W. 15.8 cm
The Cleveland Museum of Art, Gift in honor of Madeline
Neves Clapp; Gift of Mrs. Henry White Cannon by exchange;
Bequest of Louise T. Cooper; Leonard C. Hanna Jr. Fund;
From the Catherine and Ralph Benkaim Collection, 2013.306

Verses of the Ramayana inscribed on the back of this
painting recount what we are seeing.

Now an extraordinary fight ensued there between
the vulture and the rakshasa, quite violent, as if
between two great, winged mountains. With sharp
arrows . . . that immensely powerful rakshasa
forcefully showered the King of Vultures. In the
course of battle that vulture, Jatayus, Lord of Birds,
confronted that mass of arrows, the weapons of
Ravana. And then he . . . like a mountain shaken
about, fell backwards, and with his talons dragged
Ravana down, overcome by anger. And, that
immensely powerful Lord of Birds instantly made
Ravana's limbs bloodied with his sharply taloned
feet. Then, Ravana, in a rage, pierced the King

of Vultures in battle with three direct arrows,
frightful and swift. . . . Without even taking those
arrows into account, that enraged bird launched
himself at Ravana. Flying upward and then
rushing down, raising his wings overhead, he
battered Ravana with those feathered limbs. Then,
that Lord of Birds, energy blazing, splintered, with
his claws, Ravana's bow and arrows, adorned with
gems and pearls. That bird struck down the asses,
with their golden chest armor and, . . . yanking
them about, instantly deprived them of breath.
He smashed the fearsomely huge chariot, which
flies upon a wish. . . . Tearing the charioteer from
the chariot, that Lord of Birds, with talons that
seemed like elephant goads, quickly shred him,
then tossed him away. . . . Seeing Ravana fallen
to the ground, his chariot smashed, all the other
creatures celebrated the King of Vultures, crying,
"Well done, well done!" And the gods and sages
were amazed when they saw Ravana . . . who was
never defeated by the gods and asuras, defeated
now by the Best of Birds.[1]

Here, Sita waits apprehensively in the grounded
chariot, behind the slain donkeys. Ultimately,
Ravana's strength and endurance are greater, and,
"blind with rage," he deals the vulture mortal
wounds.

This painting (like cat. nos. 43, 106, and 123) comes
from a well-known manuscript that seems to have
been damaged in a fire, so portions of its paintings
show losses. F.McG.

NOTE

1. Kashi Gomez was commissioned by the Asian Art Museum to
read and translate the inscription. What is given here is a shortened,
slightly adapted version of her painstaking scholarly translation.
Gomez notes that "the inscription on this painting corresponds to
the forty-ninth sarga of the Araṇyakāṇḍa of the critical edition of the
Rāmāyaṇa. The inscription is missing significant portions of the text
both at margins as well as in other damaged areas. I have used the
printed critical edition of G. H. Bhatt to fill in these lacunas."

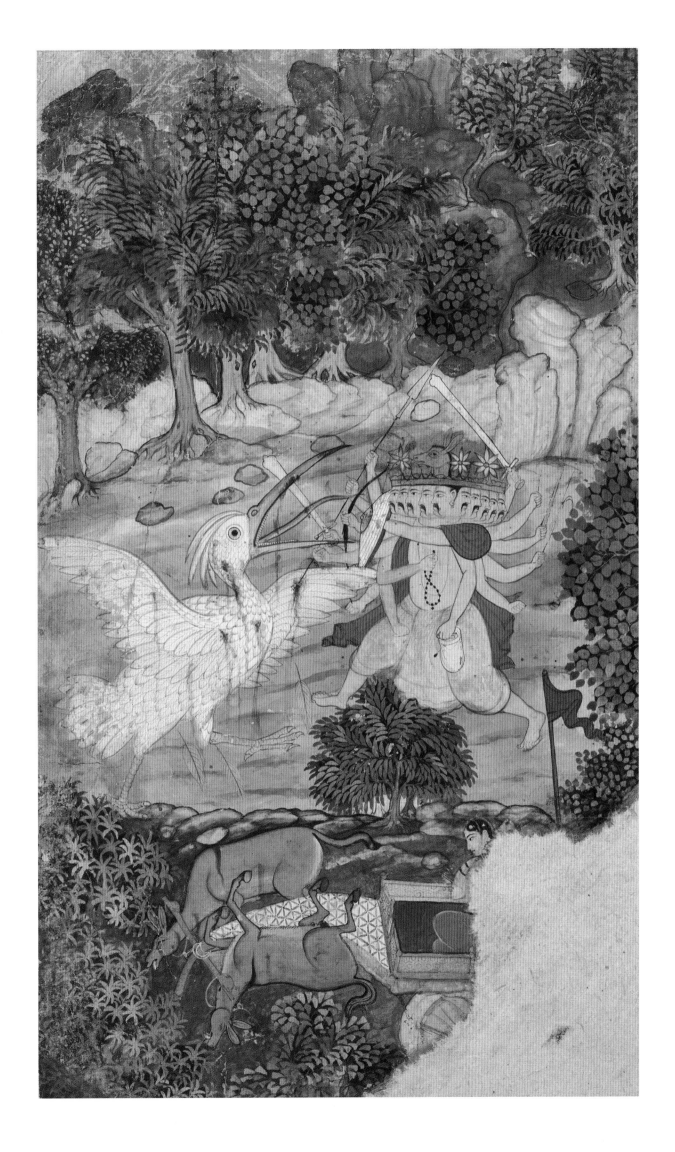

121 *also p. 117*

Manuscript with fortune-telling lore and illustrations of the stories of Rama, Sang Thong, and Manora, approx. 1800–1850

Thailand
Paint, gold, and ink on paper
H. 36.8 × W. 12.1 × TH. 5.4 cm
Asian Art Museum, Gift of George McWilliams, 2008.89

In Thai tradition, Ravana does not hack off Jatayus's wings, as he usually does in India, but pulls a powerful magic ring from Sita's finger to use as a weapon. The ring changes into a bladed war discus, which Ravana can be seen preparing to hurl at the vulture. Below, the mortally wounded bird holds the ring, returned to its original form, in his beak.

On the next two double pages of this manuscript we see Rama and Lakshmana, having realized that Sita is gone and having begun a search for her, coming upon the vulture, who tells them what has happened and passes along the ring just before he dies.

This manuscript illustrates important episodes from a number of well-known Thai legends, using them and their characters, together with astrology, to allow a specialist to read clients' fortunes. A complicated process—which involves starting with one's age and counting around a grid with numbers, compass directions, and characters' names—leads to a particular page and fortune. The text on the page that shows the battle of Ravana and Jatayus, for example, mentions Jatayus's being struck by the ring-weapon and warns that trouble is coming. Sickness will be serious; there's a likelihood of losing one's animals; a yellow-eyed woman will cause a quarrel; to relieve the serious sickness, one should make such-and-such offerings, and so on.[1]

A manuscript of this sort takes for granted that ordinary Thai people would know their Rama epic stories well and would recognize the references and illustrations.

Little squares of gold leaf have been stuck on at meaningful spots during the fortune-telling process.

F.McG.

NOTE

1. Thanks go to Thibodi Buakamsri, who read and studied the manuscript and translated several sections. For more on how such fortune-telling manuscripts work, see Wales, *Divination in Thailand*, especially 36–40. In "popular religiosity" in Buddhist Cambodia, major Rama epic characters are "associated with the twelve-year animal cycle, days of the week, and the directions"; Harris, *Cambodian Buddhism*, 92.

122 *also fig. 68*

"Valiant Eagle," from *Ramayana: Divine Loophole,* 2010

By Sanjay Patel (British, b. 1974)
Printed book
H. 21 × W. 23.2 cm
Asian Art Museum Library

Writers, artists, filmmakers, performers, and many others continue to retell the legends of Rama and his companions today.

Here Sanjay Patel, an artist with Pixar Animation Studios, depicts a famous scene in a book he wrote and illustrated. Ravana, with enough heads and arms to suggest the standard ten and twenty, slashes at the wings of the heroic vulture Jatayus (called an eagle here). Sita, traumatized by her abduction, shrinks in fear for the welfare of Jatayus as he tries to rescue her.

F.McG.

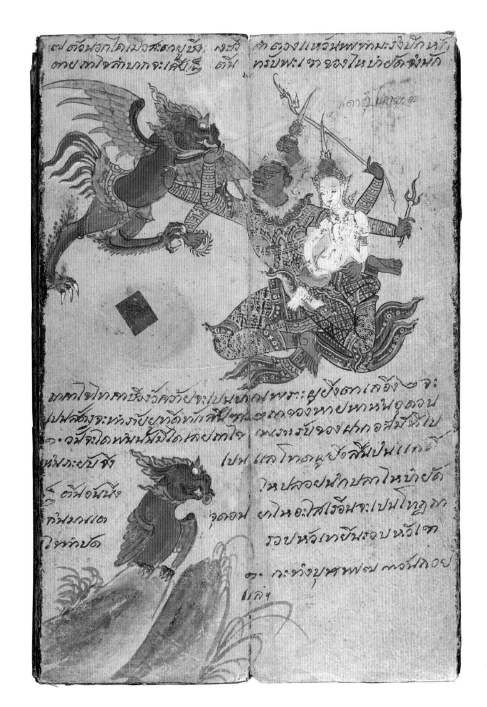

VALIANT EAGLE

AS TEARS STREAMED down Sita's face, she called out as loudly as she could for Rama and Lakshman. But it was no use, for now they were flying high above the trees. Fortunately, the demon's chariot flew right over Jatayu's nest. The majestic eagle flapped its wings, took to the air, and in moments was in pursuit of the speeding demon.

Swooping in front of Ravana's path, Jatayu demanded that he abide by the code of kings and release Sita at once. But Ravana had no intention of honoring this code. The demon took up his bow and began firing arrows at the eagle, but Jatayu flapped his mighty wings, causing a mini tempest that deflected the arrows. The eagle clawed at the chariot with his mighty talons and snatched Ravana's bow, shattering it easily. But, Ravana would not be bested by the mighty beast. With a powerful swing of his sword, the cruel demon cut straight through the eagle's wing, adding yet another crime to his notorious list. The mighty eagle fell from the sky as Ravana's chariot streaked across the horizon and disappeared.

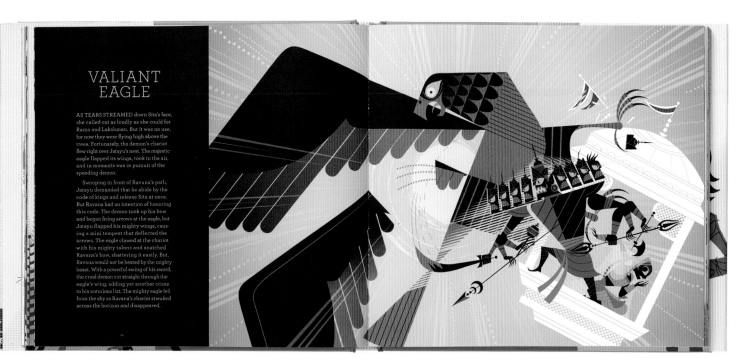

123

Mandodari admonishes her husband, the demon king Ravana, while Rama and his allies convene outside the palace, approx. 1605

India; possibly Madhya Pradesh state, former kingdom of Datia
Opaque watercolors and gold on paper
H. 26.7 × W. 18.4 cm
Asian Art Museum, Gift of the Connoisseurs' Council with
additional funding from Fred M. and Nancy Livingston Levin,
the Shenson Foundation, in memory of A. Jess Shenson, 2003.4

In stubbornness and unwillingness to heed good
advice, Ravana has few equals.

Just as Rama and his forces are reaching his
kingdom, and war is looming, several of those closest
to Ravana seek to warn him to return Sita before it is
too late.

In this episode his beautiful and high-principled
senior wife Mandodari tries, unsuccessfully, to
reason with her husband. She says, according to the
inscription on the back of the painting,

> O Indra of Kings, with my hands folded in
> supplication,
> I beg you—[listen to this request];
> O proud one, some offense is not intended by
> me in speaking
> The [city] is reported to me [as besieged].
> The rakshasas are reported to me as killed—
>
> Surely, O magnanimous one, [in battle] it is not
> appropriate
> for you to stand in front of Rama,
> whose wife, O illustrious one, was sullied by you.
> Rama, the son of Dasharatha, is not merely
> mortal.[1]

Ravana scoffs, paying no attention to the warning.
Most of his courtiers flatter him and encourage his
willfulness.

At lower right we see Rama (with blue skin, as
usual) and his brother Lakshmana, along with several
of their monkey allies. F.McG.

NOTE

1. Excerpt from the reading and translation of the inscription by
Kashi Gomez. She notes that "a parallel inscription to the one found
on object 2003.4 can be found in the Kumbakonam critical edition of
the Rāmāyaṇa printed by Nirṇayasāgar Press. The passage is from an
interpolated sarga in the Yuddhakāṇḍa following the 58th sarga. The
passage roughly corresponds to verses 6–26 of prakṣipta sarga." She
adds that the episode is discussed in Goldman, Sutherland Goldman,
and van Nooten, *Yuddhakāṇḍa,* notes on sarga 46 n. 51 (p. 870) and
sarga 51 n. 20 (p. 951).

COMBAT BETWEEN RAMA'S AND RAVANA'S FORCES

The battles between Ravana and Rama and their forces, cosmic in both size and significance (because they pit a righteous world order against its opposite), continue for more than two hundred pages in the standard translation of the Valmiki Ramayana. Demon generals combat monkey generals, both attack their masters' prime opponents, and, most momentously, Ravana and Rama fight each other directly, using their most fearsome weapons.

124 *also fig. 55*

Rama, Lakshmana, and the army of monkeys and bears attack Ravana, approx. 1690

India; Malwa, Madhya Pradesh state
Opaque watercolors on paper
H. 20.5 × W. 28.6 cm
The San Diego Museum of Art,
Edwin Binney 3rd Collection, 1990.965

Ravana in his chariot is attacked by Rama and Lakshmana, mounted on the shoulders of monkeys, and is set upon by other monkeys and a bear.[1] The tide of battle is turning against Ravana, who seems to have only one active defender, while three of his warriors lie dead or dying on the ground. F.McG.

NOTE

1. The monkeys carrying Rama and Lakshmana are presumably Hanuman and Angada. These two monkeys carry the two heroes in the Valmiki Ramayana Yuddhakanda 4:16, and Hanuman carries Rama into combat against Ravana at Yuddhakandha 47:117; Goldman, Sutherland Goldman, and van Nooten, *Yuddhakāṇḍa*, 127, 260. Two or three of the other monkeys here, those in the red garments with black spots, may also be Hanuman at other moments of the fighting.

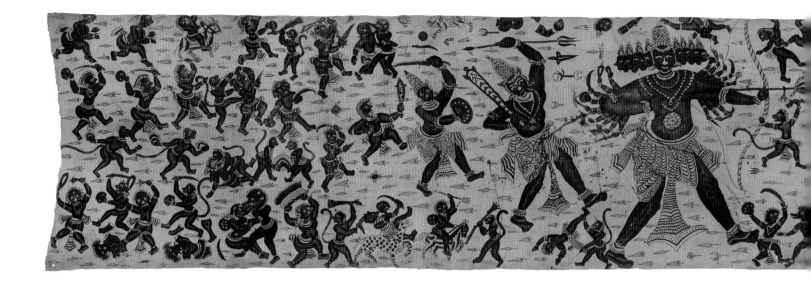

125

**The combat of Rama and Ravana
and their forces,** approx. 1750–1800

India; Tamil Nadu state
Painted and mordant-dyed cotton
H. 87 × W. 539.1 cm
The Metropolitan Museum of Art, Purchase,
Friends of Asian Art Gifts, 2008.163

Ravana and Rama face off amid a hail of arrows, surrounded by a jumble of demon warriors and monkeys armed with boulders, branches, and tree stumps. Dismembered corpses, one of an elephant-headed demon, litter the ground. The very number of combatants evokes, since it cannot really represent, the huge armies of the Rama epic. In the Valmiki Ramayana the monkey army alone is said to number "in the thousands, tens of millions, and billions."[1]

Intriguing vignettes are everywhere: two monkeys brandish severed legs, another carries what seems to be a hoof, and several creatures gnaw at each other's heads. Meanwhile, little winged celestials pour baskets of flowers over Rama to celebrate his coming victory.

Long paintings on cloth of this type were made in India, apparently for export, as examples have survived in Indonesia but not in India itself. They seem to have been produced during the eighteenth century, as one has the stamp of a Dutch trading company that went out of business in 1799. The examples from Indonesia were found on the islands of Bali and Sulawesi. The Balinese, with their vibrant Hindu-Buddhist culture, would have recognized easily who and what are represented here. An interesting question, though, is how these paintings were interpreted by the people of Sulawesi, who may not have been acquainted with Indian legends.[2] F.McG.

NOTES
1. Goldman, Sutherland Goldman, and van Nooten, *Yuddhakāṇḍa,* 204 (32:10).
2. Guy, *Woven Cargoes,* 115–117.

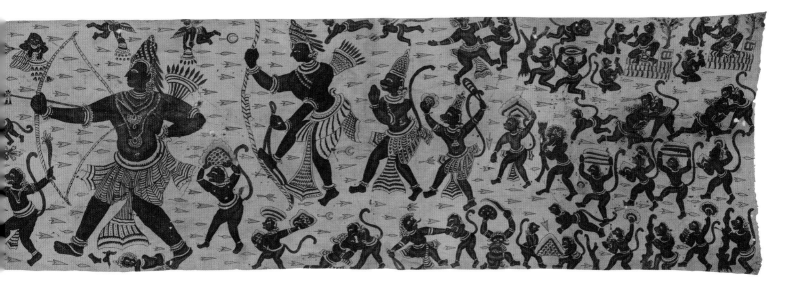

126

Rama and his allies battle Ravana,

approx. 1940–1960

> By Jamini Roy (Indian, 1887–1972) and workshop
> Tempera on canvas
> Image: H. 43.5 × W. 108 cm
> Peabody Essex Museum, The Chester and Davida Herwitz
> Collection, E301249

Again, Ravana and Rama clash on a gory battlefield. The mid-twentieth-century artist Jamini Roy looked for inspiration to the sort of folk paintings and narrative scrolls of his native Bengal (cat. no. 2).

The development of Roy's artistic career has been difficult for scholars to follow, because he seldom dated his paintings and often made copies or altered versions of his own works. Also, many of his paintings were copied or emulated by his students and followers.

In 1940, Roy completed a commission for a series of seventeen large horizontal paintings of scenes from the Ramayana.[1] In following years he created multiple variations of these Ramayana paintings. F.McG.

NOTE

1. Mitter, *Triumph of Modernism*, 107.

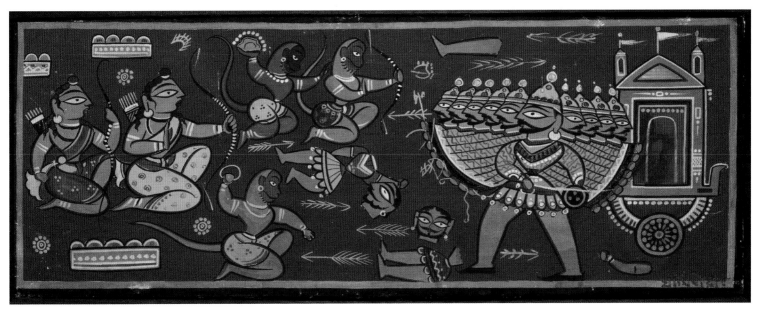

127

Ravana is attacked, approx. 1750

India
Opaque watercolors on paper
H. 15.6 × W. 19.7 cm
Brooklyn Museum, Gift of Dr. Bertram H. Schaffner, 1994.11.1

Ravana, having lost a number of his arms and bleeding profusely, continues to confront Rama or Lakshmana, who fires an arrow into the air.[1] Hanuman and another figure, probably Ravana's brother Vibhishana, who had earlier joined Rama's side, look on impassively.

Precisely what is going on here is not clearly understood. Why is the figure in blue shooting straight upward, rather than at Ravana, who stands before him? And why is he looking down into a shallow dish? Presumably he must, for one reason or another, shoot an arrow guided only by what he can see reflected there.

E-mails have flown among scholars on three continents in attempts to identify the scene,[2] which is not found in any of the better-known versions of the Rama epic. References were traced to a little-known folk tradition in which the soul of Ravana is transferred into a wasp so that he cannot be killed in any ordinary way. Complicated requirements mean that the only person who can kill Ravana is Lakshmana, and to do so he must stand on a pan of boiling oil and shoot the wasp only by seeing its reflection in the oil (and so on).[3]

This painting must relate to some such tradition. (There even seems to be a wasp on the dish.) What is puzzling, though, and unanswered, is why a painter working in an artistic style and format associated more with court than with village would depict this unusual episode from a source that would have seemed, from the point of view of city-dwelling artists and patrons, rather rural and naive.

A further question is, who is the small female figure visible between the male figures in blue and red? F. McG.

NOTES

1. Rama would be expected to have bluish, as opposed to Lakshmana's white, skin, but it might seem more likely that Rama, not Lakshmana, would have so gravely wounded Ravana.

2. Many thanks to Philip Lutgendorf, Joan Cummins, Nityanand Misra, Robert Goldman, Sally Sutherland Goldman, John Brockington, and Mary Brockington for their efforts and advice.

3. Nityanand Misra pointed us to the article "Rom-Sitmani Vāratā" by Bharati B. Jhaveri in which this story, coming from the Bhil people of northern Gujarat state, is discussed. The notion of the soul being kept separately from the body for protection turns up in many storytelling traditions. In the Thai Rama epic, Ravana's soul is kept in a secret container, and he can be killed only when Hanuman finds the container and crushes it. The motif of firing upward while looking downward at a reflection in a dish is seen in an eighteenth-century Kotah painting on the market last year. In it, however, Lakshmana shoots at Ravana flying over in an aerial chariot and Ravana is shown crashing to the ground. See Nancy Wiener Gallery, *Paths to the Divine*, 32–33.

Ravana's roles as warrior, king, wreaker of violence and injustice, and antagonist to Rama are the ones we think of first. But Ravana was also the head of a large family. Considering his relationships with his brothers and sisters, his senior wife Mandodari, and his seven sons (chief among them the eldest, Indrajit) is important in understanding his character and motivations. (For more on Ravana's relations with his siblings and his senior wife, see cat. nos. 107, 117, 118, and 123.)

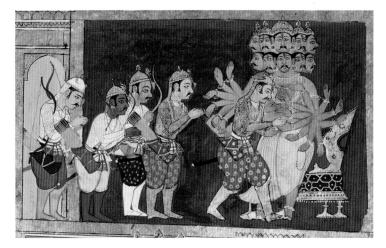

Ravana embraces Indrajit (detail of cat. no. 128).

128

Indrajit ensnares Rama and Lakshmana with his serpent weapon; Ravana congratulates him, page from the Mewar Ramayana, 1649–1653

> By Sahibdin (Indian, active approx. 1625–1660)
> Opaque watercolors on paper
> H. 26.6 × W. 46.7 cm
> The British Library, Add. 15297(1) f.34r

129

Text page for Indrajit ensnares Rama and Lakshmana with his serpent weapon; Ravana congratulates him, from the Mewar Ramayana, 1649–1653

> By the scribe Hirananda
> Ink on paper
> H. 29.1 × W. 46.6 cm
> The British Library, Add. 15297(1) f.33v

This complicated painting highlights a significant interaction between Ravana and Indrajit. The war between Ravana's forces and Rama's has reached one of its critical moments. Indrajit has made himself invisible (though *we* can see him—in a chariot at upper left) and fires magic snake arrows at Rama and his brother, who lie seriously wounded and ensnared in snakes, at left. In the yellow block in the middle of the painting, Indrajit (identifiable here by his bow and quiver of arrows) rides into his father's palace to report his victory. He is shown four more times: entering a portal, sitting before his father and reporting that he has killed Rama (an exaggeration, because Rama has not died and in fact will recover), standing respectfully as his father rises, and accepting his father's many-armed embrace. The Valmiki Ramayana reports that Ravana "leapt up in great delight and embraced his son, right in the midst of

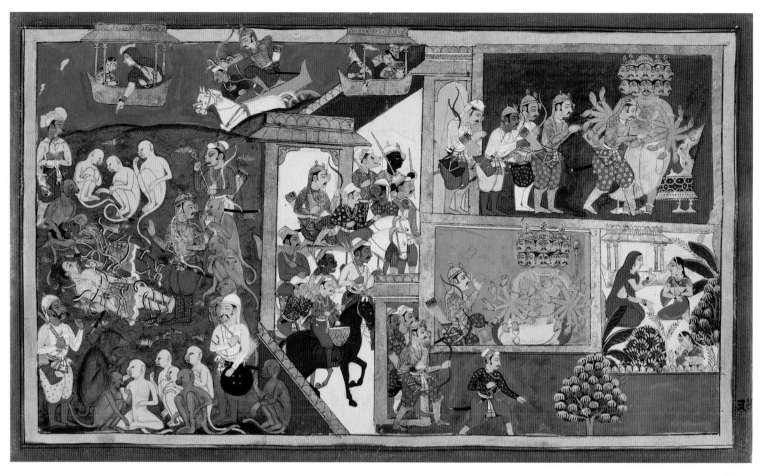

॥श्रीरामः॥
३३

लारावणिंबाःप्रजयद्व निःक्रकंयौक्तौ हत्याम्रातरौरामलक्ष्मणौ॥ वसुधाधिस्म्याहौ हतानिचय्स्मन्यासत्वरु॥ घेउरंगत्लारावणिःमसिनिजया॥ अविवेश्राम्रहेष्यामोहर्ष्यसर्वनैर्सनात्र रामलक्ष्मणयोरेश्याखारेनिभ्रनिछितं॥ बान्रेद्रुमंजातंसुग्रीवम्यमहद्यं नेउवाचपरिहृक्ल्याबानरेंदविचीनणः॥ सवाय्यवदनेदीनंक्रोध्यक्याकुललोचनै॥ अलेचासेनसुग्रीवबाय्यवेगौनिगूद्तां एवंशयातिषुग्यानिविजयोनालिनिनैष्किन॥ सरोष्याग्रगतास्माकंयदिष्य रौःनविष्यधामोस्मैनौविमोचेतेन्नात्रौरामलक्ष्मणौ॥ पर्यवस्थाम्यंयात्मानमग्रायंमंचवत्सरा सत्वधर्मसात्वरक्र नोनानिश्रांश्वयंरूतंमोहमंतापसंयुक्रोरसंप्रतिमहाकपे॥ विश्ग्यन्तत्वयंत्राम्रःक्रामामेषवनिर्लेय्राः॥ एव च क्रातत्क्रम्यजल्किज्केननपालिना॥ सुग्रीवम्यष्छनेत्रेइष्यमार्जविचीनणः॥ परुप्यवदन्तस्यक्रपिरानोरसह क्रति॥ अब्रवीत्कालसं प्राम्यमंश्रान्तो बिचीनणः॥ सकालःकपिराजेत्रय्यैक्र्यमत्रिवर्तितुं॥ अतिनीहोत्यकाले उब्यम्याय्योपपद्यते॥ तम्याडत्क्रजवैक्र्यंसर्वकार्यंविनाशनात्॥ हितंराम्रवरोगानां मैर्यातांमत्र वि तया॥ अय्याराम्यानांरामोय्यावल्ङ्ज्ञाविपर्ध्यैः॥ ल दुम्रंज्ञौउकाकुस्थौचयन्तौचयनेम्यन्त॥ नपापम्क्रिराम्रम्नव राम्रोउस्र्षति॥ नत्म्येनंत्यजतेलक्ष्मीडुर्लच्यागताच्छन्नां॥ नम्यादास्वाम्यम्यात्मनंसमासाद्यस्यसम्यव॥ याच्सर्वबएण नीकानिच्यनःसंख्यादपाघ्यहें रतेरूक्र्कुल्नव्यनम्रास्वाब्यागतम्राधम्रा॥ कर्णौक्रर्णंराम्यक्यकच्यिताचिर्ष्लंगवरहति सांवश्यष्याधावंतम्नीकेचुवधर्षिता॥ त्यस्यातिरचयस्वाम्संयर्गौज्ञीलार्निच्वच्वंॐ एवछक्राउसुग्रीवंच्च्लिग्यंरकी विचीनणः॥ चउलिःम्नविवैःमार्ग्रंत्याम्चवारेतवेलंज्ञेजिद्रुमहाकाय्रासर्वमैयसम्बित्य॥ अविवेश्रचुरीलंकाज्ञीक्रुत ३३

the *rākṣasas* [demons]. Delighted at heart, he kissed him on the head."[1]

Other emotionally charged moments are shown elsewhere in the painting. The monkeys clustered around the fallen Rama and his brother mourn and worry. The monkey king Sugriva is particularly distraught; he is reassured by Vibhishana, Ravana's brother who has earlier come over to Rama's side in the epic struggle (see cat. no. 42).

Also, Ravana, on hearing from Indrajit that Rama has been killed (though we know that he still lives), orders one of the demon women guarding Sita to take Sita aboard Ravana's flying palace and show her the battlefield where her husband lies dead. Ravana seems to have mixed evil motives, to punish Sita for her continued rejection of his advances and to make her think that, with her beloved husband killed, and with no further hope of rescue, she may as well submit.

At upper left we see Sita in the aerial palace being shown her stricken husband below. At lower right, however, her demoness guard, who turns out to be kindly, comforts Sita by informing her that Rama will survive. Sita "cupped her hands in reverence and said this: 'May it be so.' "[2]

The text page accompanying the painting is inscribed with verses from the Valmiki Ramayana:

Seeing both Rama and Lakshmana motionless on the ground and scarcely breathing, he assumed that they had been killed. Filled with delight, Indrajit, victorious in battle, entered the citadel of Lanka to the delight of all the *rakshasas* [demons], sons of chaos. When Sugriva saw that the bodies of Rama and Lakshmana were riddled with arrows in each and every limb, terror seized him. Then Vibhishana addressed the monkey king, who was terrified and dejected, his face covered with tears and his eyes suffused with sorrow. "Enough of this faintheartedness, Sugriva! Hold back this flood of tears! Battles are often like this. Victory is far from certain. If there is any remnant of good fortune left to us, hero, the brothers Rama and Lakshmana will

regain consciousness. So pull yourself together, monkey, and thus encourage me, who am without any recourse. Those who are devoted to the true path of righteousness have no fear of death."

When he had spoken in this fashion, Vibhishana dipped his hand in water and, with it, wiped Sugriva's lovely eyes. Once he had wiped the wise monkey king's face, he calmly spoke these timely words: "This is not the time to give way to despair, greatest of monkey kings. Moreover, at this inopportune moment, excessive tenderness could prove fatal. Therefore, you must abandon despair, which undermines all endeavors. You must think about what would be best for these troops under Rama's leadership. Rather, you should stand guard over Rama until he regains consciousness. Once the two Kakutsthas [Rama and his brother] have regained consciousness, they will dispel our fear. This is nothing to Rama; nor is he about to die. For that vital glow, which is never found in the dead, is not deserting him. So you must console yourself and rally your forces, while I regroup all the troops. For, bull among tawny monkeys, these tawny monkeys, filled with alarm, their eyes wide with terror, are spreading rumors from ear to ear. But once the tawny monkeys see me rushing about to encourage the army, they will cast aside their fear, as one would a used garland."

Once that foremost of *rakshasas* Vibhishana had reassured Sugriva, he set about rallying the terrified monkey army. But as for Indrajit, that great master of illusion, he entered the city of Lanka, surrounded by all his troops, and presented himself before his father.[3]

F.McG.

NOTES

1. Goldman, Sutherland Goldman, and van Nooten, *Yuddhakāṇḍa*, 217 (36:41–42).

2. Ibid., 222 (38:34).

3. Ibid., 216–217 (36:22–39). Thanks are due the Goldmans for identifying the exact verses included in the inscription.

130

Ravana takes the field against Lakshmana and Hanuman, page from the Mewar Ramayana, 1649–1653

By Sahibdin (Indian, active approx. 1625–1660)
Opaque watercolors on paper
H. 27.1 × W. 46.6 cm
The British Library, Add. 15297(1) f.60r

Ravana sends his forces, led by his sons and other generals, into battle against Rama time and time again, and he repeatedly takes the field himself, "eager for battle." Here, after the commander of his armies has been slain, Ravana flings a mighty spear and strikes Rama's brother Lakshmana. Lakshmana is shown four times: being hit by the spear while on the attack, crumpling to the ground, being carried off the field by Hanuman, and recuperating at Rama's feet, surrounded by concerned monkeys.

Meanwhile, "Hanuman, son of Vayu, enraged, rushed at Ravana. In his rage, he struck him on the chest with a fist like adamant. The blow of that fist made Ravana, lord of the *rakshasas,* slump to his knees on the floor of his chariot. He swayed for a moment and collapsed."[1] F.McG.

NOTE

1. Goldman, Sutherland Goldman, and van Nooten, *Yuddhakāṇḍa,* 259 (47:108–109).

131 *also figs. 73, 74*

Ravana grieves at Indrajit's death, and threatens Sita, page from the Mewar Ramayana, 1649–1653

By Sahibdin (Indian, active approx. 1625–1660)
Opaque watercolors on paper
H. 30.2 × W. 46.3 cm
The British Library, Add. 15297(1) f.128r

Ravana has the capacity for both deep suffering and explosive rage. His eldest and only surviving son, the awesome warrior Indrajit, has attacked Rama and his forces on Ravana's behalf in battle after ferocious battle. At last, in single combat with Rama's brother Lakshmana, he has been killed—decapitated. At the upper right of this painting, Ravana's ministers inform their master of what has taken place. "When he heard about the grievous, terrible, and horrifying death of his son Indrajit in battle, he fell into a profound stupor. Regaining his wits after a long time, the king . . . was overwhelmed with grief for his son. Despondent, his senses reeling, he gave way to lamentation."[1]

Soon, however, Ravana's grief turns to fury: "he was like the fire at the end of a cosmic age." He calls for his mightiest weapon, ordering, "Now, for the slaughter of Rama and Lakshmana in the ultimate battle, bring forth to the blare of hundreds of trumpets the great and terrible bow." The artist shows us the bow being readied at lower right and then, at left, the mobilization of a huge army in response to Ravana's further command.[2]

Next, as we see at the right center of the painting, Ravana's anger focuses on Sita. He takes up a sword and rushes, enraged, to kill her. Only a last-minute intervention by one of his trusted advisors, and the advisor's persuasive (and flattering) arguments, prevent the murder. F.McG.

NOTES

1. Goldman, Sutherland Goldman, and van Nooten, *Yuddhakāṇḍa,* 386 (80:4–5).
2. Ibid., 388 (80:27–28).

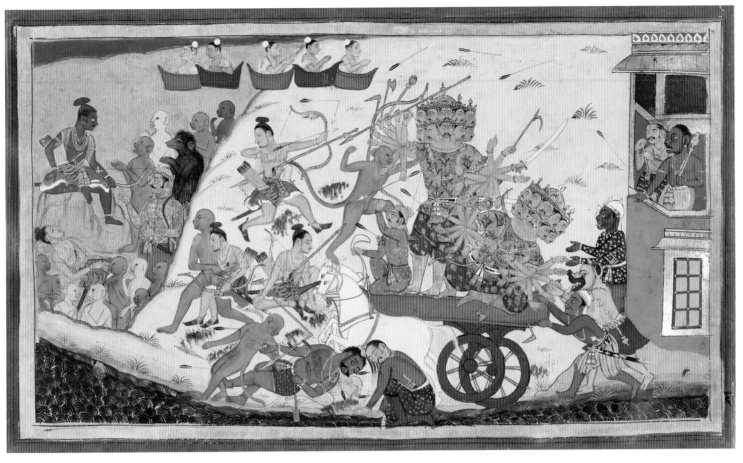

130

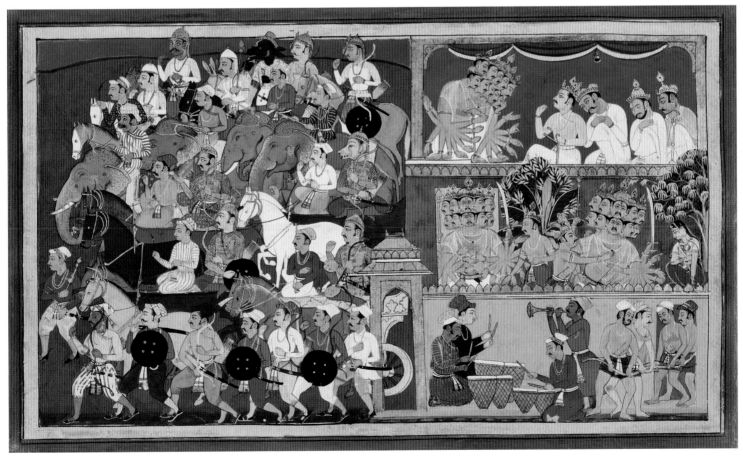

131

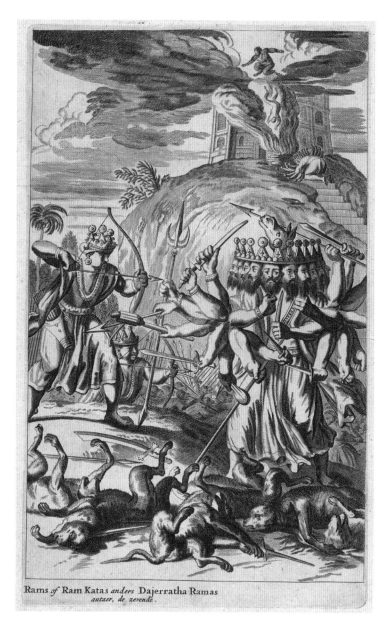

Rams *of* Ram Katas *anders* Dajerratha Ramas
autaer, de zevende.

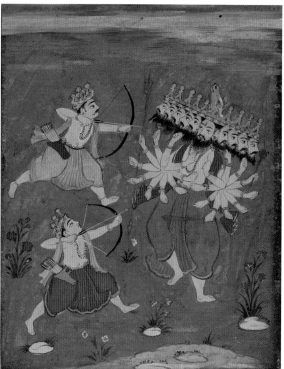

The sort of Indian painting that may have served as a partial model
for the Dutch artist's work. Rama with Lakshmana killing Ravana,
late seventeenth century, India, British Museum, 1974, 0617,0.2.64.

*Rama of the Ramakatha or Dasharatha Rama,
the seventh avatara* (Rams of Ram Katas anders
Dajerratha Ramas Autaer de zevende), approx. 1672
By Jacob van Meurs (Dutch, 1619/1620–1680)
Engraving
H. 40.6 × W. 25.7 cm
Robert J. Del Bontà Collection

By the seventeenth century, tales of Rama and
associated imagery were being introduced in Europe.
In this illustration from a Dutch writer's book on "the
Empire of the Great Mughals, and a large portion of
the Indies," a Dutch engraver depicts two episodes,
a combat between Rama and Ravana and, in the
background, an earlier moment when Hanuman
sets fire to Ravana's city. The book from which the
illustration comes includes a twenty-four-page
summary and discussion of the Rama epic.

The artist knows enough to call the story by one
of its Indian-language designations ("Ram Katas" for
Ramakatha), cite Rama's father's name ("Dajerratha"
for Dasharatha), correctly identify Rama as the
seventh avatara (of Vishnu), and accurately portray
Ravana with ten heads and twenty arms. He even
adds a donkey head above Ravana's human heads, as
Indian artists also sometimes did (for example, cat.
no. 120), in an apparent reference to Ravana's mulish
stubbornness (and the donkeys that are sometimes
said to draw his chariot).[1]

But misunderstandings have crept in, as the Dutch
artist has re-presented his model, presumably an
Indian painting. The dead dogs in the foreground (one
of which holds a sword) must have been, in the Indian
model, slain monkey warriors. F.McG.

NOTE
1. For example, Pollock, *Araṇyakāṇḍa*, 156 (33:6–7).

For all the outrages he committed, including abducting many women, of whom Sita was the foremost, Ravana was still loved by his devoted wives. When he is killed on the battlefield, they lament piteously.

133

Mourning for the death of Ravana, and preparations for his funeral, from the Mewar Ramayana, 1649–1653

By Sahibdin (Indian, active approx. 1625–1660)
Opaque watercolors on paper
H. 30.5 × W. 47 cm
The British Library, Add. 15297(1) f.173r

134

Text page for mourning for the death of Ravana, and preparations for his funeral, from the Mewar Ramayana, 1649–1653

By the scribe Hirananda
Ink on paper
H. 29.5 × W. 46.7 cm
The British Library, Add. 15297(1) f.172v

In the lower right of this painting, Ravana's chief wife, the worthy Mandodari, agonizes and waxes philosophical, attributing her husband's downfall not to Rama alone but to her husband's uncontrolled sensual appetites. She recalls how he ignored the advice of wise counselors to return Sita to Rama and avoid war (see cat. no. 123), saying, in the Valmiki Ramayana, "Through this catastrophe born of your lust and anger and characterized by your obsession, you have deprived the entire *rākṣasa* [demon] race of its protector."[1]

At the lower left, not taking notice of Mandodari's or the other wives' grieving, Rama addresses Vibhishana, Ravana's brother who had come over to Rama's side when Ravana angrily rejected his sensible advice. Rama asks him to prepare Ravana's funeral, one befitting Ravana's status as a Brahman and king. Vibhishana argues that he cannot carry out the rites of such a cruel, unrighteous being. Rama insists, however, pointing out that, whatever his myriad evil deeds, Ravana was still "a powerful and energetic hero in battle" and that, besides, "hostilities cease with death."[2]

At the upper part of the painting, Vibhishana oversees the collecting of firewood for Ravana's cremation.

133

134

The text page accompanying the painting is inscribed with verses from the Valmiki Ramayana:

[Ravana's wife Mandodari speaks:] "I really should not grieve for you, for you were a warrior famed for strength and manly valor. But still, because of the inherent nature of women, my heart is in a pitiable state. Taking with you both the good and the evil deeds you performed, you have gone to your proper destination. It is for myself that I grieve, miserable as I am, because of my separation from you. Resembling a black storm cloud, with your yellow garments and bright armlets, why do you lie here drenched in blood, splaying out all your limbs? I am overcome with sorrow. Why do you not answer me, as if you were asleep? Why do you not look at me, the granddaughter of an immensely powerful and skillful *yatudhana* [a sort of demonic creature] who never fled in battle. You always used to worship your iron club, adorned with a fretwork of gold and with a radiance like that of the sun, as if it were the *vajra* [thunderbolt weapon] of Indra, the wielder of the *vajra*. With it you used to slaughter your enemies in battle. But now that smasher of your foes in battle, shattered by arrows, lies scattered in a thousand pieces. Curse me whose heart, oppressed by sorrow, does not shatter into a thousand pieces now that you have returned to the five elements."

At this juncture, Rama said to Vibhishana, "Perform the funeral rites for your brother and send these women back."[3]

F.McG.

NOTES

1. Goldman, Sutherland Goldman, and van Nooten, *Yuddhakāṇḍa*, 443 (99:22).

2. Ibid., 445 (100:37–39).

3. Ibid., 443–444 (99:23–30). Thanks are due the Goldmans for identifying the exact verses included in the inscription.

135 *also fig. 75*

Reproductive engraving of the painting
The Death of Ravana (*La mort de Ravana*)
by Fernand Cormon, 1875

From *L'Univers Illustré*
Engraving
H. 28 × W. 39 cm
Asian Art Museum Library Special Collections, 36918

The grieving of Ravana's wives is again depicted in Fernand Cormon's painting *The Death of Ravana* (represented here by a reproductive engraving), a prize winner in the Paris Salon of 1875.

Cormon presumably knew the Ramayana from a famous French translation published by Hippolyte Fauche between 1854 and 1858. Descriptions in Fauche's translation could apply to Cormon's painting:

> At the sight of their dead husband lying in the dust of the battlefield, they dropped themselves on his limbs like vines on felled trees in a forest. This one embraced him devotedly, weeping; that one clasped his feet; another put her arms around his neck. . . . Another, seeing Ravana's face frozen in death, fainted; yet another held the monarch's head in her lap and, overcome with sorrow, bathed his pale face in her tears.[1]

Here there is no sign of Ravana's ten heads or twenty arms. In fact, there is little specifically Indian local color; the costumes and other details suggest only what nineteenth-century painters thought of as the Orient.

The painting calls to mind not only Delacroix's *Death of Sardanapalus* but also a long tradition of battlefield deaths, such as Benjamin West's *Death of General Wolfe,* and even—perhaps grotesquely—many depictions of the Lamentation over the Body of Christ.

Five years earlier Cormon had painted a work titled *Sita*. Without the title, it would appear to be a generic Orientalist portrayal of a harem woman. The present location of the painting is not known, and its appearance is suggested only by reproductive engravings. F.McG.

NOTE
1. My translation; Fauche, *Ramayana*, 2:292.

Reproductive engraving of the painting *Sita* by Fernand Cormon, 1870. Asian Art Museum Library Special Collections, 36919.

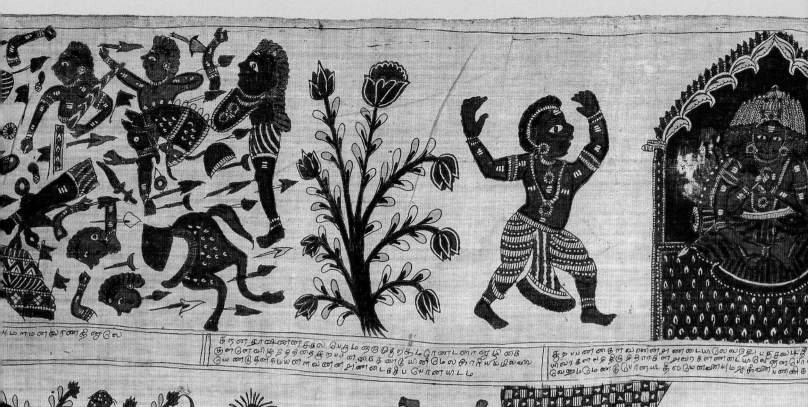

சிமாமண்டாரணக்குருலே

நரண்டாலணனத்தில பெருமருதுருத்துக்டொரேண்டாலனற்றுசை
குளோனவிழத்தைத்தைதிருப்படுத்தேவாட்டியின்மேல்காரியம்புலன
எனண்டுதன்தில்மனலைனன்வெண்டெதேனடியின்மேல்காரியம்புலன
எனண்டுதனதில்மனலைனன்என்தேதேனடிதின்மேல்காரியம்புலன அனடைதேப்போனயட்ட

சேபபணணைகாலவண்ணனண்ணையயலெலெவரேதுபகதெலடி
யிவரகளைசலுதிருகசோசாகினஅவரகளனமனையயிலென்றுன
வெலெட்டுமனடுேப்ரினபடி திதேனணையுமையக்குணபணணிகே

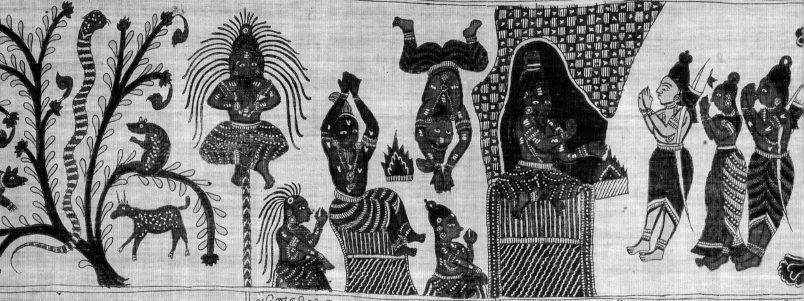

நசசுதசாரமானவணம

அனேசேஷ்களனதவசுபணணிதீற
மிட்ட

ம்மாரலெடதுமனனைசசிதைதடுண்டுபோகதுகுமசநமங்சநீஷ
சிததுமாதியசீசுதுமனதவசிண்ணைசிறையட்டதேலெவநடலைகண

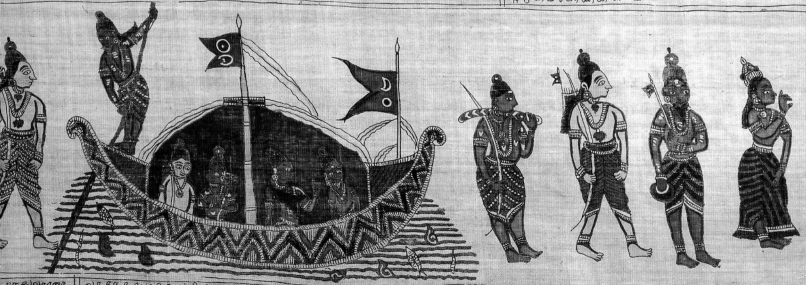

பாதுலவாணர
ம்

வந்தநசதுதுருகநலைதந்தஷ்டநுகோசயமாரதசசயணதேவண
சகலமுமடுடல்தேலே நிதிகணையபணட—யண்டேவண யண்ட வணடம

குண்டுடதைதைதுகளிலோரண்டுவலெவரநசைசக்குகோலவலிஷ்ட—
ராயமாநதசலேதேசணிதேனாயயும அகணாலைலவிடு யண்டம

Acknowledgments

The help of many kind people has been necessary to bring forth this publication and the exhibition to which it is related. First, thanks go to Director Jay Xu and the Asian Art Museum's other senior leaders for finding the project worthwhile and committing the institution's support. Then, the museum's longtime friends Helen and Raj Desai made a major early pledge of financial support that was critical in launching the Rama epic project.

From the very beginning we had the advantage of the knowledge and wisdom of world-renowned Rama epic specialists Robert Goldman, Sally Sutherland Goldman, and Philip Lutgendorf, who not only agreed to write essays but also have advised us on innumerable issues large and small. For several years, from wherever they have been traveling, they have answered e-mails late and early to puzzle through what is going on in a certain artwork or what literary source it may be related to. They were joined by three curatorial colleagues at the Asian Art Museum, Qamar Adamjee, Jeffrey Durham, and Natasha Reichle, whose knowledge of a variety of fields—from South Asia Islamic literary culture to Indian philosophy to the Hindu-Buddhist arts of Indonesia—has greatly enriched the project.

A slightly later addition to the roster of contributors was Pika Ghosh, who, in addition to her admirable

scholarship, brought to our discussions the lifetime of associations of one who grew up in India surrounded by Rama epic traditions.

Curators, administrators, registrars, and conservators at more than twenty museums and libraries have been most generous in helping with loan matters, from securing agreements to providing information from institutional files and personal research. In a number of instances, it seemed that key artworks might not be able to be lent because of their fragility or because of competing display schedules. Our friends at these museums and libraries worked through such complex issues to make the loans possible. Further, they have accommodated our needs for new photography, which involved moving artworks from display or storage to the photo studio, positioning them for optimum effect, and processing all the results.

It is impossible to list all to whom we are indebted, but several must receive special mention. Pierre Baptiste of the Musée national des arts asiatiques–Guimet took extra time and effort to advise and suggest artworks, as did Jorrit Britschgi then of the Museum Rietberg, Joan Cummins of the Brooklyn Museum, John Guy of the Metropolitan Museum, Darielle Mason of the Philadelphia Museum of Art, and Sonia Quintanilla of the Cleveland Museum. Similarly, among individual lenders, we are grateful to scholar-collectors Catherine

Benkaim, Robert J. Del Bontà, and Gursharan and El-vira Sidhu for sharing not only their artworks but also their special knowledge and insights. Other scholars in India, Thailand, Europe, and the United States have kindly answered queries and provided encouragement; some of them are thanked by name in the notes to the essays and entries. Appreciation is also due to Maria Packman and Nandan Shastri.

At the Asian Art Museum, many colleagues in every department have supported our efforts in various ways, not least through their enthusiasm and moral support. Singling out a few individuals among so many is neither easy nor comfortable, but these deserve special mention for their many months of work that have contributed to the success of the publication and exhibition: Tracy Jones and Cristina Lichauco in Registration; Jonathan Bloom and Kevin Candland in Image Services; John Stucky in the library; Clare Jacobson in Publications; Marco Centin in Exhibition Design; Mark Fenn and Shiho Sasaki in Conservation; Tashina Garcia-Garza, Sandy Shin, Pamela Brasunas, Joyce Chan, and Christina Limberakis in Curatorial; and Deborah Clearwaters, Allison Wyckoff, Lorraine Goodwin, and Caren Gutierrez in Education.

Lenders to the Exhibition

Anonymous lender

Art Institute of Chicago

Asia Society, New York

The Catherine and Ralph Benkaim Collection

The British Library, London

The British Museum, London

Brooklyn Museum

The Cleveland Museum of Art

Robert J. Del Bontà Collection

Collection of Barbara and Eberhard Fischer

Harvard Art Museums/Arthur M. Sackler Museum

Linden-Museum, Stuttgart

Los Angeles County Museum of Art

The Metropolitan Museum of Art

Musée national des arts asiatiques–Guimet, Paris

Museum of Fine Arts, Boston

Nationaal Museum van Wereldculturen, The Netherlands

The New York Public Library for the Performing Arts

Peabody Essex Museum

Philadelphia Museum of Art

Museum Rietberg Zurich

The San Diego Museum of Art

The Collection of Gursharan S. and Elvira Sidhu

Smithsonian Institution, National Museum of Natural History

Victoria and Albert Museum, London

Virginia Museum of Fine Arts

Judy Wilbur

Acri, Andrea, Helen Creese, and Arlo Griffiths, eds. *From Laṅkā Eastwards: The Rāmāyaṇa in the Literature and Visual Arts of Indonesia.* Leiden: KITLV Press, 2011.

Agrawal, Bhanu. *Valmiki Ramayana in Malwa Painting.* Varanasi: Ganga Kaveri Publishing House, 1995.

Agrawala, P. K. "The Identification of Hanumān and Rāma in a Nāgārjunakoṇḍa Relief." *Journal of the Oriental Institute of Baroda* 30, nos. 1–2 (1980): 109–111.

Ahmad, Aziz. "Epic and Counter-Epic in Medieval India." *Journal of the American Oriental Society* 83, no. 4 (September–December 1963): 470–476.

Aitken, Molly Emma. *The Intelligence of Tradition in Rajput Court Painting.* New Haven [CT]: Yale University Press, 2010.

Alter, Joseph S. "Celibacy, Sexuality, and the Transformation of Gender into Nationalism in Northern India." *Journal of Asian Studies* 53 (1994): 45–66.

———. *The Wrestler's Body: Identity and Ideology in North India.* Berkeley: University of California Press, 1992.

Anderson, Benedict R. O'G. *Mythology and the Tolerance of the Javanese.* Ithaca, NY: Modern Indonesia Project, Southeast Asia Program, Department of Asian Studies, Cornell University, 1965.

Archer, Mildred. *Indian Popular Painting in the India Office Library.* London: Her Majesty's Stationery Office, 1977, 159–170.

Arni, Samhita, Moyna Chitrakar, and Vālmīki. *Sita's Ramayana.* Toronto: Groundwood Books, 2011.

Arts et archéologie khmers: Revue des recherches sur les arts, les monuments et l'ethnographie du Cambodge, depuis les origines jusqu'à nos jours. Paris: Société d'éditions géographiques, maritimes et colonials, 1922.

Aryan, K. C., and Subhashini Aryan. *Hanumān in Art and Mythology.* Delhi: Rekha Prakashan, 1975.

Aung Thwin, U. "Myanmar Ramayana Text and Presentation." In *Texts and Contexts in Southeast Asia: Proceedings of the Texts and Contexts in Southeast Asia Conference, 12–14 December 2001,* Part 3, 132–160. Yangon: Universities Historical Research Centre, 2003.

Bandem, I Made. "*Ramayana:* The Roles of the Great Epic in Visual and Performing Arts of Bali." In Krishnan, *Ramayana in Focus,* 144–155.

Baptiste, Pierre, and Thierry Zéphir. *Angkor, naissance d'un mythe Louis Delaporte et le Cambodge.* Paris: Musée des arts asiatiques Guimet, 2013. Exhibition catalogue.

———. *L'art khmer dans les collections du Musée Guimet.* Paris: Réunion des musées nationaux, 2008.

Beach, Milo Cleveland. *The Adventures of Rama: With Illustrations from a Sixteenth-Century Mughal Manuscript.* Washington, DC: Freer Gallery of Art, Smithsonian Institution, 1983.

The Bhagavad-Gītā with the Commentary of Śrī Śaṅkarācārya. Rev. ed. Edited by Dinkar Vishnu Gokhale. Poona, India: Oriental Book Agency, 1950.

Biswas, Soutik. "Ramayana: An 'Epic' Controversy." BBC News South Asia, November 19, 2011. http://www.bbc.com/news/world-south-asia-15363181.

Bizot, François. *Ramaker ou, L'amour symbolique de Ram et Seta: Recherches sur le bouddhisme khmer, V.* Paris: École française d'Extrême-Orient, 1989.

Blackburn, Stuart H. *Inside the Drama-House: Rāma Stories and Shadow Puppets in South India.* Berkeley: University of California Press, 1996.

Blank, Jonah. *Arrow of the Blue-Skinned God: Retracing the Ramayana through India.* Boston: Houghton Mifflin, 1992.

Bofman, Theodora Helene. *The Poetics of the Ramakian.* [De Kalb]: Northern Illinois University, Center for Southeast Asian Studies, 1984.

Bose, Mandakranta, ed. *The Rāmāyaṇa Culture: Text, Performance, and Iconography.* New Delhi: D. K. Printworld, 2003.

———. *The Rāmāyaṇa Revisited.* New York: Oxford University Press, 2004.

———. *A Varied Optic: Contemporary Studies in the Rāmāyaṇa.* Vancouver: Institute of Asian Research, The University of British Columbia, 2000.

Botto, Oscar, ed. "Proceedings of the Ninth International Rāmāyaṇa Conference: Torino, April 13th–17th, 1992." *Indologica Taurinensia* 19–20 (1993–1994).

Branfoot, Crispin, and Anna L. Dallapiccola. "Temple Architecture in Bhatkal and the Ramayana Tradition in Sixteenth-Century Coastal Karnataka." *Artibus Asiae* 65, no. 2 (2005): 253–308.

Britschgi, Jorrit, and Eberhard Fischer. *Rama und Sita: Das Ramayana in der Malerei Indiens.* Zurich: Museum Rietberg, 2008.

Brockington, J. L. *Righteous Rāma: The Evolution of an Epic.* Delhi: Oxford University Press, 1984.

———. *The Sanskrit Epics.* Leiden: Brill, 1998.

Bronner, Yigal. "A Text with a Thesis: The *Rāmāyaṇa* from Appayya Dīkṣita's Receptive End." In *South Asian Texts in History: Critical Engagements with Sheldon Pollock,* edited by Yigal Bronner, Whitney Cox, and Lawrence McCrea, 45–63. Ann Arbor: Association of Asian Studies, 2011.

Buck, Harry Merwyn. *The Figure of Rama in Buddhist Cultures.* Bhubaneswar, India: Mayur Publications, 1995.

Buddhaisawan Chapel. Mural Paintings of Thailand Series. Bangkok: Muang Boran Publishing House, 1983.

Bunker, Emma C., and Douglas Latchford. *Adoration and Glory: The Golden Age of Khmer Art.* Chicago: Art Media Resources, 2004.

Cadet, J. M. *The Ramakien: The Stone Rubbings of the Thai Epic.* Tokyo: Kodansha International, 1975.

"Cambodian Dancers, Lithographs by Thomas Handforth." *Asia,* January 1936, 49–51.

Carpenter, Bruce, John Darling, H. I. R. Hinzler, Kaja M. McGowan, Adrian Vickers, and Soemantri Widagdo. *Lempad of Bali: The Illuminating Line.* [Denpasar, Indonesia]: Museum Puri Lukisan, 2014.

Chakrabhand Posayakrit. *Hun Wangnā: The Viceregal Puppets.* Bangkok: Rōngphim Krung Thēp, 1997.

Chaudhury, Shoma. "'In Hindu Culture, Nudity Is a Metaphor for Purity.'" Interview with Maqbool Fida Husain. *Tehelka Magazine* 5, no. 4 (February 2, 2008).

Copley, A. R. H. "Projection, Displacement and Distortion in Nineteenth-Century Moral Imperialism: A Re-Examination of Charles Grant and James Mill." *The Calcutta Historical Journal* 7 (1983): 1–27.

Craven, Roy C. *Ramayana: Pahari Paintings.* Bombay: Marg Publications, 1990.

———. "The Reign of Raja Dalip Singh (1695–1741) and the Siege of Lanka Series of Guler." In "Ramayana: Paintings from the Hills," *Marg, A Magazine of the Arts* 42, no. 1 (September 1990): 4–56.

Cummings, Cathleen Ann. "Composition as Narrative: Sāhibdīn's Paintings for the Ayodhyākāṇḍa of the Jagat Singh Rāmāyaṇa." *Ars Orientalis* 40 (2011): 162–203.

———. *Decoding a Hindu Temple: Royalty and Religion in the Iconographic Program of the Virupaksha Temple, Pattadakal.* Woodland Hills, CA: South Asia Studies Association, 2014.

Cummins, Joan, and Doris Srinivasan. *Vishnu: Hinduism's Blue-Skinned Savior.* Ocean Township, NJ: Grantha Corporation, 2011.

Daljeet, and V. K. Mathur. *Ramayana in Indian Miniatures: From the Collection of the National Museum, New Delhi.* 2015.

Dallapiccola, Anna L. *Indian Painting: The Lesser-Known Traditions.* New Delhi: Niyogi Books, 2011.

———. *Die "Paithan"-Malerei: Studie zur ihrer stilistischen Entwicklung und Ikonographie.* Wiesbaden, Germany: Steiner, 1980.

———. "'Paithan' Paintings: The Epic World of the Chitrakathis." In Jain, *Picture Showmen,* 66–73.

———. *South Indian Paintings: A Catalogue of the British Museum Collections.* London: British Museum Press in association with Mapin Publishing, 2010.

Dallapiccola, Anna L., John M. Fritz, George Michell, and S. Rajasekhara. *The Ramachandra Temple at Vijayanagara.* New Delhi: Manohar, American Institute of Indian Studies, 1992.

Dallapiccola, Anna L., and Anila Verghese. *Sculpture at Vijayanagara: Iconography and Style.* New Delhi: Manohar Publishers & Distributors for American Institute of Indian Studies, 1998.

Das, A. K. "Notes on the Emperor Akbar's Manuscript of the Persian Ramayana." In Iyengar, *Asian Variations in Ramayana,* 144–153.

Datta, Sona, and Rivka Israel. *Urban Patua: The Art of Jamini Roy.* Mumbai: Marg Publications, 2010.

Dehejia, Vidya. *The Legend of Rama: Artistic Visions.* Bombay: Marg Publications, 1994.

———. "The Treatment of Narrative in Jagat Singh's 'Rāmāyaṇa': A Preliminary Study." *Artibus Asiae* 56, no. 3/4 (1996): 303–324.

Dehejia, Vidya, Richard H. Davis, Irā Nākacāmi, and Karen Pechilis. *The Sensuous and the Sacred: Chola Bronzes from South India.* New York: American Federation of Arts, 2002.

de Jong, J. W. "An Old Tibetan Version of the Rāmāyaṇa." *T'oung Pao,* 2nd ser. 58 (1972): 190–202.

Dey, Mukul. *Birbhum Terracottas.* [New Delhi]: Lalit Kala Akademi, 1959.

Dhanit Yupho. *The Khōn and Lakon: Dance Dramas Presented by the Department of Fine Arts.* Bangkok: Department of Fine Arts, 1963.

———. *Khon Masks.* Bangkok: Department of Fine Arts, 1962.

Dikshit, Rajesh. *Hanumān upāsanā.* Delhi: Dehāti Pustak Bhaṇḍār, 1978.

Din, Jayram Das. *Mānas rahasya.* Gorakhpur, U.P.: Gita Press, 1942.

Dodiya, Jaydipsinh, ed. *Critical Perspectives on the Rāmāyaṇa.* New Delhi: Sarup and Sons, 2001.

Doniger, Wendy. *The Hindus: An Alternative History.* New York: Penguin Press, 2009.

Dutt, Gurusaday. *Paṭuẏā saṅgīta.* Kolkata [Calcutta]: Kalakātā Biśvabidyālaẏa, 1939.

Dutt, Michael Madhusudan, and Clinton B. Seely. *The Slaying of Meghanada: A Ramayana from Colonial Bengal.* New York: Oxford University Press, 2004.

Ekhtiar, Maryam, et al., eds. *Masterpieces from the Department of Islamic Art in The Metropolitan Museum of Art.* New York: Metropolitan Museum of Art, 2011.

Exhibition of Khon Masks / Nithatsakān hūakhōn. [Bangkok]: [Krom Sinlapākǫn], 1971.

Fauche, Hippolyte, trans. *Le Ramayana: poème sanscrit.* Paris: Librairie Internationale, 1864. gallica.bnf.fr.

Ferrars, Max, and Bertha Ferrars. *Burma.* London: S. Low, Marston & Co., 1900.

Fontein, Jan. "The Abduction of Sītā: Notes on a Stone Relief from Eastern Java." *Boston Museum Bulletin* 71, no. 363 (1973): 21–35.

Fritz, John M. "Vijayanagara: Authority and Meaning of a South Indian Imperial Capital." *American Anthropologist* 88 (1986): 44–55.

Gaspar, Ana, Antonio Casanovas, Jean Couteau, and I Gusti Nyoman Lempad. *Lempad: A Timeless Balinese Master.* Wijk en Aalburg: Pictures Publishers, Art Books, 2014.

Ghosh, Anindita. *Power in Print.* Oxford and New Delhi: Oxford University Press, 2006.

Ghosh, Pika. "A Bengali *Ramayana* Scroll in the Victoria and Albert Museum Collection: A Reappraisal of Content." *Journal of the Society for South Asian Studies* 19, no. 1 (2003): 157–167.

———. "Embroidering Ramayana Episodes in Nineteenth and Early Twentieth-Century Bengal." In Krishnan, *Ramayana in Focus,* 112–121.

———. "The Story of a Storyteller's Scroll." *RES Journal of Anthropology and Aesthetics* 37 (2000): 166–185.

———. "Unrolling a Narrative Scroll: Artistic Practice and Identity in Late Nineteenth-Century Bengal." *Journal of Asian Studies* 62 (August 2003): 835–871.

Gillet, Valérie. "Entre démon et dévot: La figure de Rāvana dans les réprésentations *pallava.*" *Arts Asiatiques* 62 (2007): 29–45.

Ginsburg, Henry. *Thai Manuscript Painting.* Honolulu: University of Hawaii Press, 1989.

———. "Thai Painting in the Walters Art Museum." *Journal of the Walters Art Museum* 64/65 (2006–2007): 99–148.

Giteau, Madeleine. "Note sur Kumbhakara dans l'iconographie khmère." *Arts Asiatiques* 50 (1995): 69–75.

Goldman, Robert P., trans. *Bālakāṇḍa.* Book 1 of *The Rāmāyaṇa of Vālmīki: An Epic of Ancient India.* Introduction by Robert P. Goldman. Translation and annotation by Robert P. Goldman and Sally J. Sutherland. Princeton, NJ: Princeton University Press, 1984.

———. "Fathers, Sons, and Gurus: Oedipal Conflict in the Sanskrit Epics." *Journal of Indian Philosophy* 6 (1978): 325–392.

———. "The Ghost from the Anthill: Valmīki and the Destiny of the Rāmakathā in South and South-East Asia." In Bose, *The Rāmāyaṇa Culture,* 11–35.

———. "Rāmaḥ Sahalakṣmaṇaḥ: Psychological and Literary Aspects of the Composite Hero of Vālmīki's *Rāmāyaṇa.*" *Journal of Indian Philosophy* 8 (1980): 11–51.

———. "To Wake a Sleeping Giant: Vālmīki's Account(s) of the Life and Death of Kumbhakarṇa." In Goldman and Tokunaga, *Epic Undertakings,* 119–138.

Goldman, Robert P., and Jeffery M. Masson. "Who Knows Rāvaṇa?—A Narrative Difficulty in the Vālmīki Rāmāyaṇa." *Annals of the Bhandarkar Oriental Research Institute* 50, no. 1/4 (1969): 95–100.

Goldman, Robert P., and Sally J. Sutherland Goldman, trans. *Sundarakāṇḍa.* Book 5 of *The Rāmāyaṇa of Vālmīki: An Epic of Ancient India.* Introduction, translation, and annotation by Robert P. Goldman and Sally J. Sutherland Goldman. Princeton, NJ: Princeton University Press, 1996.

———, trans. *Uttarakāṇḍa.* Book 7 of *The Rāmāyaṇa of Vālmīki: An Epic of Ancient India.* Translation and annotation by Robert P. Goldman and Sally J. Sutherland Goldman. Princeton, NJ: Princeton University Press, forthcoming.

Goldman, Robert P., Sally J. Sutherland Goldman, and Barend A. van Nooten, trans. *Yuddhakāṇḍa.* Book 6 of *The Rāmāyaṇa of Vālmīki: An Epic of Ancient India.* Translation and annotation by Robert P. Goldman, Sally J. Sutherland Goldman, and Barend A. van Nooten. Princeton, NJ: Princeton University Press, 2009.

Goldman, Robert P., and Muneo Tokunaga, eds. *Epic Undertakings.* Papers of the 12th World Sanskrit Conference, vol. 2. Delhi: Motilal Banarsidass, 2009.

Goldwater, Robert, and Marco Treves, eds. *Artists on Art: From the XIV to the XX Century. . . .* London: Kegan Paul, 1947.

Gombrich, Richard. "The Vessantara Jātaka, the Rāmāyaṇa and the Dasaratha Jātaka." *Journal of the American Oriental Society* 105, no. 3 (1985): 427–437.

Gopala Krishna Rao, T. *Folk Ramayanas in Telugu and Kannada.* Nellore, Andhra Pradesh, India: Saroja Publications, 1984.

Gosling, L. Mya. "Ramayana in Thailand: Interrelation and the National Epic." 2004.

Goswāmī, Māmaṇi Raẏachama, and Manjeet Baruah. *Ravana: Myths, Legends, and Lore.* Delhi: B. R. Publishing Corporation, 2009.

Goswamy, B. N. "Leaves from an Early Pahari Ramayana Series: Notes on a Group of Nine Paintings in the Rietberg Museum, Zurich." *Artibus Asiae* 43, no. 1/2 (1981): 153–164.

———. *The Spirit of Indian Painting: Close Encounters with 101 Great Works, 1100–1900.* Gurgaon, India: Allen Lane, 2014.

Goswamy, B. N., and Caron Smith. *Domains of Wonder: Selected Masterworks of Indian Painting.* San Diego: San Diego Museum of Art, 2005.

Govindacandra, Rāya. *Hanumān ke devatva tathā mūrti kā vikāsa.* Allahabad: Hindī Sāhitya Sammelana, Prayāga, 2004.

Granoff, Phyllis. "A la mode: The Jain Rāmāyaṇa in Medieval India." *Journal of Literary and Cultural Studies* (Ravenshaw University) 3 (January 2013): 22–45.

Guy, John. *Woven Cargoes: Indian Textiles in the East.* New York: Thames and Hudson, 1998.

Haque, Enamul. *Pāhārpur* Alias *Somapura Mahāvihāra: A World Cultural Heritage Site.* Dhaka: International Centre for Study of Bengal Art, 2014.

Hara, Minoru. "Rama Stories in China and Japan: A Comparison." In Iyengar, *Asian Variations in Ramayana,* 340–356.

Harris, Ian Charles. *Cambodian Buddhism: History and Practice.* Honolulu: University of Hawai'i Press, 2008.

Hauptman, Jodi. *Beyond the Visible: The Art of Odilon Redon.* New York: Museum of Modern Art, 2005.

Hawley, John Stratton, and Vasudha Narayanan. *The Life of Hinduism.* Berkeley: University of California Press, 2006.

Hawley, John Stratton, and Donna Marie Wulff. *The Divine Consort: Rādhā and the Goddesses of India.* Boston: Beacon Press, 1986.

Heeramaneck, Alice N. *Masterpieces of Indian Painting: From the Former Collections of Nasli M. Heeramaneck.* N.p.: A. N. Heeramaneck, 1984.

Hess, Linda. "Rejecting Sita: Indian Responses to the Ideal Man's Cruel Treatment of His Ideal Wife." *Journal of the American Academy of Religion* 67, no. 1 (March 1999): 1–32.

Holt, Claire. *Art in Indonesia: Continuities and Change.* Ithaca, NY: Cornell University Press, 1967.

Irons, David. *Ketut Madra and 100 Years of Balinese Wayang Painting: Museum Puri Lukisan, Ubud, Bali, 7 October to 7 November 2013.* New York: IS Publishing, 2013.

Iyengar, K. R. Srinivasa, ed. *Asian Variations in Ramayana: Papers Presented at the International Seminar on "Variations in Ramayana in Asia: Their Cultural, Social, and Anthropological Significance": New Delhi, January 1981.* New Delhi: Sahitya Akademi, 1983.

Jacob, Judith M., and Kuoch Haksrea. *Reamker (Rāmakerti): The Cambodian Version of the Rāmāyaṇa.* London: Royal Asiatic Society, 1986.

Jain, Jyotindra, ed. *Picture Showmen: Insights into the Narrative Tradition in Indian Art.* Mumbai: Marg Publications on behalf of National Centre for the Performing Arts, 1998.

Jain, Kajri. "Muscularity and Its Ramifications: Mimetic Male Bodies in Indian Mass Culture." *South Asia* 24, special issue (2001): 197–224.

Jarunee Incherdchai [Charuni Inchoetchai], Khwanchit Loetsiri, and Somchai Supphalakamphaiphon. *Nang phra nakhon wai.* Bangkok: Fine Arts Department, 2008.

Jessup, Helen Ibbitson, and Thierry Zéphir. *Sculpture of Angkor and Ancient Cambodia: Millennium of Glory.* Washington, DC: National Gallery of Art, 1997.

Jhaveri, Bharati B. "Rom-Sitmani Vāratā." In Dodiya, *Critical Perspectives on the Rāmāyaṇa,* 91–103.

Joffee, Jennifer Beth. "Art, Architecture and Politics in Mewar, 1628–1710." PhD diss., University of Minnesota, 2005.

Jordaan, Roy E. *In Praise of Prambanan: Dutch Essays on the Loro Jonggrang Temple Complex.* Leiden: KITLV Press, 1996.

Kaimal, Padma Audrey. "Jagat Singh's Ramayana Manuscripts: Relation between Text and Illustration." Master's thesis, University of California, Berkeley, 1982.

Kakar, Sudhir. *Intimate Relations: Exploring Indian Sexuality.* New Delhi: Penguin Books, 1989.

Kala, Jayantika. *Epic Scenes in Indian Plastic Art.* New Delhi: Abhinav Publications, 1988.

Kam, Garrett. *Ramayana in the Arts of Asia.* Singapore: Select Books, 2000.

Kamban, Pazmarneri Subrahmanya Sundaram, and N. S. Jagannathan. *Kamba Ramayana.* New Delhi: Penguin Books India, 2002.

Kapoor, Ramesh, and Suneet Kapoor. *A Sterling Collection of Indian and Himalayan Art.* New York: Kapoor Galleries, 2011.

Kapur, Anuradha. *Actors, Pilgrims, Kings and Gods: The Ramila at Ramnagar.* London: Seagull Books, 2006.

Khon: Thai Masked Dance Sala Chalermkrung. Bangkok: The Crown Property Bureau, 2006.

Kishwar, Madhu. "Yes to Sita, No to Ram: The Continuing Hold of Sita on Popular Imagination in India." In Richman, *Questioning Ramayanas,* 285–308.

Klokke, Marijke J. "Hanuman in the Art of East Java." In *Archaeology: Indonesian Perspective: R. P. Soejono's Festschrift,* edited by Truman Simanjuntak, M. Hisyam, Bagyo Prasetyo, and Titi Surti Nastiti, 391–405. Jakarta: Indonesian Institute of Sciences, 2006.

———. *Narrative Sculpture and Literary Traditions in South and Southeast Asia.* Leiden: Brill, 2000.

Klokke, Marijke J., and Véronique Degroot, eds. *Materializing Southeast Asia's Past: Selected Papers from the 12th International Conference of the European Association of Southeast Asian Archaeologists.* Vol. 2. Singapore: NUS Press, 2013.

Kossak, Steven. *Indian Court Painting, 16th–19th Century.* New York: Metropolitan Museum of Art, 1997.

Kramrisch, Stella. *Painted Delight: Indian Paintings from Philadelphia Collections.* Philadelphia: Philadelphia Museum of Art, 1986.

Krishna, Anand, and Rai Krishnadasa. *Chhavi.* 2, 2. Banaras, India: Bharat Kala Bhavan, 1981.

Krishnan, Gauri Parimoo. *Ramayana: A Living Tradition.* Singapore: National Heritage Board, 1997.

———, ed. *Ramayana in Focus: Visual and Performing Arts of Asia.* Singapore: Asian Civilisations Museum, 2011.

Krittibasa, and Harekṛṣṇa Mukhopādhyāya. *Rāmāyaṇa.* Kolkata: Sāhitya Saṃsada, 1989.

Krittibasa, and Shudha Mazumdar. *Ramayana.* Bombay: Orient Longman, 1974.

Kulkarni, Vaman Mahadeo. *The Story of Rāma in Jain Literature: As Presented by the Śvetāmbara and Digambara Poets in the Prakrit, Sanskrit, and Apabhraṁśa Languages.* Ahmedabad: Saraswati Pustak Bhandar, 1990.

Leach, Linda York. *Indian Miniature Paintings and Drawings.* Cleveland: Cleveland Museum of Art in cooperation with Indiana University Press, 1986.

Lefeber, Rosalind, trans. *Kiṣkindhākāṇḍa.* Book 4 of *The Rāmāyaṇa of Vālmīki: An Epic of Ancient India.* Introduction, translation, and annotation by Rosalind Lefeber. Edited by Robert P. Goldman. Princeton, NJ: Princeton University Press, 1994.

Levin, Cecelia. "The Rāmāyaṇa of Loro Jonggrang: Indian Antecedents and Javanese Impetus." PhD diss., New York University, Institute of Fine Arts, 1999.

———. "Recasting the Sacred Heroes: A New Discovery of Sculptural Epic Narration from Ancient Champa." In *Interpreting Southeast Asia's Past: Monument, Image and Text: Selected Papers from the 10th International Conference of the European Association of Southeast Asian Archaeologists,* vol. 2, edited by Elisabeth A. Bacus, Ian C. Glover, Peter D. Sharrock, John Guy, and Vincent C. Pigott, 85–99. Singapore: NUS Press, 2008.

Losty, Jeremiah P. *The Ramayana: Love and Valour in India's Great Epic: The Mewar Ramayana Manuscripts.* London: British Library, 2008.

Lutgendorf, Philip. "Hanuman's Adventures Underground: The Narrative Logic of a Ramayana 'Interpolation.'" In Bose, *The Rāmāyaṇa Revisited,* 149–163.

———. *Hanuman's Tale: The Messages of a Divine Monkey.* Oxford: Oxford University Press, 2007.

———. *The Life of a Text: Performing the Rāmcaritmānas of Tulsidas.* Berkeley: University of California Press, 1991.

———. "Ramayan: The Video." *The Drama Review* (New York University, School of Arts) 34, no. 2 (1990): 127–176.

Ly, Boreth. "Protecting the Protector of Phimai." *The Journal of the Walters Art Museum* 64/65 (2006): 35–48.

Mair, Victor H. *Painting and Performance: Chinese Picture Recitation and Its Indian Genesis.* Honolulu: University of Hawaii Press, 1988.

———. "Suen wu-kung = Hanumat? The Progress of a Scholarly Debate." In *Proceedings of the Second International Conference on Sinology,* 659–752. Taipei: Academia Sinica, 1989.

Manich Jumsai. *Ramayana: Masterpiece of Thai Literature Retold from the Original Version Written by King Rama I of Siam.* Bangkok: Chalermnit Bookshop, 1967.

Markel, Stephen. "The 'Rāmāyaṇa' Cycle on the Kailāsanātha Temple at Ellora." Supplement 1, *Ars Orientalis* 30 (2000): 59–71.

Matics, K. I. "Homage to the Abbot Prince Paramanuchit Chinorot." *Journal of the Siam Society* 66, no. 1 (January 1978): 126–128.

McCutchion, David, and Suhrid K. Bhowmik. *Patuas and Patua Art in Bengal.* Calcutta: Firma KLM, 1999.

McDermott, Rachel Fell. *Revelry, Rivalry, and Longing for the Goddesses of Bengal: The Fortunes of Hindu Festivals.* New York: Columbia University Press, 2011.

McGill, Forrest, and M. L. Pattaratorn Chirapravati. "Thai Art of the Bangkok Period at the Asian Art Museum." *Orientations* 34, no. 1 (2003): 28–34.

McGill, Forrest, M. L. Pattaratorn Chirapravati, Peter Skilling, and Kazuhiro Tsuruta. *Emerald Cities: Arts of Siam and Burma, 1775–1950.* San Francisco: Asian Art Museum–Chong-Moon Lee Center for Asian Art & Culture, 2009.

McQuail, Lisa. *Treasures of Two Nations: Thai Royal Gifts to the United States of America.* Washington, DC: Asian Cultural History Program, Smithsonian Institution, 1997.

Mechai Thongthep, and Pramote Na Ranong. *Ramakien: The Thai Ramayana.* Bangkok: Naga Books, 1993.

Mittal, Jagdish. *Andhra Paintings of the Ramayana*. Hyderabad: Andhra Pradesh Lalit Kala Akademi, 1969.

Mittal, Sushil, and Gene R. Thursby. *The Hindu World*. New York: Routledge, 2004.

Mitter, Partha. *The Triumph of Modernism: India's Artists and the Avant-Garde, 1922–1947*. London: Reaktion Books, 2007.

Mokashi, Raupali. "The Ass Curse Stele Tradition: Gaddhegal of Ancient Maharashtra." *Marg, A Magazine of the Arts* 66, no. 1 (September 2014): 66–75.

Mukherjee, Bratindra Nath, Dipak Chandra Bhattacharyya, and Devendra Handa. *Prācī-Prabhā = Perspectives in Indology: Essays in Honour of Professor B. N. Mukherjee*. New Delhi: Harman Publishing House, 1989.

Nafilyan, Jacqueline, and Guy Nafilyan. *Peintures murales des monastères bouddhiques au Cambodge*. [Paris]: Maisonneuve & Larose, 1997.

Nagar, Shanti Lal. *Hanumān in Art, Culture, Thought, and Literature*. New Delhi: Intellectual Publishing House, 1995.

Nagaswamy, R. *Masterpieces of South Indian Bronzes*. New Delhi: National Museum, 1983.

Nambudirippad, Olappamanna Subrahmanian. "Major Kathakali Institutes Kerala Kalamandalam." In "Kathakali: A Three Dimensional Art," *Marg, A Magazine of the Arts* 44, no. 4 (June 1993): 45–52.

Nancy Wiener Gallery. *Paths to the Divine*. New York: Nancy Wiener Gallery, 2014.

Natthaphat Chanthawit and Promporn Pramualratana. *Thai Puppets and Khon Masks*. Bangkok: River Books, 1998.

Nidda Hongvivat. *The Story of Ramakian from the Mural Paintings along the Galleries of the Temple of the Emerald Buddha / Lao rueang Rammakian*. Bangkok: Phuean Dek, 2004.

Niyada Laosunthon. *Hotrai Krom Somdet Phraparamanuchit Chinorot: laeng rianru phraphutthasatsana lae phumpanya Thai nai Wat Pho*. [Bangkok]: Khana Song Wat Phrachettuphon, 2005.

———. *The Ramakien Bas-reliefs at Wat Phra Chettuphon / Sila chamlak rueang Rammakian: Wat Phrachettuphonwimonmangkhalaram*. Bangkok: Wat Phrachettuphonwimonmangkhalaram, 1996.

Ohno, Toru. *Burmese Ramayana: With an English Translation of the Original Palm Leaf Manuscript in Burmese Language in 1233 Year of Burmese Era (1871 A.D.)*. Delhi: B. R. Publishing, 1999.

———. "The Burmese Versions of the Rama Story and Their Peculiarities." In *Tradition and Modernity in Myanmar: Proceedings of an International Conference Held in Berlin from May 7th to May 9th, 1993*, edited by Uta Gärtner and Jens Lorenz, 305–326. Münster: LIT, 1994.

Ohri, Vishwa Chander. *The Exile in the Forest*. New Delhi: Lalit Kala Akademi, 1983.

Pal, Pratapaditya. *Indian Sculpture: A Catalogue of the Los Angeles County Museum of Art Collection*. Los Angeles: Los Angeles County Museum of Art in association with University of California Press, Berkeley, 1986.

Pal, Pratapaditya, and Hiram W. Woodward. *Desire and Devotion: Art from India, Nepal, and Tibet in the John and Berthe Ford Collection*. Baltimore: Walters Art Museum, 2001.

Paley, Nina, dir. *Sita Sings the Blues*. Film. 2008. www.sitasingstheblues.com.

Pandey, Shyam Manohar. "Surasa, Simhika and Lanka in the Valmiki and other Ramayanas." In "Proceedings of the Ninth International Rāmāyaṇa Conference: Torino, April 13th–17th, 1992." *Indologica Taurinensia* 19–20 (1993–1994): 227–244.

Pattaratorn Chirapravati, M. L. *Divination au royaume de Siam:*

Le corps, la guerre, le destin: manuscrit siamois du XIXe siècle. Cologny, Switzerland: Fondation Martin Bodmer, 2011.

———. "Funeral Scenes in the Rāmāyaṇa Mural Painting at the Emerald Buddha Temple." *European Association of Southeast Asian Archaeologists* 2 (2013): 221–232.

Paul, Ashit, ed. *Woodcut Prints of Nineteenth Century Calcutta* (Calcutta: Seagull Books, 1983).

Pauwels, Heidi Rika Maria. *The Goddess as Role Model: Sītā and Rādhā in Scripture and on Screen*. Oxford: Oxford University Press, 2008.

———. "'Only You': The Wedding of Rāma and Sītā, Past and Present." In Bose, *The Rāmāyaṇa Revisited*, 165–218.

Pech Tum Kravel. *Sbek Thom: Khmer Shadow Theatre*. Ithaca, NY: Southeast Asia Program, Cornell University, 1995.

Phutthayotfa Chulalok. *Wannakam samai rattanakosin (meuat banthoeng khadi): Botlakhon rueang Rammakian*. [Bangkok]: Krom Sinlapakon, 1997.

Pictorial Book of Wat Phra Chettuphon / Samutphap Wat Phrachettuphonwimonmangkhalaram. [Bangkok]: Krom Sinlapakon, 1992.

Pollock, Sheldon I., trans. *Araṇyakāṇḍa*. Book 3 of *The Rāmāyaṇa of Vālmīki: An Epic of Ancient India*. Introduction, translation, and annotation by Sheldon I. Pollock. Edited by Robert P. Goldman. Princeton, NJ: Princeton University Press, 1991.

———, trans. *Ayodhyākāṇḍa*. Book 2 of *The Rāmāyaṇa of Vālmīki: An Epic of Ancient India*. Introduction and annotation by Sheldon I. Pollock. Edited by Robert P. Goldman. Princeton, NJ: Princeton University Press, 1986.

———, ed. *Literary Cultures in History: Reconstructions from South Asia*. Berkeley: University of California Press, 2003.

———. "Rākṣasas and Others." In "Proceedings of the Sixth World Sanskrit Conference: Philadelphia, October 13th–20th, 1984," *Indologica Taurinensia* 13 (1985–1986): 263–281.

———. "Rāmāyaṇa and Political Imagination in India." *Journal of Asian Studies* 52, no. 2 (May 1993): 261–297.

Poovaya-Smith, Nima, Jeremiah P. Losty, and Jane Bevan. *Manuscript Paintings from the Ramayana*. Bradford: Bradford Art Galleries and Museums, 1989.

Porée-Maspero, Éveline. "Le Rāmāyaṇa dans la vie des Cambodgiens." *Seksa Khmer* 6 (1983): 19–24.

Poster, Amy G., Sheila R. Canby, Pramod Chandra, and Joan M. Cummins. *Realms of Heroism: Indian Paintings at the Brooklyn Museum*. New York: Brooklyn Museum in association with Hudson Hills Press, 1994.

Pou, Saveros. *Études sur le Rāmakerti: XVIe–XVIIe siècles*. Paris: École française d'Extrême-Orient, 1977.

———. "From Vālmīki to Theravāda Buddhism: The Example of the Khmer Classical *Rāmakerti*." In "Proceedings of the Ninth International Rāmāyaṇa Conference: Torino, April 13th–17th, 1992," *Indologica Taurinensia* 19–20 (1993–1994): 267–284.

———. "Indigenization of Ramayana in Cambodia." *Asian Folklore Studies* 51 (1992): 89–102.

———. "Ramakertian Studies." In Iyengar, *Asian Variations in Ramayana*, 252–262.

———. "Les traits bouddhiques du Râmakerti." *Bulletin de l'École française d'Extrême-Orient* 62 (1975): 355–368.

Pou, Saveros, and Grégory Mikaelian. *Râmakerti I, "La gloire de Râma": Drame épique médiéval du Cambodge*. Paris: L'Harmattan, 2007.

"Proceedings of the Ninth International Rāmāyaṇa Conference: Torino, April 13th–17th, 1992." *Indologica Taurinensia* 19–20 (1997): 315–326.

Raghavan, Venkatarama, ed. *The Ramayana Tradition in Asia: Papers Presented at the International Seminar on the Ramayana*

Tradition in Asia, New Delhi, December 1975. New Delhi: Sahitya Akademi, 1980.

Rajagopal, Arvind. *Politics after Television: Religious Nationalism and the Reshaping of the Indian Public.* Cambridge, UK: Cambridge University Press, 2001.

The Ramakian (Rāmāyaṇa) Mural Paintings Along the Galleries of the Temple of the Emerald Buddha/Čhittrakam Fāphanang Rūang Rāmmakīan Rộp Phrarabīang Wat Phrasīrattanasātsadārām. Bangkok: Samnak Rātchalēkhāthikān, 1982.

Ramanujan, A. K. "Three Hundred *Rāmāyaṇas*: Five Examples and Three Thoughts on Translation." In Richman, *Many Rāmāyaṇas,* 22–49.

Ramaswamy, Sumathi. *Barefoot across the Nation: M. F. Husain and the Idea of India.* Delhi: Routledge India, 2010.

Ranganayakamma, Muppala, and B. R. Bapuji. *Ramayana, the Poisonous Tree: Stories, Essays and Foot-Notes.* Hyderabad: Sweet Home Publications, 2004.

Rao, Ajay K. *Re-figuring the Rāmāyaṇa as Theology: A History of Reception in Premodern India.* New York: Routledge, 2015.

Rao, Velcheru Narayana. "When Does Sita Cease to Be Sita?: Notes toward a Cultural Grammar of Indian Narratives." In Bose, *The Rāmāyaṇa Revisited,* 219–240.

Ray, Himanshu Prabha. "Narratives in Stone: The *Ramayana* in Early Sculptures." In Verghese and Dallapiccola, *Art, Icon and Architecture in South Asia,* 202–221.

Reichle, Natasha, Francine Brinkgreve, and David J. Stuart-Fox. *Bali: Art, Ritual, Performance.* San Francisco: Asian Art Museum, Chong-Moon Lee Center for Asian Art & Culture, 2010.

Reynolds, E. Frank. "The Holy Emerald Jewel: Some Aspects of Buddhist Symbolism and Political Legitimation in Thailand and Laos." In *Religion and Legitimation of Power in Thailand, Laos, and Burma,* edited by Bardwell L. Smith, 175–193. Chambersburg, PA: ANIMA Books, 1978.

———. "*Rāmāyaṇa, Rāma Jātaka,* and *Ramakien*: A Comparative Study of Hindu and Buddhist Traditions." In Richman, *Many Rāmāyaṇas,* 50–63.

Rice, Yael. "A Persian Mahabharata: The 1598–1599 Razmnama." *Manoa* 22, no. 1 (2010): 125–131.

Richman, Paula. "Epic and State: Contesting Interpretations of the Ramayana." *Public Culture: Bulletin of the Project for Transnational Cultural Studies* 7 (1995): 631–654.

———. "E. V. Ramasami's Reading of the *Rāmāyaṇa*." In Richman, *Many Rāmāyaṇas,* 175–201.

———. "Looking at Ravana: Images of Rama's Foe in Visual Art and Performance." In Krishnan, *Ramayana in Focus,* 61–69.

———, ed. *Many Rāmāyaṇas: The Diversity of a Narrative Tradition in South Asia.* Berkeley: University of California Press, 1991.

———, ed. *Questioning Ramayanas: A South Asian Tradition.* Berkeley: University of California Press, 2001.

Robb, Peter, and David Taylor. "The Genesis of the Babu: Bhabanicharan Bannerji and Kalikata Kamalalay." In *Rule, Protest, Identity: Aspects of Modern South Asia,* 193–206. London: Curzon Press, 1978.

Rooney, Dawn F. "The Rama Story in Burma: A Visual Depiction." *Lotus Leaves* 14, no. 2 (2012): 7–14.

Rosselli, John. "The Self-Image of Effeteness: Physical Education and Nationalism in Nineteenth Century Bengal." *Past and Present* 86 (February 1980): 121–148.

Roveda, Vittorio. *Images of the Gods: Khmer Mythology in Cambodia, Thailand and Laos.* Bangkok: River Books, 2005.

Sagar, Pratima, ed. *Ramayana in Performing Arts: Collection of Articles by Renowned Artists and Cultural Commentators.* Chennai: Natya Kala Conference and Sri Krishna Gana Sabha, 2008.

Sagar, Ramanand, dir. *Ramayan* (film). Bombay: Sagar Video International, 1992.

Sahai, Sachchidanand, and Phuttaphōchān. *The Rama Jataka in Laos: A Study in the Phra Lak Phra Lam.* Delhi: B. R. Publishing Corporation, 1996.

San Phalla. "The Influence of the Ramakien Murals in the Grand Palace of Siam on the Reamker Murals in the Royal Palace of Cambodia." *Udaya* no. 8 (2007): 179–217.

Sanford, David Theron. "Early Temples Bearing Ramayana Relief Cycles in the Chola Area: A Comparative Study." PhD diss., University of California, Los Angeles, 1974.

Saran, Malini, and Vinod C. Khanna. *The Ramayana in Indonesia.* New Delhi: Ravi Dayal, 2004.

———. "The *Rāmāyaṇa* Kakawin: A Product of Sanskrit Scholarship and Independent Literary Genius." *Bijdragen tot de taal-, land- en volkenkunde van Nederlandsch-Indië* 149, no. 2 (1993): 226–249.

Sattar, Arshia. "Hanuman in the *Ramayana* of Valmiki: A Study in Ambiguity." PhD diss., University of Chicago, 1990.

Seely, Clinton. "The Raja's New Clothes: Redressing Rāvaṇa in *Meghanādavadha Kāvya*." In Richman, *Many Rāmāyaṇas,* 137–155.

Sen, Dineshchandra. *The Bengali Ramayanas: Being Lectures Delivered to the Calcutta University in 1916, As Ramtanu Lahiri Research Fellow in the History of Bengali Language and Literature.* Calcutta: University of Calcutta, 1920.

Seyller, John. "Model and Copy: The Illustration of Three 'Razmnāma' Manuscripts." *Archives of Asian Art* 38 (1985): 37–66.

Sharma, Ramashraya. "The Non-Aryans in the *Rāmāyaṇa*: The *Rākṣasas*." In "Proceedings of the Ninth International Rāmāyaṇa Conference: Torino, April 13th–17th, 1992," *Indologica Taurinensia* 19–20 (1993–1994): 315–326.

Shastri, Hari Prasad, trans. *The Ramayana of Valmiki.* 3 vols. London: Shanti Sadan, 1962.

Shelton, Suzanne. *Divine Dancer: A Biography of Ruth St. Denis.* Garden City, NY: Doubleday, 1981.

Singaravelu, S. "A Comparative Study of the Sanskrit, Tamil, Thai, and Malay Versions of the Story of Rāmā with Special Reference to the Process of Acculturation in the Southeast Asian Versions." *Journal of the Siam Society* 56, no. 2 (July 1968): 137–185.

———. "The Episode of Maiyarāb in the Thai 'Rāmakīen' and Its Possible Relationship to Tamil Folklore." *Asian Folklore Studies* 44, no. 2 (1985): 269–279.

———. "The Rama Story in the Thai Cultural Tradition." *Journal of the Siam Society* 70, nos. 1 and 2 (January–July 1982): 50–70.

———. *The Ramayana Tradition in Southeast Asia.* 2004.

Singer, Joel F. "The Ramayana at the Burmese Court." *Arts of Asia* 19, no. 6 (November–December 1989): 90–103.

Singer, Milton B. *Semiotics of Cities, Selves, and Cultures: Explorations in Semiotic Anthropology.* Berlin: Mouton de Gruyter, 1991.

Singh, Avadhesh K. *Rāmāyaṇa through the Ages: Rāma-gāthā in Different Versions.* New Delhi: D. K. Printworld, 2007.

Sinha, Mrinalini. *Colonial Masculinity: The 'Manly Englishman' and the 'Effeminate Bengali' in the Late Nineteenth Century.* Manchester and New York: Manchester University Press, 1995.

Sinphet. *Nang yai chut phra nakhǭn wai.* Bangkok: Mūang Bōrān, 1983.

Sivaramamurti, Calembur. *South Indian Bronzes*. New Delhi: Lalit Kala Akademi, 1963.

Siworphot, Buntuan. *Chitrakam Rammakian Wat Suthatthepwararam*. Bangkok: Krom Sinlapakon, 2013.

Skilling, Peter. "King, Sangha, and Brahmans: Ideology, Ritual, and Power in Pre-modern Siam." In *Buddhism, Power, and Political Order*, edited by Ian Harris, 182–216. London: Routledge, 2007.

Smith, W. L. *Rāmāyaṇa Traditions in Eastern India: Assam, Bengal, Orissa*. New Delhi: Munshiram Manoharlal, 1995.

Sophearith, Siyonn. "The Life of the Rāmāyaṇa in Ancient Cambodia: A Study of the Political, Religious and Ethical Roles of an Epic Tale in Real Time (I)." *Udaya* no. 6 (2005): 93–149.

———. "The Life of the Rāmāyaṇa in Ancient Cambodia: A Study of the Political, Religious and Ethical Roles of an Epic Tale in Real Time (II)." *Udaya* no. 7 (2006): 45–72.

Srisurang Poolthupya. "The Influence of the Ramayana on Thai Culture: Kingship, Literature, Fine Arts and Performing Arts." *The Journal of the Royal Institute of Thailand* 31, no. 1 (January–March 2006): 269–277.

Stutterheim, Willem Frederik, R. P. Jain, and C. D. Paliwal. *Rāma-Legends and Rāma-Reliefs in Indonesia*. New Delhi: Indira Gandhi National Centre for the Arts, 1989.

Subhadradis Diskul, M. C. "The Difference between Valmiki *Ramayana* and the Thai Version of *Ramayana* (*Ramakirti*) of King Rama I of Thailand (1782–1809)." In "Proceedings of the Ninth International Rāmāyaṇa Conference: Torino, April 13th–17th, 1992," *Indologica Taurinensia* 19–20 (1993–1994): 113–126.

Sudibyoprono, R. Rio. *Ensiklopedi wayang purwa*. Jakarta: Balai Pustaka, 1991.

Sunseng Sunkimmeng. "Une importante série de cuirs découpés du Cambodge au musée Guimet." *La Revue du Louvre et des musées de France* 27 (1977): 358–365.

Suresh, K. M. *Ramayana Sculptures from Hampi-Vijayanagara*. Delhi: Bharatiya Kala Prakashan, 2010.

———. *Vijayanagara Sculptures at Hampi*. Delhi: Bharatiya Kala Prakashan, 2011.

Sutherland Goldman, Sally J. "Anklets Away: The Symbolism of Jewelry and Ornamentation in *Vālmīki's Rāmāyaṇa*." In Bose, *A Varied Optic*, 125–153.

———. "Gendered Narratives: Gender, Space, and Narrative Structures in Vālmīki's *Bālākāṇḍa*." In Bose, *The Rāmāyaṇa Revisited*, 47–85.

Sweeney, P. L. Amin. *The Rāmāyaṇa and the Malay Shadow Play*. Kuala Lumpur: National University of Malaysia Press, 1972.

Thaw Kaung, U. "The *Ramayana* Drama in Myanmar." *Journal of the Siam Society* 90, nos. 1 and 2 (2002): 137–148.

Thein Han, U, and U Khin Zaw. "Rāmāyaṇa in Burmese Literature and Arts." In Raghavan, *The Ramayana Tradition in Asia*, 301–331.

———. "Ramayana in Burmese Literature and Arts." *Journal of the Burma Research Society* 59, nos. 1 and 2 (December 1976): 137–154.

Thiel-Horstmann, Monika. *Rāmāyaṇ and Rāmāyaṇas*. Wiesbaden: Otto Harrasowitz, 1991.

Thompson, Stith. *Motif-Index of Folk-Literature: A Classification of Narrative Elements in Folk-Tales, Ballads, Myths, Fables, Mediaeval Romances, Exempla, Fabliaux, Jest-Books, and Local Legends*. Bloomington: Indiana University, 1932–1936.

Topsfield, Andrew, ed. *In the Realm of Gods and Kings: Arts of India*. London: Philip Wilson, 2004.

Tuchman, Maurice, Judi Freeman, and Carel Blotkamp. *The Spiritual in Art: Abstract Painting, 1890–1985*. New York: Abbeville Press, 1986.

Tulasīdāsa [Tulsidas]. *The Rāmāyaṇa of Tulasīdāsa*. Translated by Frederic Salmon Growse. Edited and revised by R. C. Prasad [Rāmacandra Prasāda]. 1978; Delhi: Motilal Banarsidass, 1987. First published approx. 1878.

———. *The Ramayana of Tulsidas*. Translated by A. G. Atkins. 2 vols. 1954; Calcutta: Birla Academy of Art & Culture, 1966.

Tully, Mark. "The Rewriting of the *Ramayan*." In *No Full Stops in India*, 127–152. London: Penguin Books, 1991. Volume published as *The Defeat of a Congressman and Other Parables of Modern India*. New York: Alfred A. Knopf, 1992.

Vālmīki. *Ramayana de Valmiki illustré par les miniatures indiennes du XVIe au XIXe siècle*. 7 vols. Paris: Diane de Selliers Editions, 2011.

Vatsyayan, Kapila Malik. *Ramayana in the Arts of Asia*. Teheran: Asian Cultural Documentation Centre for UNESCO, 1975.

Venkatachalam, V. "Vālmīki's Rāma: A New Perspective from the Viewpoint of His Enemies." In "Proceedings of the Ninth International Rāmāyaṇa Conference: Torino, April 13th–17th, 1992," *Indologica Taurinensia* 19–20 (1993–1994): 375–404.

Verghese, Anila. *Religious Traditions at Vijayanagara as Revealed through Its Monuments*. New Delhi: Manohar, 1995.

Verghese, Anila, and Anna L. Dallapiccola, eds. *Art, Icon and Architecture in South Asia: Essays in Honour of Dr. Devangana Desai*. New Delhi: Aryan Books International, 2015.

Vickers, Adrian. "The Old Javanese *Kapiparwa* and a Recent Balinese Painting." In Acri, Creese, and Griffiths, *From Laṅkā Eastwards*, 119–130.

Vickery, Michael. "Bayon, New Perspectives Reconsidered." *Udaya* no. 7 (2006): 101–173.

Võ, Thu Tịnh. *Phra Lak Phra Lam: Le Ramayana lao*. Vientiane, Laos: Vithagna, 1972.

Wales, H. G. Quaritch. *Divination in Thailand: The Hopes and Fears of a Southeast Asian People*. London: Curzon Press, 1983.

Wat Dusidaram. Mural Paintings of Thailand Series. Bangkok: Muang Boran Publishing House, 1983.

Wat Ratchasittharam. Mural Paintings of Thailand Series. Bangkok: Muang Boran Publishing House, 1982.

Wat Yai Intharam. Mural Paintings of Thailand Series. Bangkok: Muang Boran Publishing House, 1982.

Welch, Stuart Cary. *India: Art and Culture, 1300–1900*. New York: Metropolitan Museum of Art, 1985.

Whaling, Frank. "The Growth of the Religious Significance of Rāma in North India." PhD thesis, Harvard University, 1973.

———. *The Rise of the Religious Significance of Rāma*. Delhi: Motilal Banarsidass, 1980.

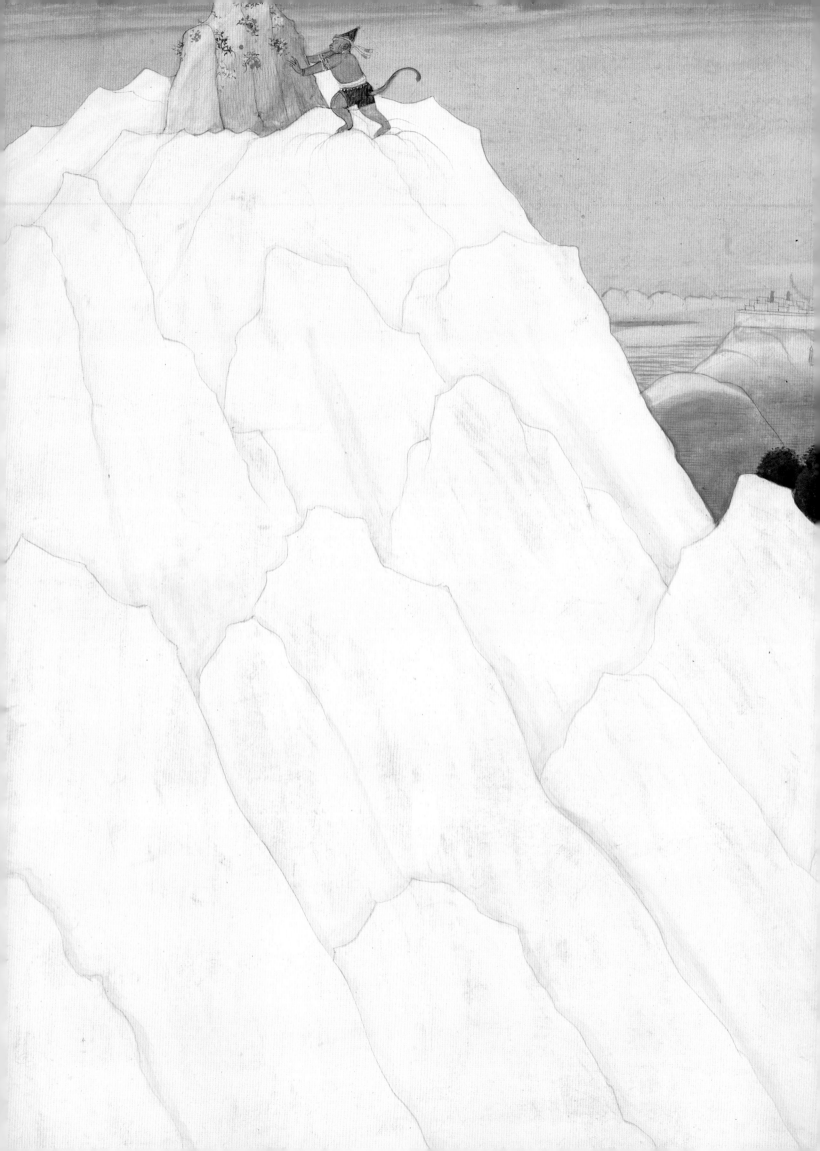

Image Sources

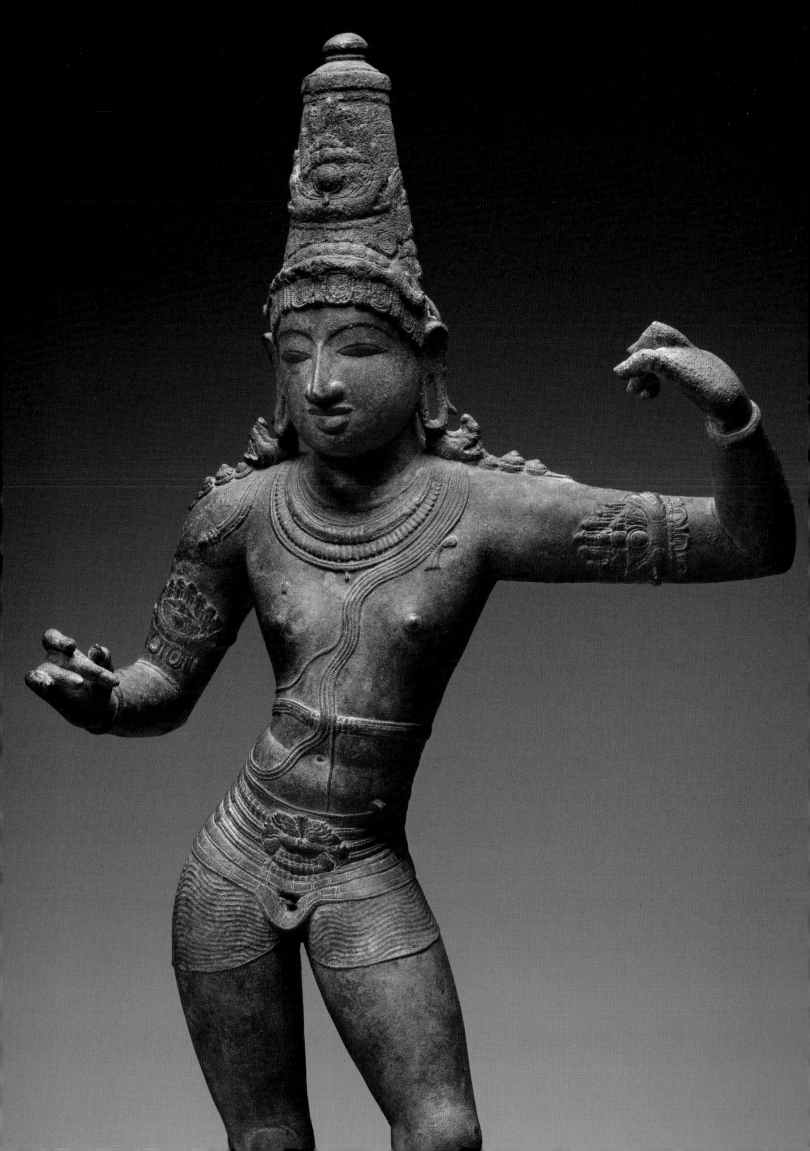

Index

Kamasan-style painting, 183; *pataka*, 162–163, 168, **169**, **170**; regional styles, 6. *See also* illustrated manuscripts; scrolls; textiles; *and under individual artists and subjects*

Paley, Nina, 114

Pandit Seu of Guler, workshop of: Hanuman, Angada, and Jambavan climb Mount Mahendra, **160**, 177, **177**; Hanuman leaps across the ocean, 182, **182**

Parvati, 225

pataka paintings, 163, 168, **169**, **170**

Patel, Sanjay: "Valiant Eagle," from *Ramayana: Divine Loophole*, **205**, 232, **233**

Paumacariya (Vimalasuri), 24

Paz, Octavio: *The Monkey Grammarian*, 152

Pech Tum Kravel, 216

Penataran Temple, East Java, **217**

performances: masks, 171, **171**, 219, 224, **224**; by monkeys, 2–3; opera, 210; of Rama epic, 2–3, 5, 6, **6**, 13–16, 181; Ramlilas, 26, **26**, 209, **210**; scrolls used in, 6, 11n10, 13–16; songs, 3–4, 6, 13, 14, 15–16; in Southeast Asia, 41, 150, 194, 210. *See also* dance; shadow puppets; television serials

Pollock, Sheldon, 202

prints: images of Hanuman, **147**, **148**, **151**, **156**, 174, 175; images of Rama, **27**, **29**; images of Sita, **103**

Punnakay (Benyakai), 150, 192, **192**, 193

puppets: of Hanuman, 172, **172**, **173**; performances of, 52, 217; of Ravana, 222. *See also* shadow puppets

Puranas, 103, 115n21, 150–151

Raghuvamsha (Kalidasa), 33n6

rakshasas: Rama's battle with, 60, 203, 204; in Ramayana of Valmiki, xvi. *See also* demons

Rama: ambivalent responses to, 30–32; appeal to Durga, 4, 6–7, 17, **27**; appearance of, 7, 9–10, 34; as avatara of Vishnu, xv, 9, 24–26, 36, 201; battle with rakshasas, 60, 203, 204; birth of, xv, 2, 25; brothers of, 25; Buddhist view of, 24, 26–27, 30, 33n16; cultural importance of, 23–24, 28, 32–33; death of, xviii; divinity of, xviii, 7–9, 26, 28, 38; in exile, xvi, 13–14, 104–105; filial devotion of, 29, 49, 56; as ideal man, 25, 28–29, 31, 32; as ideal monarch, 28, 29–30, 32, 41, 46; Jain view of, 24, 30; monkey performing as, 3; in Ramayana of Valmiki, xv–xvii, xviii, 24–25, 29, 31–32; as role model, 6, 26, 28–30; search for Sita, 63, 64, 73, 74, 152; Sharabhuja and, 11n15; sons of, xviii, 32, 112, 113; strength of, 50, 102; treatment of Sita, 31–32; virtues of, 26, 28, 31, 57; wedding of, 102, 104

Rama, battle with Ravana: classical dance-drama, 88, 89; combat scenes from Thai illustrated manuscript, **30**, 88–89, **88**, **89**; death of Ravana, 91, **91**; Dutch engraving, 244, **244**; manuscript cabinet, 80, **81**; paintings of, 90, **90**, 235, **235**, 236, **236–237**

Rama, images of: abandonment of Sita, **28**; advertising card, **25**; battles with Indrajit, 82, **83**, 86, 136, **136**, 184, **185**; battling demons, 60, **61**; bending Shiva's bow, **8**, 50, **51**, 102, **103**; birth of, **25**; with bow, 34, **34**, 39, **40**, 42, 49–50, 62; in Buddhist texts, 44, **45**; Burmese hanging, 52, **52–53**; concerns for Sita, 122, **122**; coronation of, 96, **96–97**; crossing river into exile, 55, **55**; enthroned, **5**, **9**, **10**, 35, **94**, 95, **95**, 140, **140**; European, 244, **244**; in exile, 34, 55, 56, **56**, 121, **121**, 123, **123**; in forest with Vishvamitra, 46–47, **47**; with Hanuman, 75, **75**, 152, 156, **156**, 174, 175, 184, **185**, 188, 189, 195n3; as incarnation of Vishnu, **25**, 36, **36**; with Jatayus, 66, **66**, 67, **67**; and killing of Valin, **31**, 68, 70, **71**, 72, **72**; as king, 29, **29**, 34, **35**, 36, 46, **46**, **94**; Lakshmana pulling thorn from foot, 58, **59**, 79, **79**; Lanka invasion, 78, **78**; in Mewar Ramayana, 11n7, **25**, **28**, 239–241, **239**, **240**; with monkeys, 74, **74**, 75, **75**; on Mount Prasravana, **20–21**, 73, **73**; in prints, **27**, **29**; in Ramayashorasayana of Kesharaja, 26, **27**, 28; of return

from Lanka, 93, **93**; in Scenes from the Rama epic, 18–19, **18–19**; in scrolls, 6–7, **7**, **10**, 13–15, 16; sculpture (Chola period), 36, **37**; sculpture (ivory from Tamil Nadu), **94**, **94**; sculpture (Madurai), 40, **40**; sculpture (overdoor panel), 96, **96–97**; sculpture (Sri Lankan ivory), 184, **185**; sculpture (Vijayanagara), 38–39, **38**; searching for Sita, 63, **63**, 64, **65**, 73, 74; with Shurpanakha, 57, **57**; Sita's ordeal by fire, 92, **92**; skin color, 34, **34–35**; slaying golden deer, 62, **62**; slaying Tataka, **22**, **34**, 46–47, **48**, 49–50, **49**; with Sugriva, 68, **69**; taking leave of mother, 54, **54**; terra-cotta plaques, 3, **8**, **9**, 58, **59**; in Thailand, 88; with Vibhishana, 76, **77**, 245, **245**; as warrior, 34, 49–50, 76, **77**, 85, 86, **87**, 88–89, **88**, **89**; of wedding, **8**; wooden pediment, 42, **42**; worshiping goddess, 6–7, **7**

Ramachandra Temple, Vijayanagara, 38, **39**, 167

Rama epic: critiques of, 31, 32; cultural importance of, 1, 2–10; key characters of, xiii; political meanings found in, 1–2, 24, 33n16, 157–158, 202; proverbs from, 4; stories told to children from, 1, 2, 5

Rama epic tellings: Adbhuta Ramayana, 104, 107; Adhyatma Ramayana, 115n21; Assamese, 103; Bhushundi Ramayana, 107; Burmese, 30, 52, 104; Cambodian, 215; French translation, 247; Hikayat Seri Rama, 30, 107, 111; in Indonesia, 178, 236; Jain, 24, 26, **27**, 28, 103, 113, 155; of Kamban, 7, 104, 108, 184n1, 206; Kannada, 103; Khotanese, 107, 115n6; languages of, 23–24, 33n2, 47; Lao, 104; Malay, 24, 30, 104, 107, 111; number of, 23–24; *Paumacariya* (Vimalasuri), 24; Persian translation, 33n2, 47, 76, 141; in popular culture, 4, 26, 32, 104, 114, 161–162; Ramayana Kakawin, 30; Ramayashorasayana of Kesharaja, 26, **27**, 28; *Ramcaritmanas* (Tulsidas), 32, 33n7, 104, 107, 149, 155; rural, 238; in Southeast Asia, 24, 42, 114, 155, 157, 192, 193; Telegu, 104; television serial, 26, 32, 104; Thai, 30, 41, 44, 80, 104, 134, 206–207, 210, 238n3; Tibetan, 113, 115n6; of Tulsidas, 7, 32, 33n7, 104, 107, 149, 155. *See also* Mewar Ramayana; performances; Ramayana of Valmiki; "Shangri" Ramayana

Rama Jamadagnya, xvi

Ramanujan, A. K., 23–24, 33n16, 210

Ramasami, E. V., 202, 203

Ramayan (television serial), 26, **26**, 32, 104

Ramayana Kakawin, 30

Ramayana of Valmiki: *Aranyakanda* (The Forest), xvi, 106–107, 230; author of, 10–11n1, 11n12; *Ayodhyakanda* (Ayodhya), xvi, 104–105; *Balakanda* (Boyhood), xv–xvi, 101–102; *Kishkindhakanda* (Kishkindha), xvii, 87; as model for Ashvaghosha, 27; origins of, 28; political meanings found in, 29–30; *Sundarakanda* (Sundara), xvii, 108–111, 153–154; *Uttarakanda* (The Last Book), xvii–xviii, 32, 112, 200–201; *Yuddhakanda* (War), xvii, 110–111, 234, 241

Ramayashorasayana of Kesharaja, 26, **27**, 28

Ramcaritmanas (Tulsidas), 7, 32, 33n7, 104, 107, 149, 155

Ramlilas, 26, **26**, 209, **210**

Rammakian (Thailand), 41, 134, 210

Ramopakhyana (Mahabharata), 26

Rao, V. Narayana, 114

Rasamanjari (Bhanudatta), 122

Ravana: appearance of, 212–213, 219; back story of, 199–201; battle with Jatayus, 67, 124, 128, 132, 204–205; brothers of, xvii, 76, 85, 183, 208; character of, 202, 207, 208, 210, 211n1; death of, 91, 209–210, 245–246, 247; funeral of, 210, 211n33, 245; palace of, 155, 200; positive interpretations of, 202, 203–204, 211n4; in Ramayana of Valmiki, xv, xvi, xvii, 91, 200–206, 207, 209, 210, 235, 239–241; as ruler of Lanka, 199–200; sister of, xvi, 124, 202–204, 228; as Sita's father, 103, 115n6, 199, 211n1; Sita's picture of, 113–114; sons of, 208–209, 239–241, 242; Thai view of, 210; as villain, 209; violence toward women, 200–201, 205; wives of, 199, 200, 207–208,

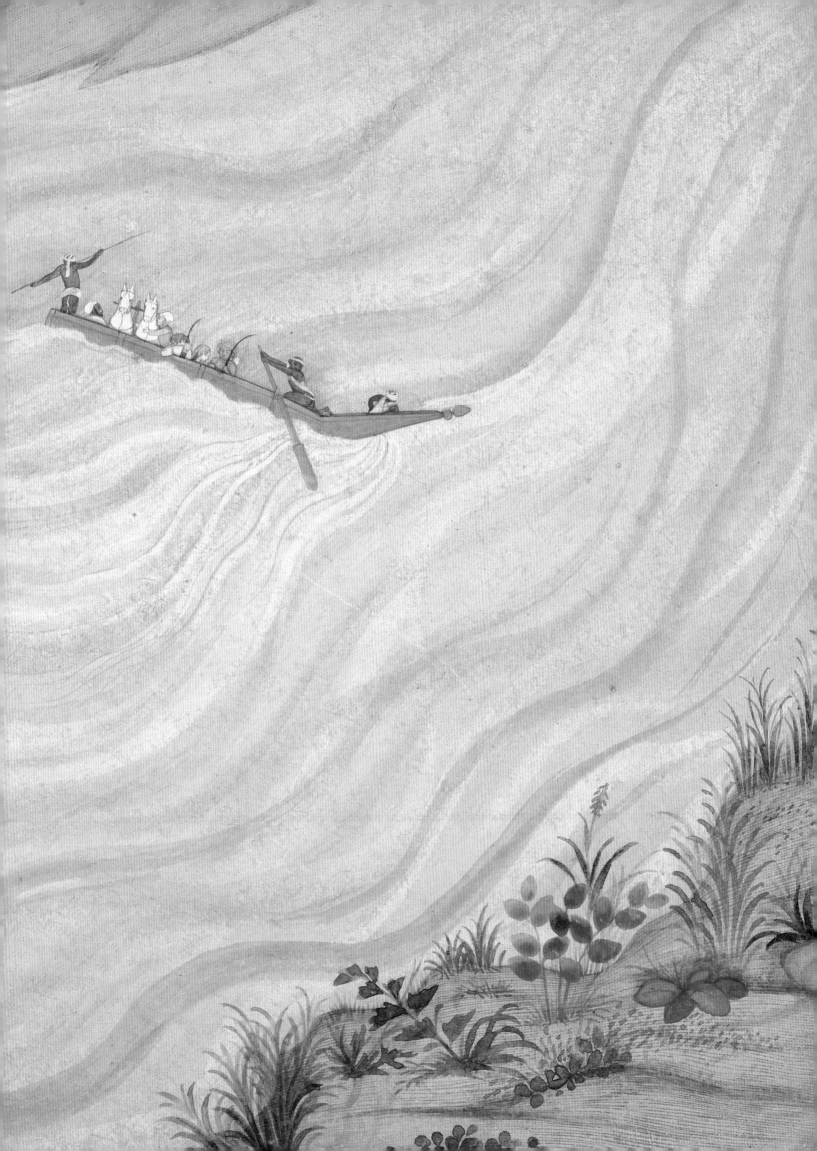

THE RAMA EPIC
Hero, Heroine, Ally, Foe

was produced under the auspices of the
Asian Art Museum
Chong-Moon Lee Center for Asian Art and Culture

Museum Director Jay Xu
Wattis Senior Curator of South and Southeast Asian Art Forrest McGill
Head of Publications Clare Jacobson

Produced by Wilsted & Taylor Publishing Services
Project manager Christine Taylor
Production assistant LeRoy Wilsted
Copy editors Nancy Evans and Melody Lacina
Designer and compositor Yvonne Tsang
Indexer Mary Mortensen
Printer's devils Maisie Tsang Choi, Miles Tsang Choi,
 Lillian Marie Wilsted

This book was composed in Minion Pro with Cronos Pro,
Gotham, and Weiss display. The paper is 157 gsm
China Gold East matte art paper. The book was
printed and bound by Asia Pacific Offset.